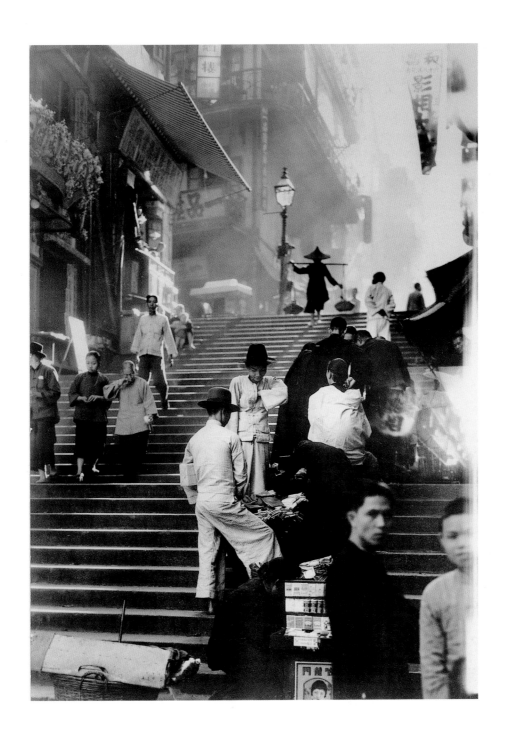

W. ROBERT MOORE | 1932 | HONG KONG *In the Far East*

NATIONAL GEOGRAPHIC

IMAGE COLLECTION

FOCAL POINT

NATIONAL GEOGRAPHIC
WASHINGTON, D.C.

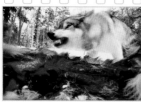
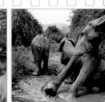

CONTENTS

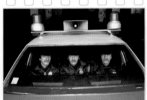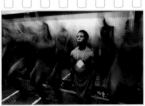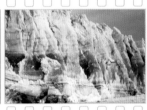

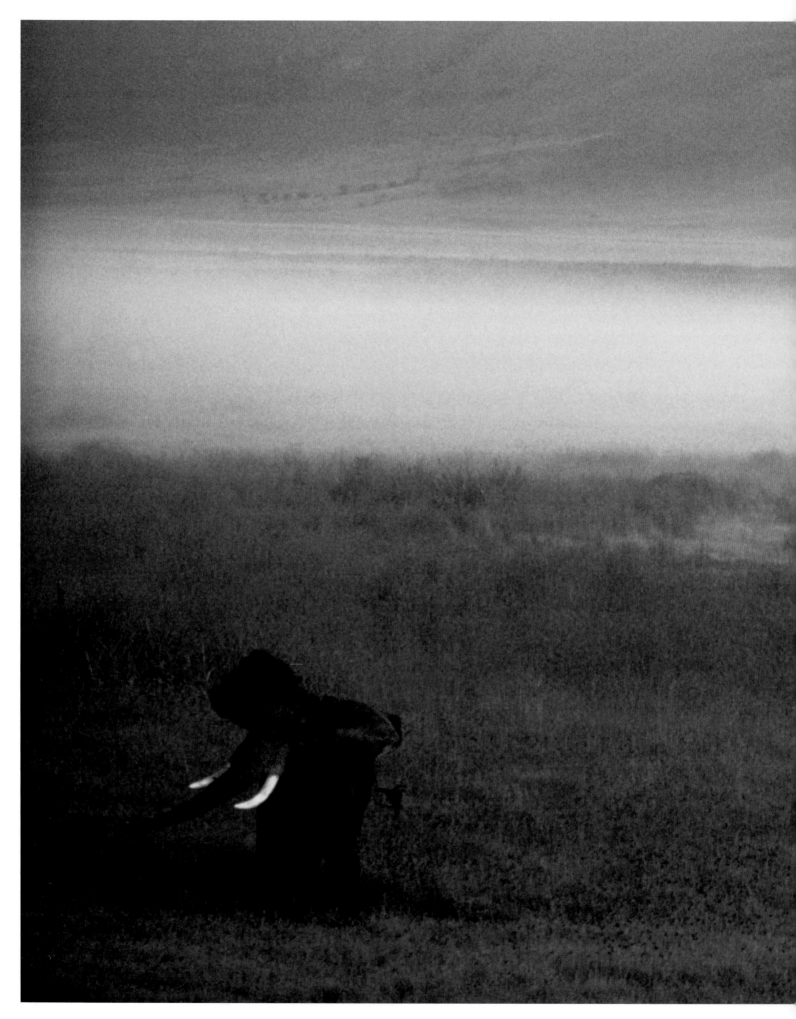

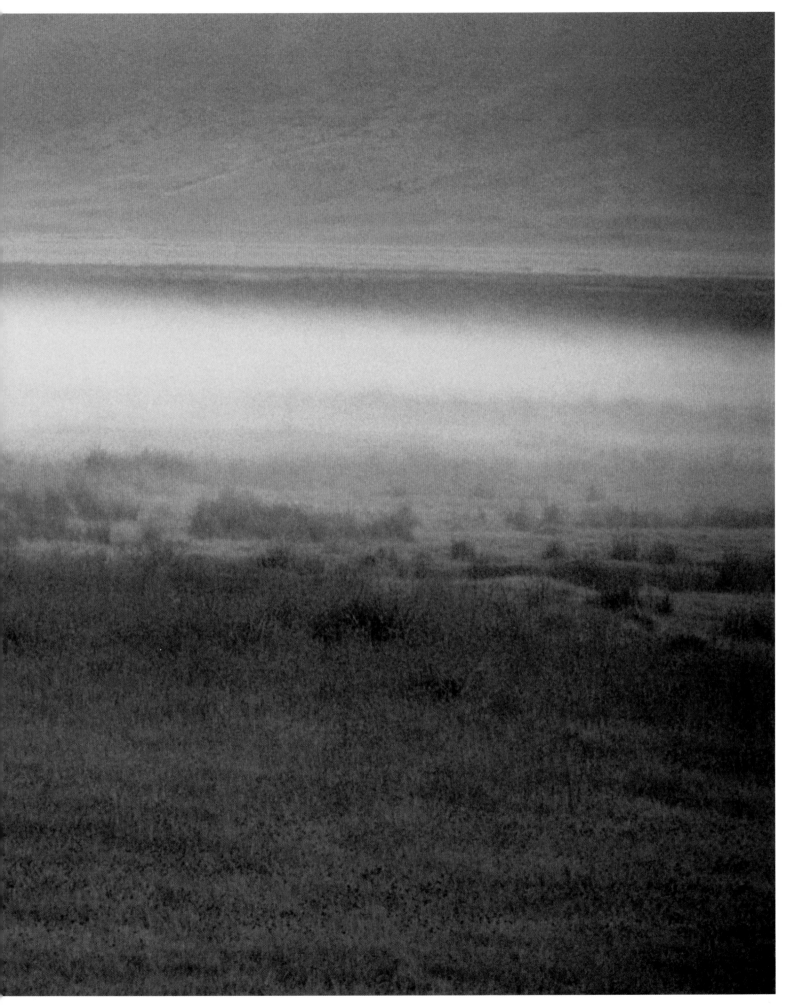

CHRIS JOHNS | 1988 | TANZANIA *In Ngorongoro Crater* 7

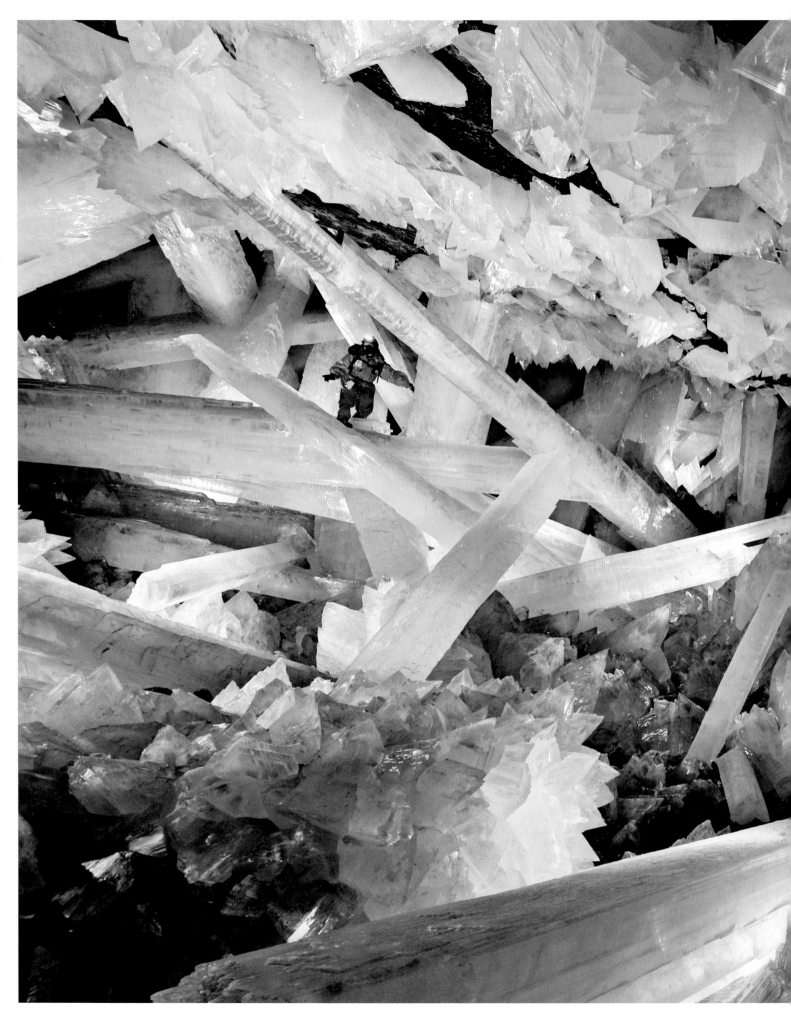

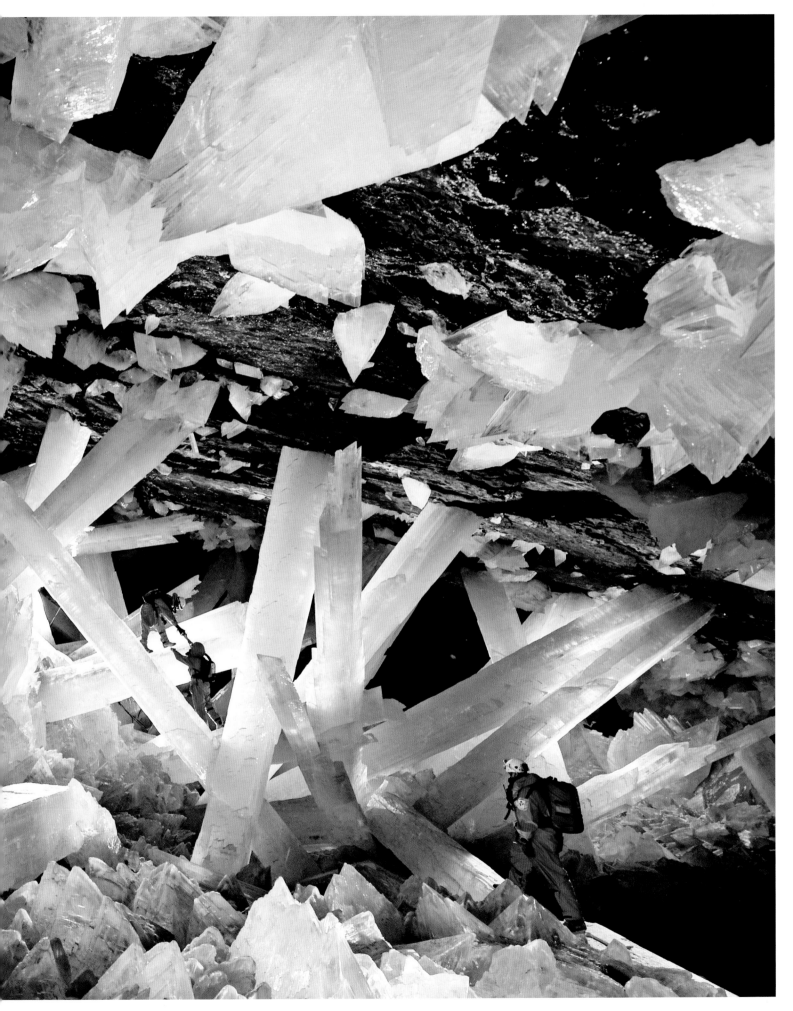

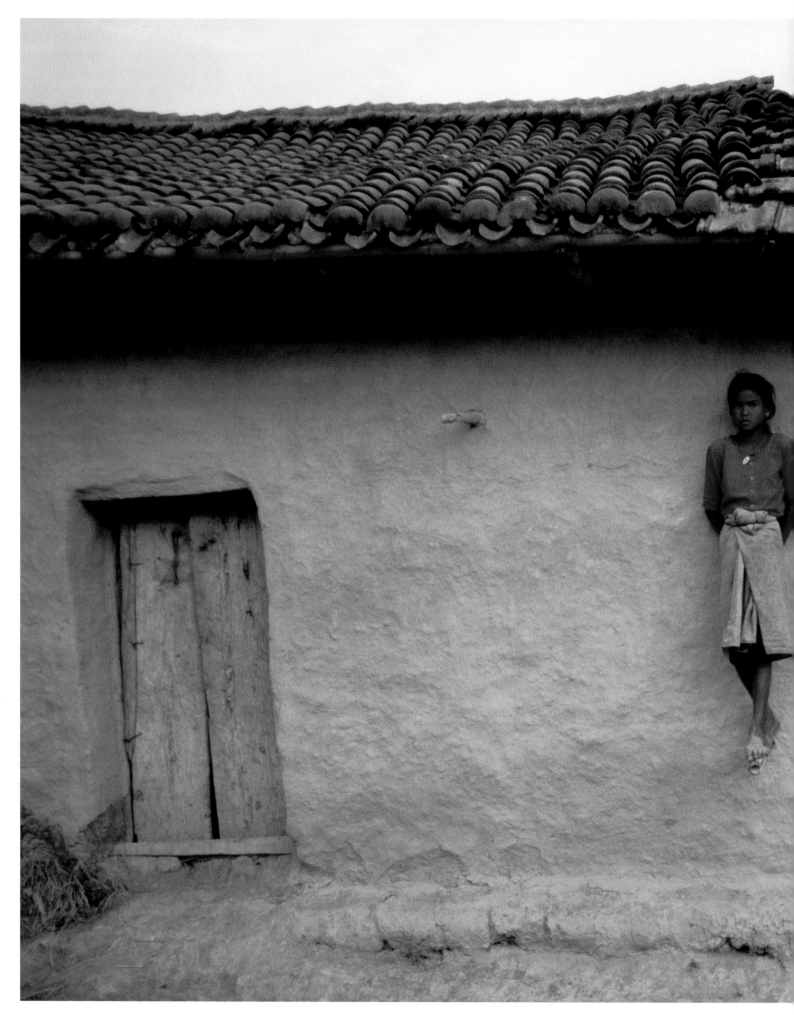

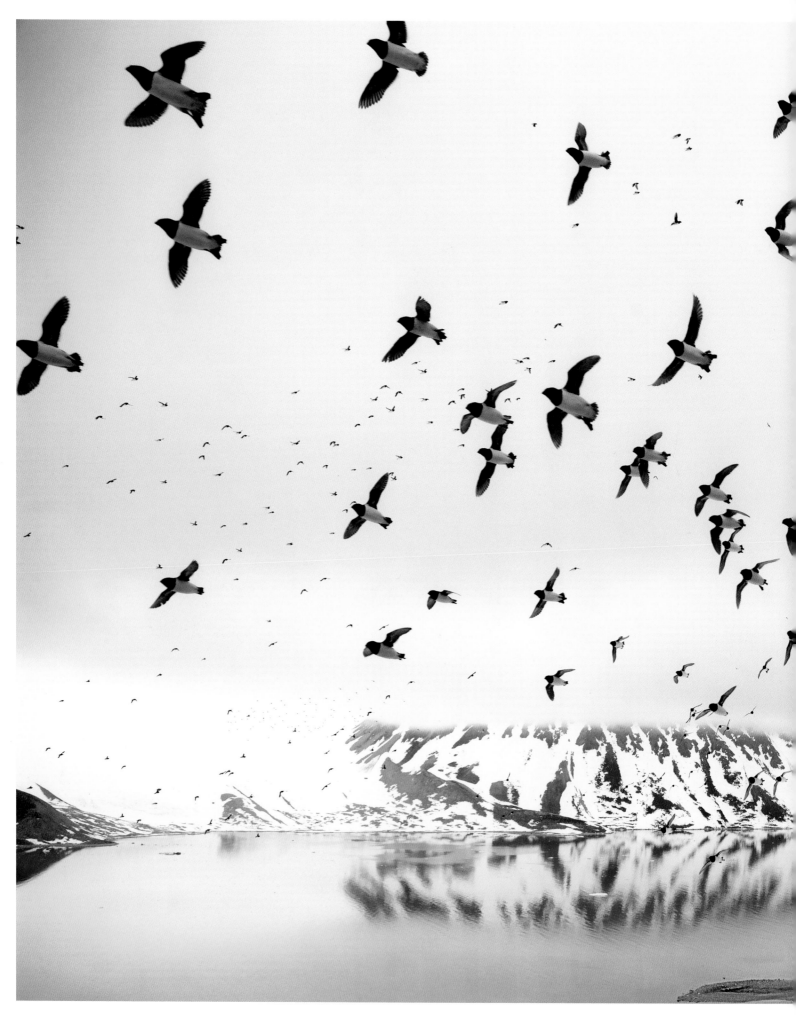

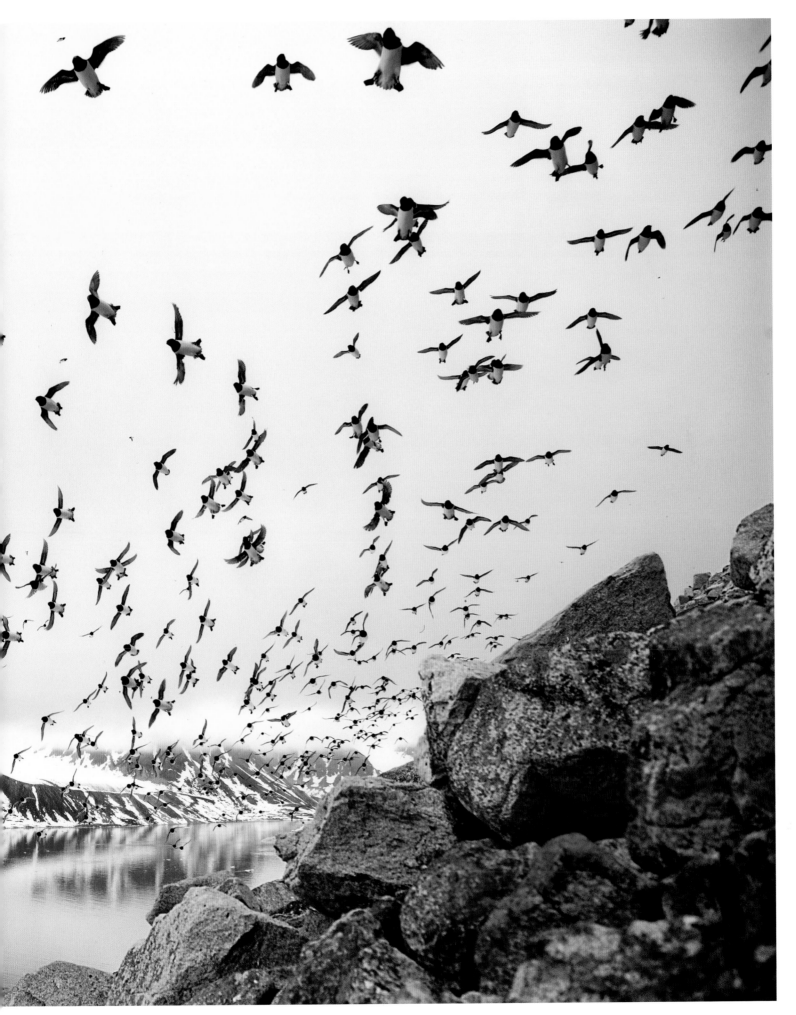

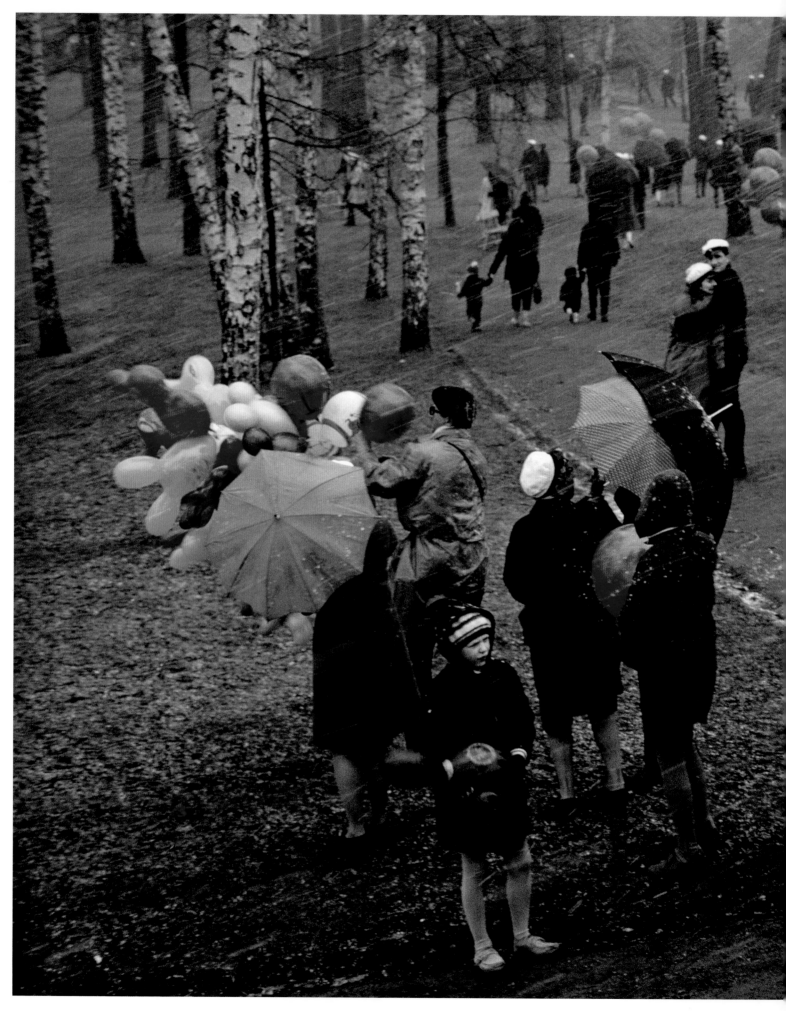

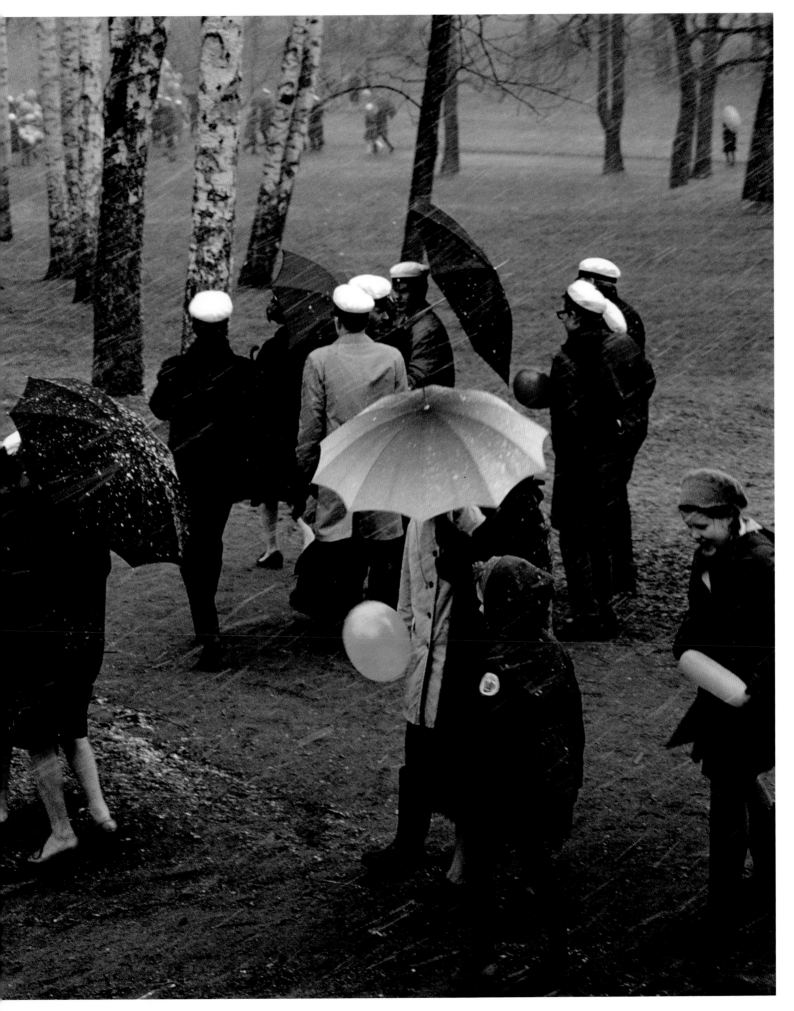

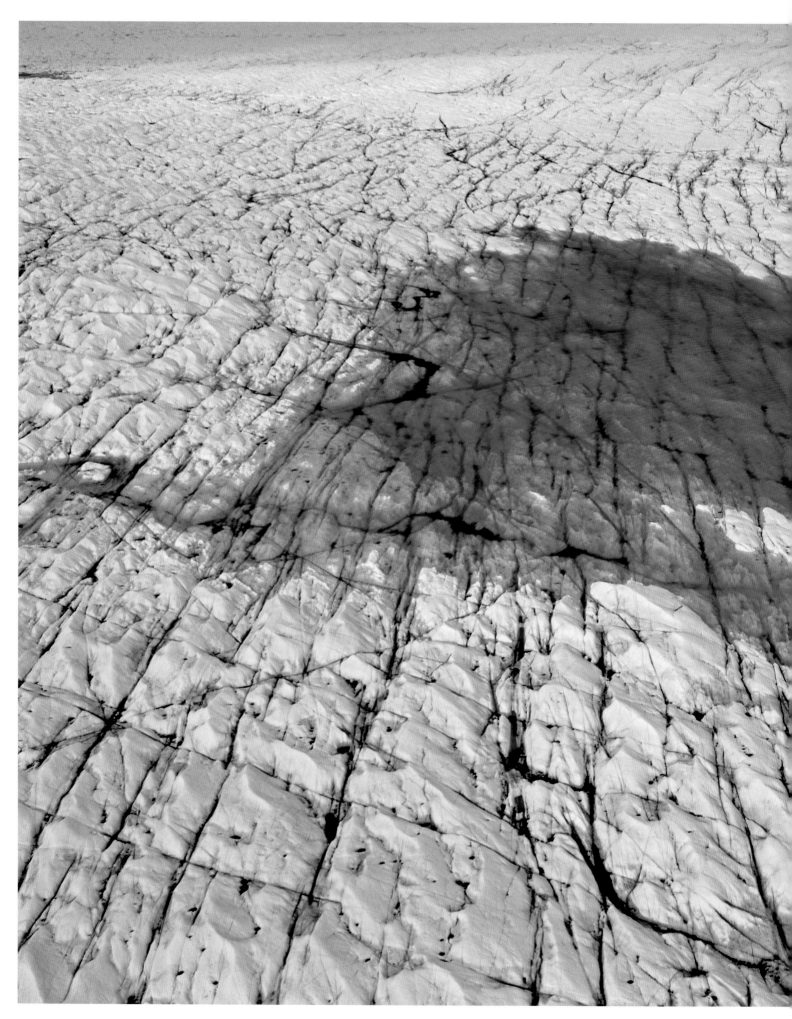

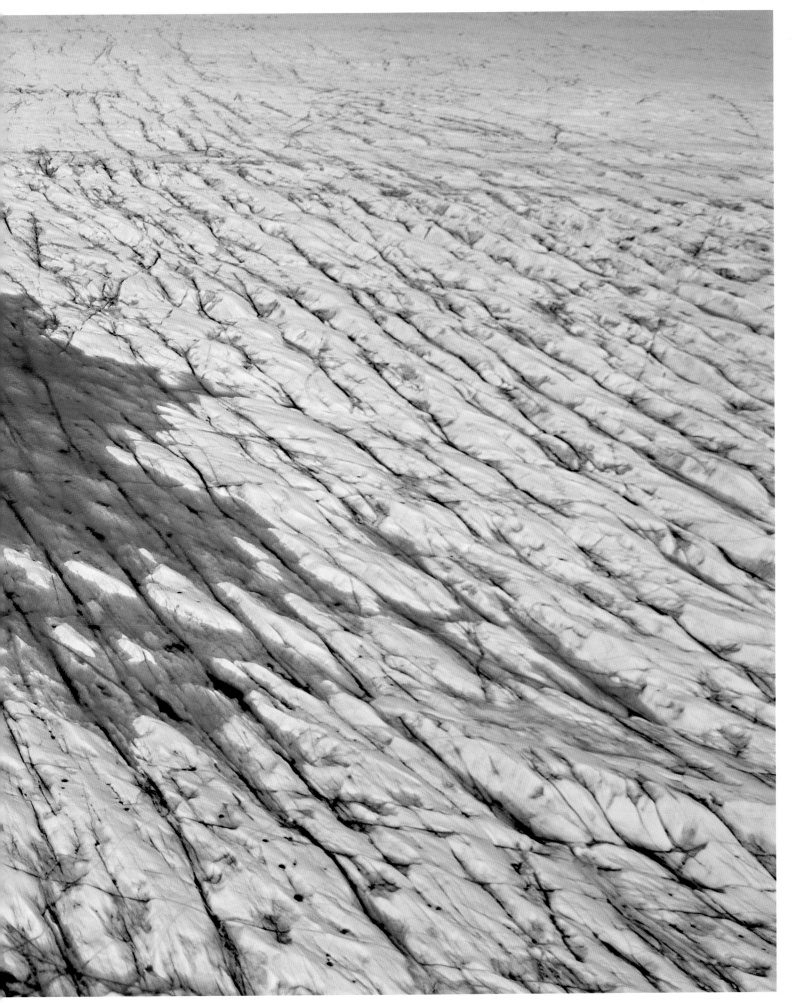

acknowledgments

Fruitful partnerships are behind virtually all major photography books, and this one is no exception. The volume you are now holding is the culmination of a special collaboration among people who love the photography and art housed in National Geographic's Image Collection.

Selecting 450 photographs to stand for some ten million, then explaining the endeavor, has been a daunting though invigorating task to say the least. Image Collection director Maura Mulvihill and her team worked generously and closely alongside our book team with the shared goal of making a book that would be thorough, accurate, and as amazing as we know the Collection to be.

Photography curator Michelle Delaney accepted our invitation to write an essay offering a historical perspective on our Collection. Illustrations editor Adrian Coakley consulted with contributing illustrations editors Bill Bonner and Steve St. John, going through tens of thousands of pictures. Art director Melissa Farris brought visual coherence to our book structure and picture selections. Mark Jenkins contributed captions and commentary throughout, and Becky Lescaze edited the text. All gave their time, insights, and enthusiasm unstintingly.

Choices had to be made and good pictures given up; it wasn't easy. Each person's work was enlarged by everybody else's. We hope you will find the outcome as wonderful as we do.

Leah Bendavid-Val

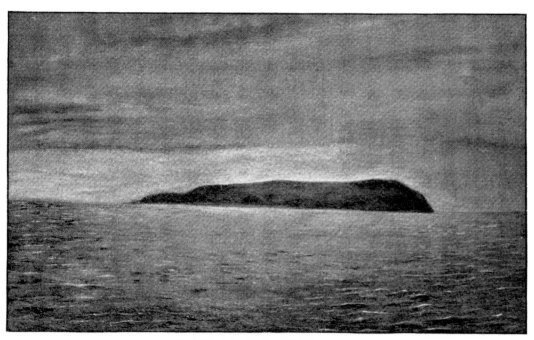

Herald Island, bearing about W. by S. (magnetic).
From a photograph by Assistant Paymaster J. Q. Lovell, U. S. N.

foreword **by Leah Bendavid-Val**

The book you hold in your hands discloses the full contents of the National Geographic Image Collection for the first time. This sprawling collection of almost 11 million images, with all its diversity, has a unique, unmistakable National Geographic personality. To do justice to it, our book tells multiple stories, personal and technical, chronological and thematic. We've singled out our Special Collections and our photographic breakthroughs. We've made room for the whimsical, the quirky, and the unexpected pictures that have, through various paths, made their way into this extraordinary archive. All together the photographs add up to a singular history of the world, concrete and suggestive, from 1890 until today.

The National Geographic Society's founders never planned to build such a large and consequential photography collection. It is safe to say that none of the 33 esteemed gentlemen-explorers who met in Washington, D.C., on a cold, damp January evening in 1888 had photography on his mind when considering the possibility of establishing a society for "the increase and diffusion of geographical knowledge."

They were all science-minded men, albeit with an irrepressible zest for adventure. Their ideas for disseminating yet-to-be-acquired geographical knowledge included lectures and meetings and a journal with a scholarly style that educated laymen could enjoy and respect.

National Geographic magazine was launched nine months after that January meeting, in October 1888, and was an immediate though modest success. The first photograph appeared in July 1890 *(above)*. It was of Herald Island, a small, rocky piece of land isolated in the Arctic's Chukchi Sea. The island loomed darkly on the magazine page like a whale floating in a watery expanse.

Alexander Graham Bell, the Society's exuberant, impetuous second president, loved photography, and so did his reserved 23-year-old son-in-law Gilbert Hovey Grosvenor, the magazine's first full-time editor. In a letter dated March 5, 1900, Bell famously urged Grosvenor to publish "more dynamical pictures—pictures of life and action—pictures that tell a story." The young man needed little encouragement. The Society's funds were scanty in the early days, and Grosvenor took advantage of every opportunity to acquire photographs at low or no cost. He loved to travel, uncomfortable as that was in those days, and he took

pictures with relish everywhere he went, using a cumbersome 4A folding Kodak camera. He published some of his own pictures in the magazine but looked elsewhere for images as well. He obtained inexpensive or free pictures from galleries and from serendipitous encounters when he traveled. Back home, he appealed for photographic donations at every opportunity, from friends he ran into, clubs he belonged to, and from all branches of the U.S. government. (Government file drawers were and still are repositories for photographs that go all the way back to the Civil War, and all are in the public domain.)

Grosvenor collected broadly in order to have a wide variety of choices on hand to publish when and if the need arose, but many of the pictures he had coaxed out of his contacts never made it into print. His publishing policy was decidedly different from his acquisitions policy. He was committed to displaying photography as an objective, potent eyewitness to every kind of human endeavor. In January 1905, the magazine showed readers 11 dramatic photographs of the Tibetan capital, Llasa, taken by two explorers who offered them free of charge. No one had seen such pictures before. A 1906 issue featured 74 revealing "flashlight photographs" of wildlife at night by Congressman George Shiras III. Publishing these and other pictures were bold moves at the time. The readership loved it, but board members did not. Two of them resigned. "Wandering off into nature is not geography," they declared, and they were enraged by the idea of reducing their journal to a mere "picture book."

Grosvenor prevailed, and by 1908 photographs appeared on more than half the magazine's pages. National Geographic's strict publishing policy called for documentation unencumbered by the personalities of the photographers. The two seemed separable in photography's early days. The pictures had to be about geography, defined simply as "the world and all that's in it." The magazine had to stay away from politics, controversy, and subjectivity. This was a policy that excluded important and interesting topics but opened the door for deeper coverage of others.

As a science-minded photography lover, Grosvenor also wanted to break new technical ground. He did this by investing in printing technologies and in the development of films, lighting, and gadgetry as needed. National Geographic's contribution to color publishing stood out, and the archive swelled. Editors commissioned drawings and paintings for magazine stories when they deemed photographs and text insufficient, and an art collection grew quietly and stunningly alongside the photographs.

Over the years a deep and lasting culture of photography developed at National Geographic. A photography staff was put in place, and photography regulars contributed their individual visions and talents. New talent was welcome. Technical support was generous and responsive to the imaginations and plans of photographers and editors. Photographers with big dreams hoped for assignments that would allow them to work in exotic places, witness never-before-seen natural and cultural events, and create photographs that would surpass everything done before. Despite long-held principles of neutrality, National Geographic has increasingly made room for diverse styles and topics. Photographers with hugely different interests and approaches have found a home and a niche in the culture. The Geographic has contributed to and benefited from new social realities, yet has remained devoted to its original mission.

This volume presents the facts and also the character and spirit of National Geographic's photography holdings. Michelle Delaney, curator of photography at the Smithsonian's National Museum of American History, offers a view from outside the collection looking in, and Maura Mulvihill, a vice president and director of the collection, gives us her perspective from inside.

Photography has been around long enough now for the world to be awed repeatedly by technical innovations and for us to witness dramatically changing tastes and values. But as these pages show, good pictures somehow stay enigmatic and grow more meaningful with time. It is this and everything yet to be discovered about the ever changing "world and all that's in it" that keeps the photographic work going forward as creatively and passionately as ever.

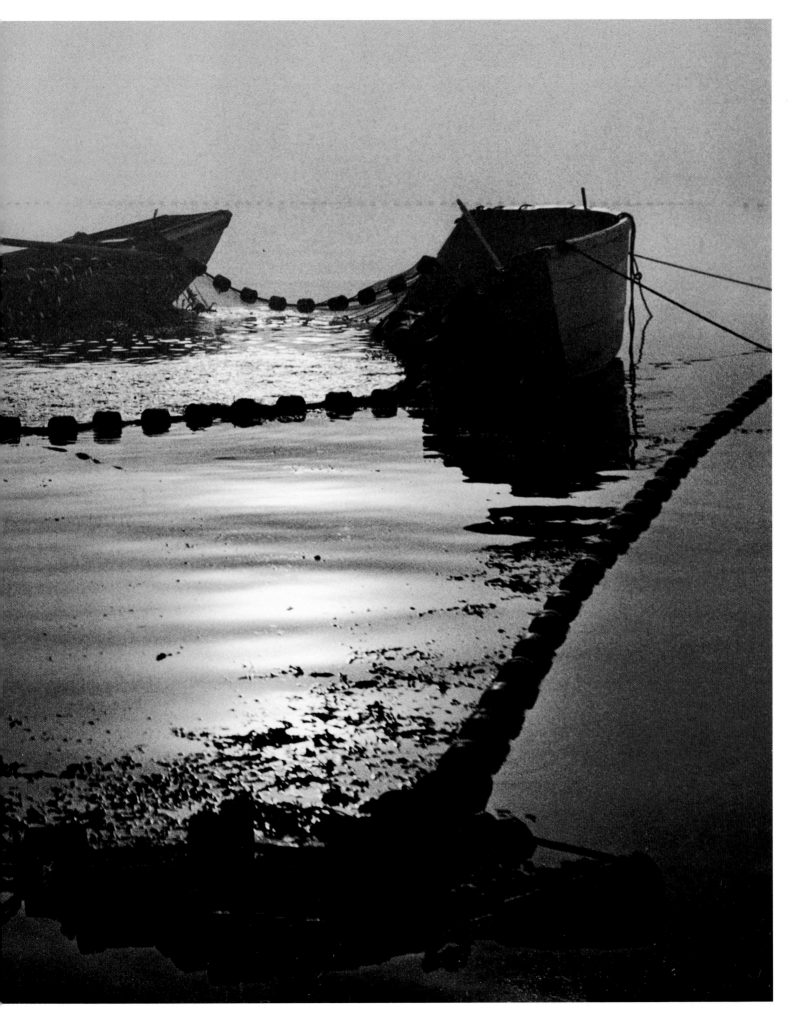

the national geographic image collection: a historical perspective by Michelle Delaney

Washington, D.C., is home to many of the world's foremost photographic history collections. The first to come to mind usually are those collections in the Smithsonian museums, the Library of Congress, the National Archives, or the National Gallery of Art. Each holds millions of images documenting national and international art and history. These collections record the development of photography as a tool of the sciences and the arts. But, often forgotten in the midst of the vast collections on the National Mall is another special photography collection located in cold storage underneath the headquarters of Washington's National Geographic Society. The quality and diversity of the Geographic Image Collection is quite outstanding when compared to the others mentioned. The Society's magazine and ultimately the broader Image Collection document more than a century of our world, a global perspective on change. The Geographic photographers and special collections acquired provide the visual representation of our world—the exploration, wildlife, science, peoples and cultures—and its changing nature.

The strength of the National Geographic Society Image Collection begins with the dedicated staff caring for it throughout more than a hundred years, collecting and commissioning photographers' work to document our planet. What an indulgence for a history-of-photography curator to be asked to participate in presenting the Geographic collection in historical perspective. Immediately, memories come rushing back to me of lengthy afternoon discussions with my friend and longtime Geographic photographer Volkmar "Kurt" Wentzel. How I wish he were still with us to witness the further study and appreciation of his beloved Geographic Collection. Volkmar and I spent hours discussing his long Geographic career spanning almost 50 years (1937-1985), his assignments, travels, and, of course, his never-ending mission to preserve the images once labeled for discard by Geographic in the 1960s. With his passing in 2005, the historic images he saved from ultimate

destruction have been reincorporated into the Geographic Image Collection. Some of the photographs were from his own 1930s "Washington at Night" series, and some dated back almost a century from Gilbert Hovey Grosvenor's early tenure as president and photographer for the Society. Now with almost 11 million photographs of various subjects and formats, the National Geographic Society boasts one of the preeminent image collections in the world, if lesser known than most American museum collections.

My full introduction to the depth of the Geographic Image Collection came in 1995 when Volkmar Wentzel and I met to discuss my research project and planned exhibition on the beginnings of the Smithsonian's own Photographic History Collection, now a unit within the National Museum of American History. We reviewed together 50 photographs acquired from the 1896 Washington Salon and Art Photographic Exhibition held at the city's prestigious Cosmos Club. This first acquisition of art photography for the Smithsonian was arranged by its first photographer, Thomas Smillie, whose efforts to collect photography for the Smithsonian's United States National Museum dated back a decade to the 1880s. Smillie's professional and personal relationships with Washington's elite men of the sciences and the arts included the gentlemen and explorers who founded the National Geographic Society. Volkmar introduced me to the Geographic side of the story. His lifelong interest in the history of photography, the significance of the Geographic Image Collection, and our common interest in the intersections of all things photographic in our adopted city of Washington, D.C., cemented our ten-year friendship.

The Geographic and Smithsonian photography collections are most closely linked in their late 19th-century beginnings, and the efforts employed in building premier history-of-photography collections. However, while the Smithsonian may be better known for its photography research collections and art holdings, the Geographic Image Collection remained for years a vastly underutilized resource. The two institutions began on parallel paths with several milestone dates in common. In 1888, the same year Smillie began collecting photography and related equipment for the Smithsonian, the National Geographic Society was founded. Soon afterward, the Society began publishing its journal. Less than a decade later, both institutions acknowledged the growing importance of photography in American society by starting historic collections. In 1896, the Smithsonian officially established a Section of Photography within the Graphic Arts Collection of the U.S. National Museum. Smillie was given a second title, honorary custodian of the Section of Photography, and thus initiated what is today the oldest collection of photography in an American museum. Geographic utilized the new halftone printing process to add photography to the magazine beginning in 1896, a pivotal move that changed the nature of the magazine and collecting efforts of the Society forever.

Turn-of-the-century Washington, D.C., was a dynamic place embracing all the possibilities—the science, technology, and art—of photography, a medium just 60 years old at the time, and ever evolving. The Geographic and Smithsonian each embraced the international nature of the field, collecting the best examples by professionals and amateurs advancing photography. The local D.C. community was thriving with camera clubs and a small circle of wealthy men experimenting in the newest technology and art.

There was one individual instrumental in the beginnings of both the Geographic and Smithsonian collections: explorer John Wesley Powell. Both organizations fostered strong ties with the U.S. Geological Survey photographers under the leadership of Powell. As one of the original founders of the National Geographic Society, Powell understood the powerful potential of photography for government studies, as well as general public interest. Photographs from Powell's earliest Surveys

of the American West of the 1870s were added to both collections. Powell was singularly the most important guide in these early efforts toward collecting of photography as visual documentation of our country and its undocumented West. He brought to Washington, D.C., and the attention of the Geographic and Smithsonian administrators and collectors, the best photographers working for him on the U.S. Geological Surveys, including William Henry Jackson. Americans were introduced to these western scenes through publications such as *National Geographic* magazine, as well as to published stereograph images made three-dimensional in special viewers, a very popular family pastime in the late 19th century. Later in his life, Powell led the U.S. Bureau of American Ethnology. There he directed a growing photography collection that eventually transferred important images to the Smithsonian's Department of Anthropology and Section of Photography.

The new medium of photography was enthusiastically collected by many institutions in Washington, and collected earlier for museums and societies here than in most other U.S. cities. The Smithsonian's earliest collecting included Samuel F. B. Morse's 1840s daguerreotype camera and equipment; Eadweard Muybridge's 1888 Animal Locomotion Studies and his patent models; select cameras and apparatuses representing the fast-advancing camera and printing technology, from manufacturers like George Eastman of Rochester, New York, and G. Cramer of St. Louis; as well as the images from the 1896 Washington Salon documenting the new movement in American art photography. Yet, Smillie's Smithsonian unit remained limited in collecting when compared to the Geographic's.

The National Geographic Society launched its image collection so quickly and aggressively as to potentially not even realize the significance of building its own archive. The standard for excellence in selection of photographs and stories to publish determined criteria for the earliest collecting and commissioning of photographs for the Geographic. The images made during Robert E. Peary's North Pole expedition in 1906, Gilbert H. Grosvenor's photographs of early flight experiments in 1907, and technical achievements in early color and underwater photography processes are early acquisitions of note within the first decades of collecting and printing for *National Geographic* magazine. The Geographic Image Collection has always been considered primarily an illustrations collection by most Geographic staff, as well as some outside curators of photography, despite numerous exhibitions and books to counter this notion. As Volkmar Wentzel adamantly voiced throughout his life, the Geographic holds a photography collection of international museum quality, significant to the history, science, and art of photography, from the late 19th century forward. Even a short research visit or tour of the Geographic Image Collection attests to the quality and diversity of the special collections within the archive.

The largest of the special collections in the Geographic's holdings is certainly the Autochrome collection, numbering close to 15,000 images. The Autochrome was introduced to international mass markets by the French brothers Auguste and Louis Lumière in 1907. It provided photographers the first commercially viable process for capturing their work in natural color, but with some restrictions. This process was slow and cumbersome; photographers needed to transport heavy wooden cameras, tripods, and trunks of equipment on assignments. The glass color transparencies were fragile and light sensitive, and not very good for exhibition use, as the leading art photographers of the period determined. But, the Lumières' use of dyed potato starch grains in the emulsion mixture did illicit subtle colors and beautiful pictures. Many leading art and history museums have collections of Autochromes, but the Geographic Image Collection holds one of the foremost collections of these images dating from their invention to the end of their production in the 1930s.

The Geographic first published an Autochrome in the magazine in 1914, the first natural color image printed in the journal. It was "A Ghent Flower Garden" by Paul G. Guillumette, who began experimenting with the Lumière Bros.' Autochrome process in 1912. He was a pioneer in the use of early color photography. Guillumette's daughter, Doris, meticulously kept most of her father's collection of Autochromes, stereo-autochromes, later Kodachrome slides, and personal notes together until donating them to the Smithsonian's Photographic History Collection in 1995. The notes describe how the U.S. division of the French Lumière Bros. Company was so impressed with his work it hired him to produce samples for world distribution, and later to run its color department. Guillumette was in contact with government agencies, institutions, and professional and amateur photographers. Some of the individual contacts he made through his position at Lumière Bros. included Geographic's Alexander Graham Bell and master photographers Alfred Stieglitz and Arnold Genthe. But, it was another contact at the Geographic, Gilbert H. Grosvenor, who made the most lasting impact on Guillumette's career, with the decision to publish color Autochromes in the Geographic magazine.

The prospect of replacing illustrations in the magazine with natural color photographs interested Grosvenor. In 1913 Guillumette traveled extensively in Europe photographing scenery and the Ghent World's Fair. Subsequently, one image from the trip was selected by National Geographic for the July 1914 issue, a scene of the Horticulture Hall. The accompanying caption concludes, "The picture makes one wonder which the more to admire—the beauty of the flowers or the power of the camera to interpret the luxuriant color so faithfully." For many years Guillumette retained his original fur business but eventually his passion for photography, especially color, led him to pursue his interest full-time. Doris Guillumette understood her father's inspiration to be more than an attempt to conquer the technique of color photography, "as it had the potential of a new art form."

Guillumette, like many photographers whose work was selected by the Geographic, chose to explore foreign lands, especially the European countries of France, Italy, Switzerland, Belgium, and Holland. He was ever curious of the natural scenery. On rare occasions Guillumette included people in his photographs. Several in the Smithsonian's collection are self-portraits. Doris Guillumette recalls fondly, "Father was convinced that technique, artistry, and inspiration were all needed to make a truly great picture." Guillumette's legacy in color photography attests to that. Yet, much as his contemporaries in the art photography movement hoped the Autochrome process would prove lasting as the format to bring color pictures to museum and gallery exhibitions, it did not. These images were too light sensitive and fragile. But there also remain 40 identified Guillumette Autochromes in the Geographic Image Collection. For decades, *National Geographic* magazine remained the premier journal to publish these unique color—and now historic—images. Today, the thousands of unpublished Autochromes collected by Geographic are among the priceless images needing further study by their staff and researchers.

National Geographic's successful magazine and effective use of photographs to engage readers led to the creation of a photography lab and the hiring of staff photographers at the Society in the 1920s and 1930s. The photographers were considered explorers in their own right, populating the magazine with its own style of technical and artistic work. Charles Martin, the first man hired to staff the lab, later became the chief photographer for Geographic. His duties allowed for special assignments, pushing the limits of existing photographic technologies and color photography. In the late 1920s, Martin collaborated with Dr. W. H. Longley of Goucher College to make the first underwater Autochromes of fish species, near Dry Tortugas, Florida. Longley first used his Graflex underwater housing with a 4x5-inch Auto-Graflex camera for marine photography in 1918. For the expedition to the Dry Tortugas, Longley not only planned to use the watertight camera again, but this time, with Martin's assistance, the team discharged a pound of magnesium flash powder floated on three pontoons and used a reflector to light the underwater scene below. Five of their successful photographs illustrate the article, "First Autochromes From the Ocean Bottom," by Longley in *National Geographic* magazine, January 1927. The pair produced a historic series of images now in the Geographic Image Collection. The Graflex camera outfit—underwater housing, camera, and one plate holder—made by the Folmer and Schwing Department of the Eastman Kodak Company, Rochester, New York, was donated to the Smithsonian's Photographic History Collection in 1940 by U.S. National Museum curator Waldo L. Schmidt, a specialist in marine invertebrates. Both the Geographic and Smithsonian greatly increased efforts toward building their photography collections in the 1940s. And, as National Geographic reached its 50th anniversary, additional staff photographers were hired, further establishing the commitment to visual storytelling. Significant time and money were allotted for extended assignments abroad.

In the late 1930s, a young Volkmar Wentzel was encouraged to show his "Washington at Night" series of photographs to staff at National Geographic. The images so impressed a personnel specialist that Wentzel landed a staff position. While Volkmar's first personal project was to photograph his adopted home of Washington, D.C., he thrived on the travel available to him through the position at Geographic. He traveled the world for the next half century. Influenced by such masters of photography as Arnold Genthe, Brassaï, and D.C.'s own Frances Benjamin Johnston, Volkmar used his camera as a tool of exploration and education. His photographs of the United States, Europe, and Asia portray life in the mid-20th century. Beginning his professional career at the height of the Great Depression, Volkmar introduced readers of *National Geographic* magazine to scenes of everyday life in the nation's capital, rural America, and life abroad over the course of the next many

decades. His early photographs establish a visual landscape of the mid-Atlantic region, and a cultural identity of its citizens, eventually becoming what he called his "Vintage Americana" series, dating 1935-1960. However, the biggest assignment of his career came with the overwhelming task to "Do India." He spent two years, 1946-48, traveling throughout India and Nepal documenting many never-before-seen lands and cultures. The experience was life-altering. Volkmar had the advantage of retrofitting a former ambulance into a National Geographic Society van and portable darkroom, using it throughout his long journey. He used smaller format cameras on tripods and handheld cameras to produce eight albums of photographs now residing in the Geographic Image Collection. Hours can be spent turning the pages of history you'll find within these albums. Volkmar befriended a nation, and the results show a nation in transition, and people as curious of the foreign photographer as he was of them.

The second half of the 20th century saw Geographic photographers focused on more stories and documentary photo essays of a photojournalistic nature—including Jodi Cobb's Saudi women; Nick Nichols's elephants and gorillas; Jim Blair's views of Eastern Europe and Africa; David Alan Harvey's photographs from Europe and the Americas; and Brian Skerry's digital work in New Zealand waters. The photographers captured images of countries in modern transition. The Geographic Image Collection holds a visual history of cultures underrepresented in the photography collections of U.S. national art and history museums. The collection illustrates the plight of cultures and individual citizens living day-to-day through apartheid, political upheaval, drug wars, and the realities of daily life, far removed from the comparative metropolitan lives of most readers of *National Geographic* magazine. This shift to an increased focus on photojournalistic topics and world issues did not preclude the magazine's continuing to commission stories and photographs of more traditional Geographic subjects, such as land and wildlife. Editors just expanded the capacity (and the Geographic Image Collection) to document our world more fully. Longtime Geographic photographers Blair and Harvey are just two examples of the many dedicated staff photographers and freelancers who continue to provide the Geographic with the poignant and harsh realities of the world.

In 1988, the Geographic celebrated its hundredth anniversary, honoring the outstanding accomplishments of the Society, and printing a special issue of the magazine charting its own history over one century. The anniversary issue is rich with the history of photography; many images are republished from core special collections of the National Geographic Society. Starting with Alexander Graham Bell and the Grosvenor men, and continuing with the talented men who headed the illustrations editorial office and the photography lab, the Geographic Image Collection has benefited from the clear and ever-present notion that photography is the best medium to present subjects most often covered by the magazine—exploration, science, wildlife, and cultures. Geographic has encouraged photographers to push the limits of technology, and their own vision for a story, from the first expeditions of the 1890s to the present. The result is most often success. This is evident among the millions of images found in the massive archive housed in the National Geographic Society headquarters in Washington, D.C.—millions of photographs that are rarely if ever seen, but preserved with meticulous care for future research and publication. Whether a glass-plate negative, an early color Autochrome, a Kodachrome transparency, 35mm negative, panorama, small-format print, or new digital file, the photographers' work found in the Geographic Image Collection represents images exploring international history and art. Previously curators may have had better access to the other long-standing American national photography collections, but this is no longer the case, and none should ignore the hidden treasure of the National Geographic Image Collection.

EXPLORATION

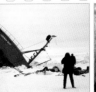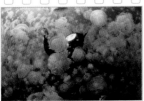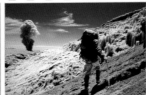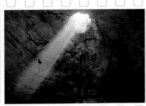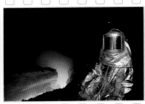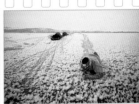

"THE PHOTOGRAPHY CRAZE IS IN FULL SWING," Robert Falcon Scott scribbled in his journal in August 1911, shortly before departing the cozy hut on the edge of icebound Antarctica for his fateful journey to the South Pole. "Ponting's mastery is ever more impressive, and his pupils improve day by day; nearly all of us have produced good negatives."

Producing good negatives, according to a tenet of those times, was the goal of all good expedition photography, the reason why the brass-bound, hardwood camera and all of its appurtenances—tripods, glass plates, plate holders, processing chemicals—formed as essential a component of one's kit as any compass, barometer, or specimen box. As one devotee advised would-be explorers, good negatives offered the "only trustworthy means of obtaining pictorial records" of a journey.

Good negatives and prints and color transparencies and now digital files—having sponsored exploration for well over a century, the National Geographic Society has amassed a splendid collection, ranging from the days of Scott and Peary to the space program, of such trustworthy images. They are the ones that helped instill a sense of wonder at those enchanted realms above, below, or otherwise beyond the pale of ordinary life: the Poles, the deep sea, the moon. They reflect that hopeful time when men and machines and futuristic domes cropped up in these unlikely places and civilization seemed on the verge of colonizing alien frontiers. And for every depiction of audacity, of people scrambling, scaling, or cresting some obstacle, there is an image of people sampling, weighing, measuring, surveying—informing us that even in these brave new worlds, human endeavor was present in all of its manifestations.

Until it reached its limits, that is. There are places that even the most stalwart hero cannot go, and there the camera has become our ultimate explorer. Space-based telescopes and unmanned probes scattered throughout the solar system now transmit a steady stream of data—modern "negatives"—that through the alchemy of digital processing, yield sublime images of stupendous marvels at which all of us today can but gaze in wonder.

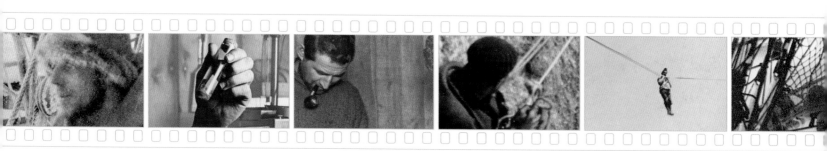

the early photographs

IT WAS CALLED THE HEROIC AGE OF EXPLORATION, those years before mechanization largely replaced heart and muscle; it might well be called the heroic age of expedition photography as well. For someone had to be the first to hoist those heavy cameras up the pinnacled crags or onto the ice floes and make those images that we find so evocative today.

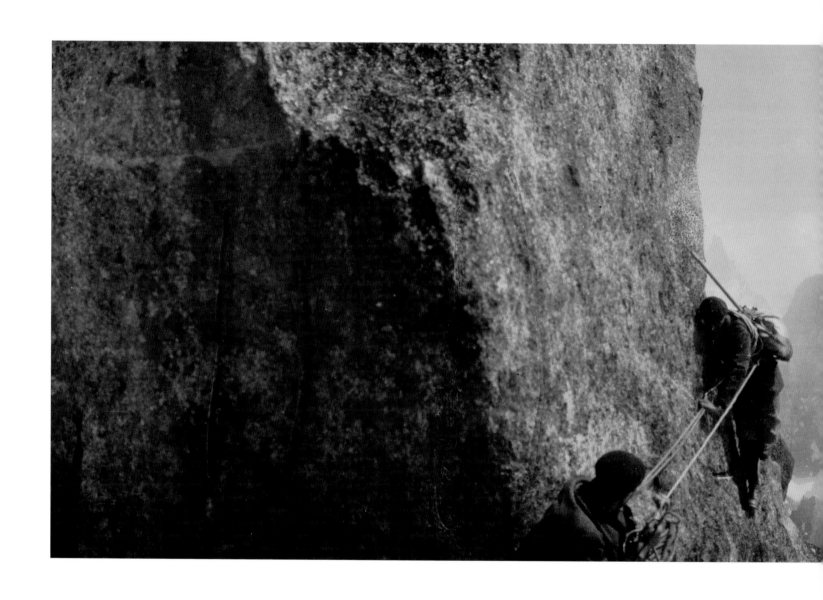

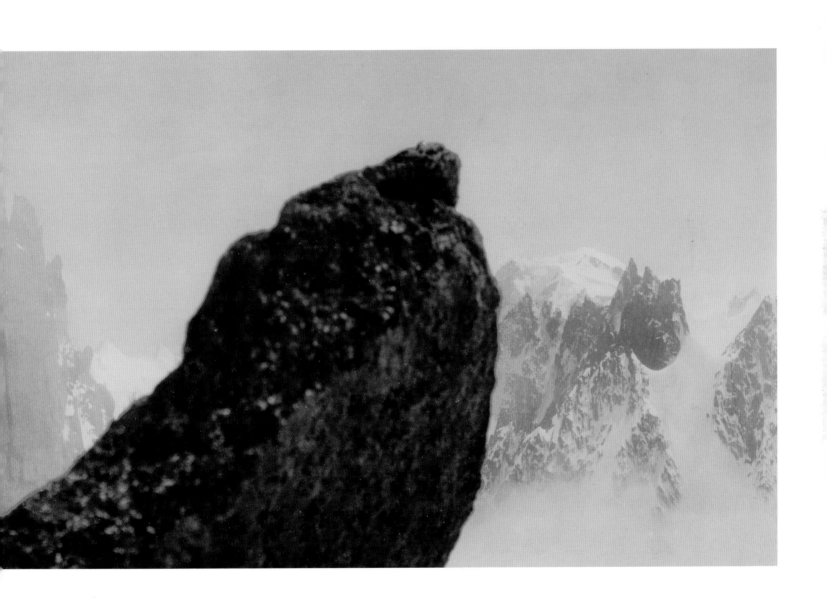

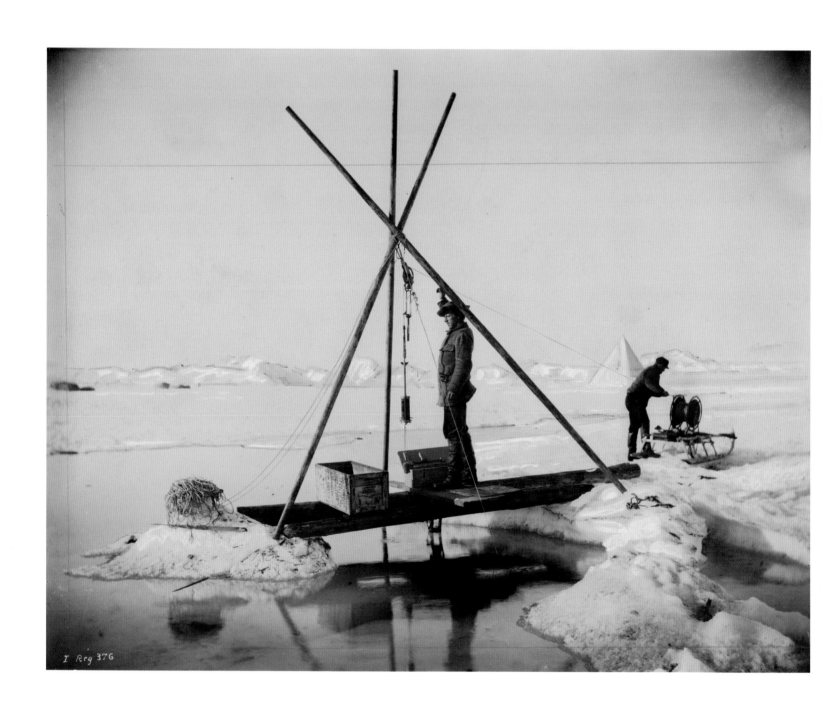

FRIDTJOF NANSEN | 1894 | ARCTIC OCEAN *Scientific sampling in the Arctic*

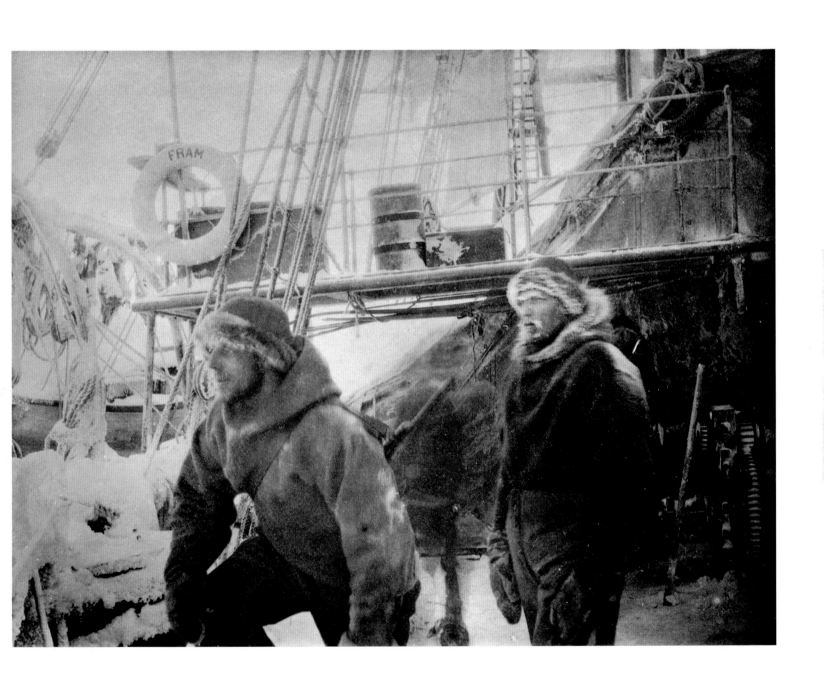

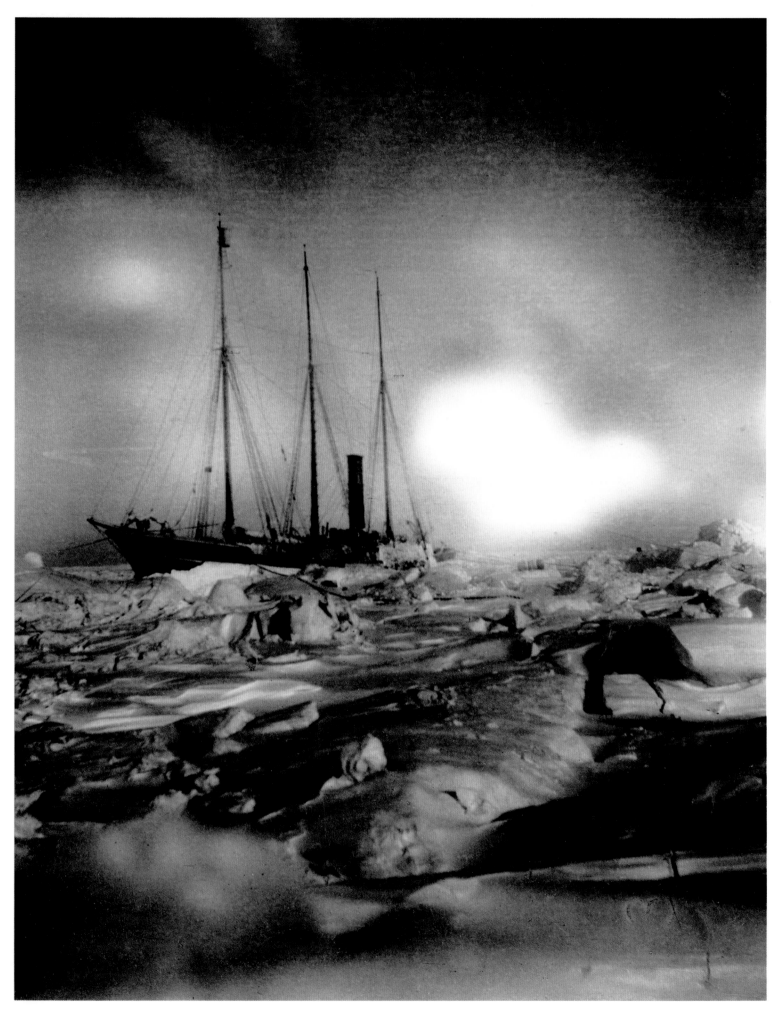

PEARY ARCTIC EXPEDITION **|** 1905-6 **|** ARCTIC OCEAN *Icebound beneath the aurora*

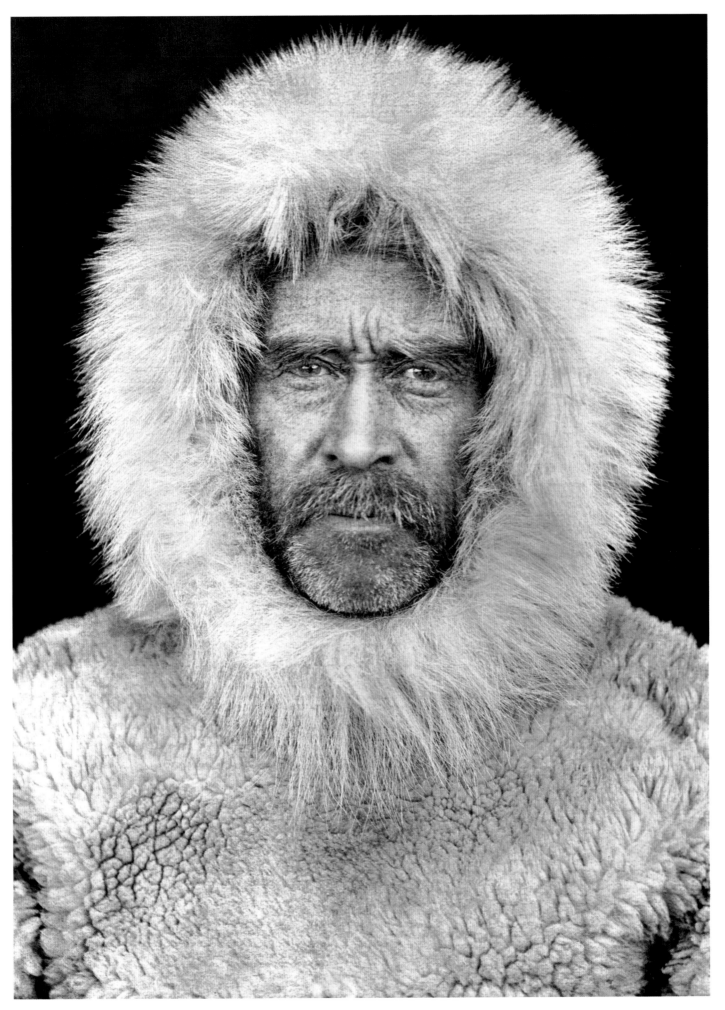

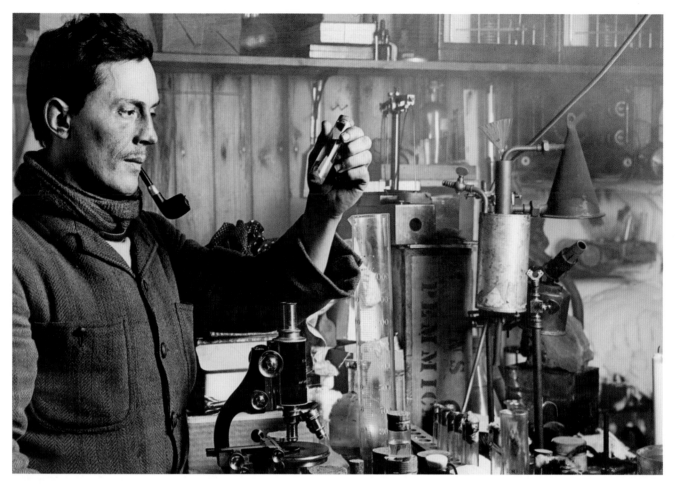

HERBERT G. PONTING | 1911 | ANTARCTICA *Dr. Edward Atkinson in his lab*

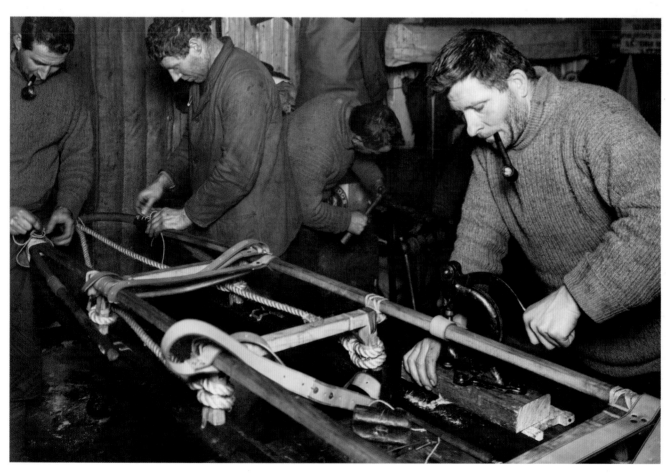

HERBERT G. PONTING | 1911 | ANTARCTICA *Putting a sledge together*

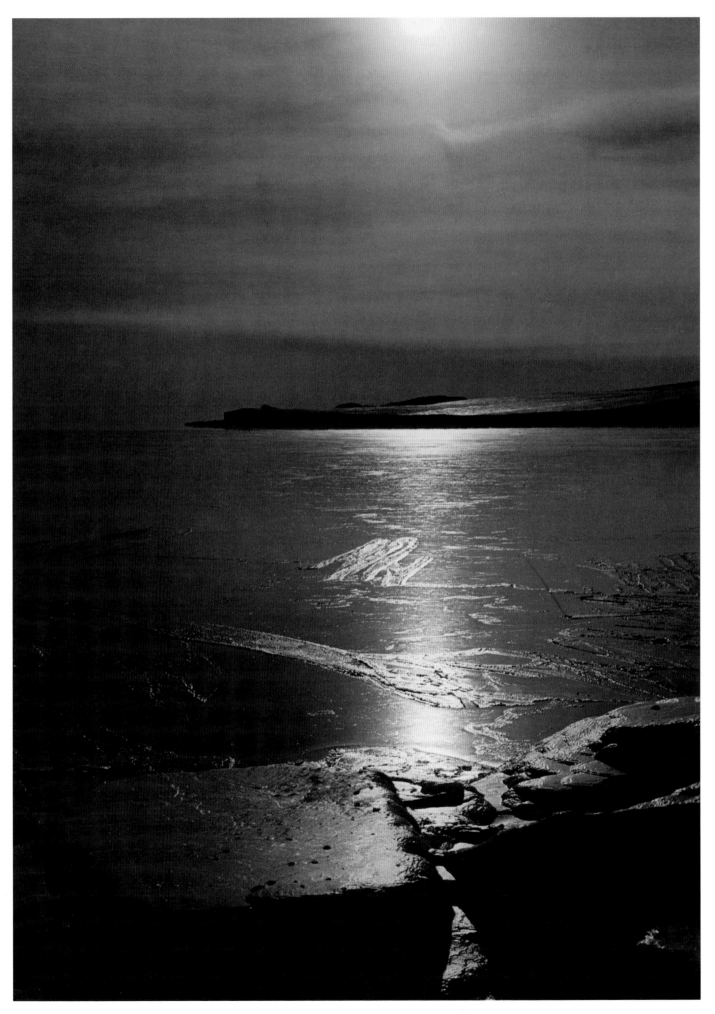

HERBERT G. PONTING | 1911 | ANTARCTICA *Twilight over McMurdo Sound*

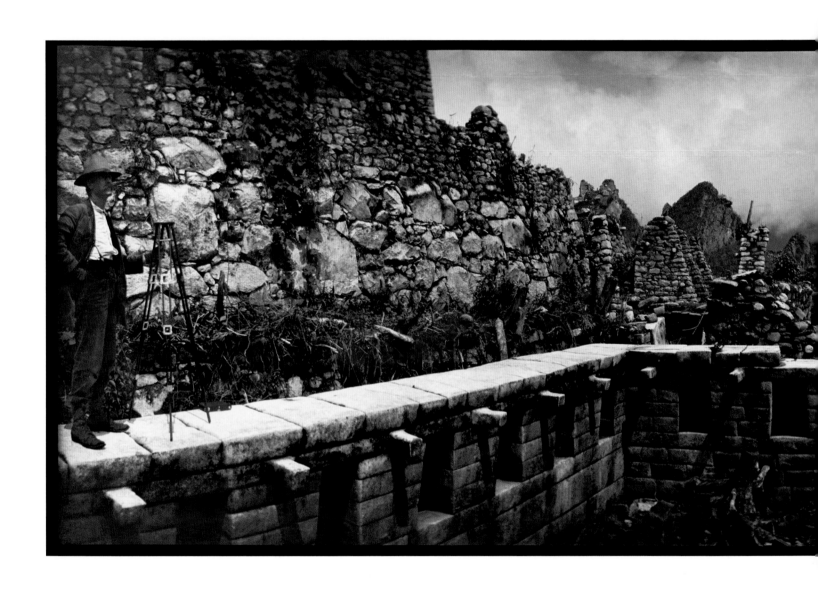

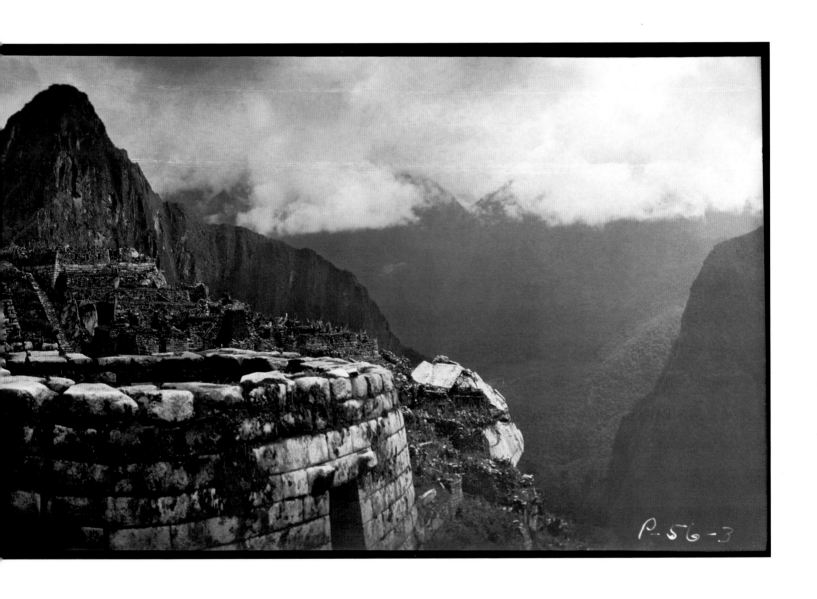

P.56-3

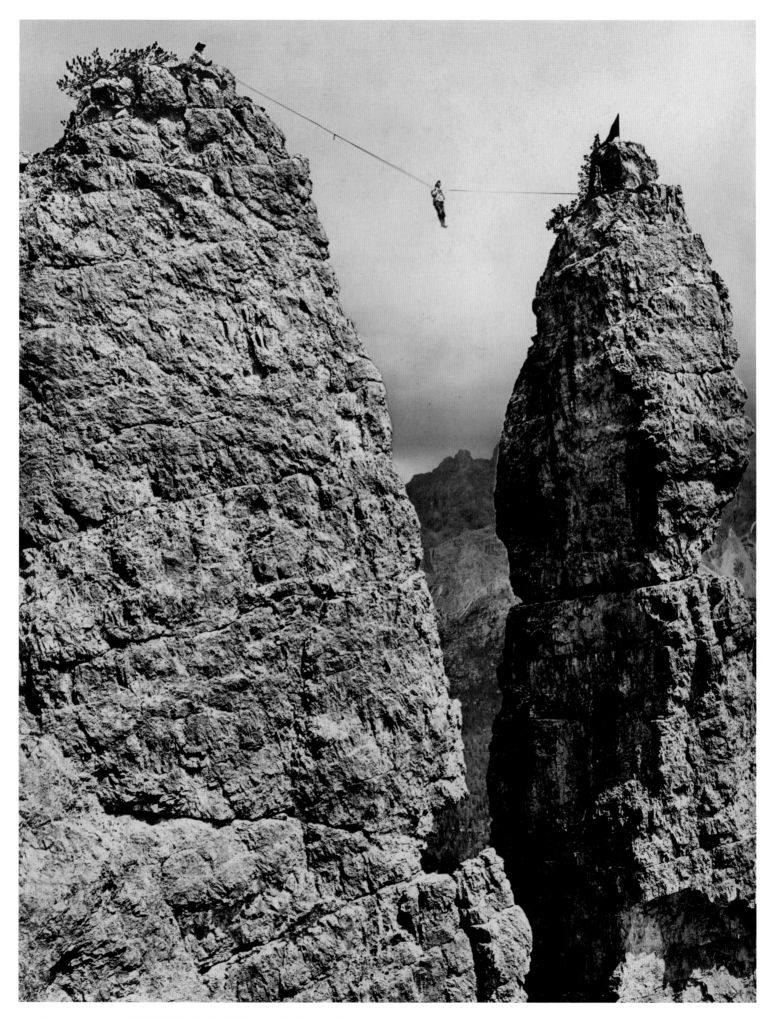

UNKNOWN | EARLY 1900S | ITALY *A daredevil in the Dolomites*

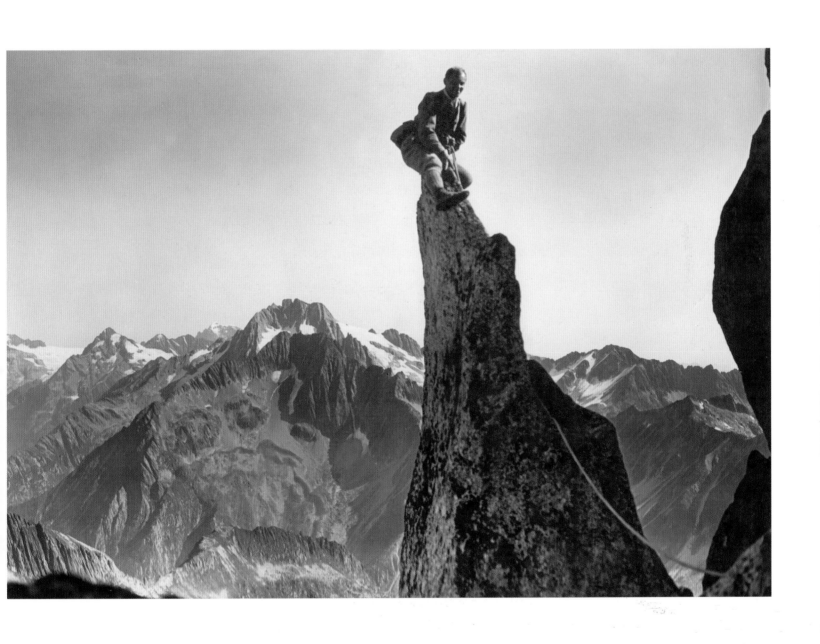

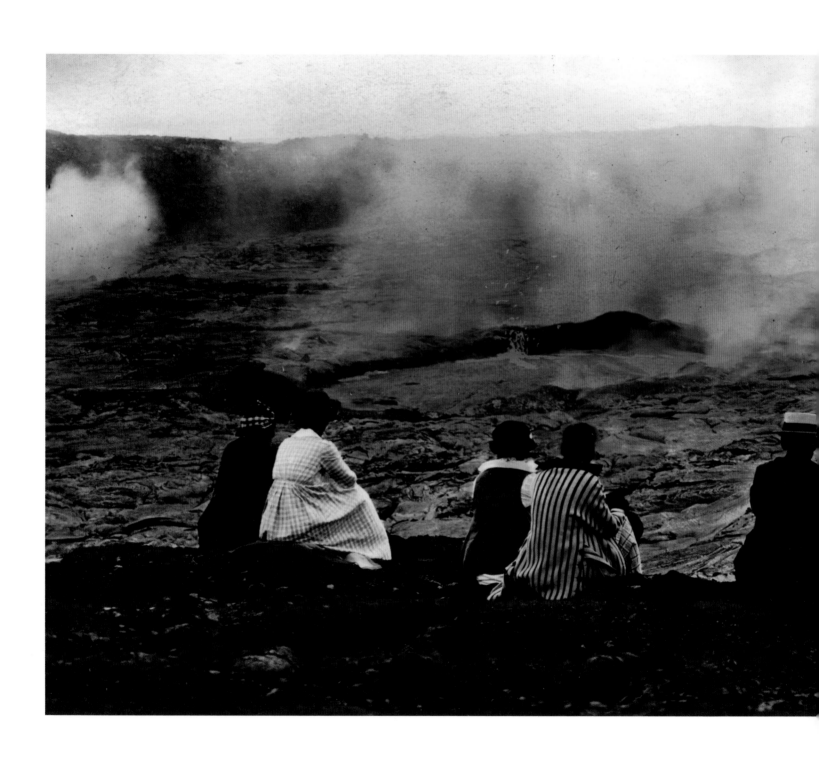

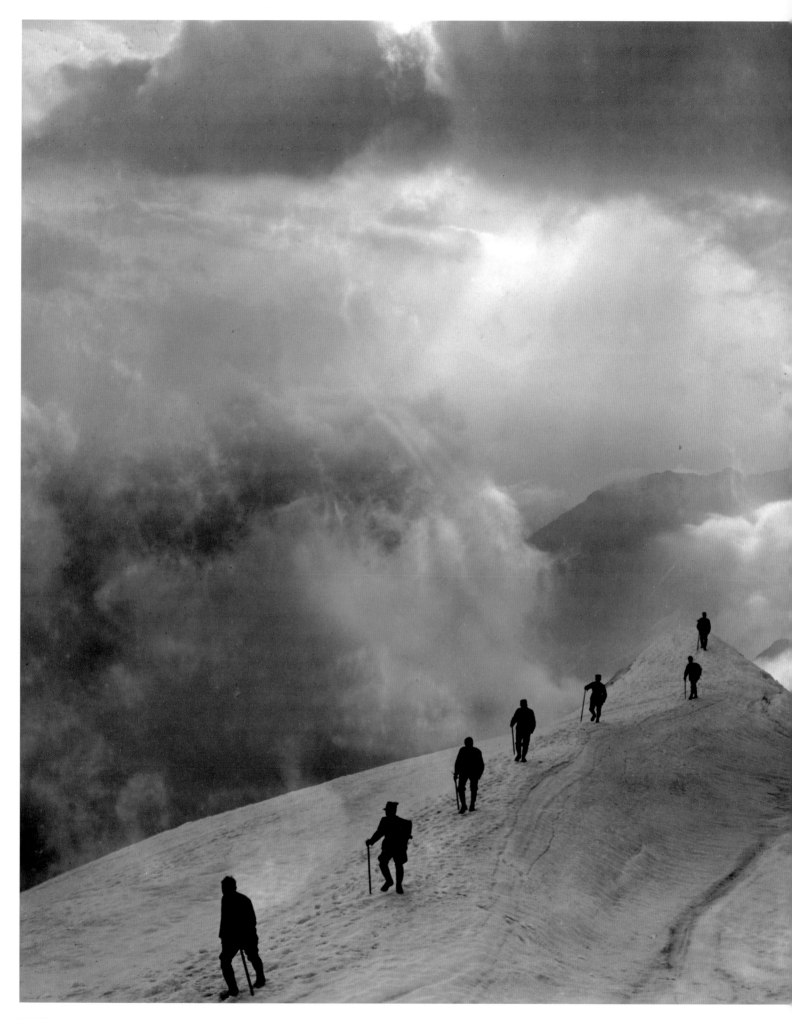

JEAN GABERELL **|** 1920 **|** SWITZERLAND *Above the clouds*

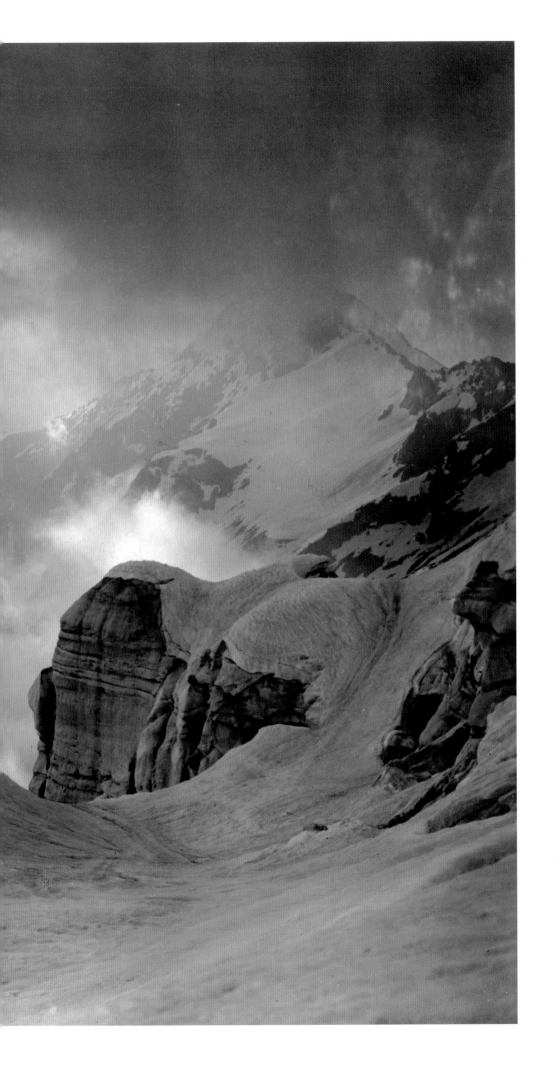

"Mountaineering transcends all everyday matters," wrote Italian alpinist Guido Tonelli. "It transcends all natural frontiers. Mountaineers are bands of brothers. They are all one party on one rope."

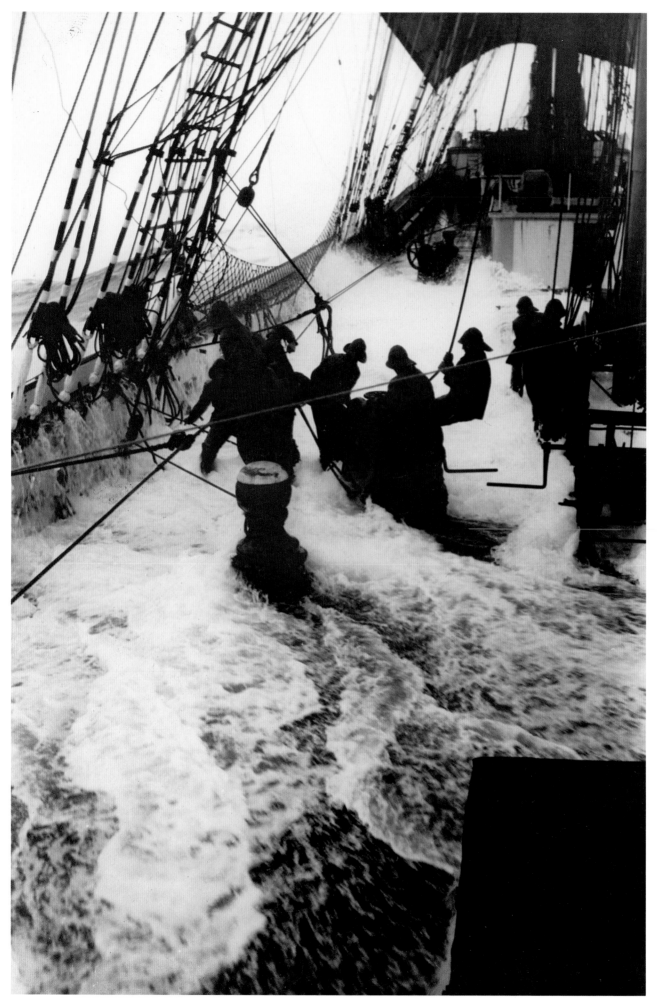

ALAN VILLIERS | 1933 | AT SEA *Hauling the braces*

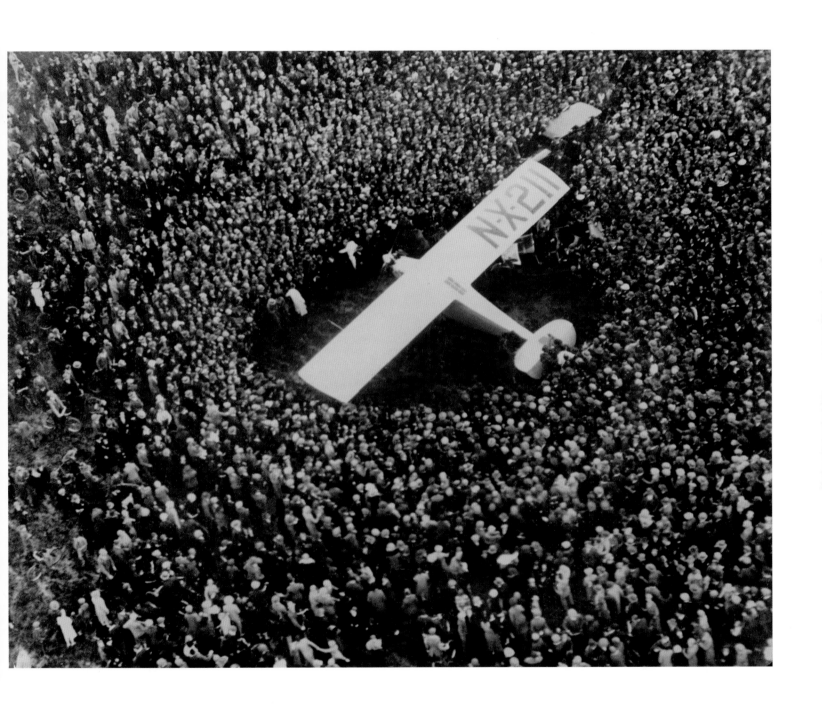

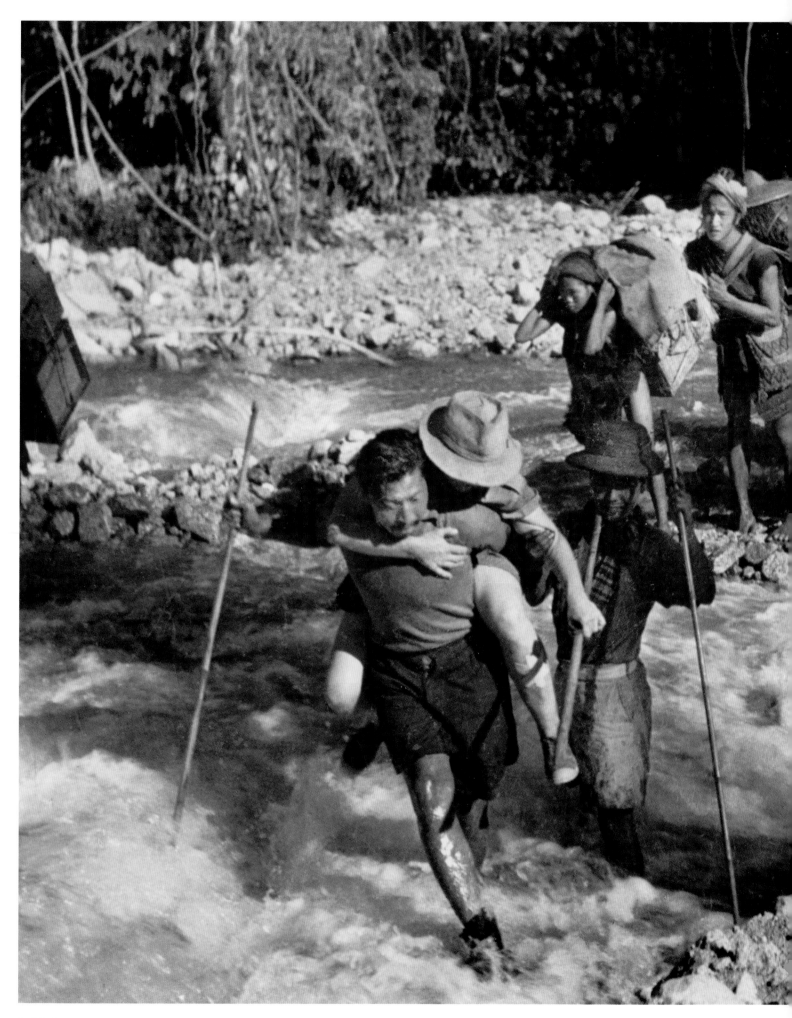

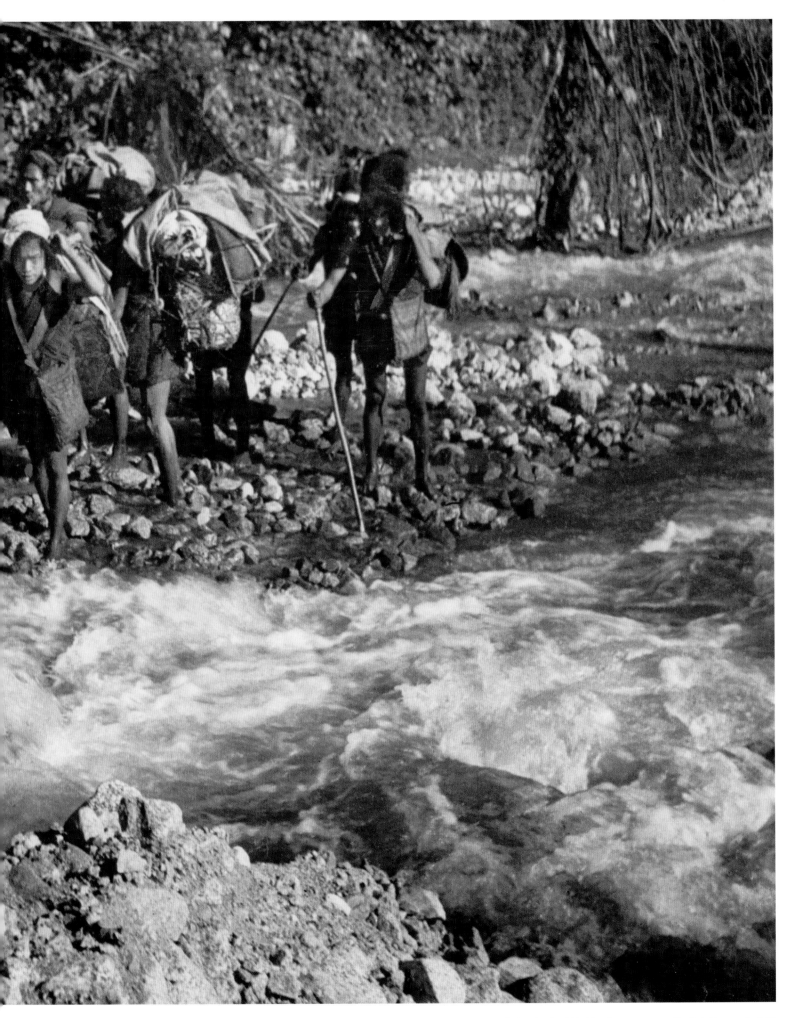

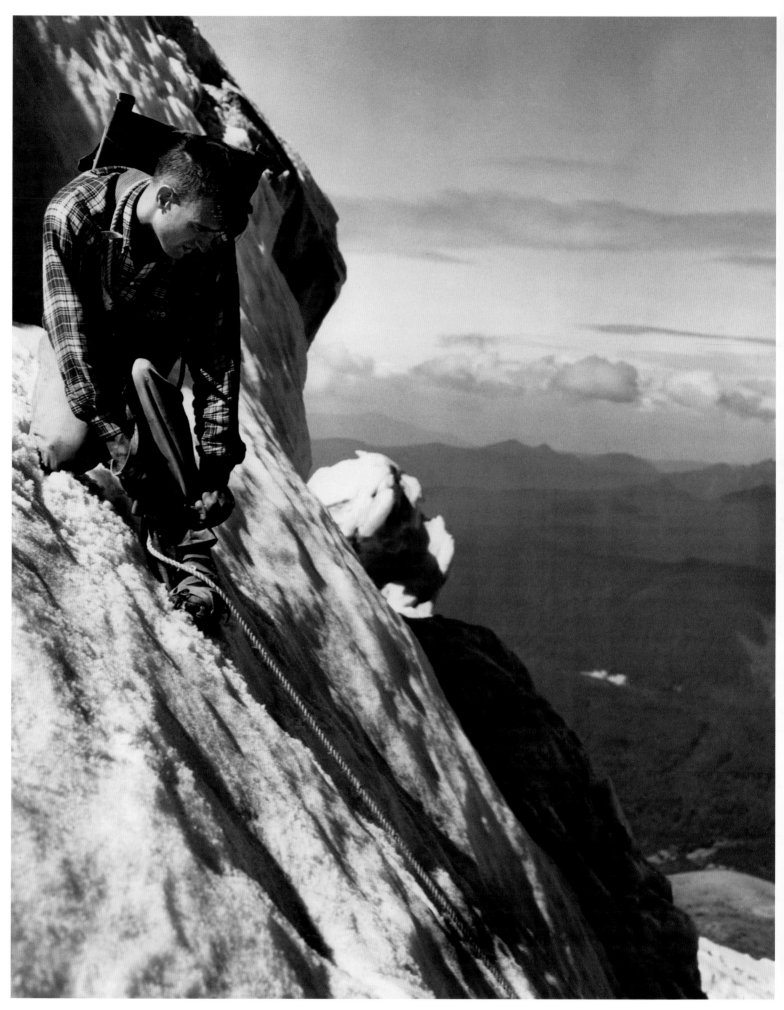

BOB AND IRA SPRING | 1952 | WASHINGTON STATE *A wall of rock above the world*

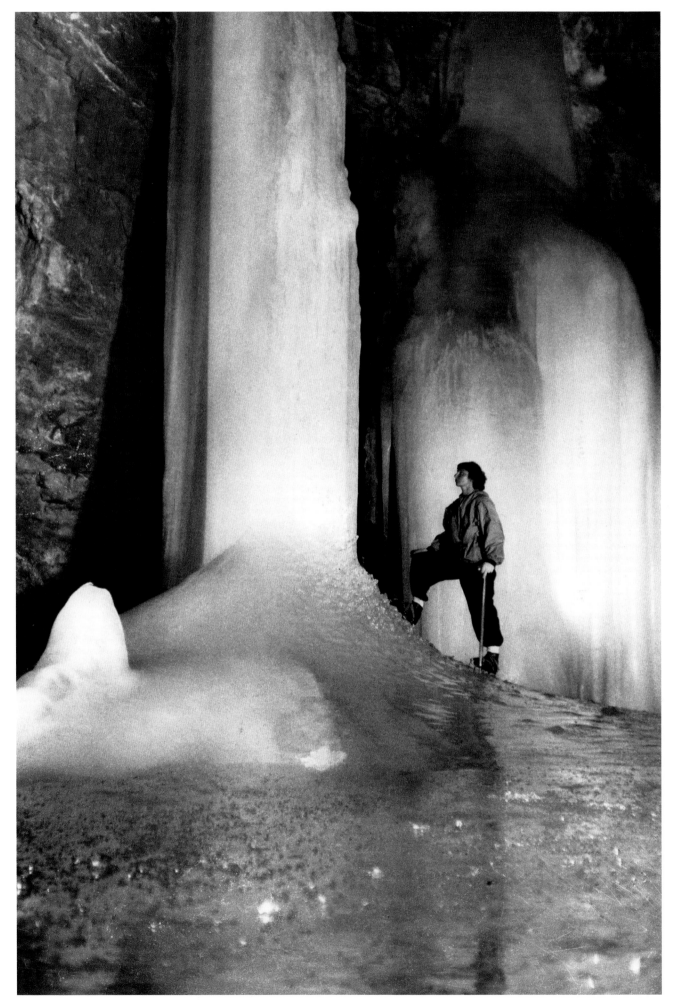

NORBERT CASTERET | 1953 | SPAIN *A shaft of ice beneath the world*

color & optimism

ONCE THE MACHINES APPEARED, victory seemed assured. After World War II, as explorers pushed deeper and farther into such demanding places as Antarctica, the oceans, and space, they brought their technology with them. Brightly clad men were depicted, in glorious Kodachrome, undertaking the seeming colonization of alien, even extraterrestrial, environments.

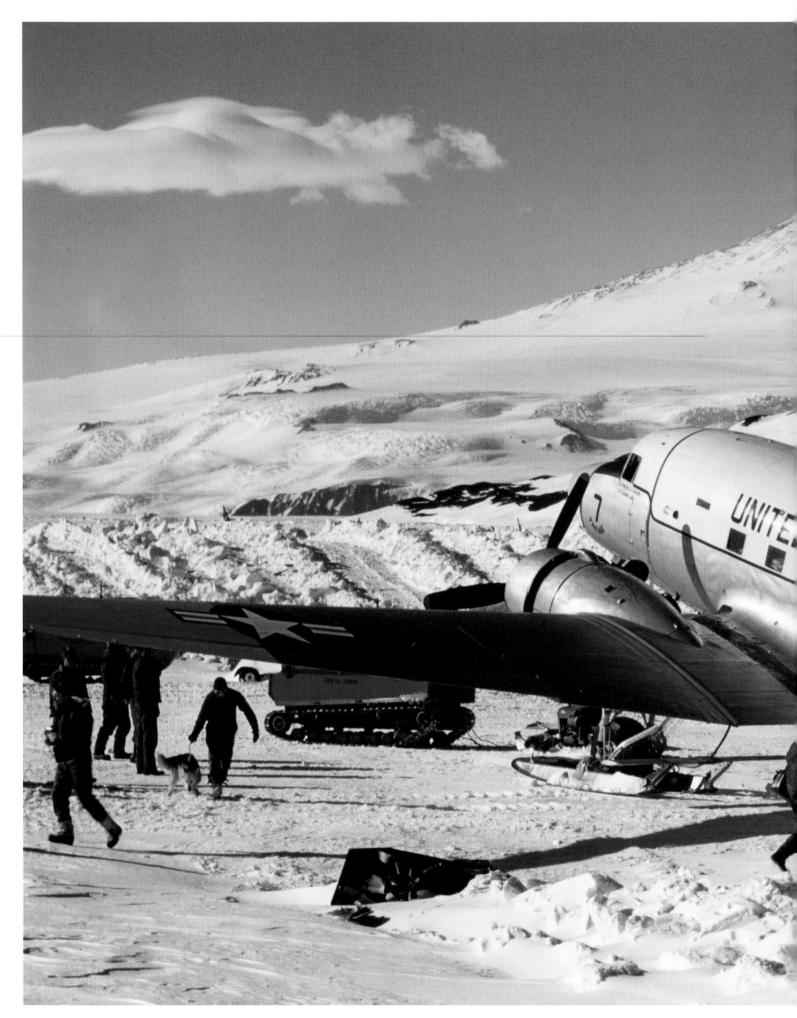

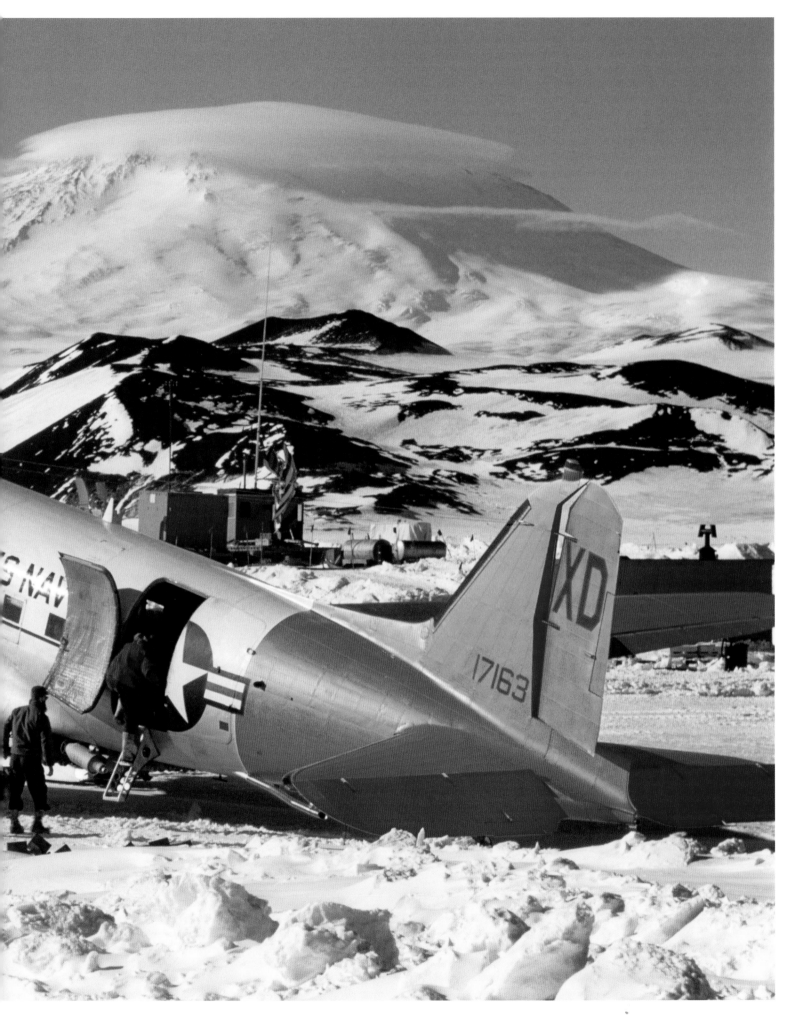

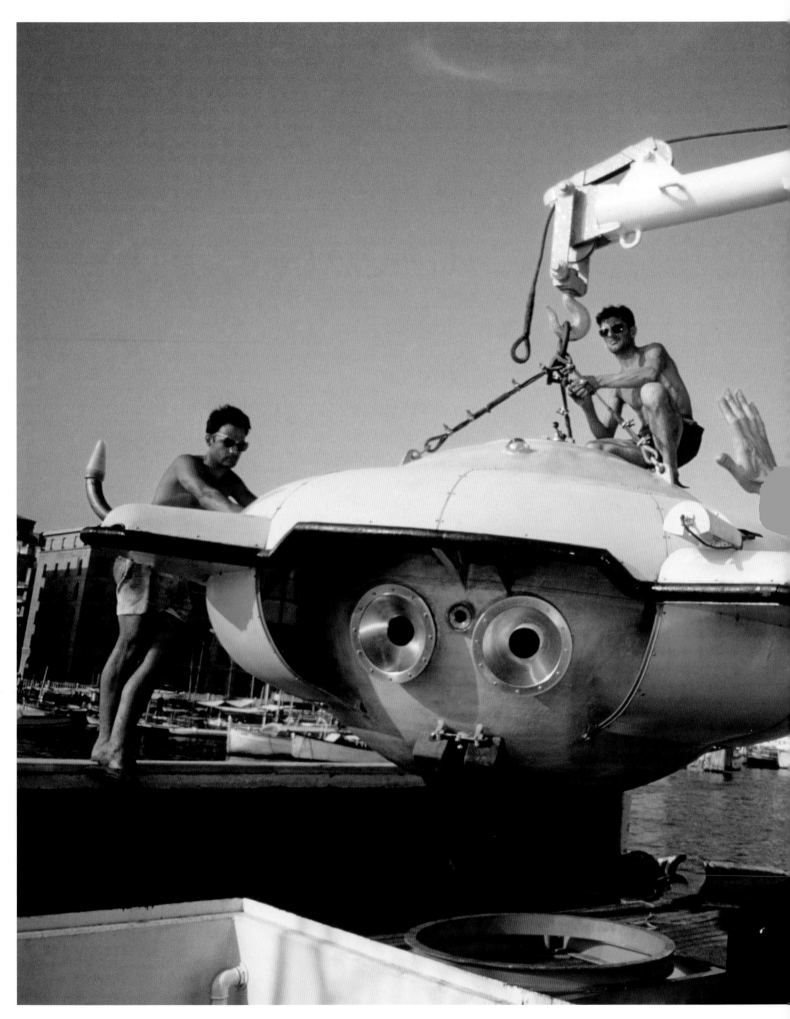

THOMAS J. ABERCROMBIE | 1960 | PUERTO RICO *Jacques-Yves Cousteau and his "diving saucer"*

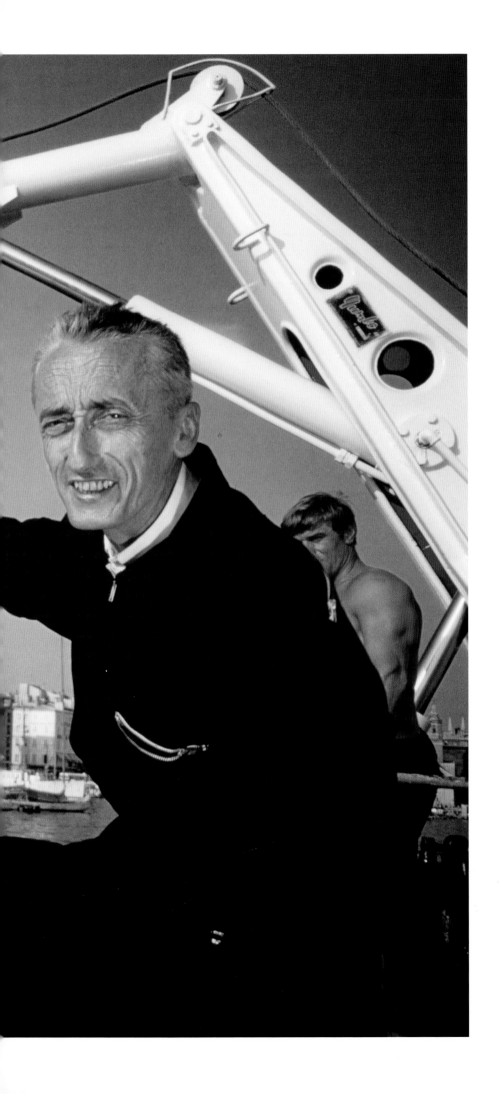

"I address it in French, of course," Jacques Cousteau quipped about Denise the diving saucer. Underwater, however, he saw it as a "natural marine creature... poised like some great bivalve or strange crustacean."

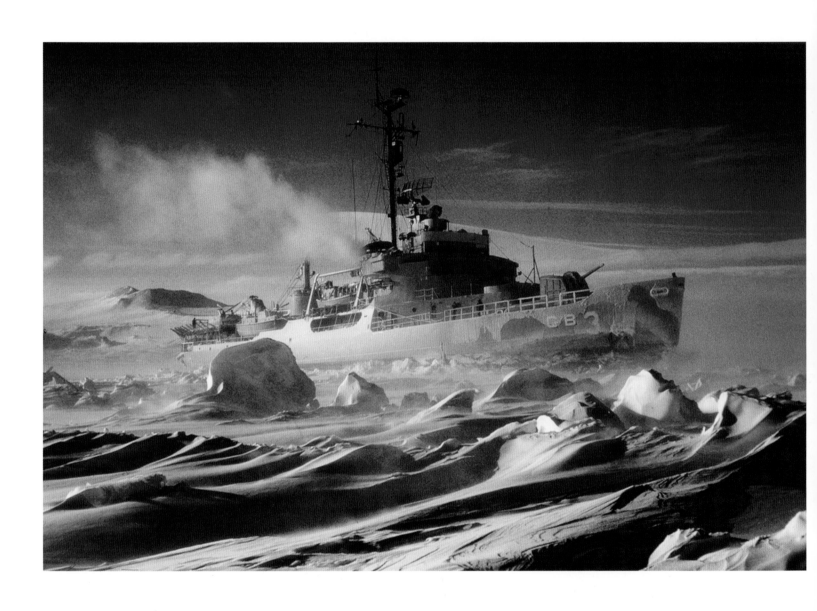

CHARLES SWITHINBANK | 1963 | ANTARCTICA *An icebreaker in the Antarctic*

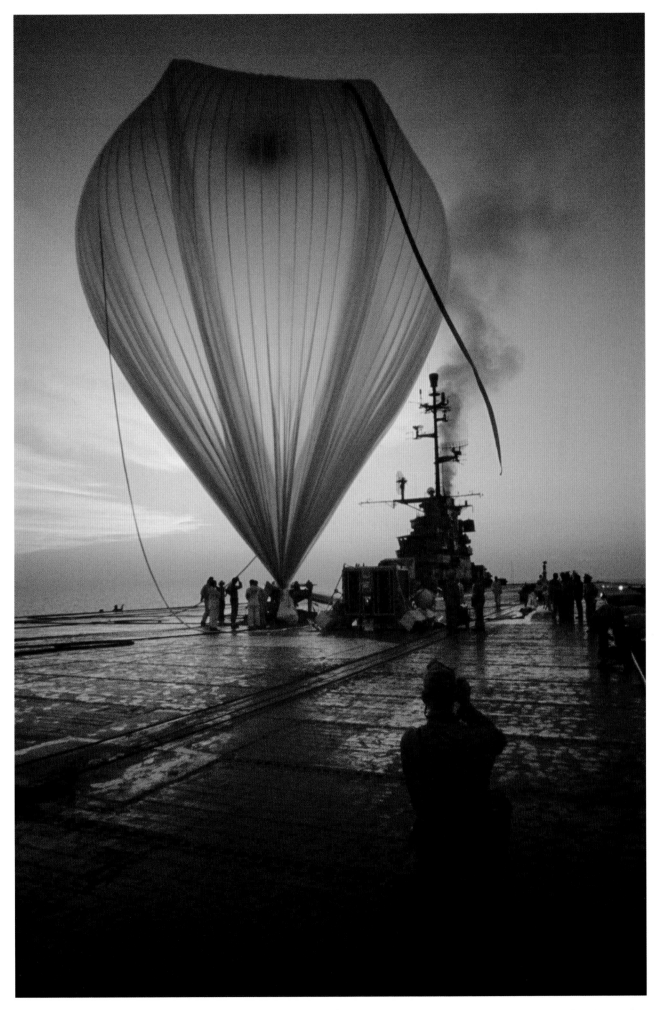

WALTER M. EDWARDS | 1961 | GULF OF MEXICO *Stratolab 5 beginning its record-setting ascent* Color & Optimism | 67

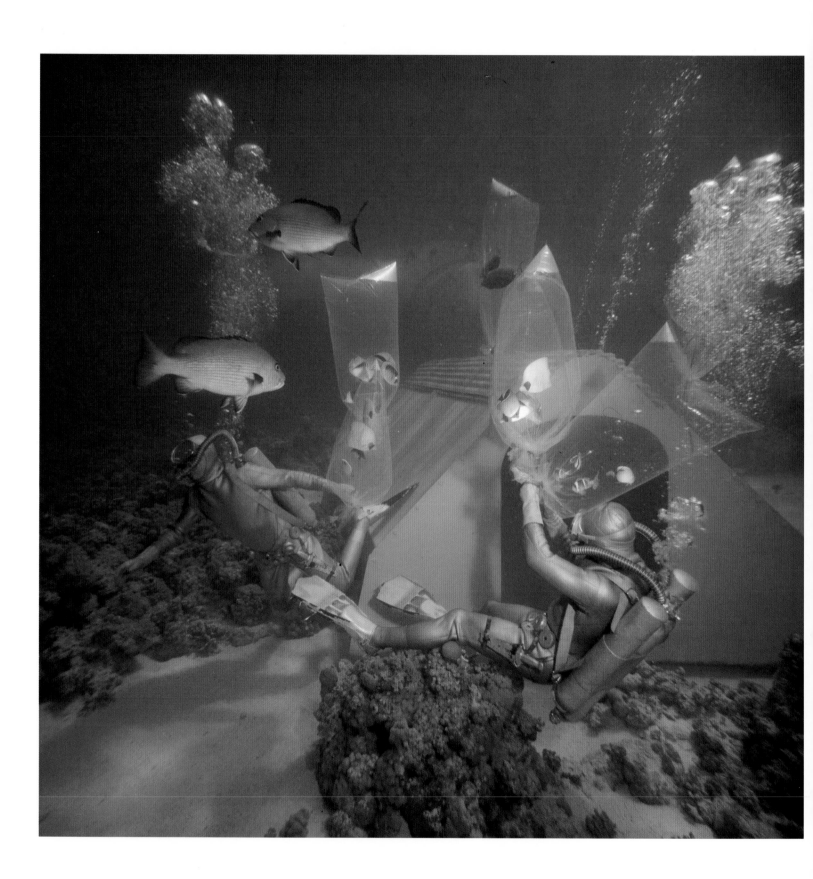

ROBERT B. GOODMAN | 1963 | RED SEA *Camping beneath the sea*

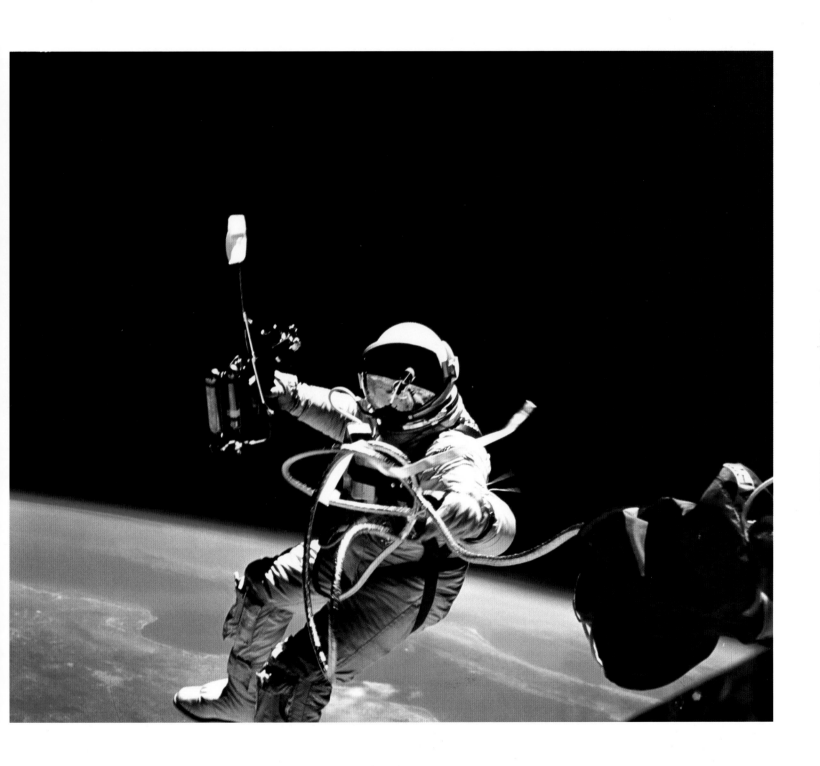

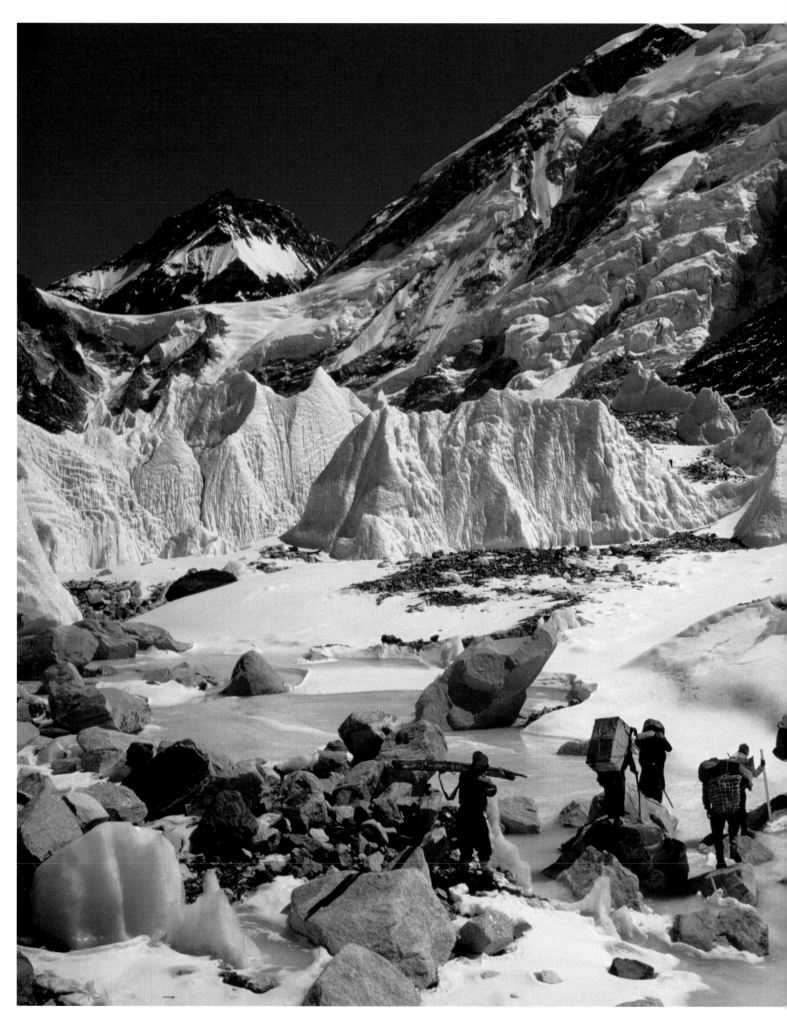

BARRY BISHOP | 1963 | NEPAL *The approach to Mount Everest*

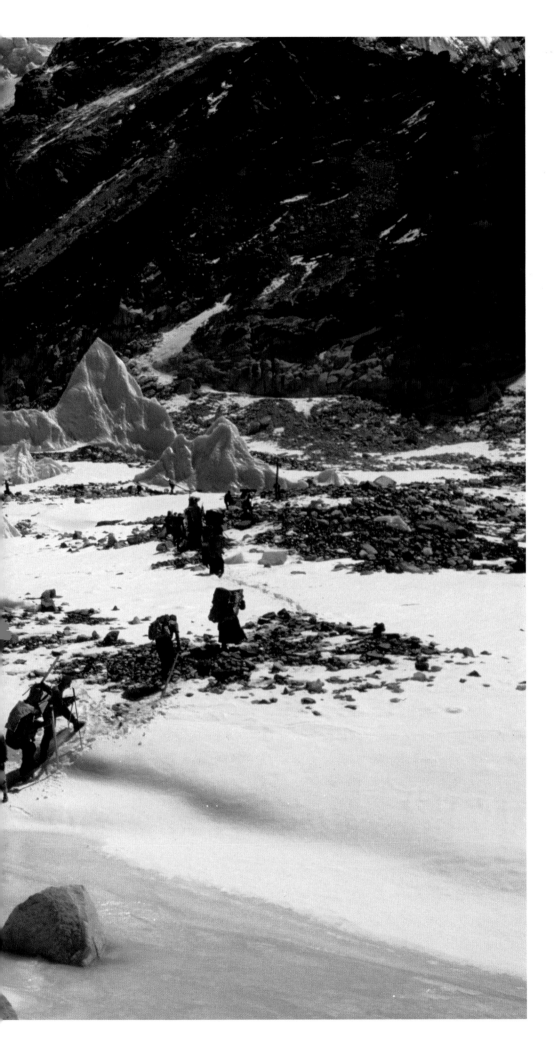

"The possibility of entering the unknown," recalled Sir John Hunt, leader of the 1935 Mount Everest expedition, "the simple fact that it was the highest point on the world's surface— these things goaded us on."

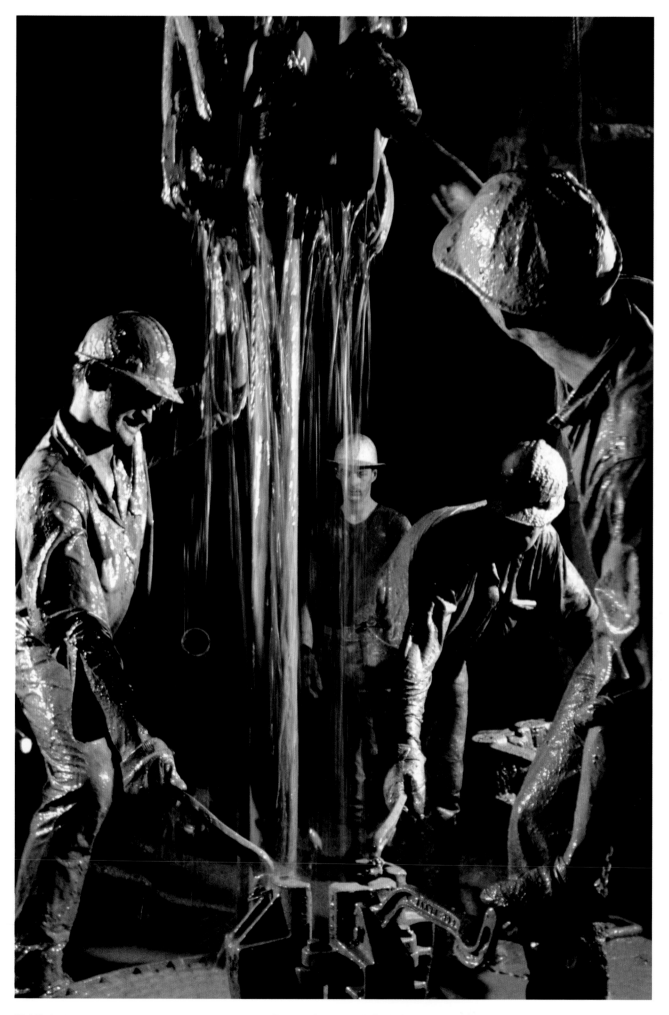

DAVID S. BOYER | 1968 | CANADA *Journey to the center of the Earth: Oilmen inspecting a drill bit*

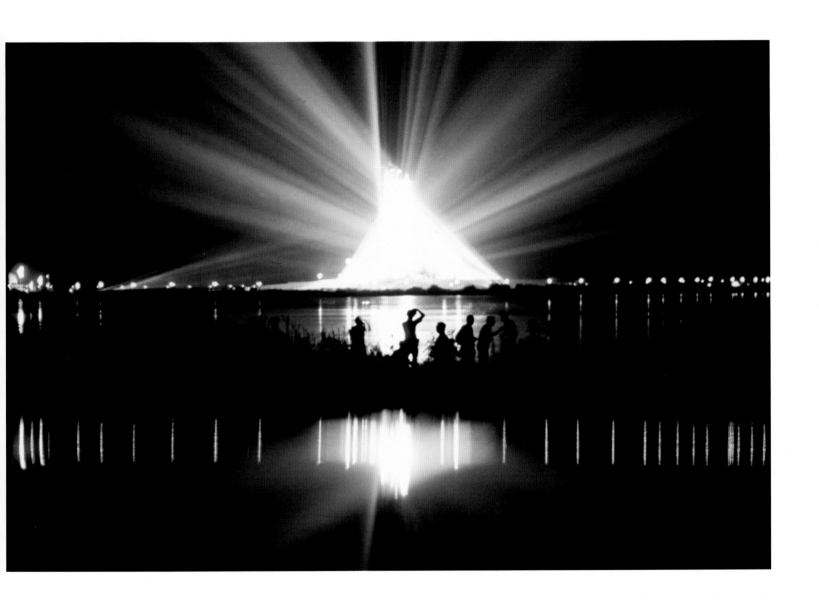

documentary realism

MEN MAY HAVE REACHED THE MOON, but on Earth, as the 20th century drew toward its close, photographers began depicting a different kind of exploration, one more grindingly tedious, more labor-intensive, and still occasionally dangerous, though it was an exploration not without its satisfactions—or even its peak experiences.

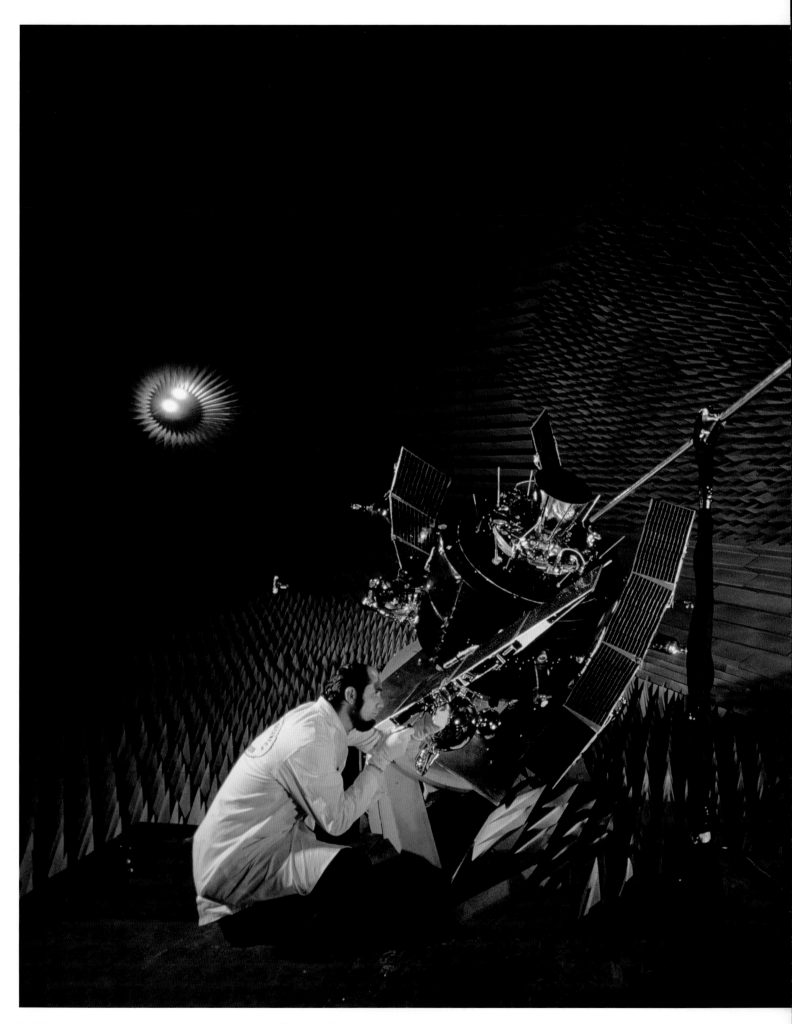

JAMES P. BLAIR | 1973 | MARYLAND *Testing a satellite antenna system*

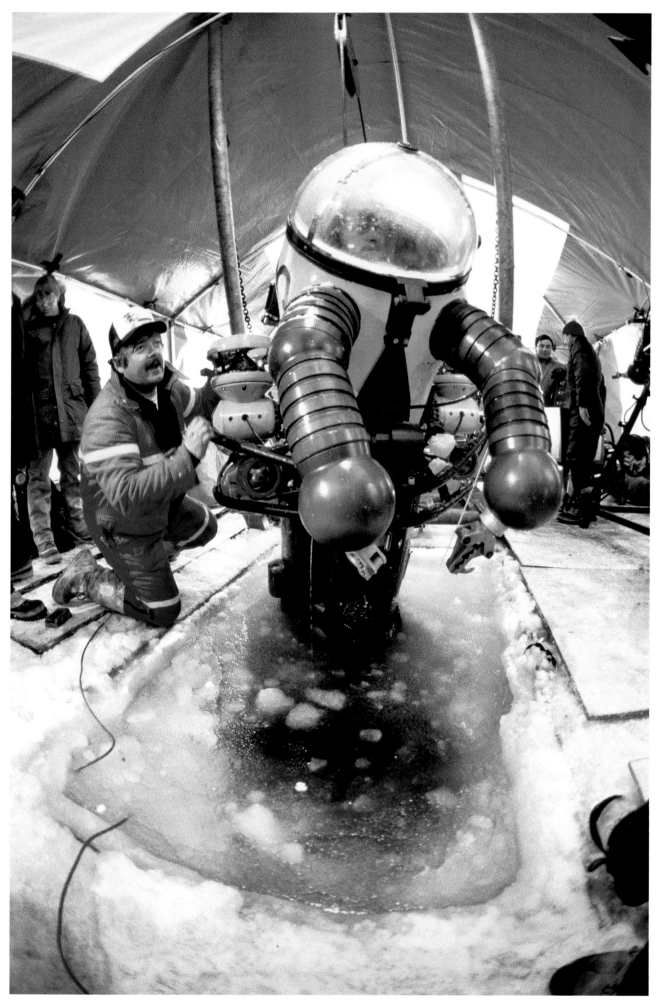

EMORY KRISTOF | 1983 | CANADA *Going down onto a shipwreck in Barrow Strait*

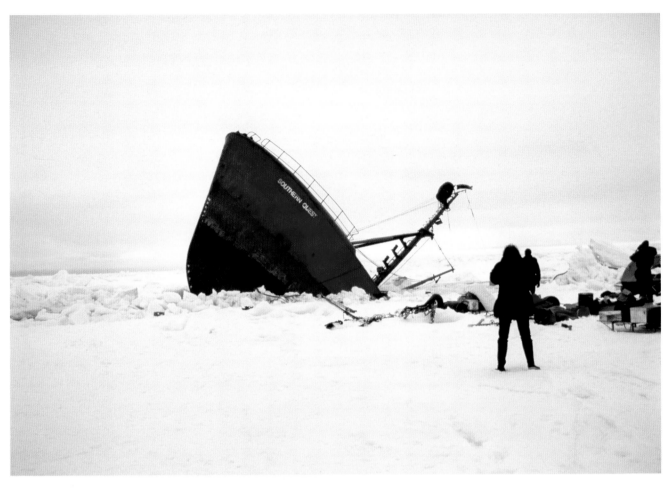

REBECCA WARD | 1987 | ANTARCTICA *Going down after being crushed in the ice*

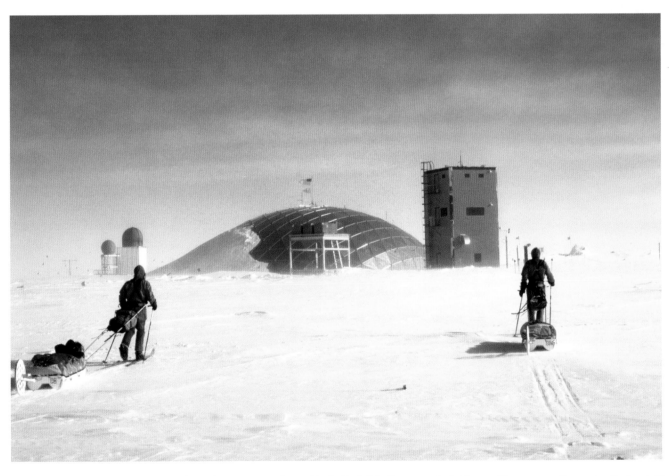

ROGER MEAR | 1986 | ANTARCTICA *Approaching the South Pole after a 900-mile sledging expedition*

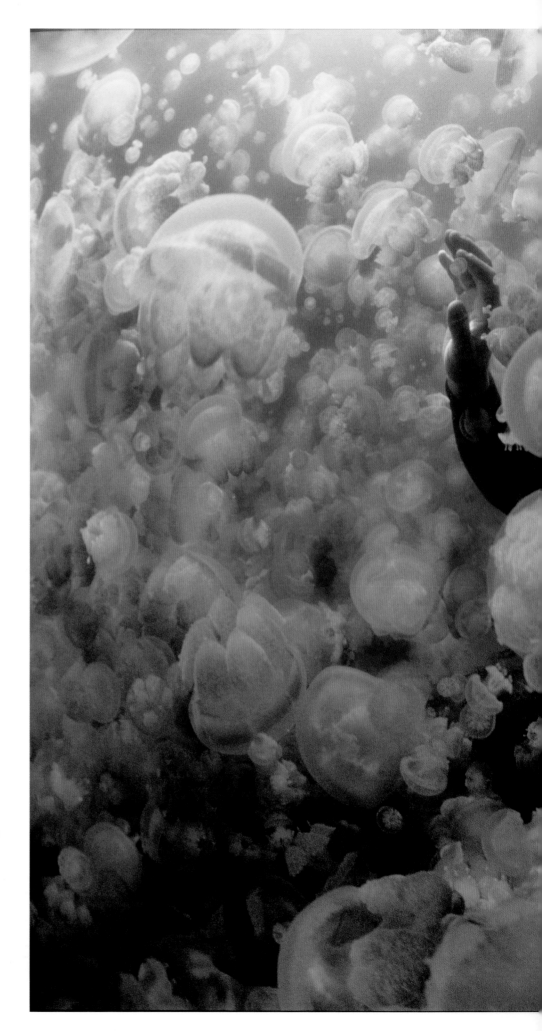

Diving among Palau's jellyfish, biologist Bill Hamner and photographer David Doubilet could only marvel at "the exquisiteness, the profusion, of these living things that have no need or knowledge of mankind but that, strangely, we feel a need to know."

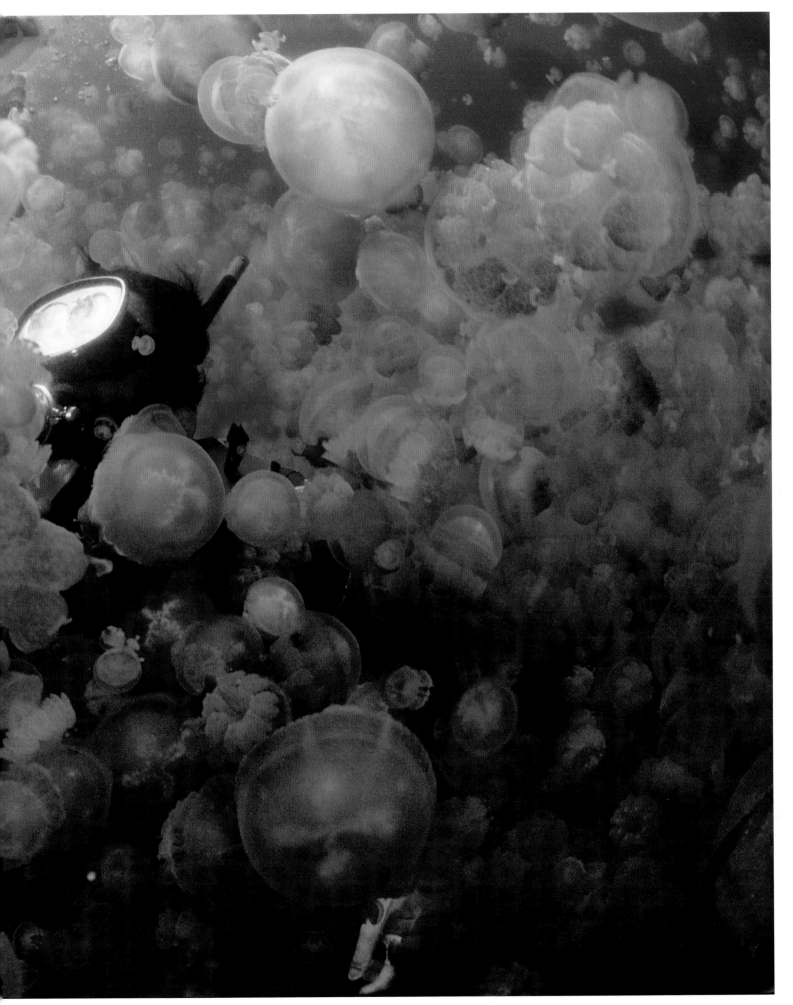

DAVID DOUBILET | 1982 | PALAU *Diving among jellyfish in a salt lake* Documentary Realism | 81

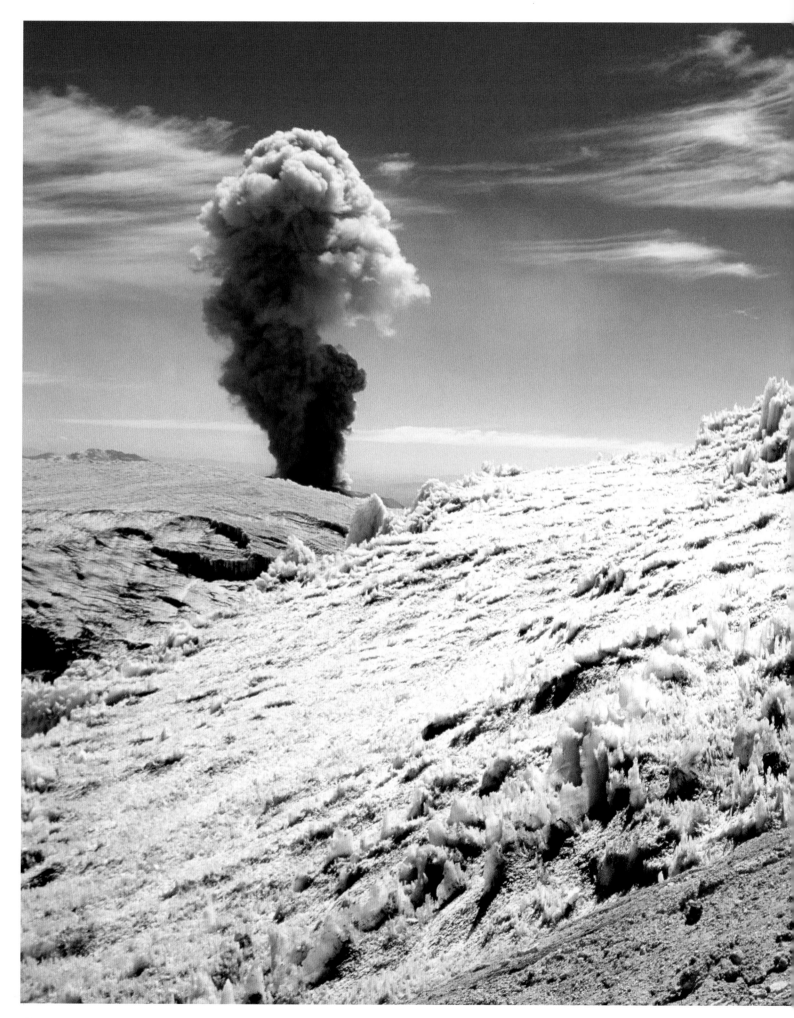

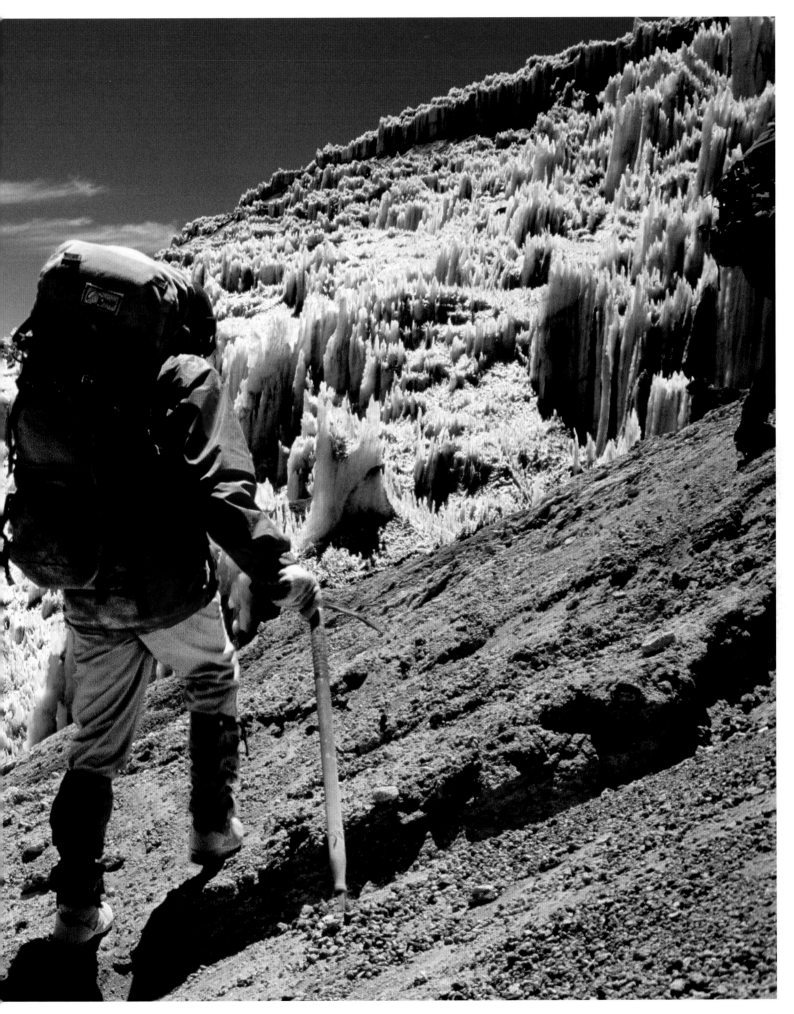

STEPHEN ALVAREZ | 1987 | PERU *Fire and ice in the Andes* Documentary Realism | 83

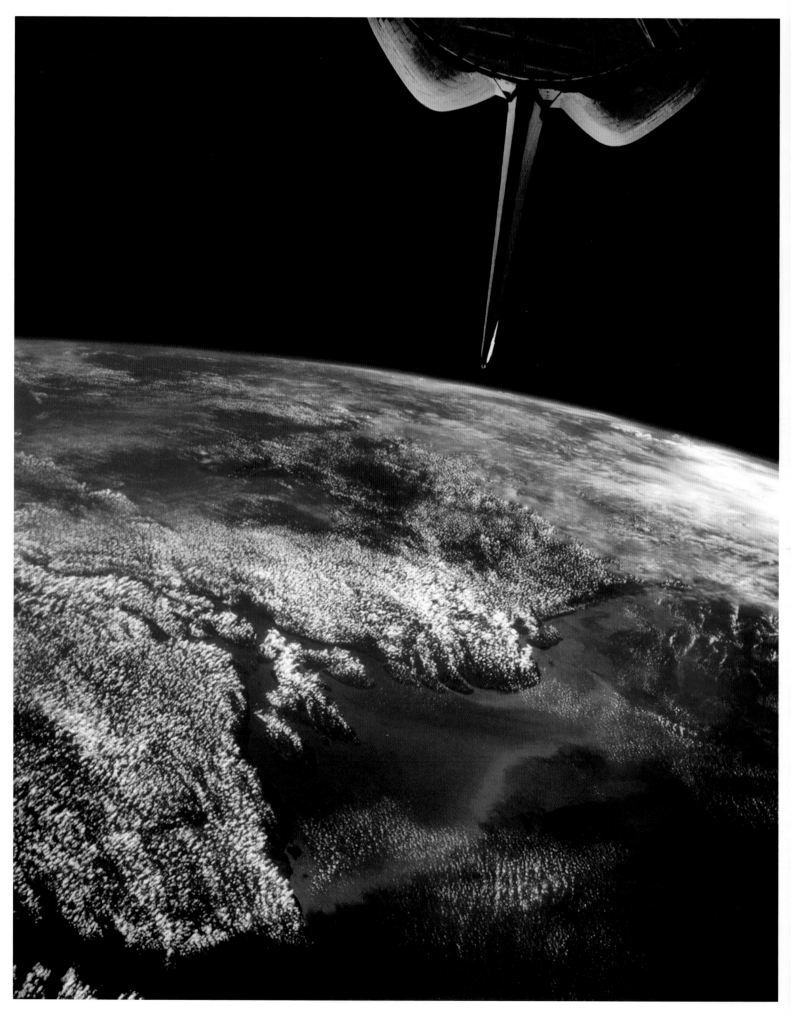

NASA | ROGER RESSMEYER | 1996 | EARTH ORBIT *Mouth of the Amazon River*

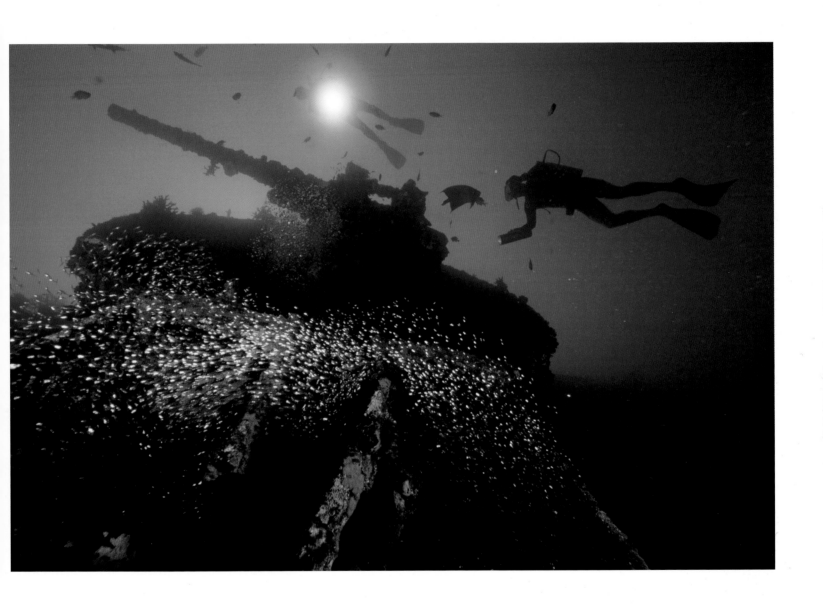

the digital range

TODAY'S BROAD ARRAY OF TECHNOLOGIES has given rise to a photography of exploration unequaled in reach, amplitude, and versatility. From caves and chasms and other dark places of the Earth to the stars and nebulae, modern digital imaging is providing a harvest of data for technical and scientific uses while providing us with occasional images of unsurpassed aesthetic impact.

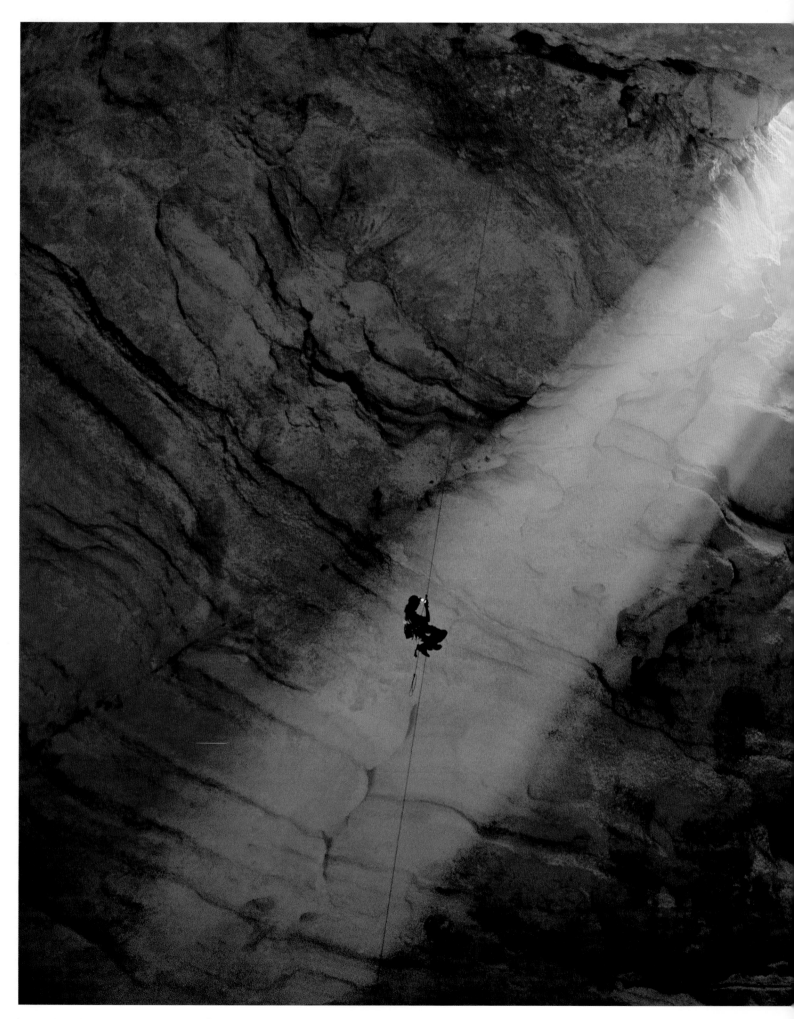

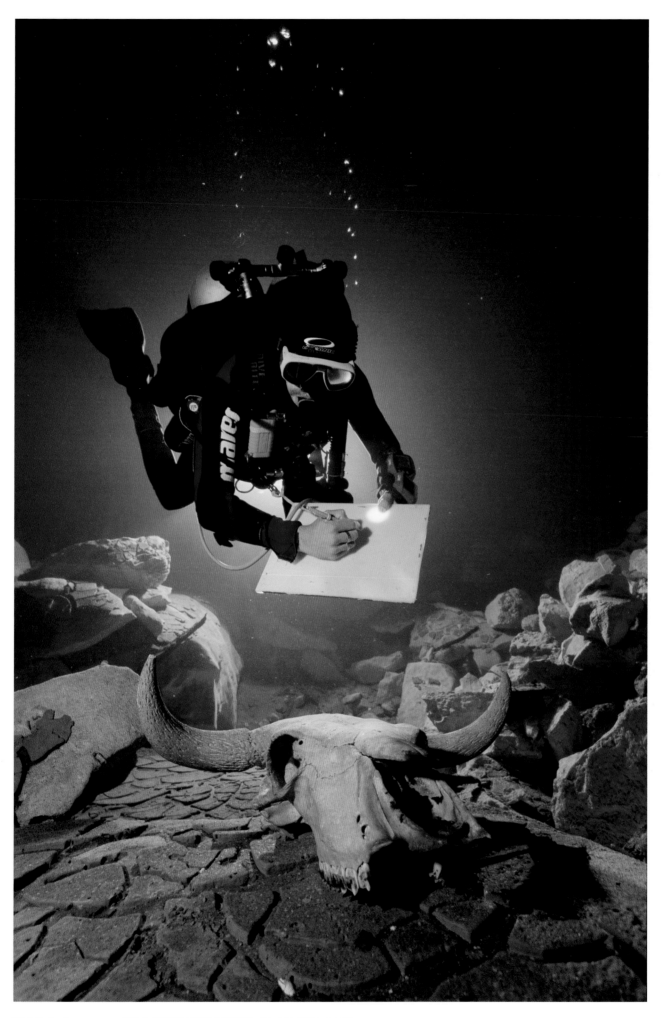

WES C. SKILES | 2003 | MEXICO *An unexpected encounter*

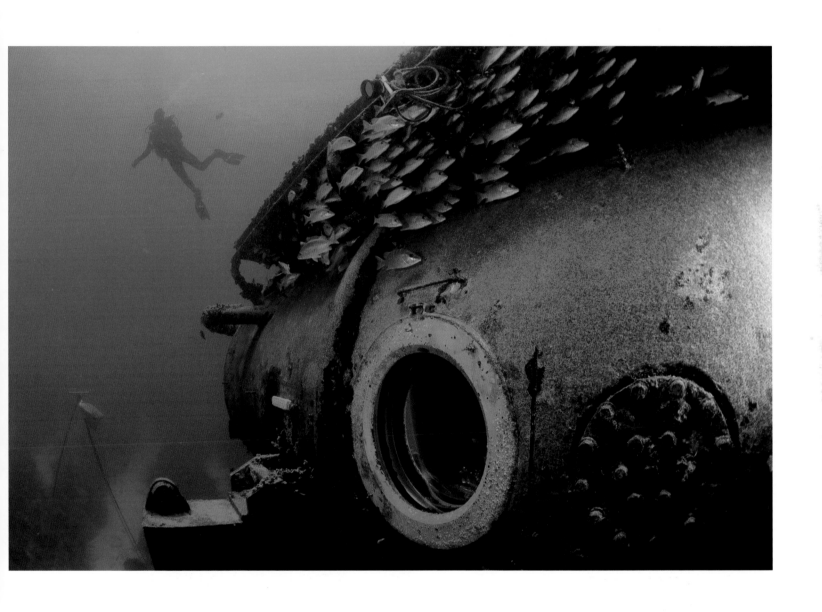

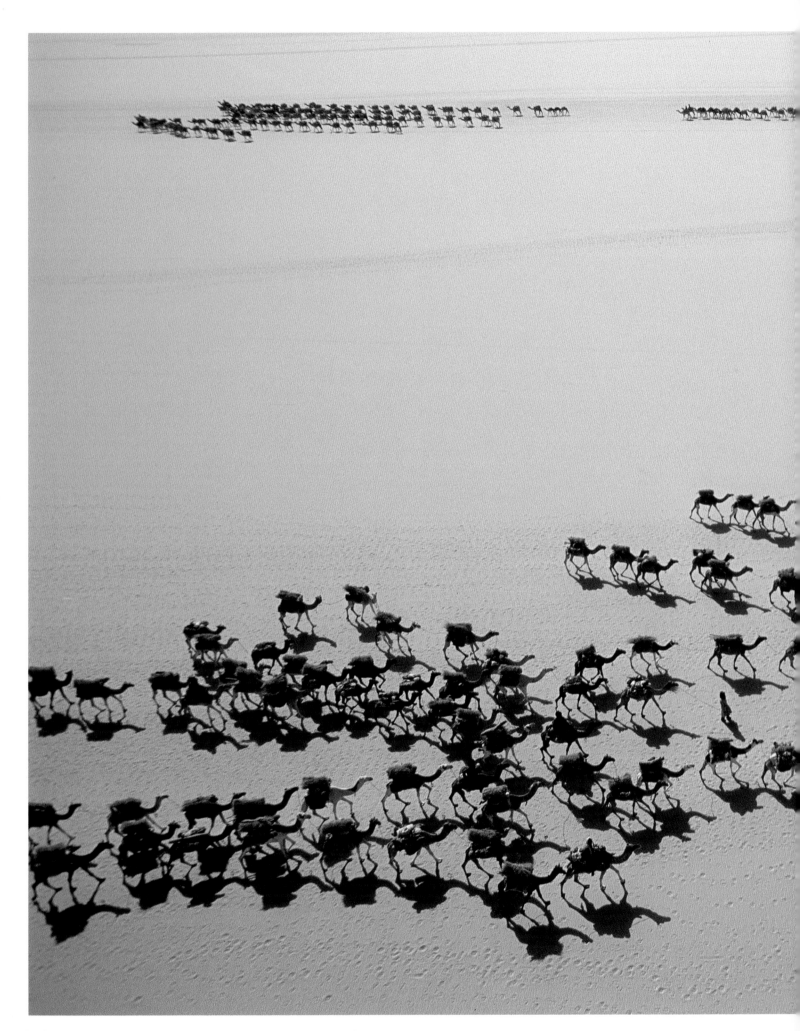

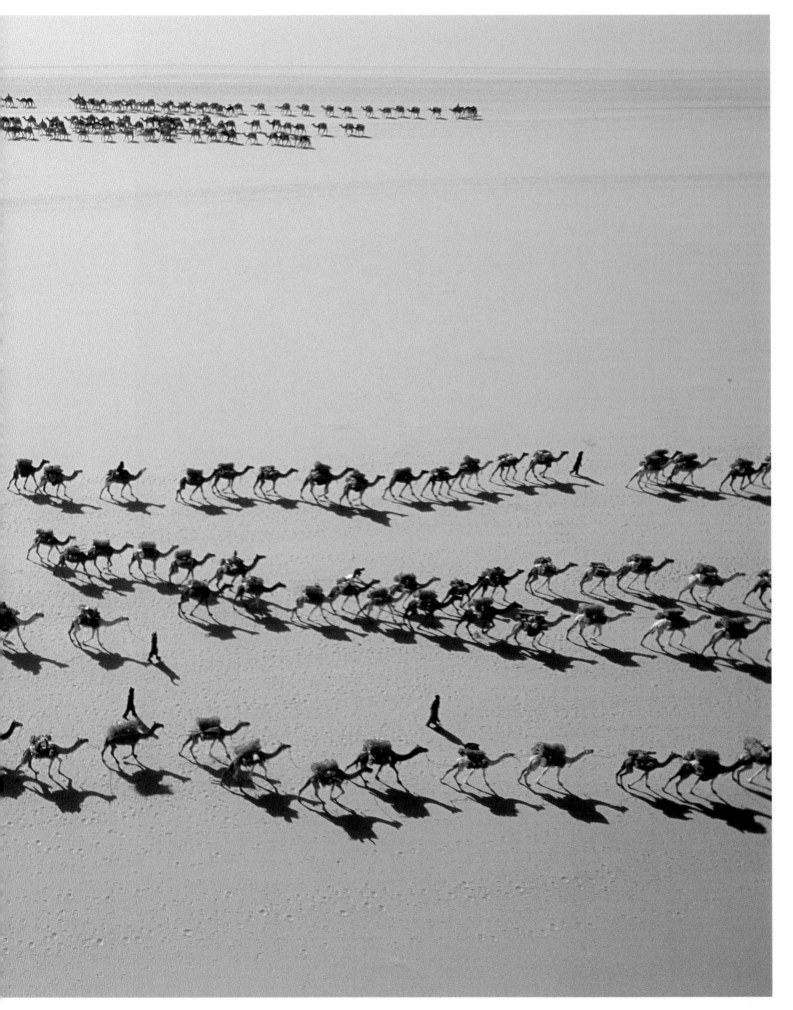

GEORGE STEINMETZ | 1999 | NIGER *Salt caravans crossing the Sahara*

GORDON WILTSIE | 2004 | PERU *An Inca ceremonial center*

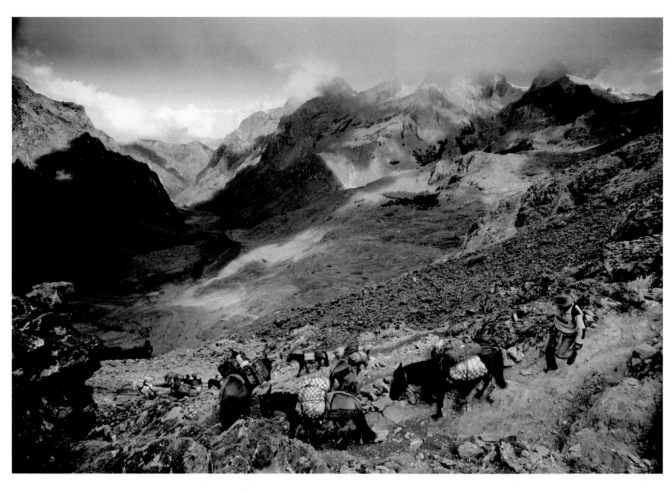

GORDON WILTSIE | 2004 | PERU *Crossing the rugged Vilcabamba Range*

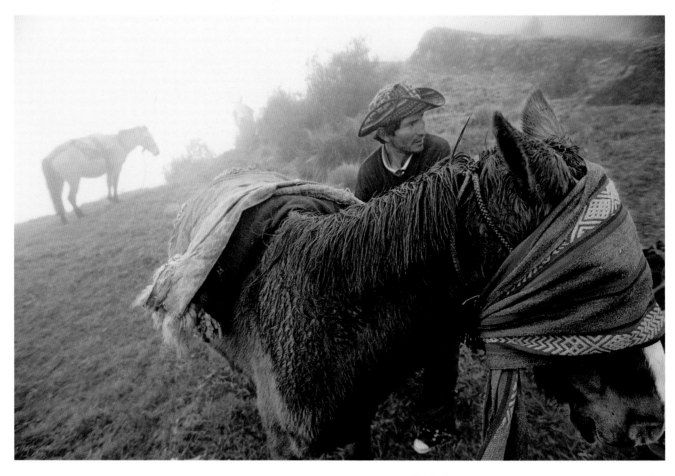

GORDON WILTSIE | 2004 | PERU *Blindfolding a nervous packhorse*

"You think you understand the Earth and its geology," says daredevil photographer Carsten Peter, "but once you look down into a volcanic crater and see what's there, well, you realize we will never understand. It is that powerful."

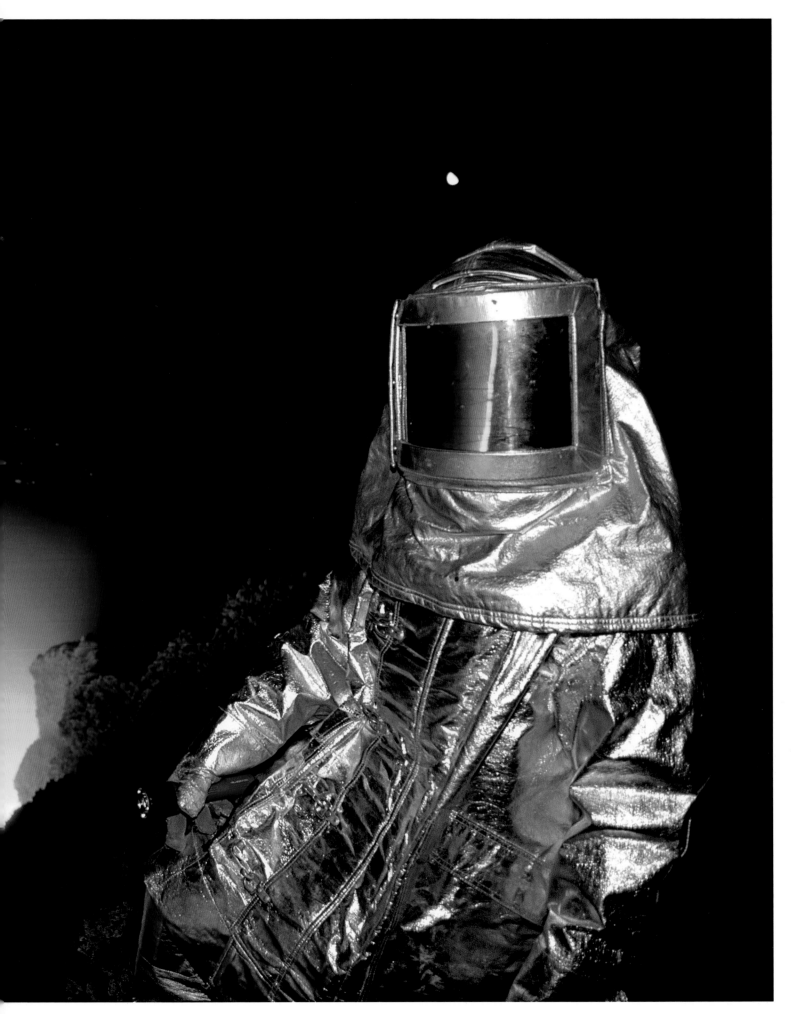

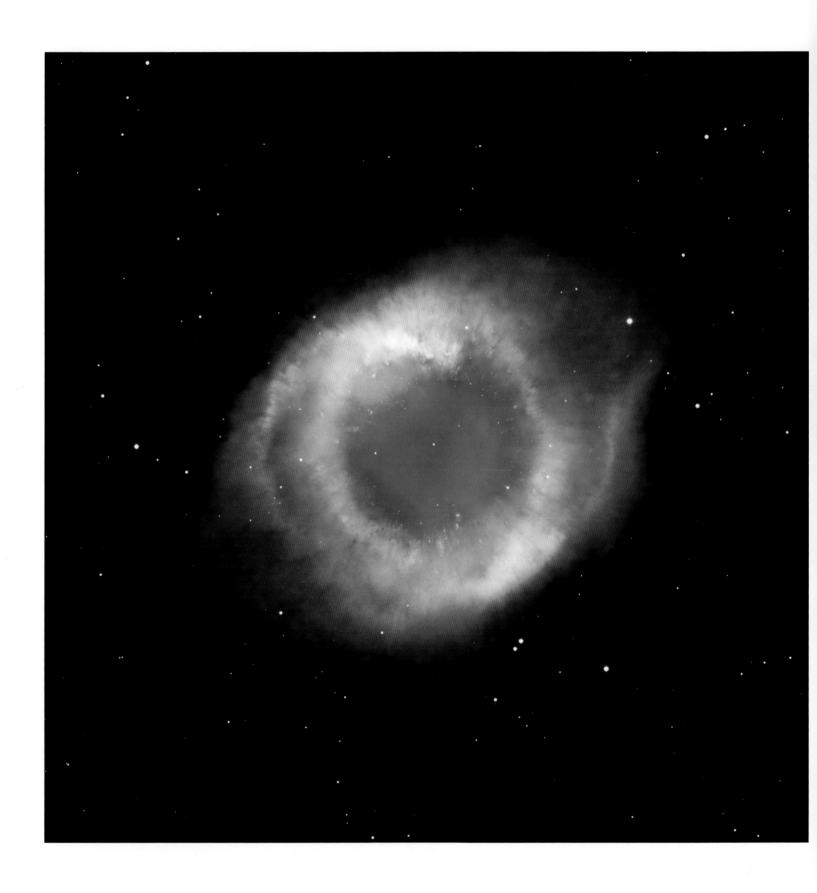

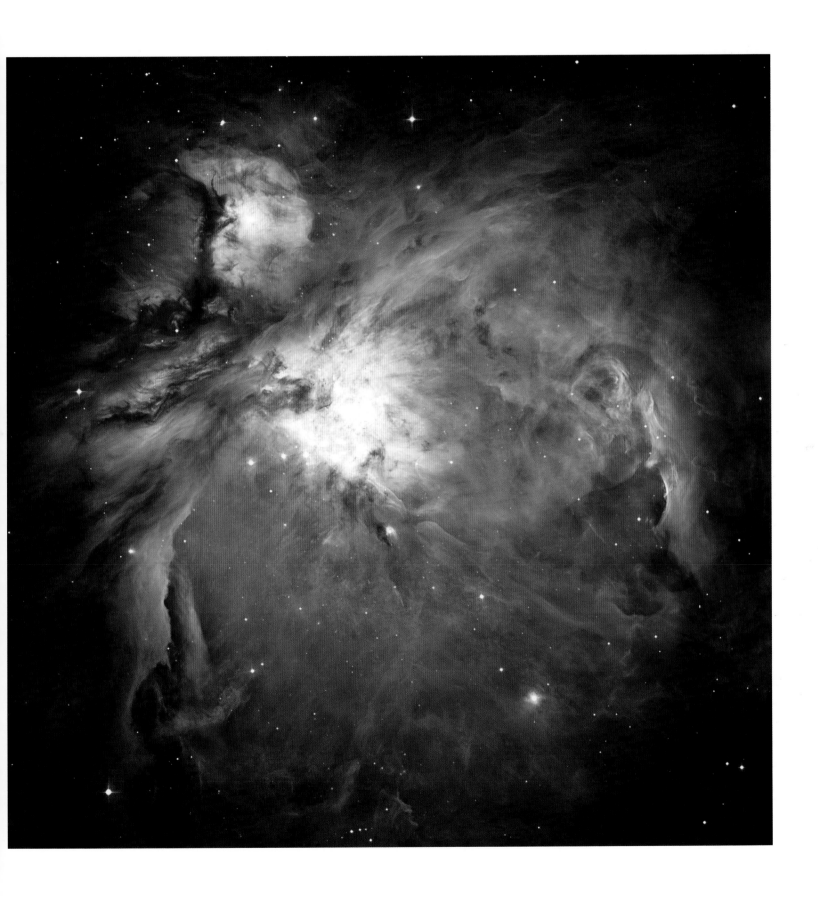

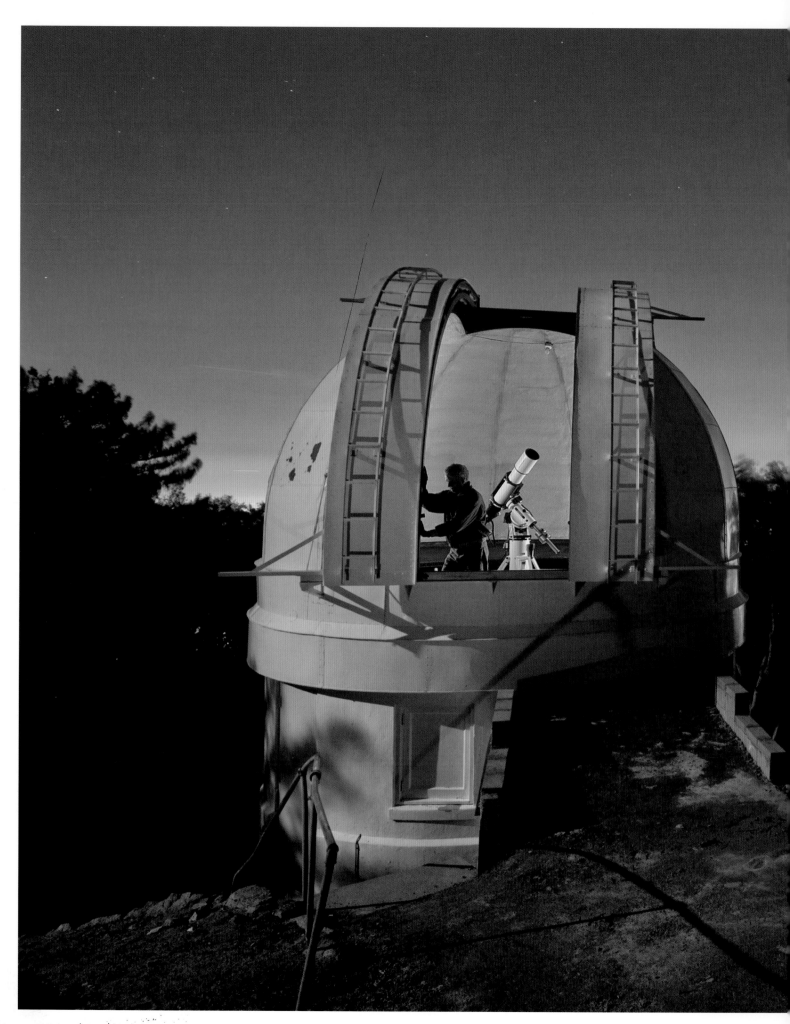

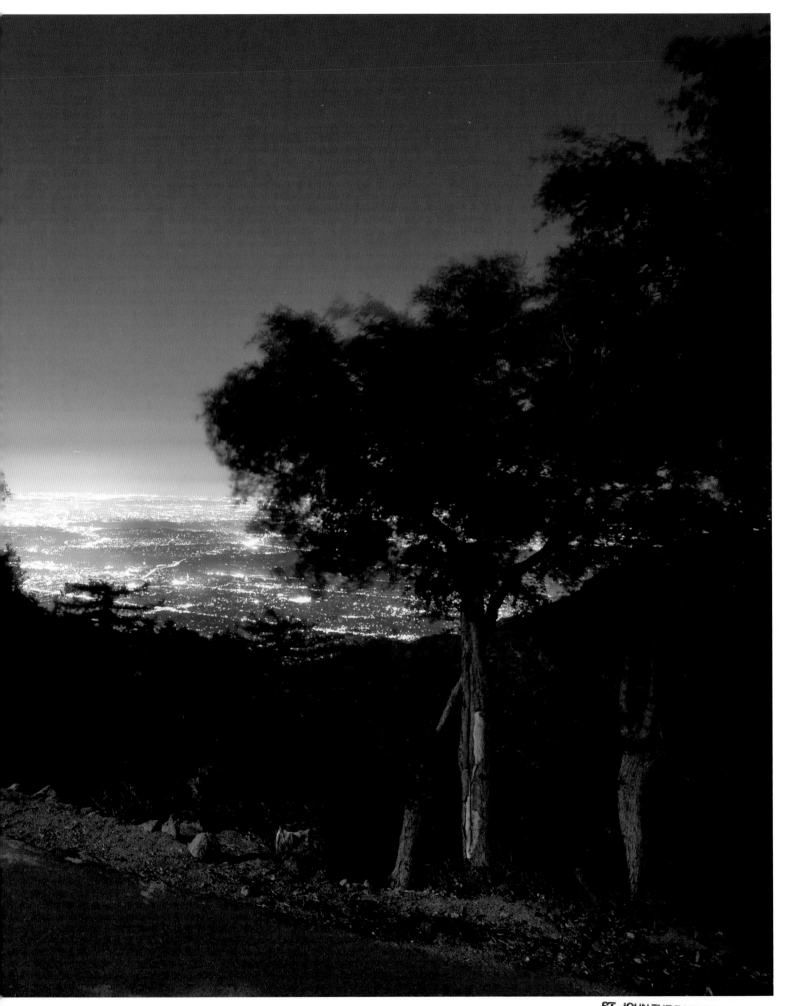

JIM RICHARDSON | 2008 | CALIFORNIA *Counting stars at Mount Wilson Observatory*

NASA | 2008 | MARS *A Martian sunset*

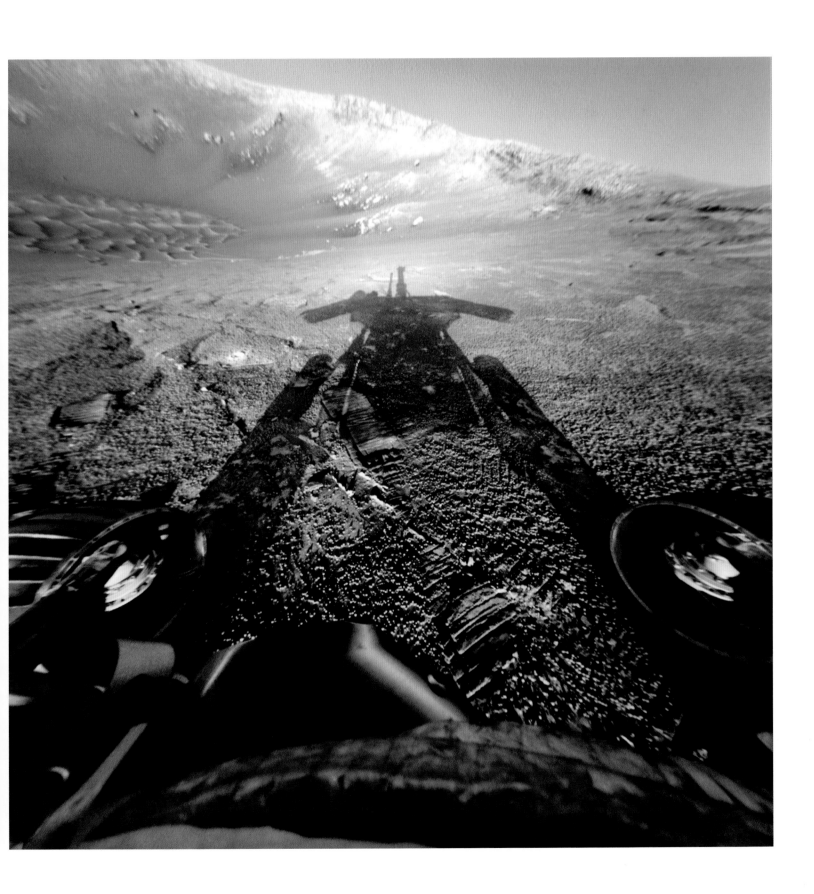

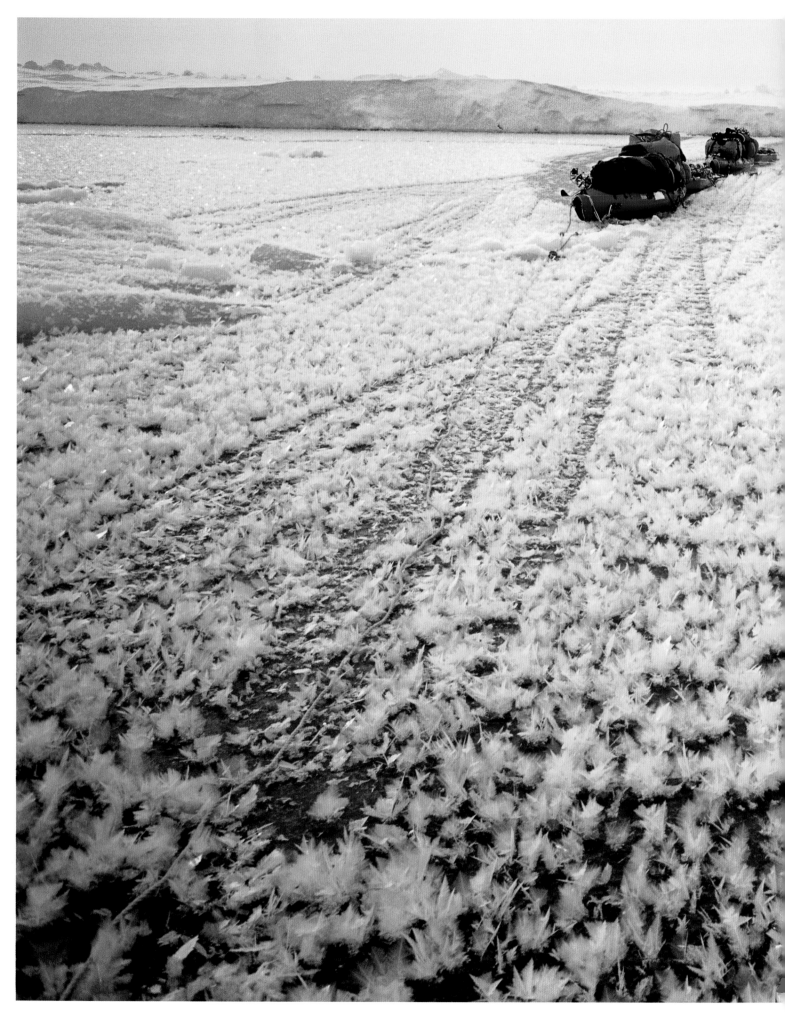

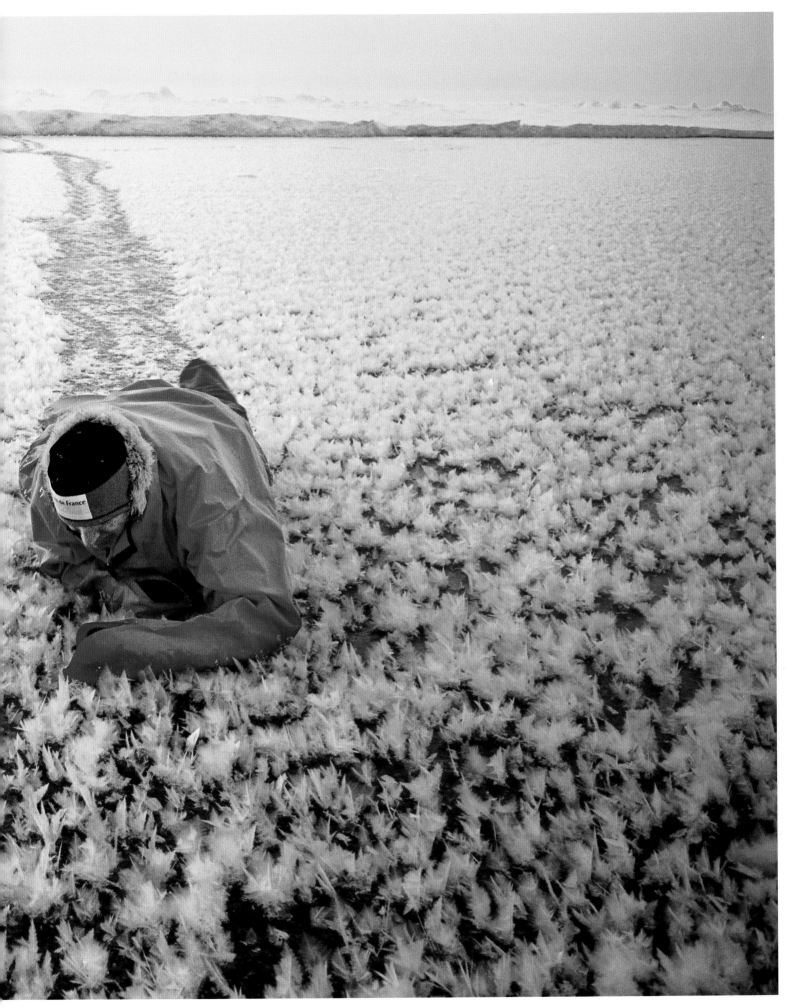

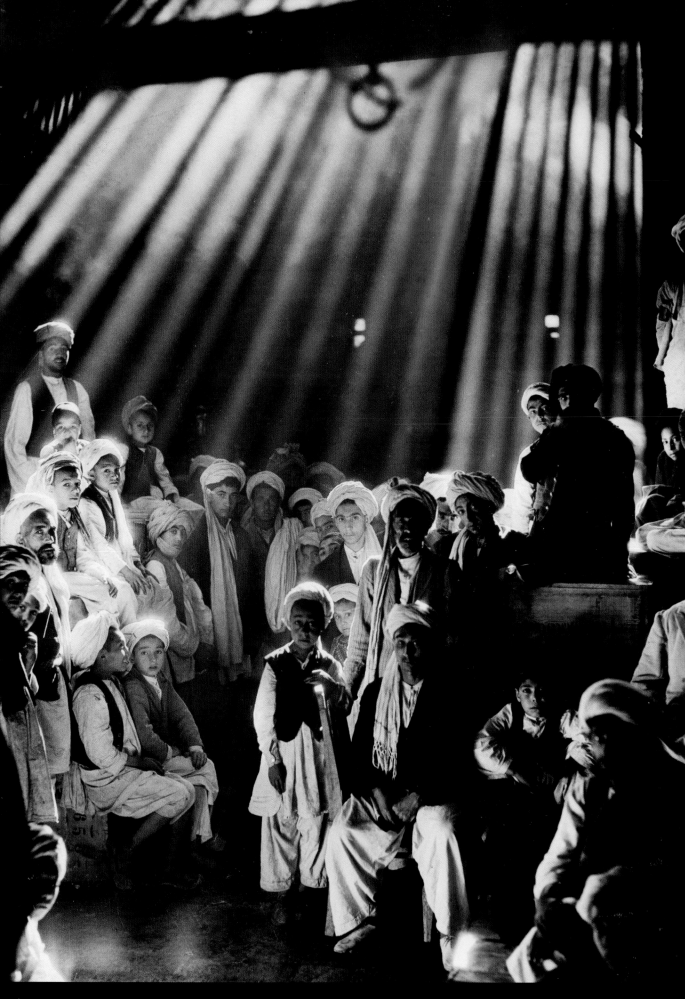

MAYNARD OWEN WILLIAMS | 1931 | AFGHANISTAN *In a Herat warehouse*

citroën-haardt expedition

THE GEOGRAPHIC'S MAYNARD OWEN WILLIAMS would always remember them as the "greatest adventure" of his life, those months in 1931-32 when he accompanied the French-sponsored Citroën-Haardt Expedition—via half-track, pony, camel, and yak—from Beirut all the colorful, spectacular, meandering, 7,000-mile way to Beijing.

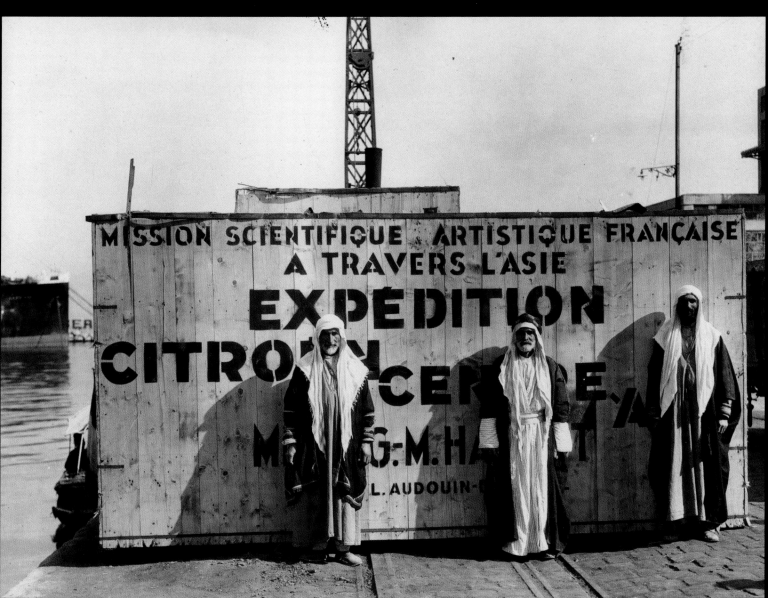

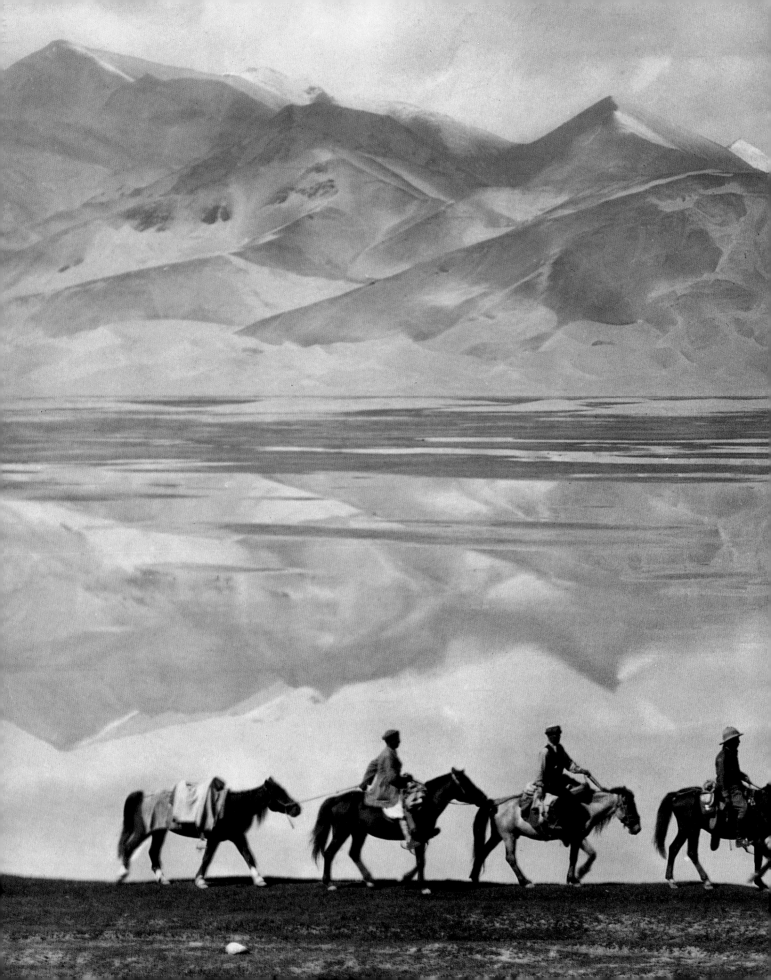

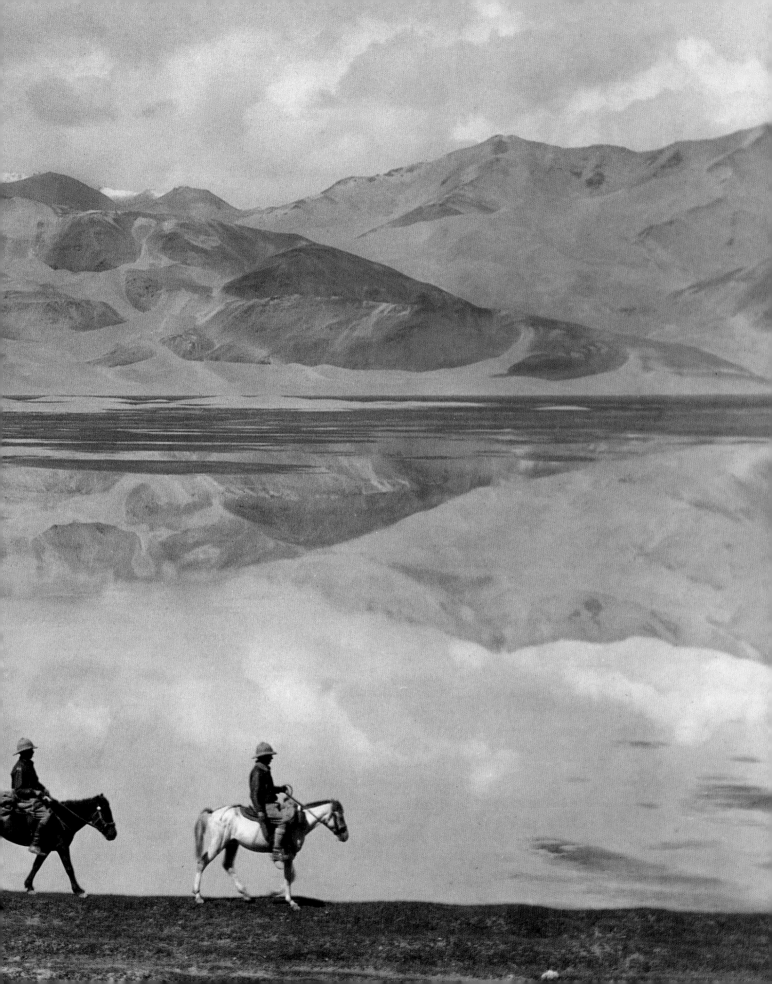

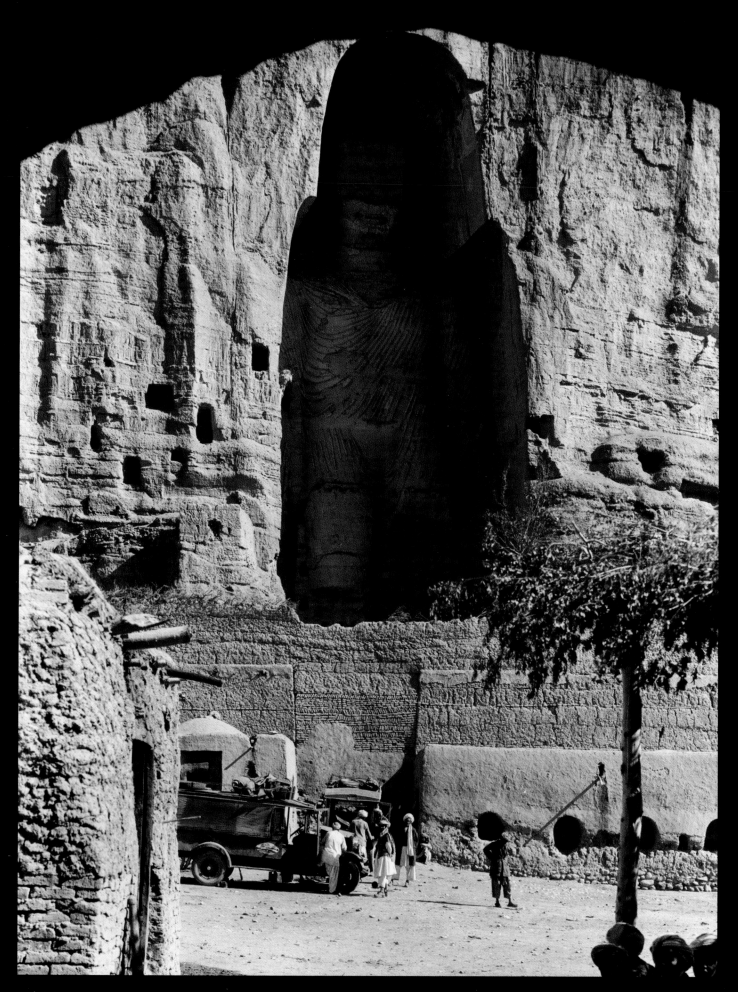

MAYNARD OWEN WILLIAMS | 1931 | AFGHANISTAN *The Great Buddha at Bamian*

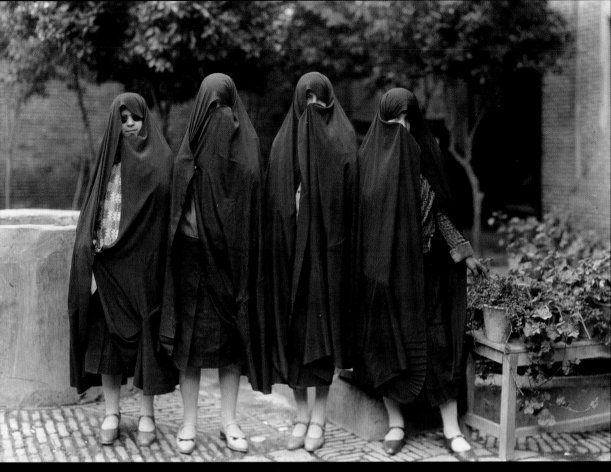

MAYNARD OWEN WILLIAMS I 1931 I IRAN *Schoolgirls of Persia*

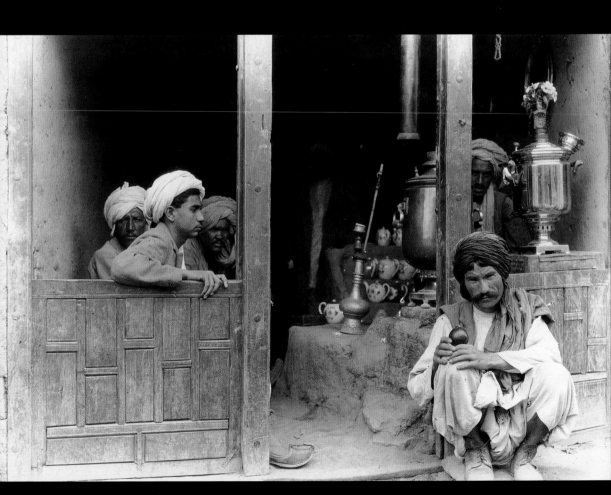

MAYNARD OWEN WILLIAMS I 1931 I AFGHANISTAN *In an Afghan bazaar* Citroën-Haardt Expedition I 111

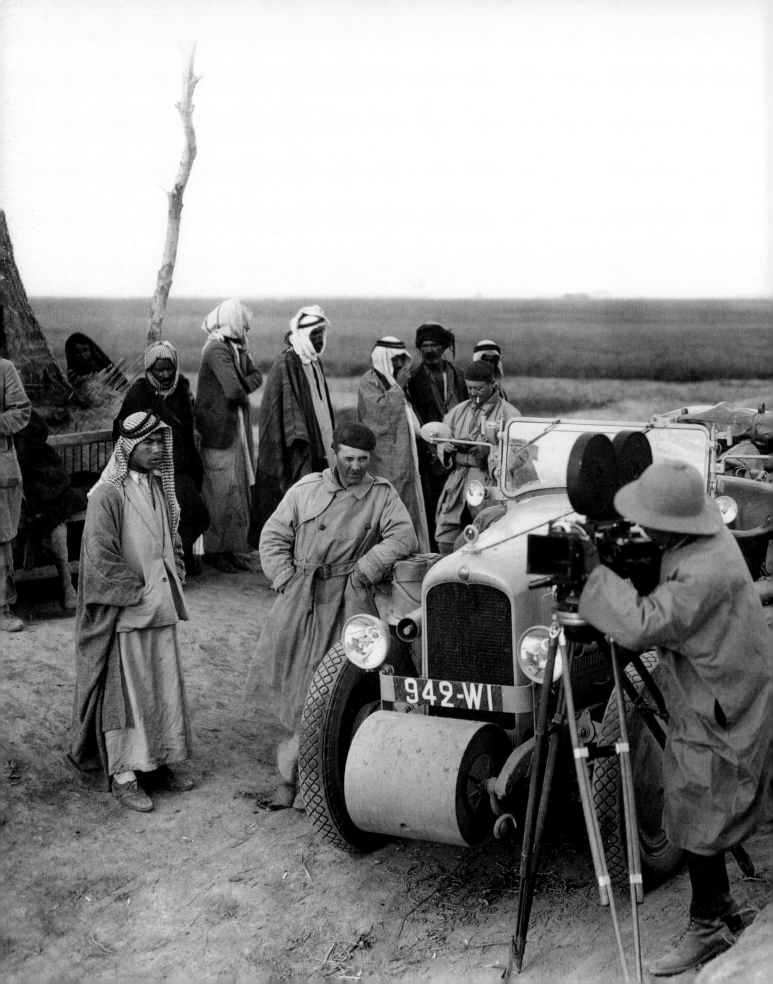

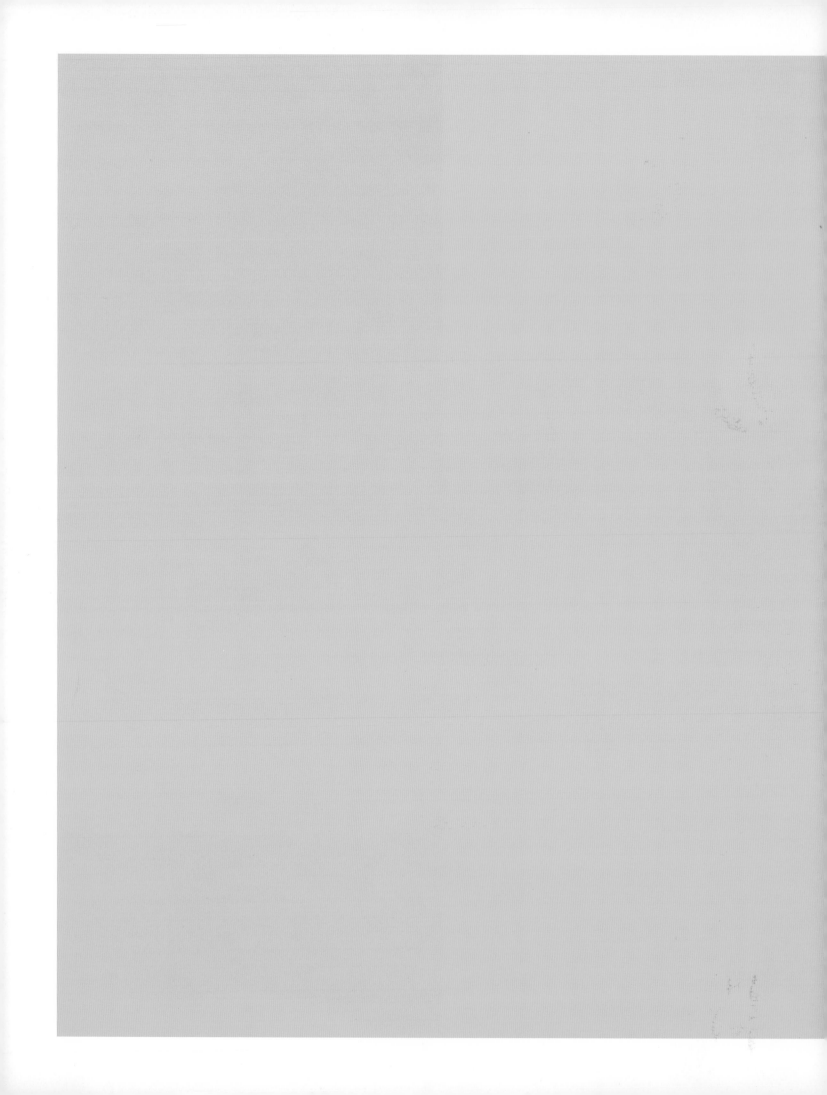

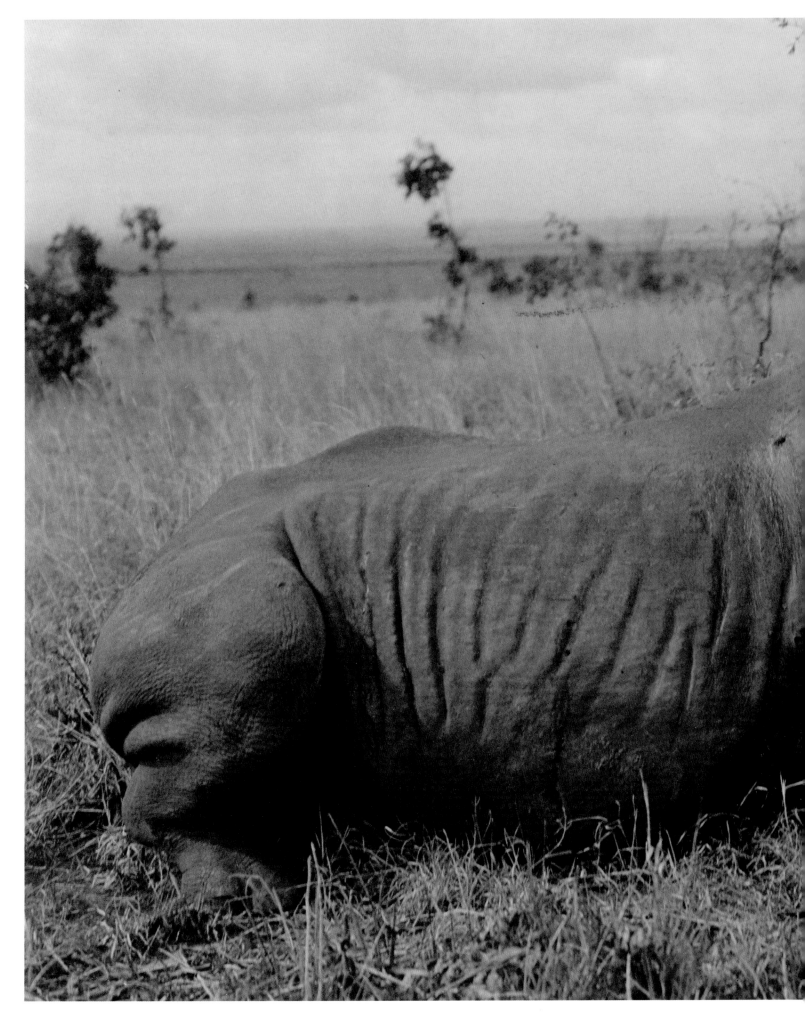

WILDLIFE

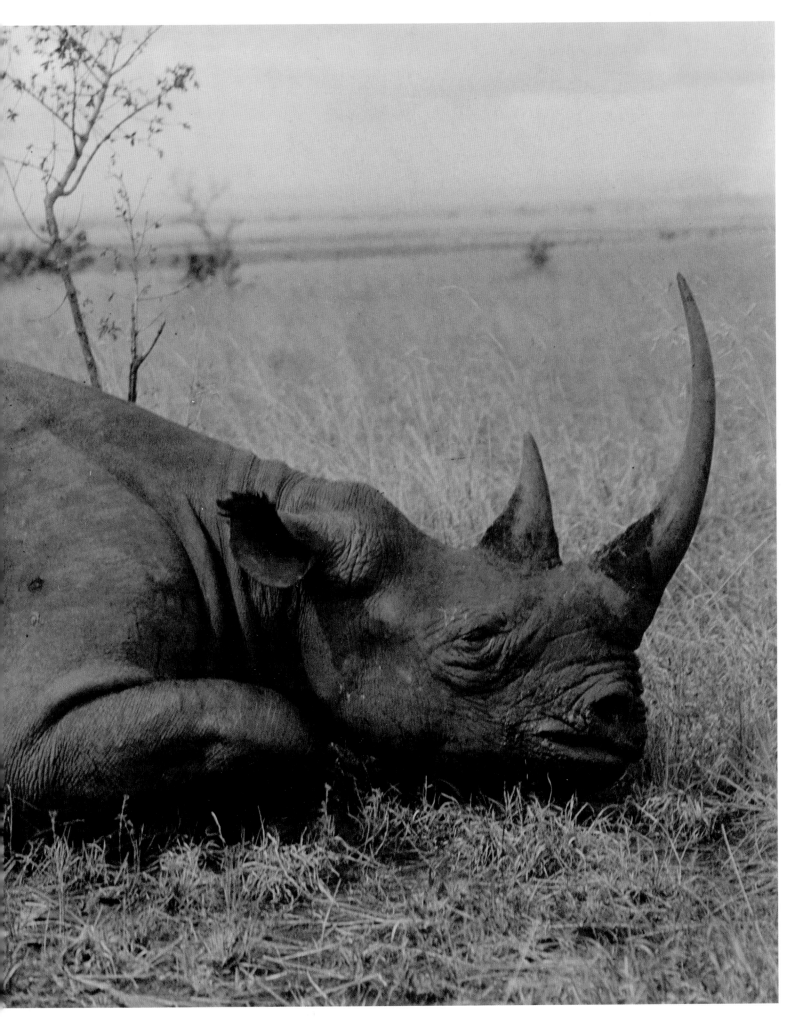

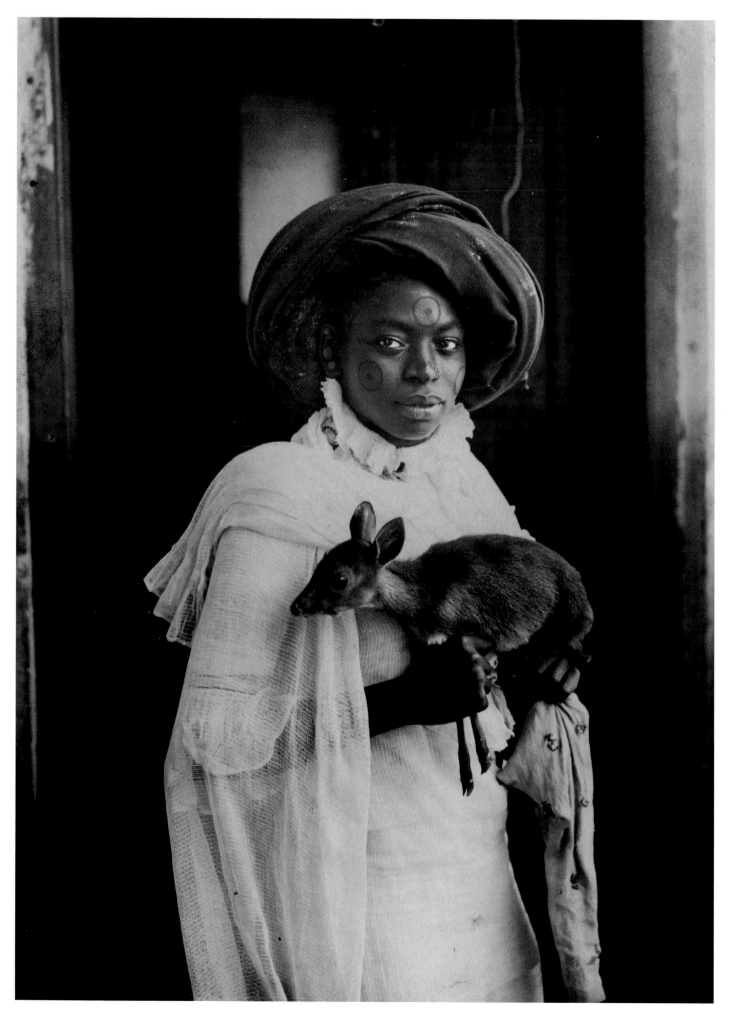

UNDERWOOD AND UNDERWOOD | 1909 | EAST AFRICA *Woman and antelope*

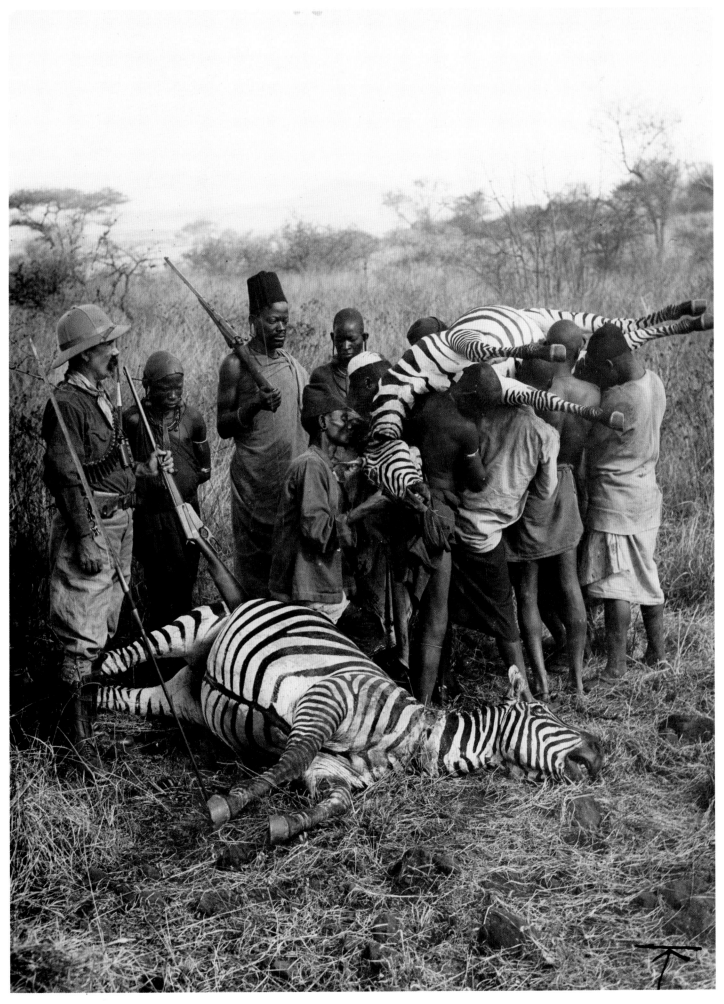

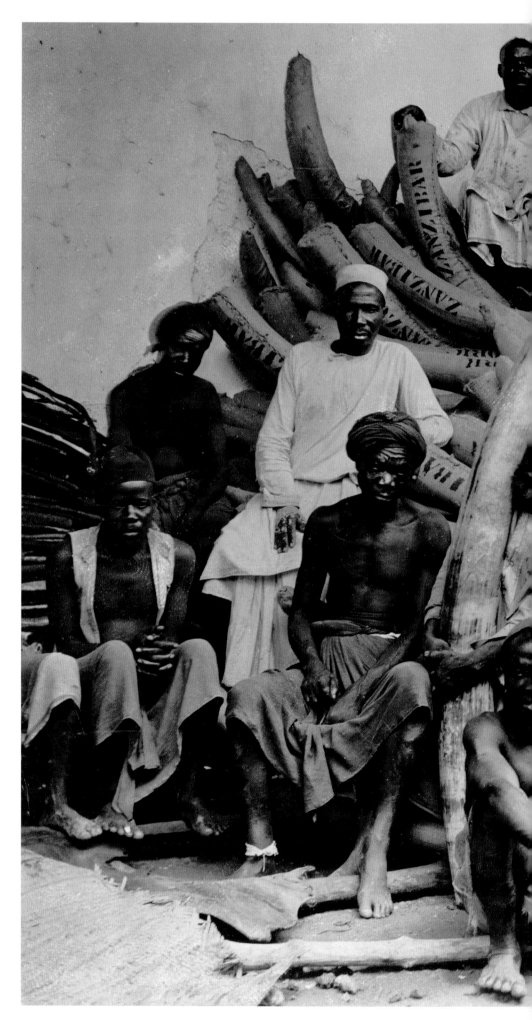

As early as 1910, Theodore Roosevelt had observed that the ivory of the African elephant was already "of such great value as well nigh to bring about the mighty beast's utter extermination."

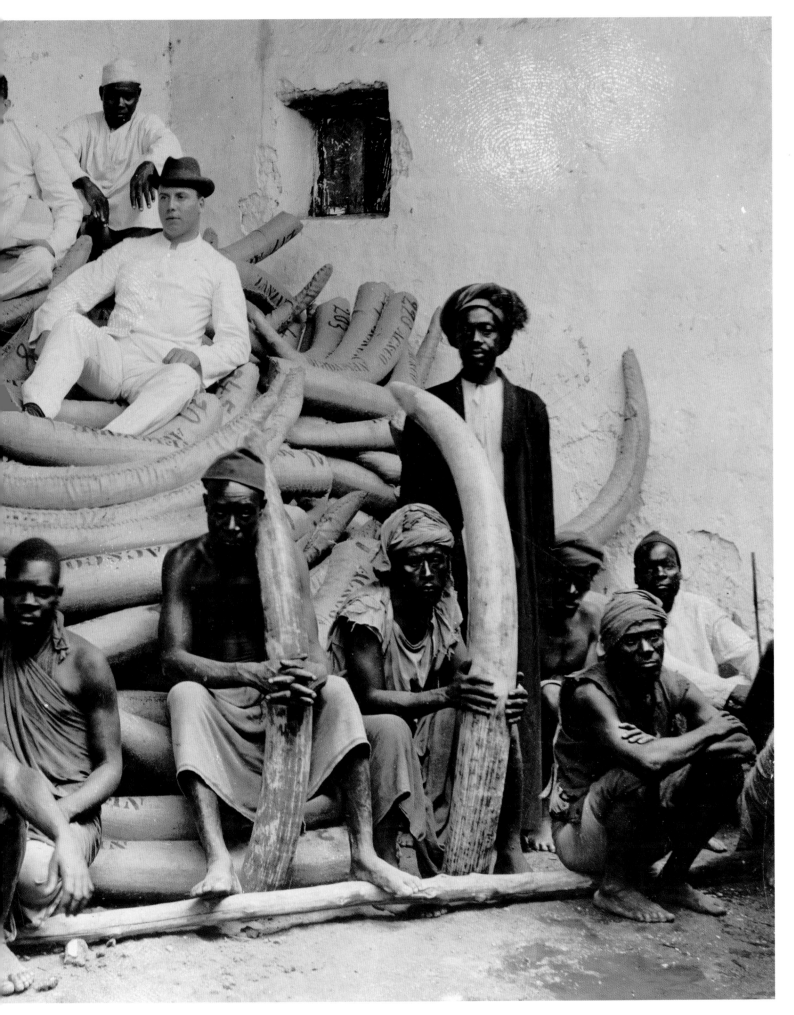

PHOTOGRAPHER UNKNOWN | DATE UNKNOWN | ZANZIBAR *Elephant tusks in an ivory market*

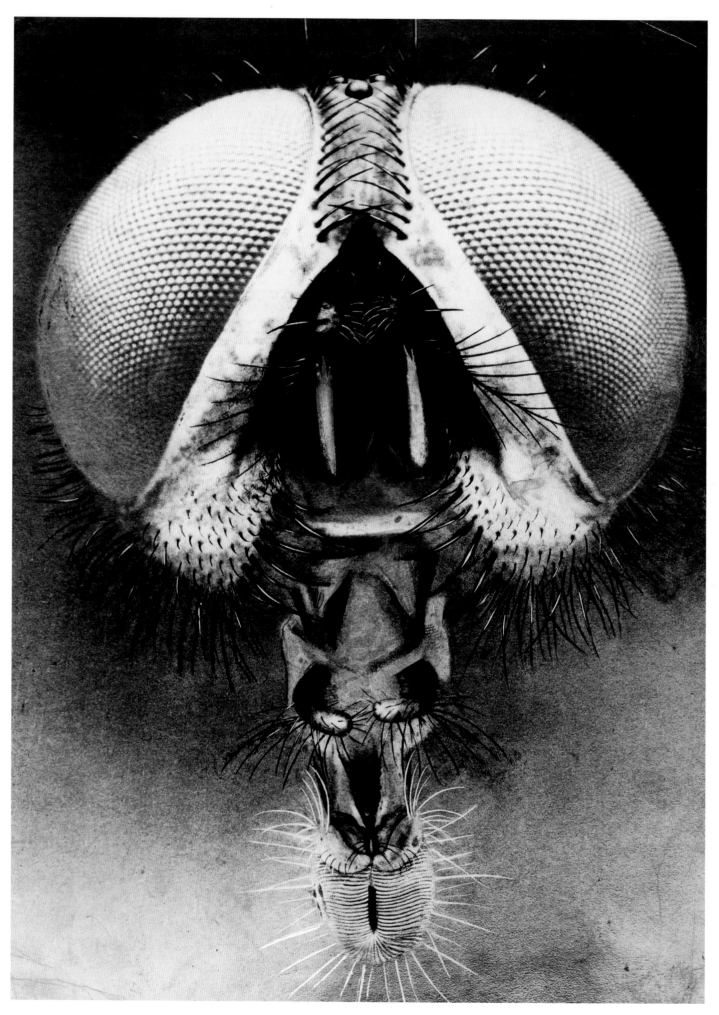

N. A. COBB | 1910 | LOCATION UNKNOWN *Face of a fly*

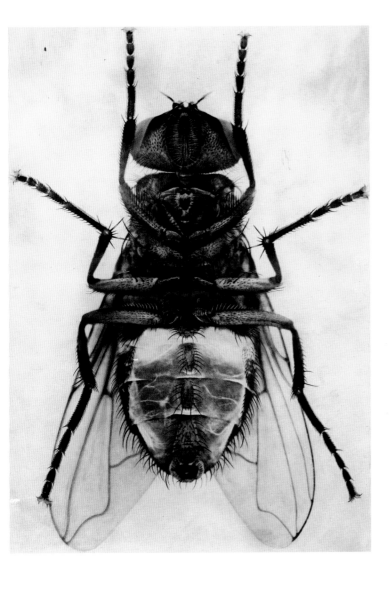

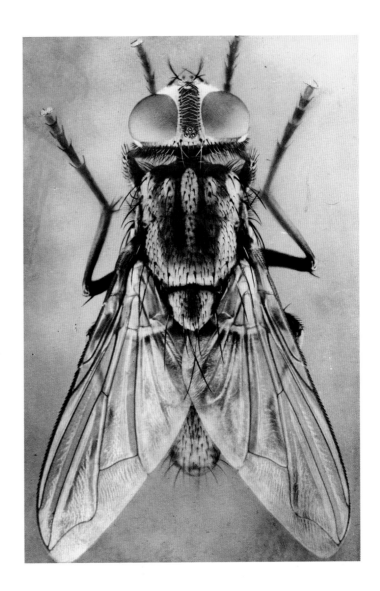

OTHO WEBB | 1930 | AUSTRALIA *Riding a sea turtle*

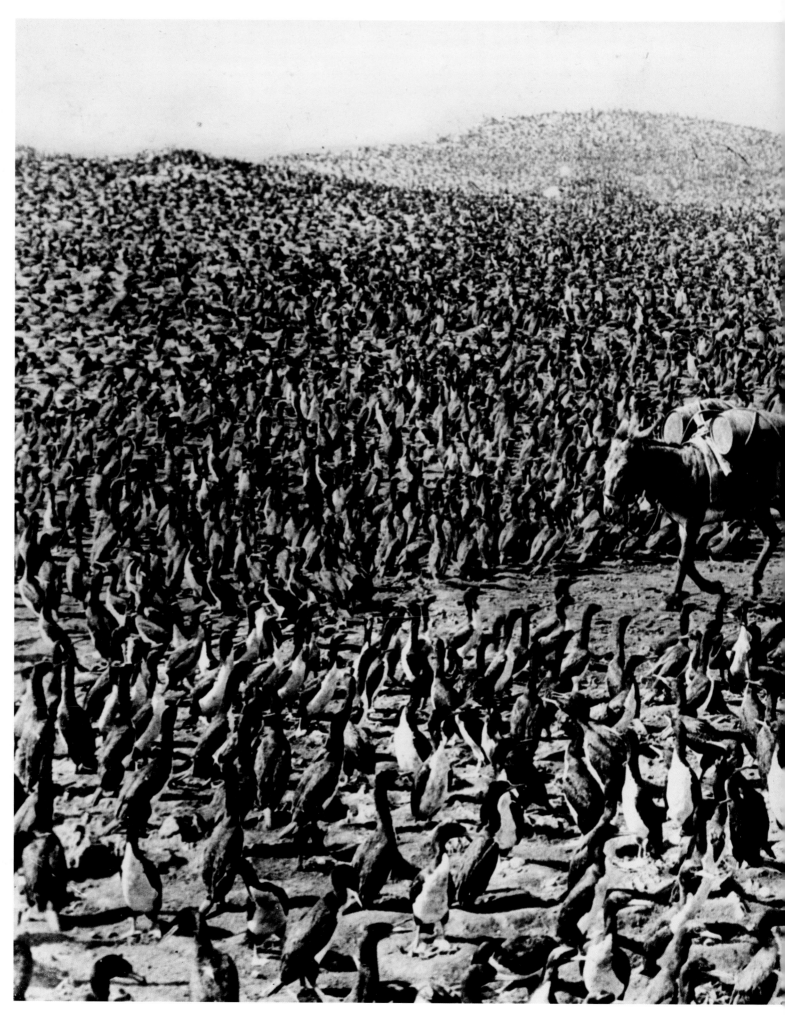

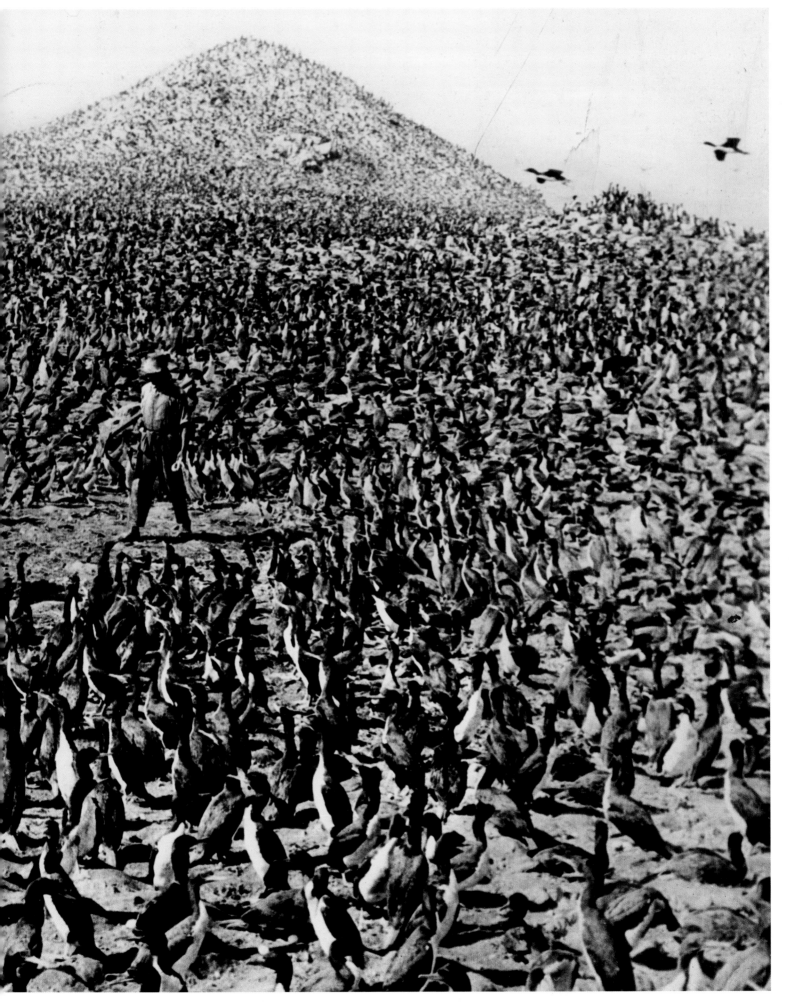
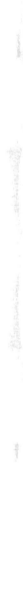

W. H. LONGLEY AND CHARLES MARTIN | 1926 | FLORIDA *A hogfish—one of the first undersea color photographs*

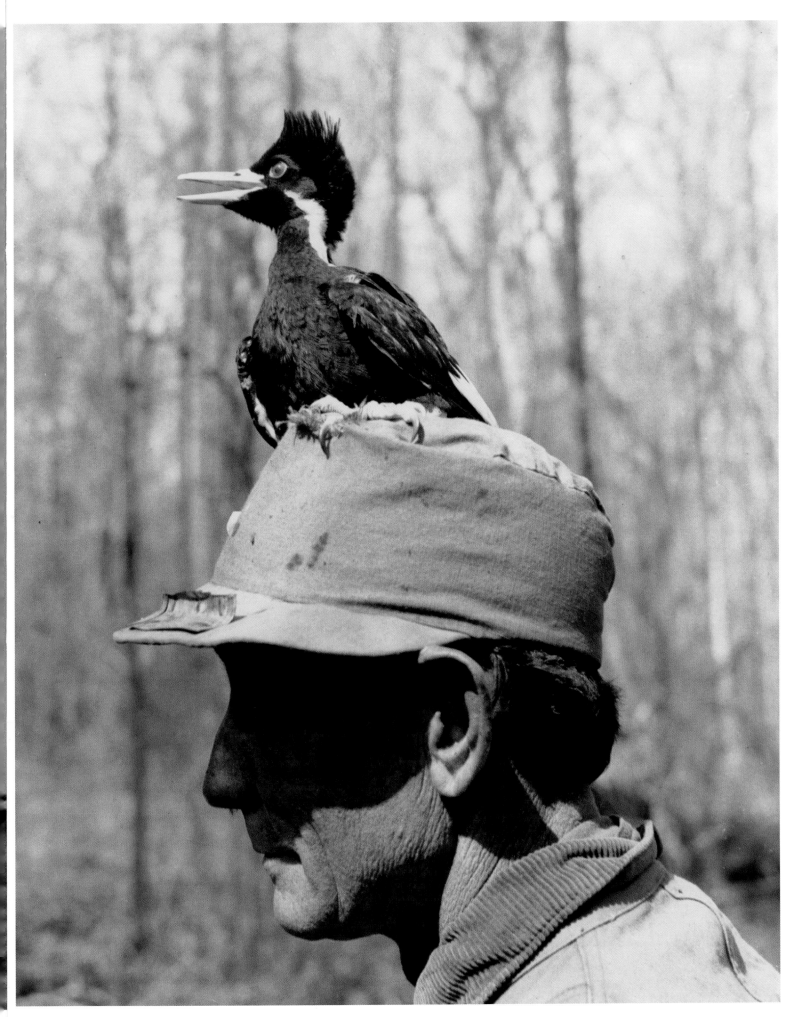

JAMES T. TANNER | 1939 | LOUISIANA *Ivory-billed woodpecker*

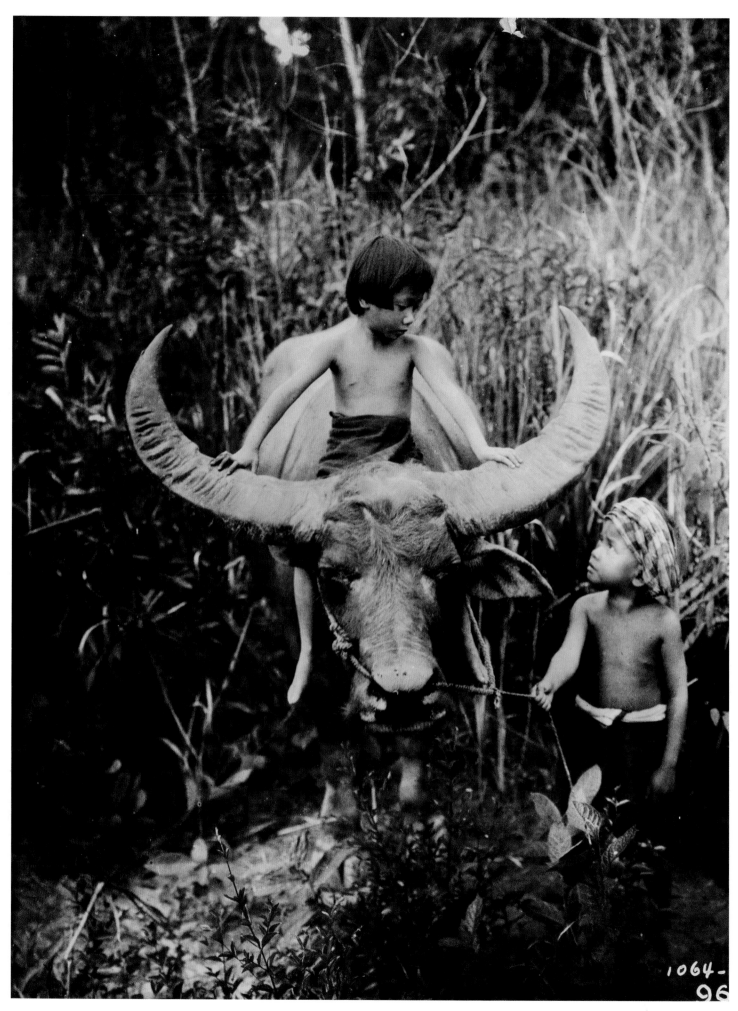

ERNEST B. SCHOEDSACK | 1927 | SIAM *Asian water buffalo*

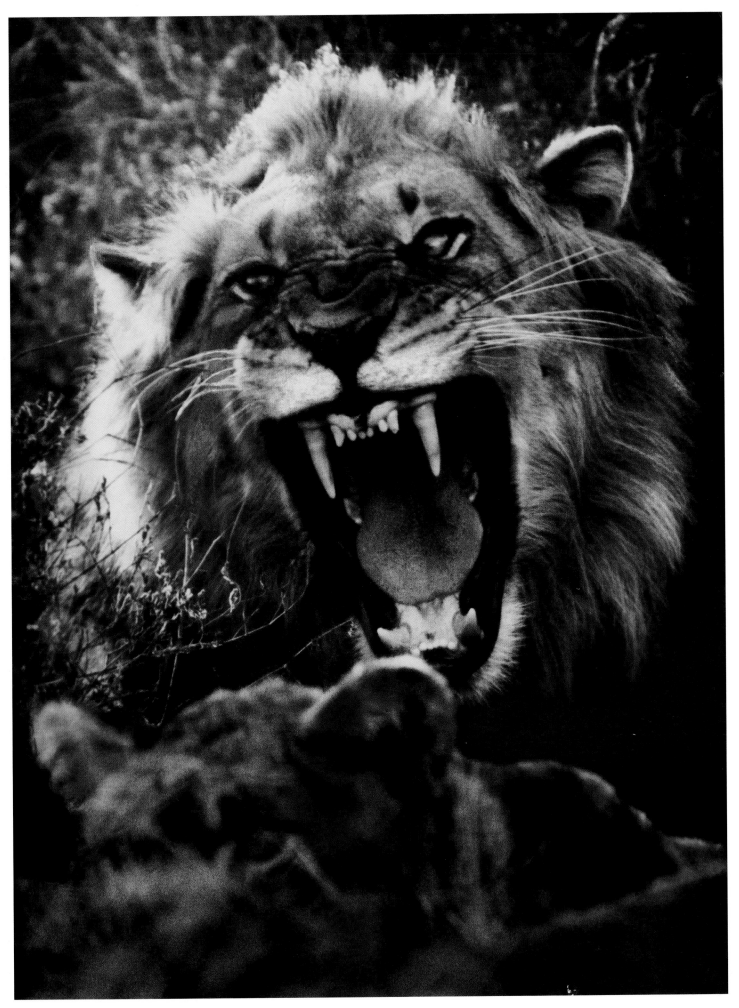

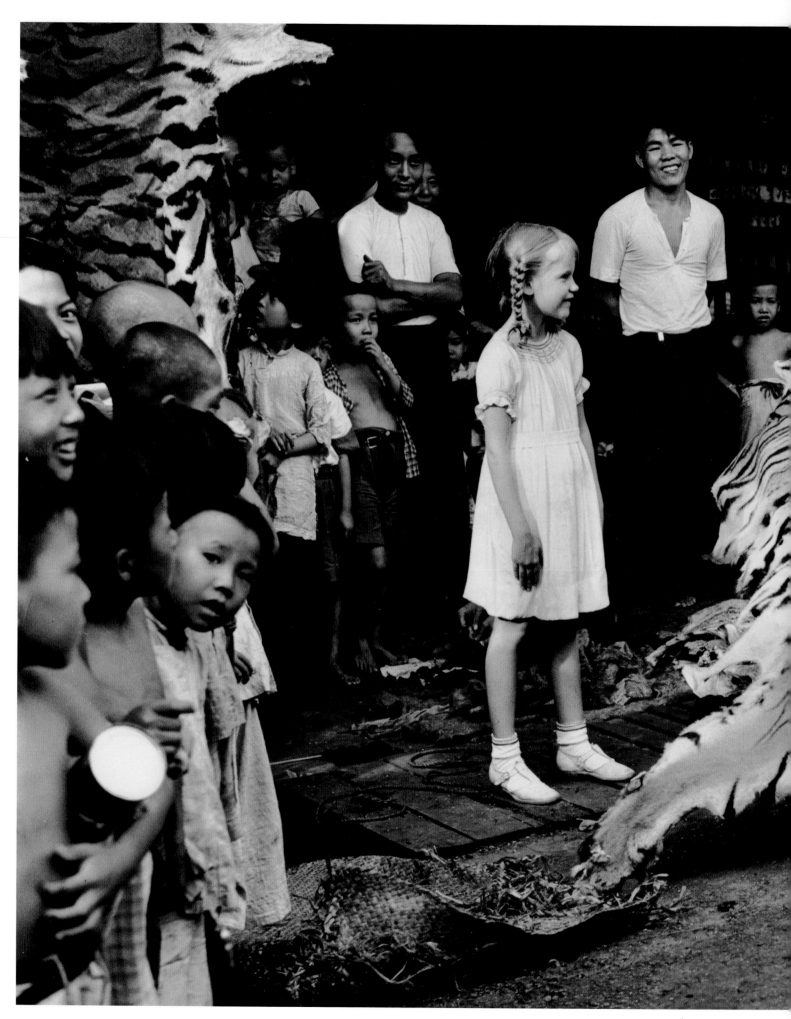

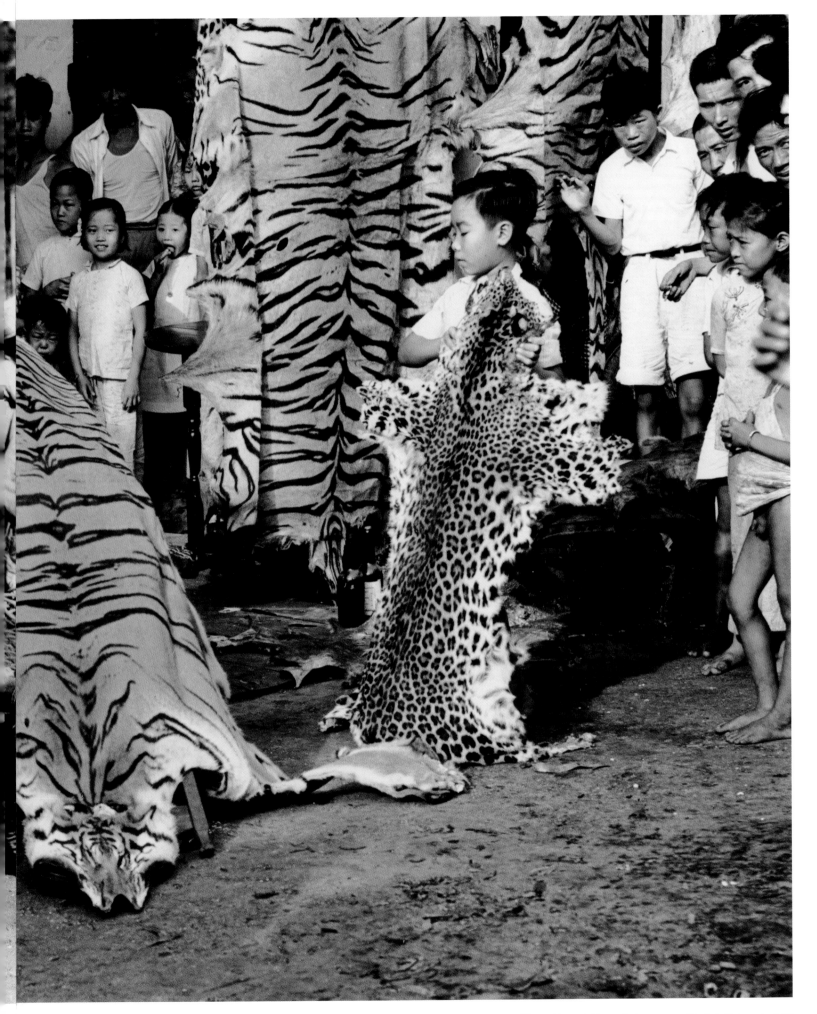

J. BAYLOR ROBERTS | 1939 | SINGAPORE *Tiger and leopard skins on display*

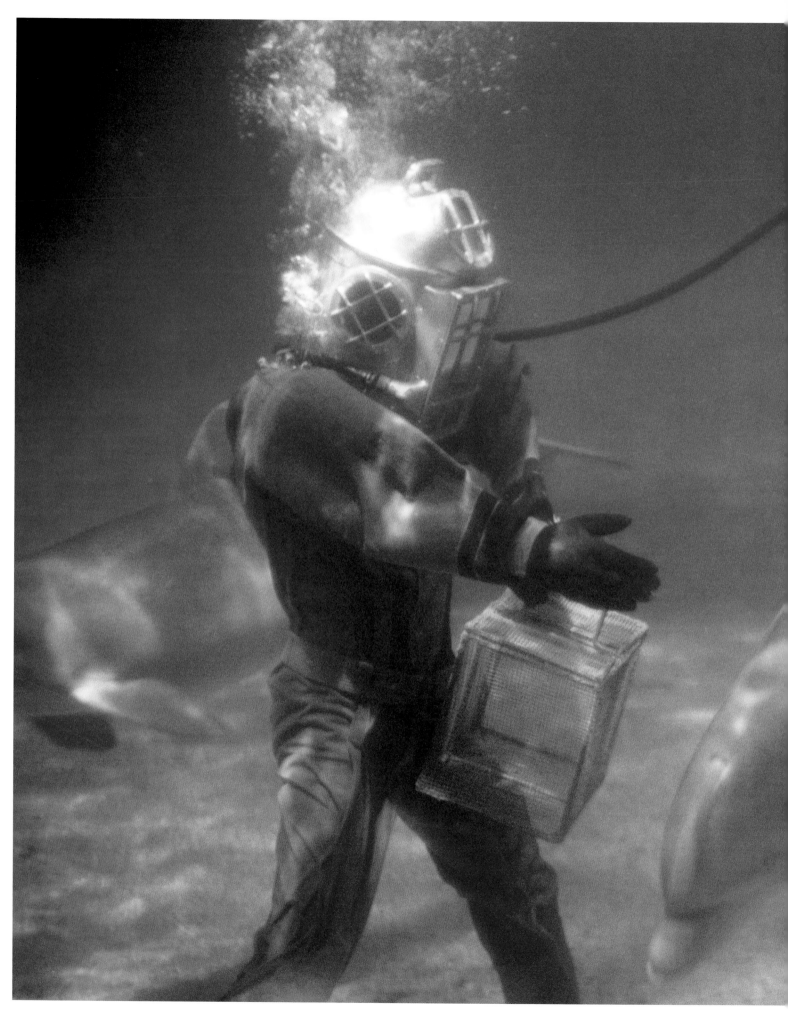

LUIS MARDEN | 1952 | FLORIDA *Caged man and free-swimming dolphins at Marineland*

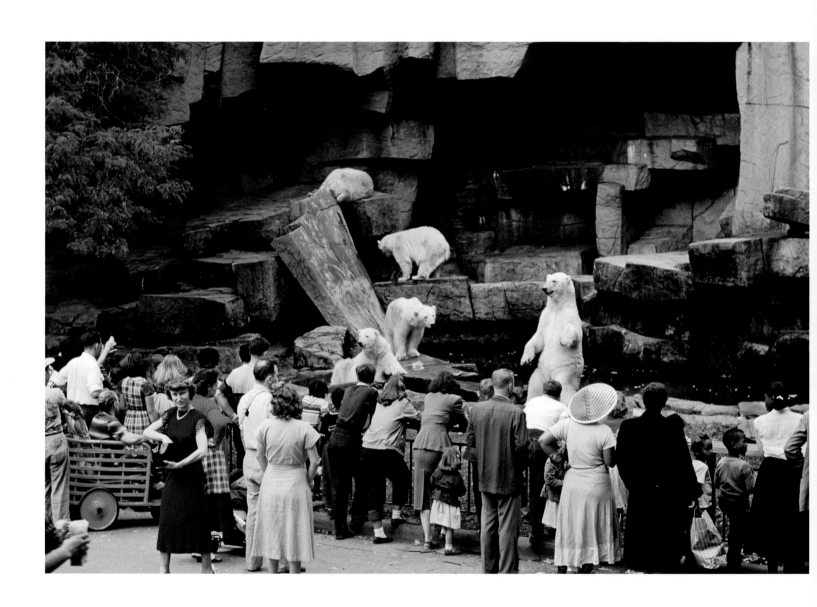

B. ANTHONY STEWART | 1953 | CHICAGO *People and bears eyeing each other at the zoo*

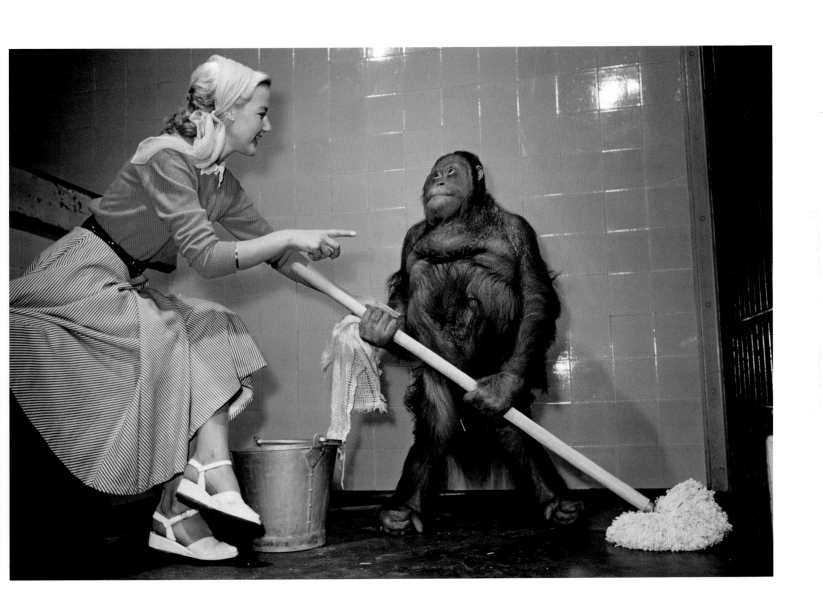

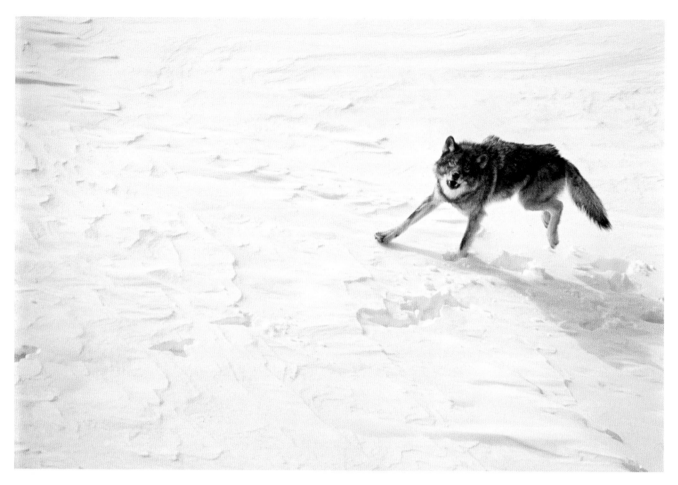

DR. DURWARD L. ALLEN | 1962 | MICHIGAN *Gray wolf on Isle Royale*

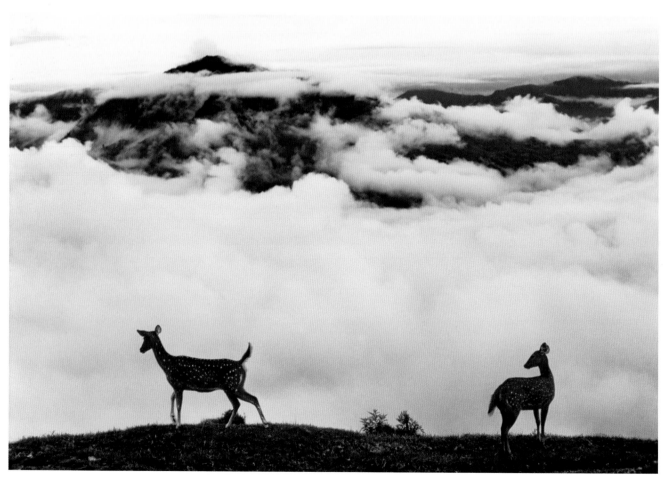

STEPHANIE DINKINS | 1963 | SIKKIM *Spotted deer in the Himalaya*

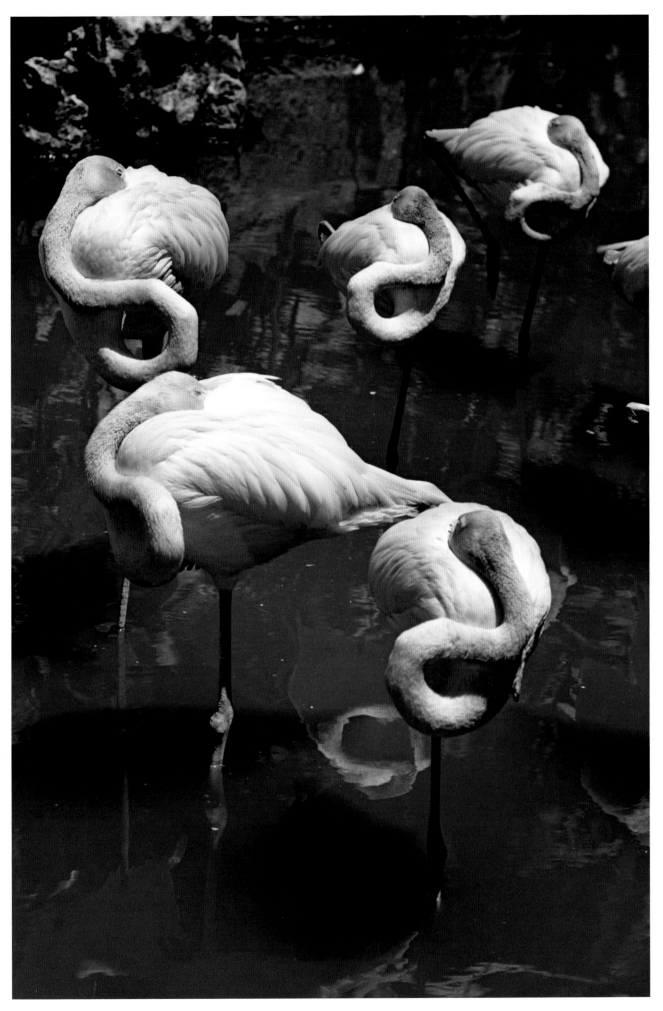

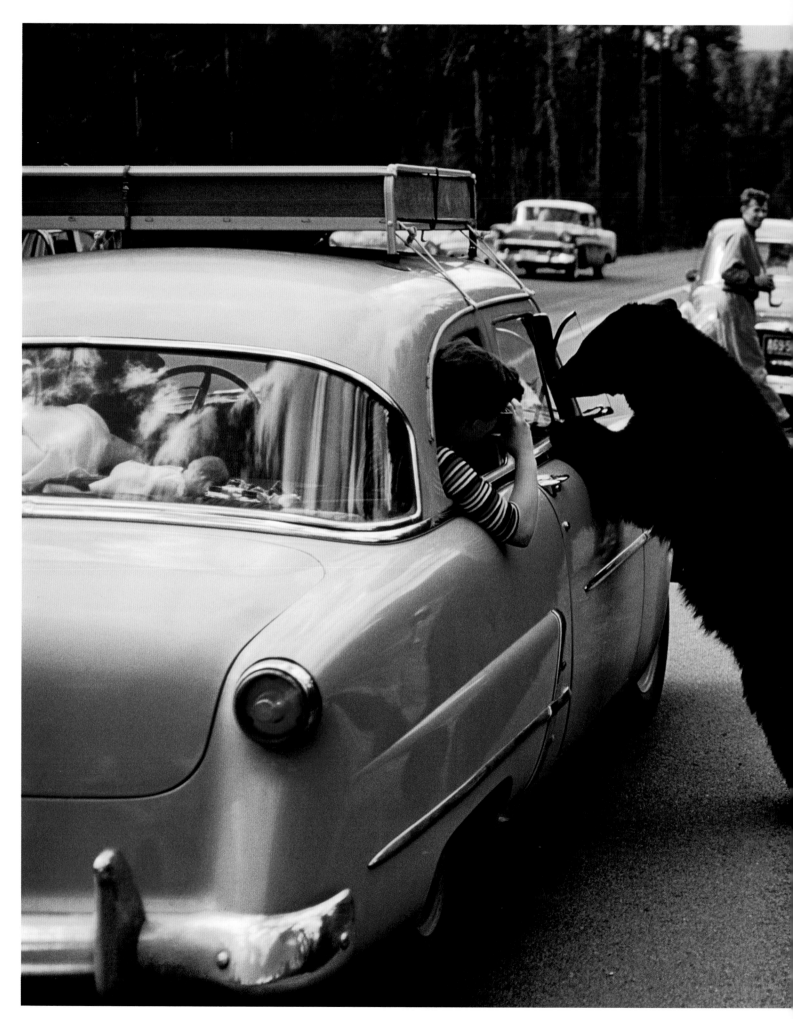

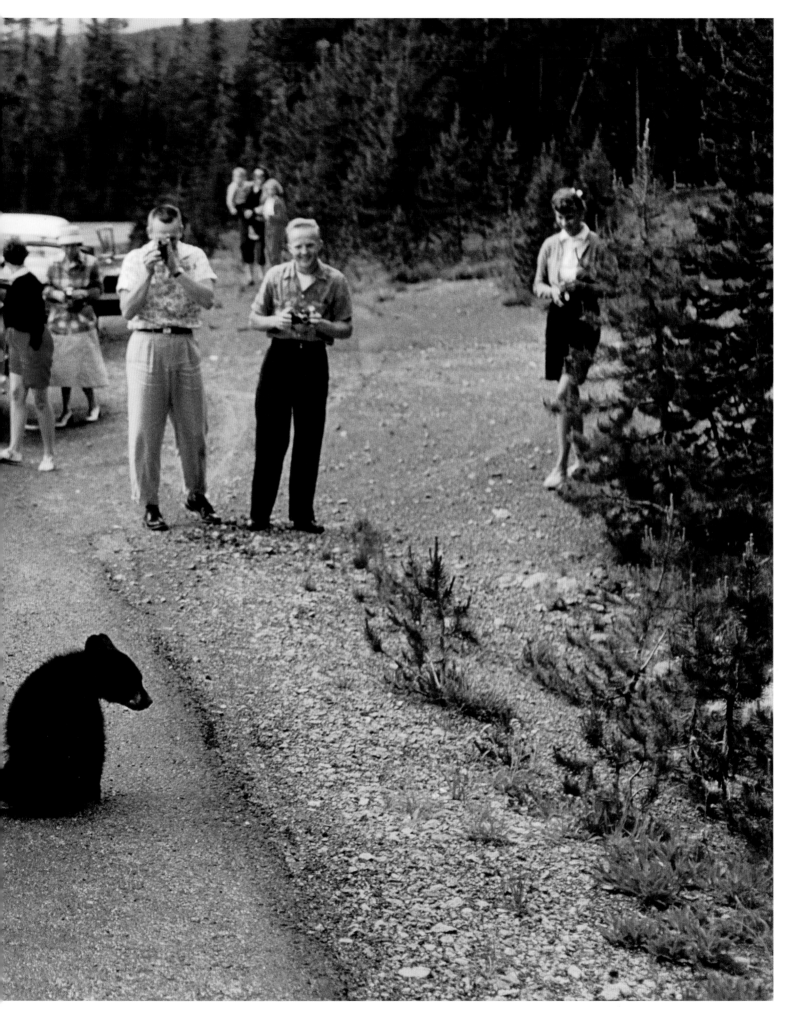

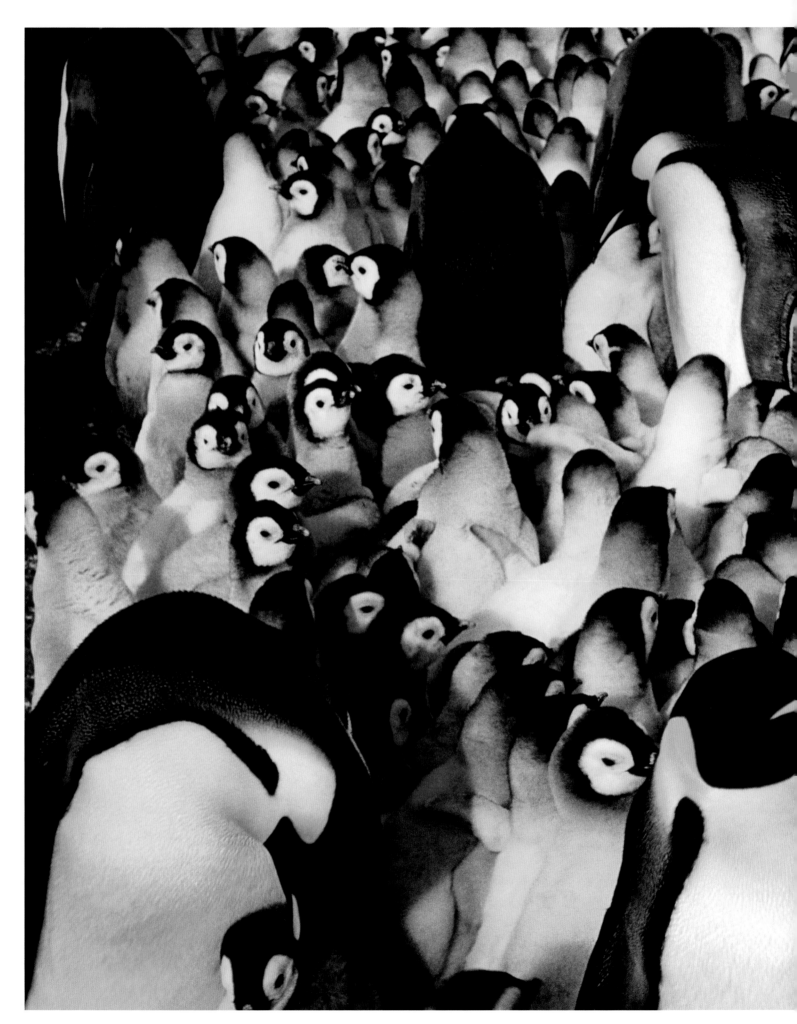

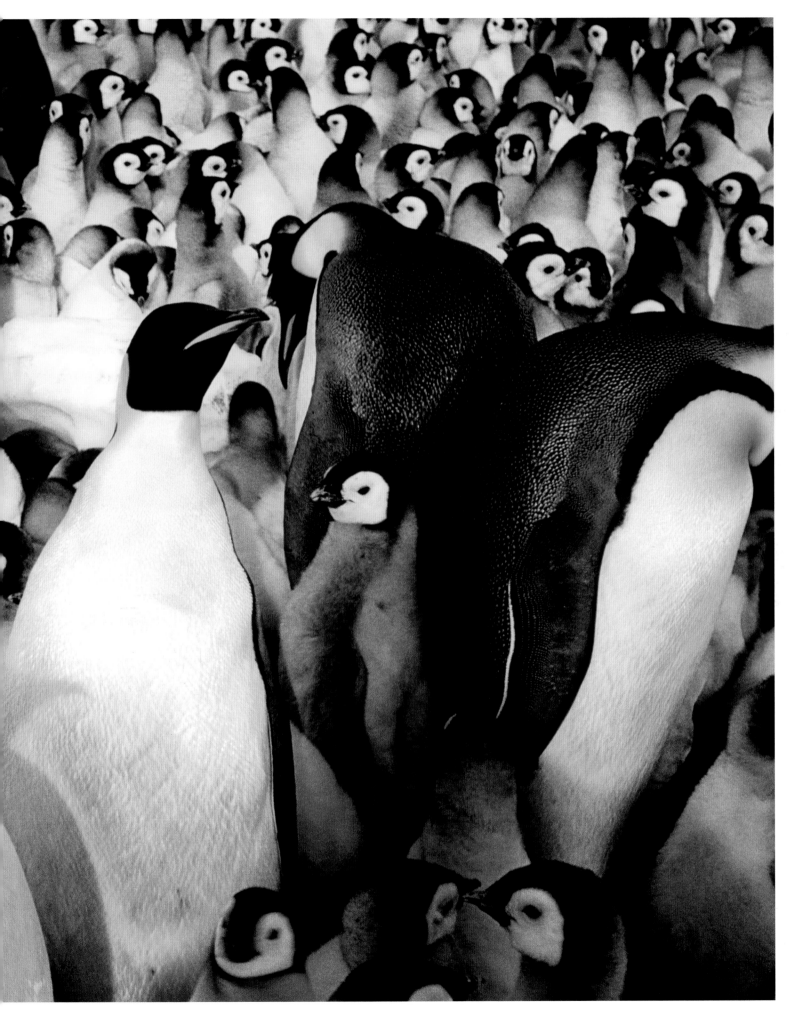

FRANK KAZUKAITIS | 1963 | ANTARCTICA *Youth and age among emperor penguins*

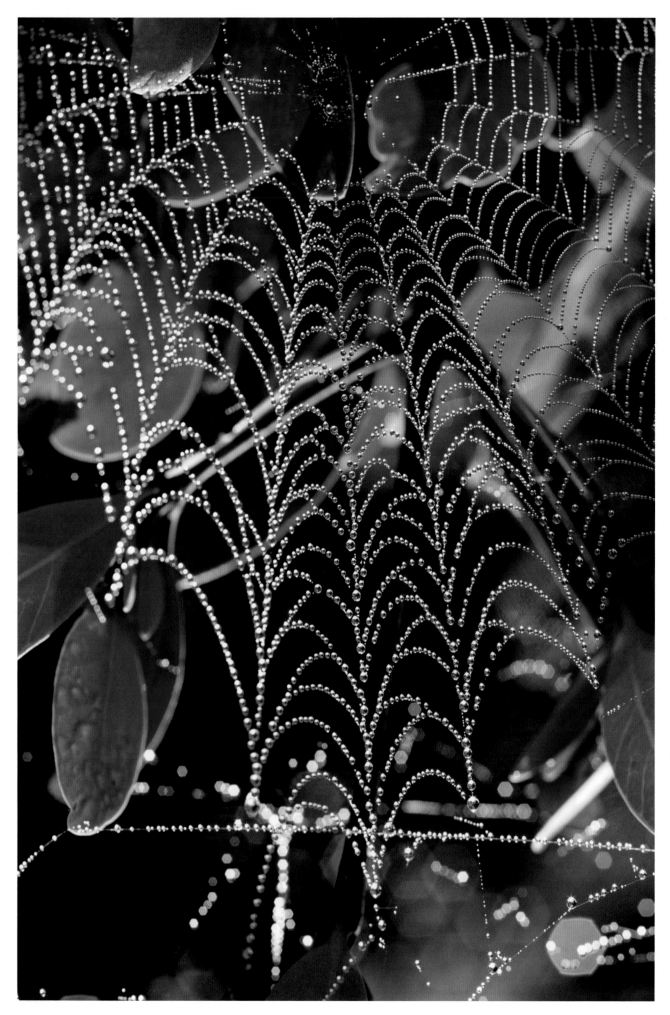

JAMES A. KERNS | 1967 | FLORIDA *Spider's web in the Everglades*

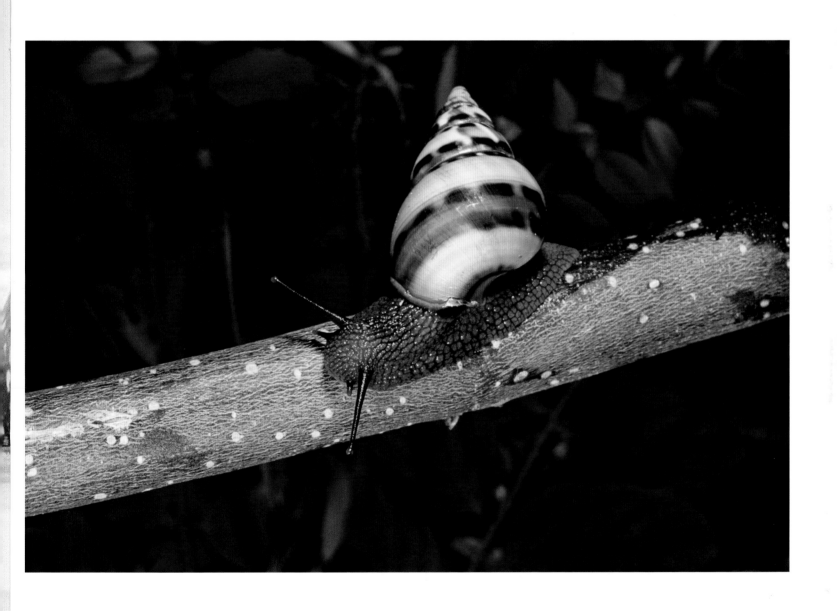

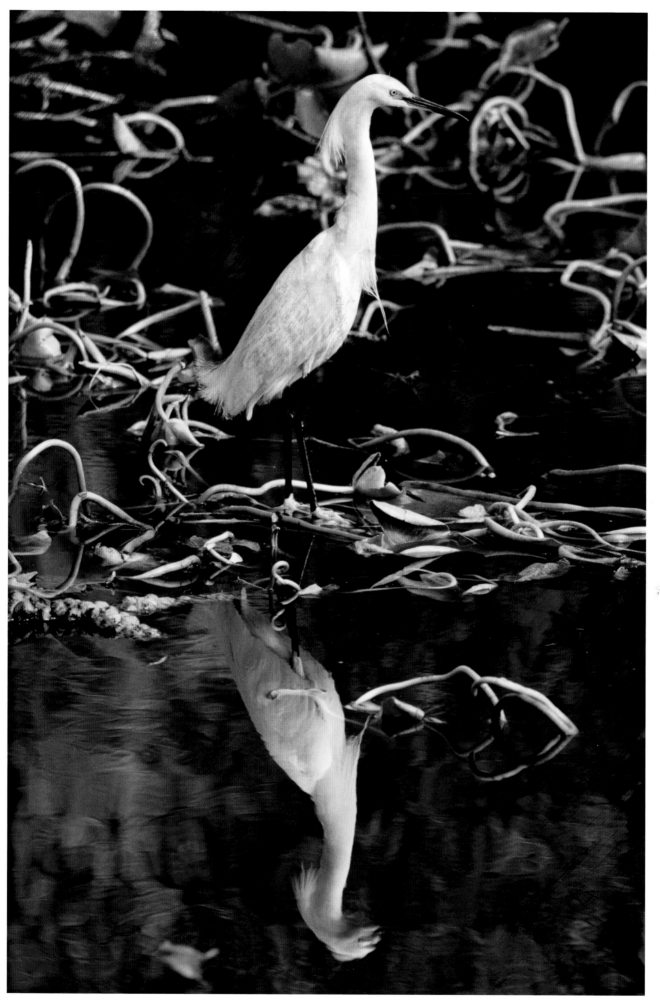

FREDERICK KENT TRUSLOW | 1967 | FLORIDA *Snowy egret in the Everglades*

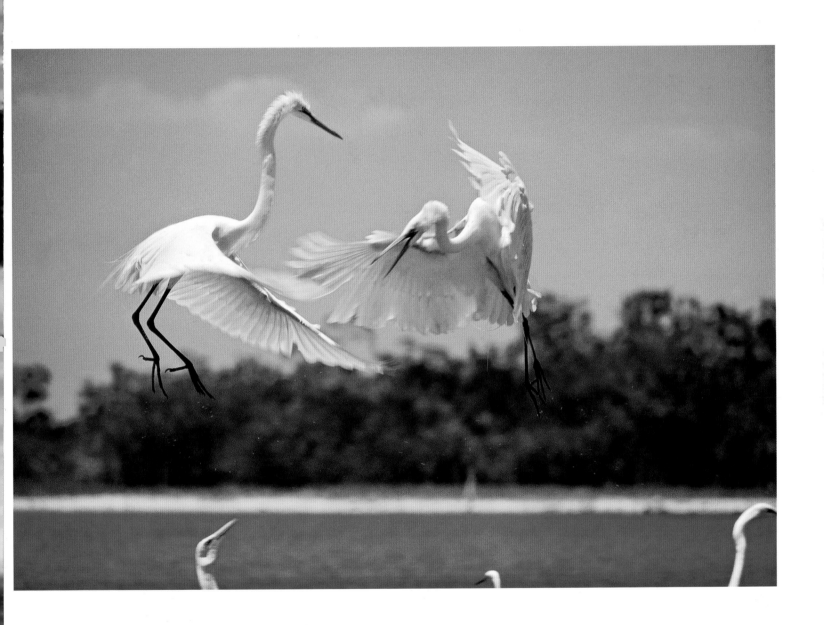

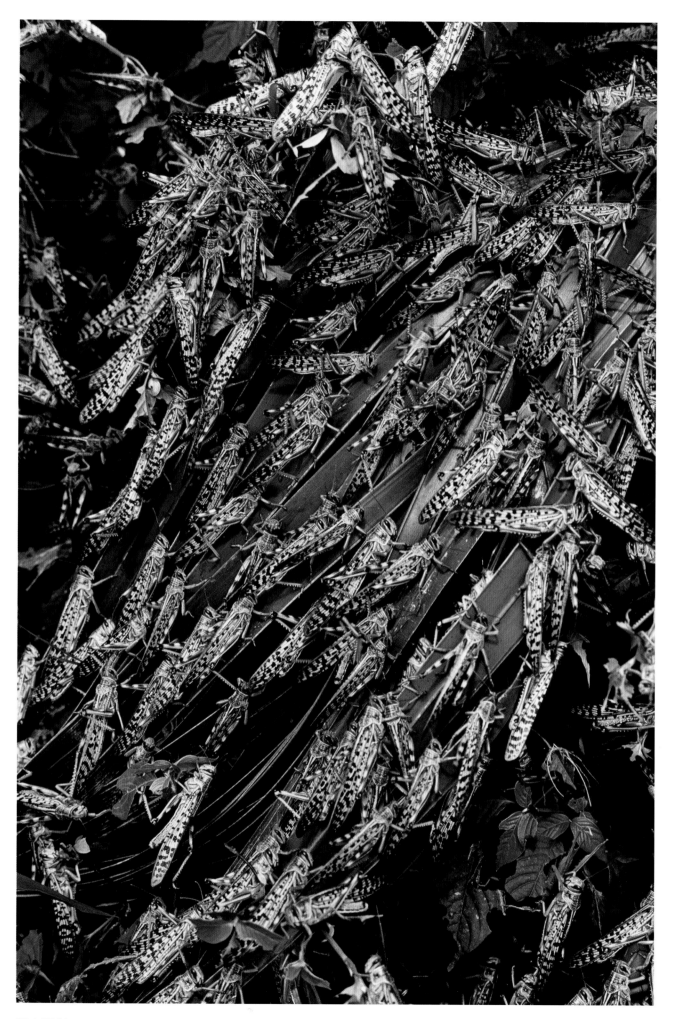

GIANNI TORTOLI | 1969 | ETHIOPIA *Locusts feeding*

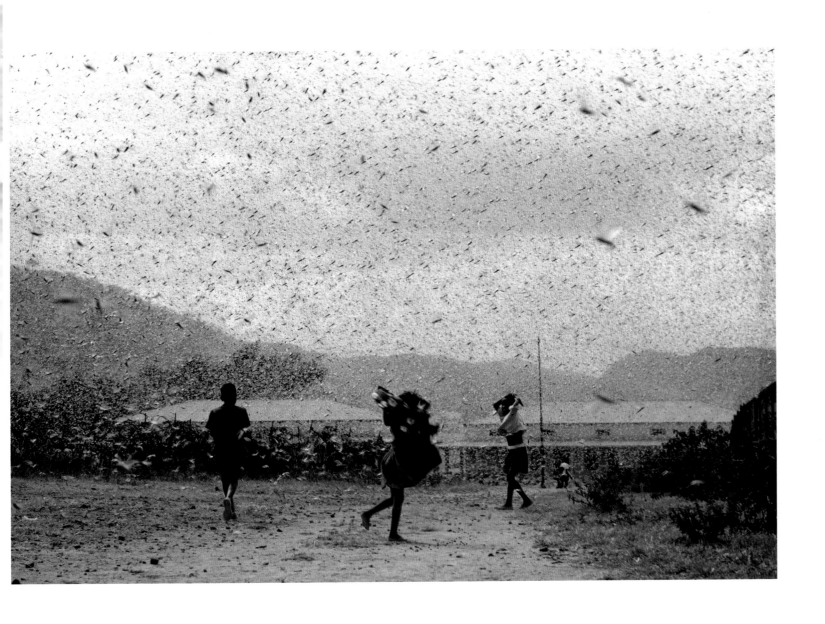

PAUL ZAHL | 1973 | COSTA RICA *Tadpoles' coiled intestines revealed by transparent skin*

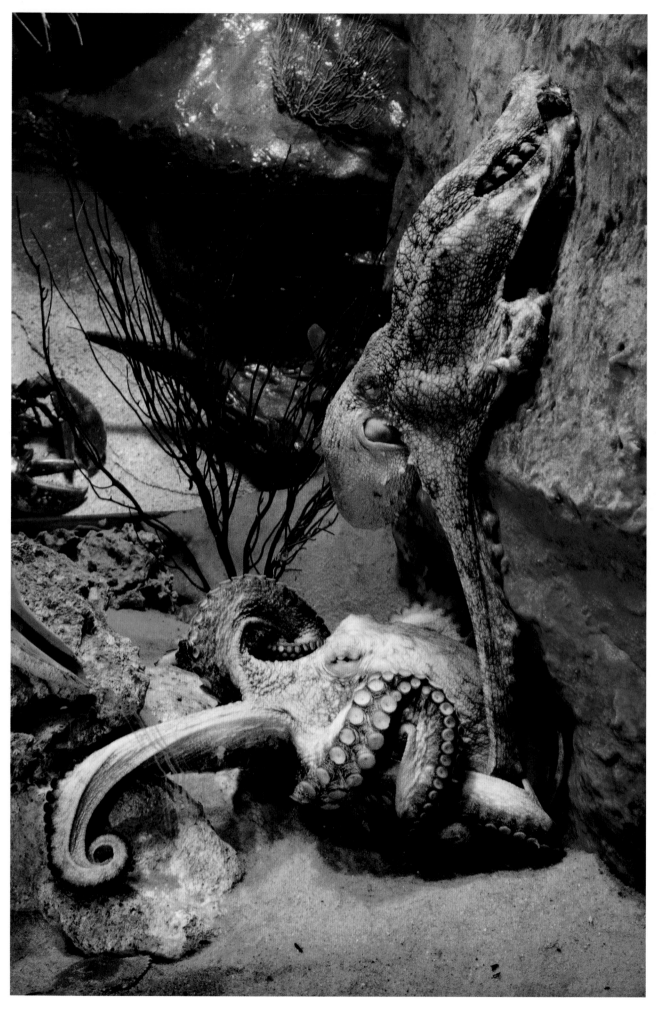

ROBERT F. SISSON | 1971 | FLORIDA *Mating octopuses*

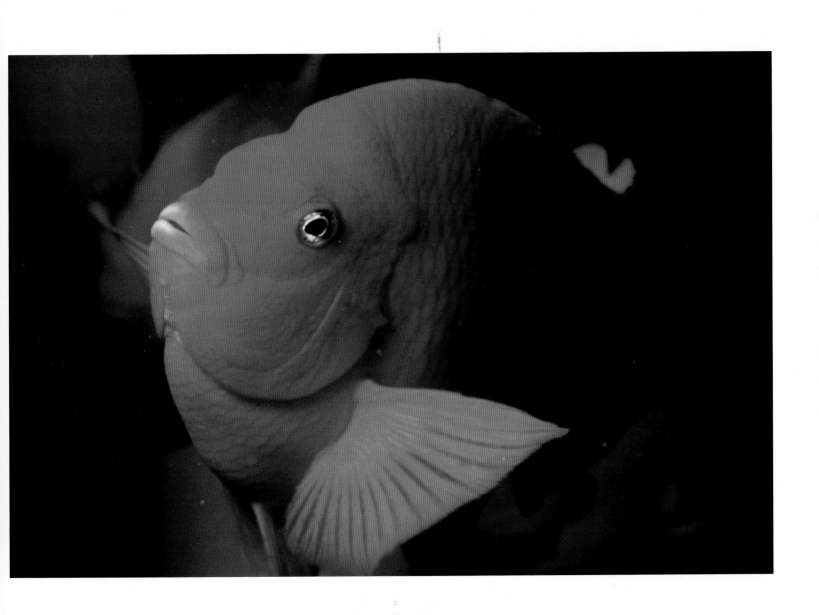

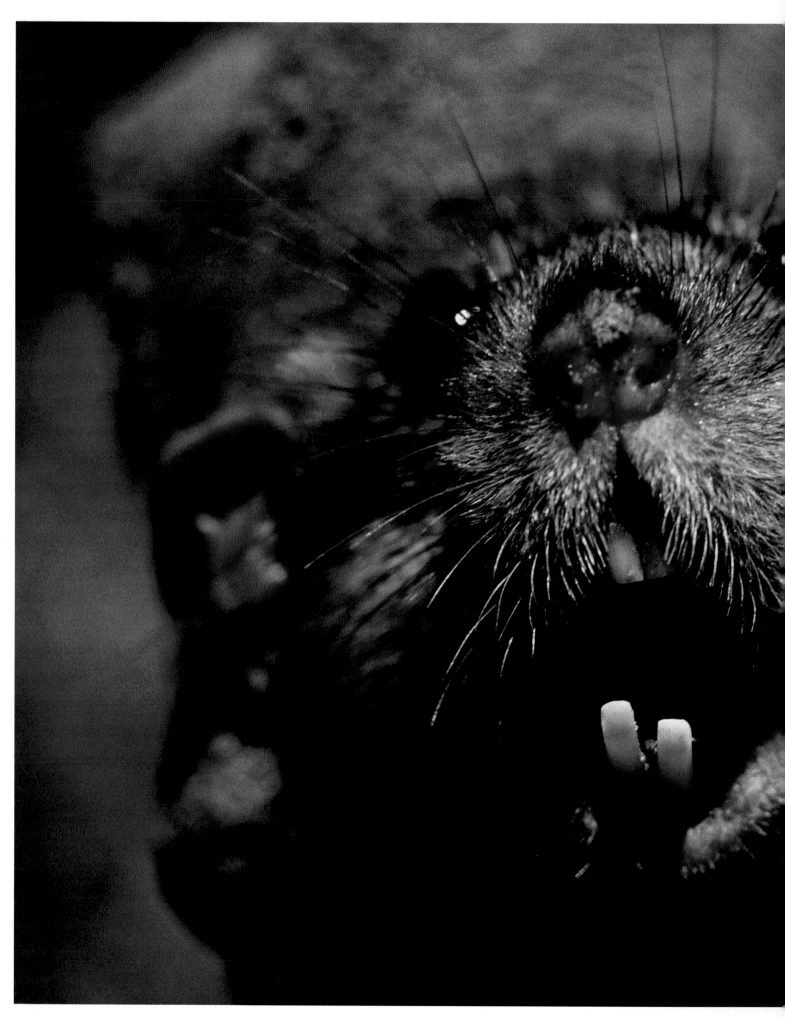

JAMES L. STANFIELD | 1975 | UNITED STATES *Portrait of a rat*

"Gnaw or die" states this picture's original caption. "Fast-growing teeth require perpetual gnashing." Without such incessant grinding, this rat's upper teeth might curl back into the roof of its mouth.

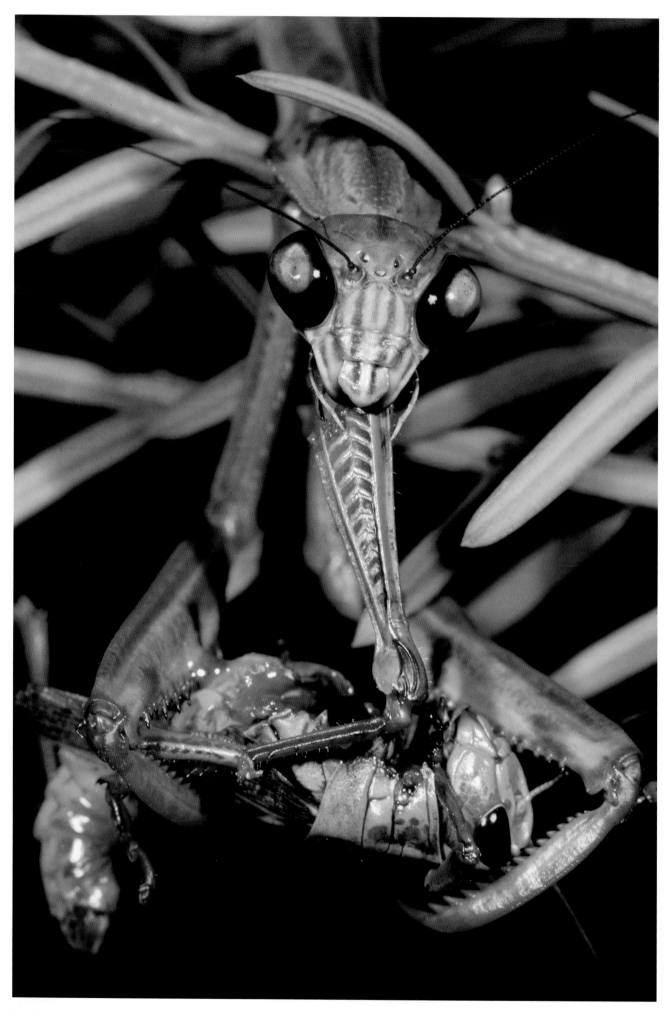

DWIGHT R. KUHN | 1984 | MAINE *Mantis devouring a grasshopper*

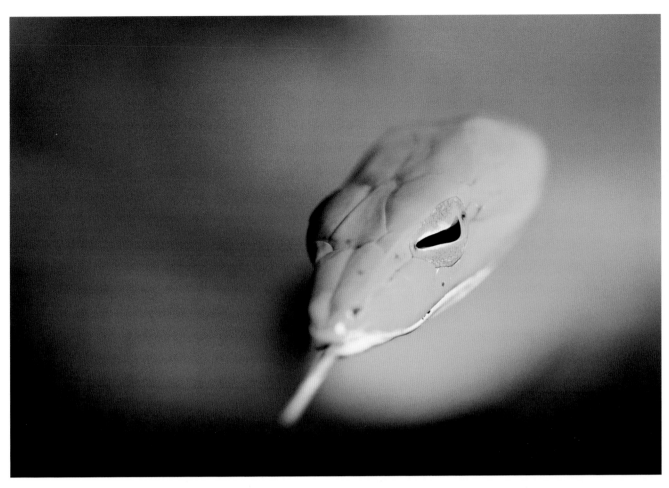

MATTIAS KLUM | 1985 | BORNEO *Green whipsnake*

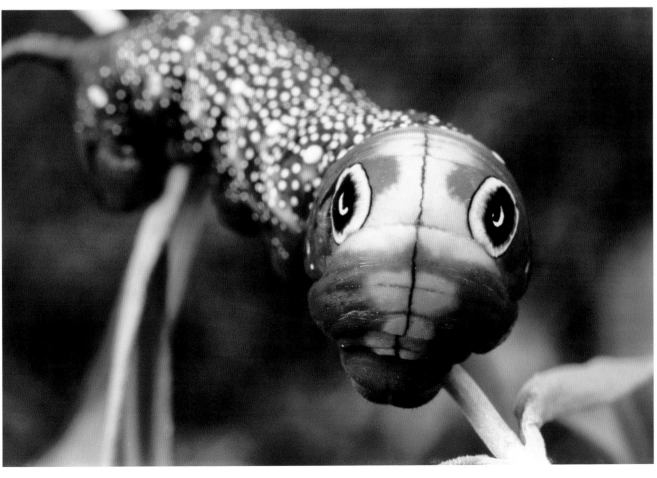

DARLYNE A. MURAWSKI | 1994 | MEXICO *Sphinx moth caterpillar*

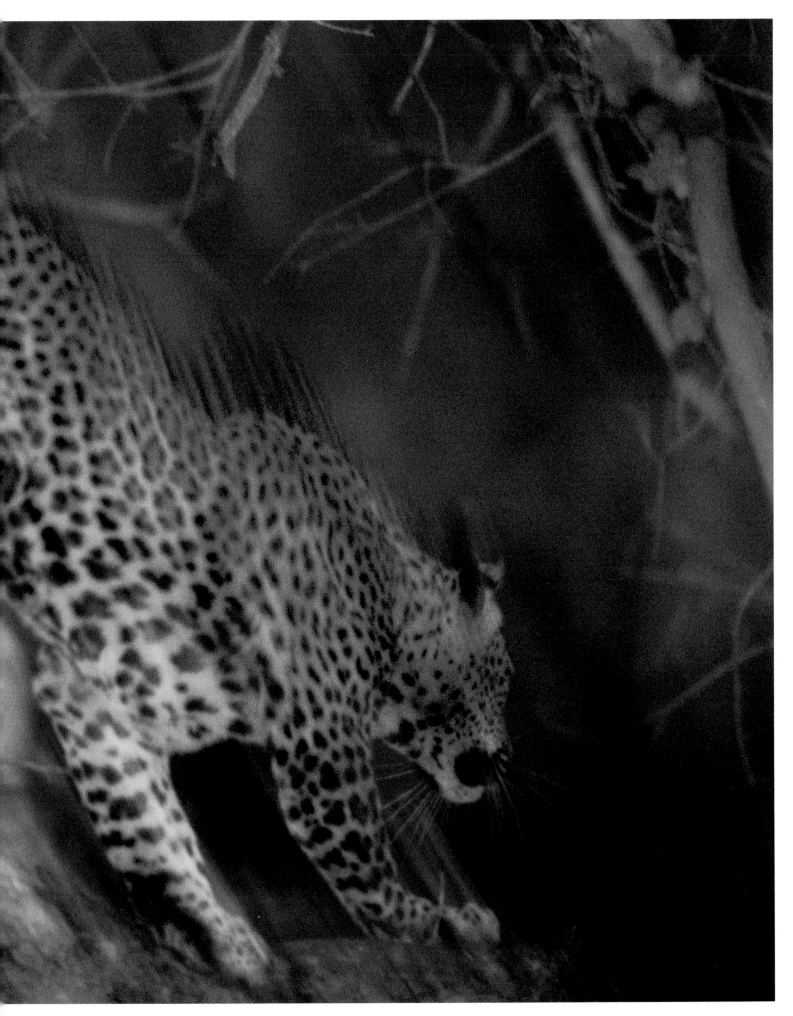

CHRIS JOHNS | 1988 | TANZANIA *A leopard slipping away*

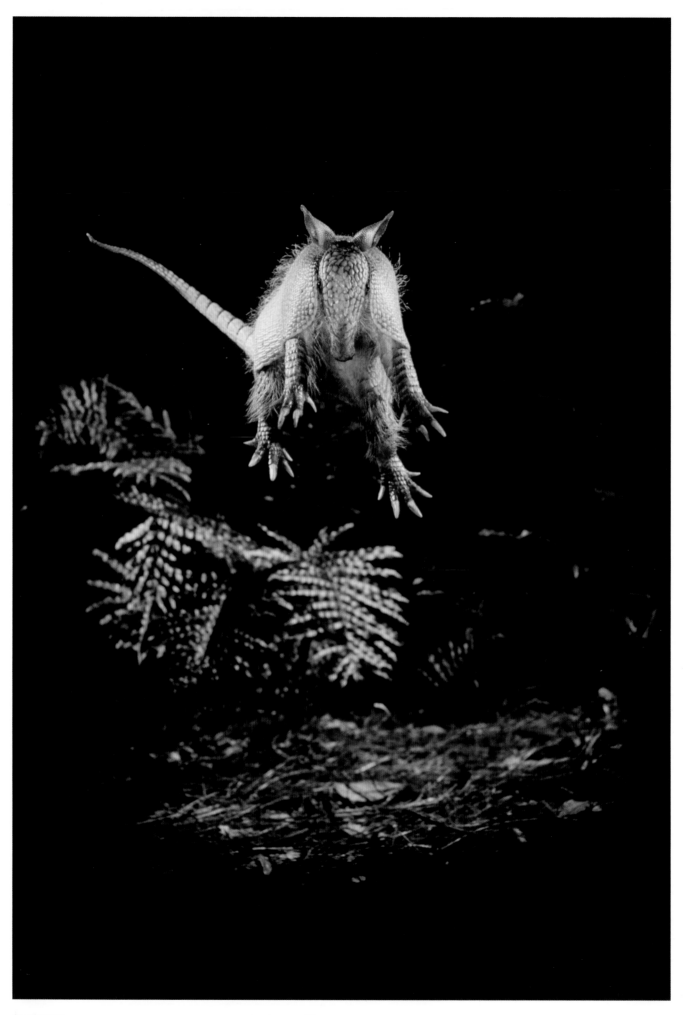

BIANCA LAVIES | 1982 | FLORIDA *Leaping armadillo*

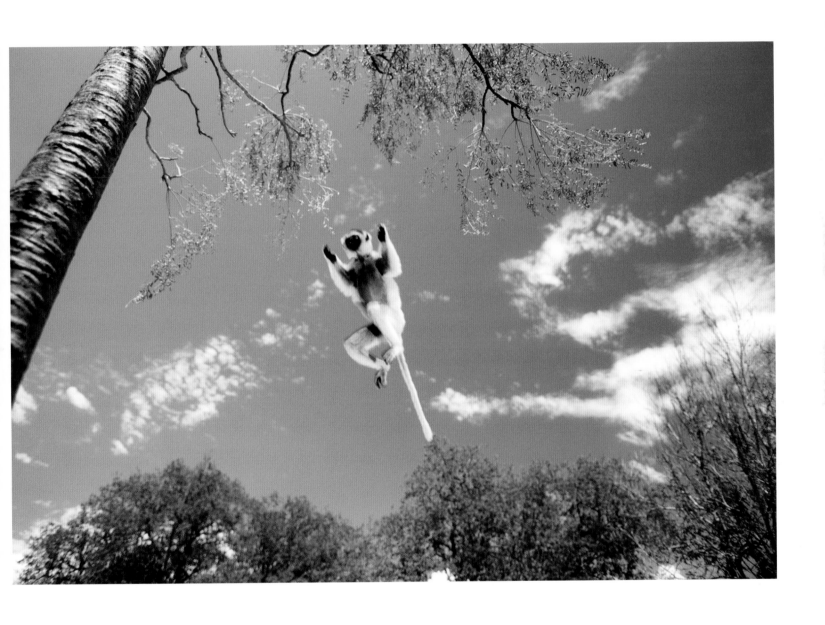

According to Rudyard Kipling, "it is the hardest thing in the world to frighten a mongoose." The Old World snake charmer has become an introduced New World pest, ravaging, for instance, Hawaii's indigenous wildlife.

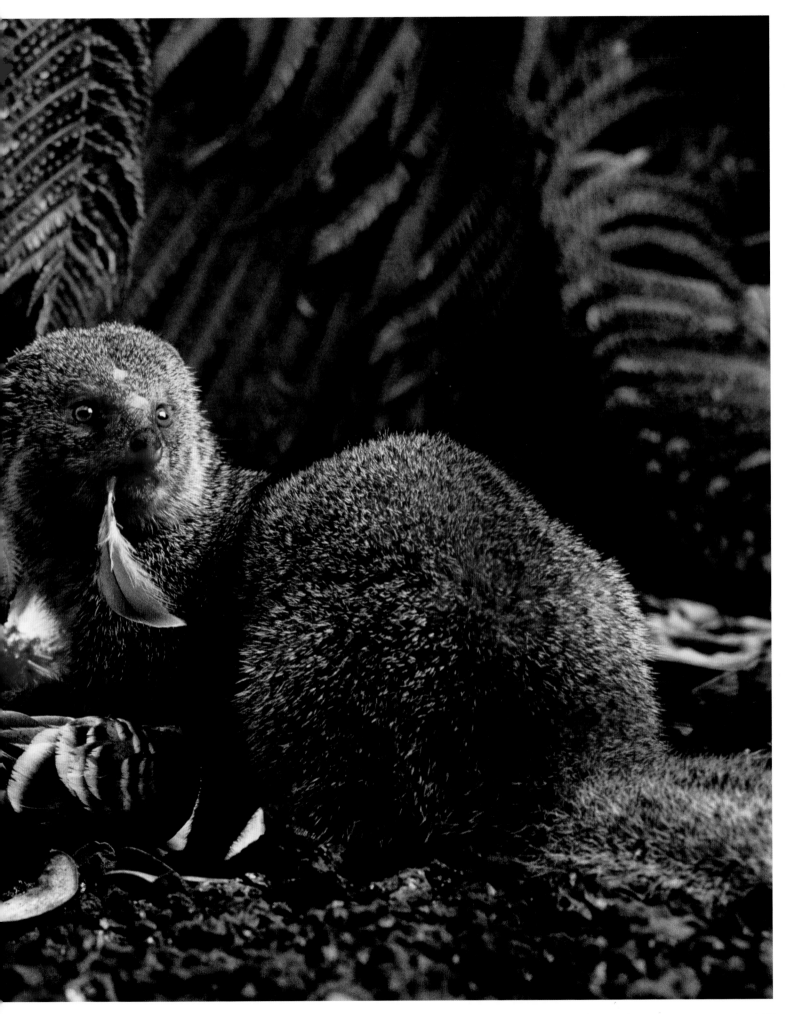

CHRIS JOHNS | 1993 | HAWAII *An introduced mongoose devouring a nene, Hawaii's state bird*

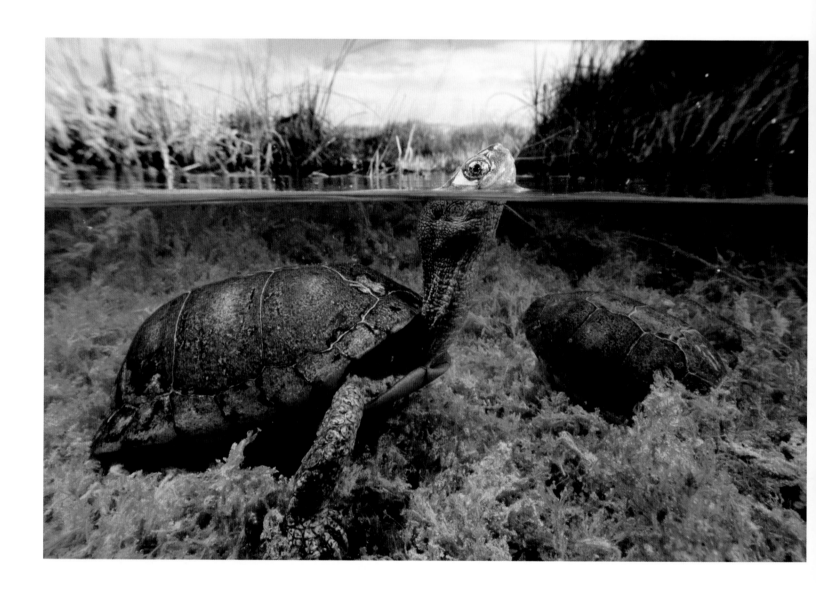

GEORGE GRALL | 1995 | MEXICO *A Coahuilan box turtle taking a peek around*

CHRIS JOHNS | 1995 | SOUTH AFRICA *White rhino in a protective pen*

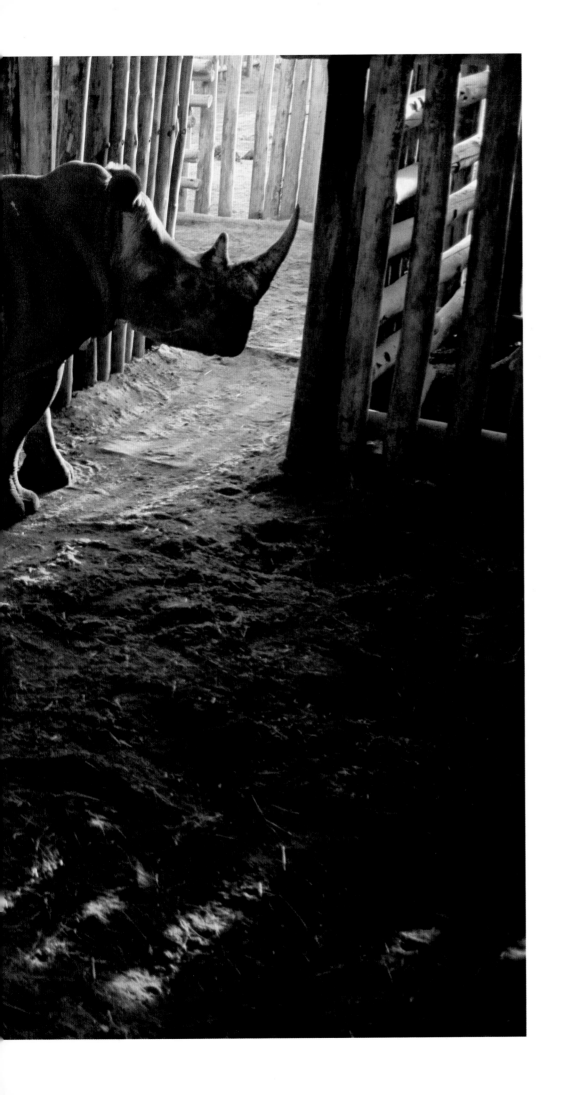

"They are not brethren, they are not underlings," wrote naturalist Henry Beston of animals, "they are other nations, caught with ourselves in the net of life and time, fellow prisoners of the splendor and travail of earth."

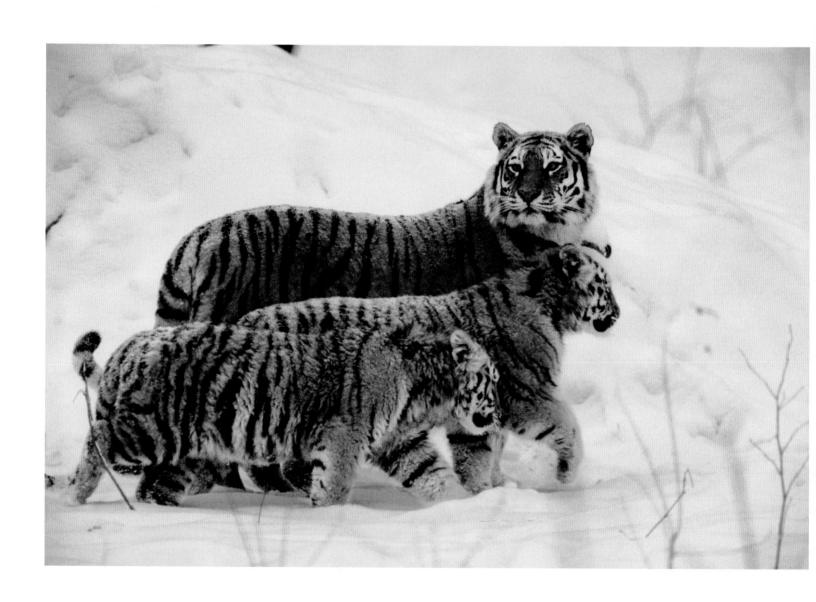

MICHAEL NICHOLS | 1995 | RUSSIA *Siberian tiger and cubs*

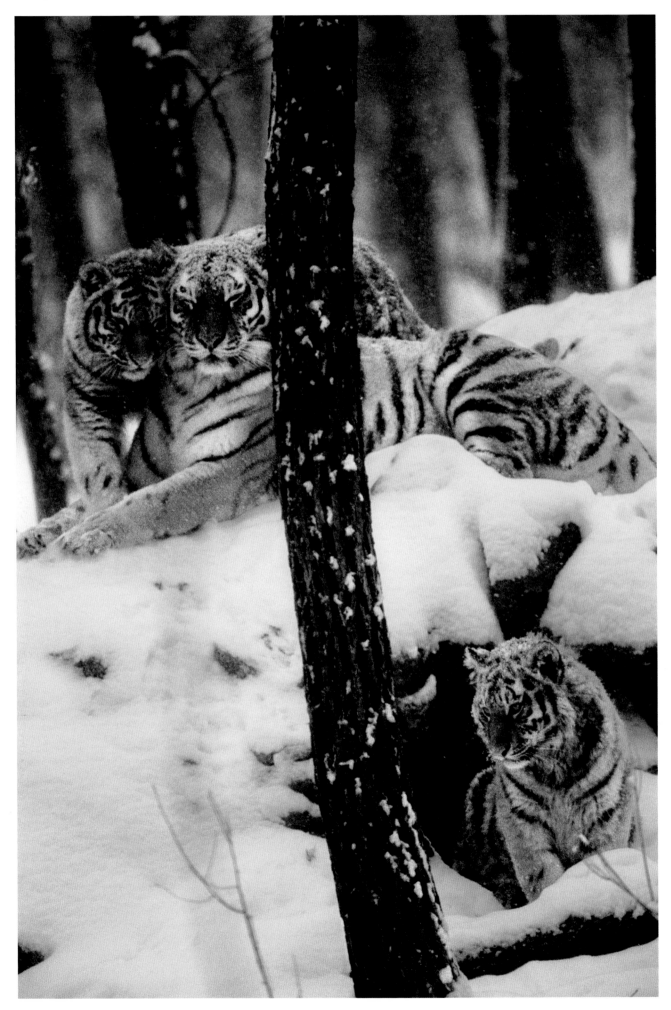

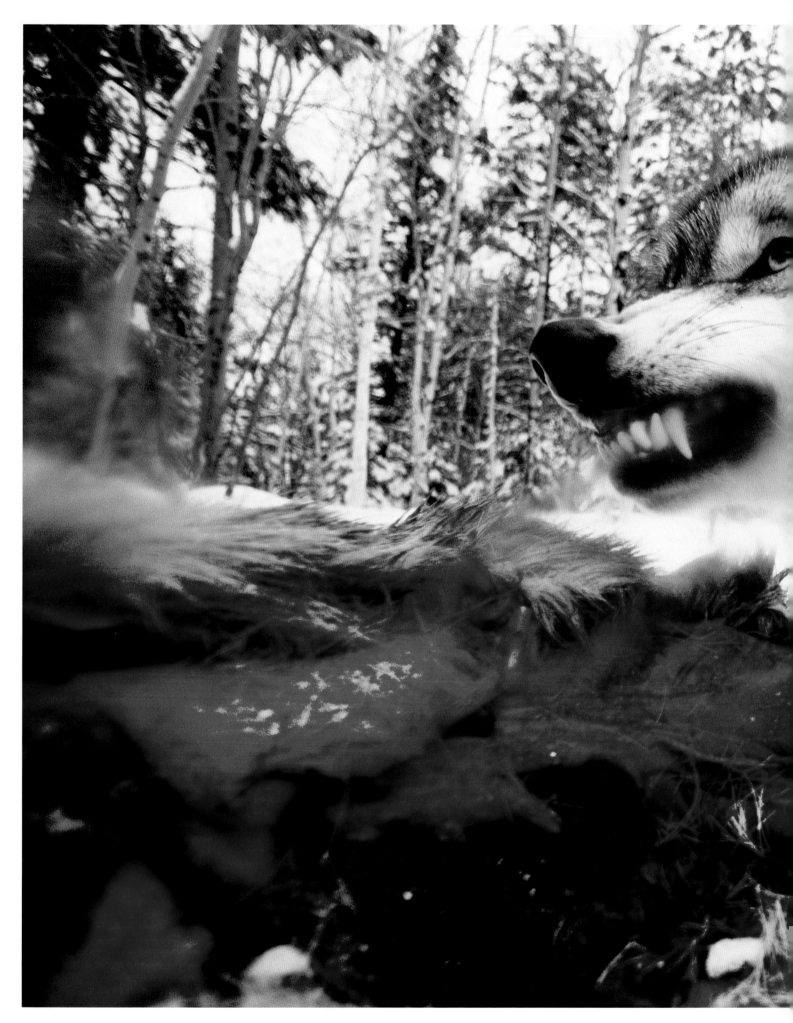

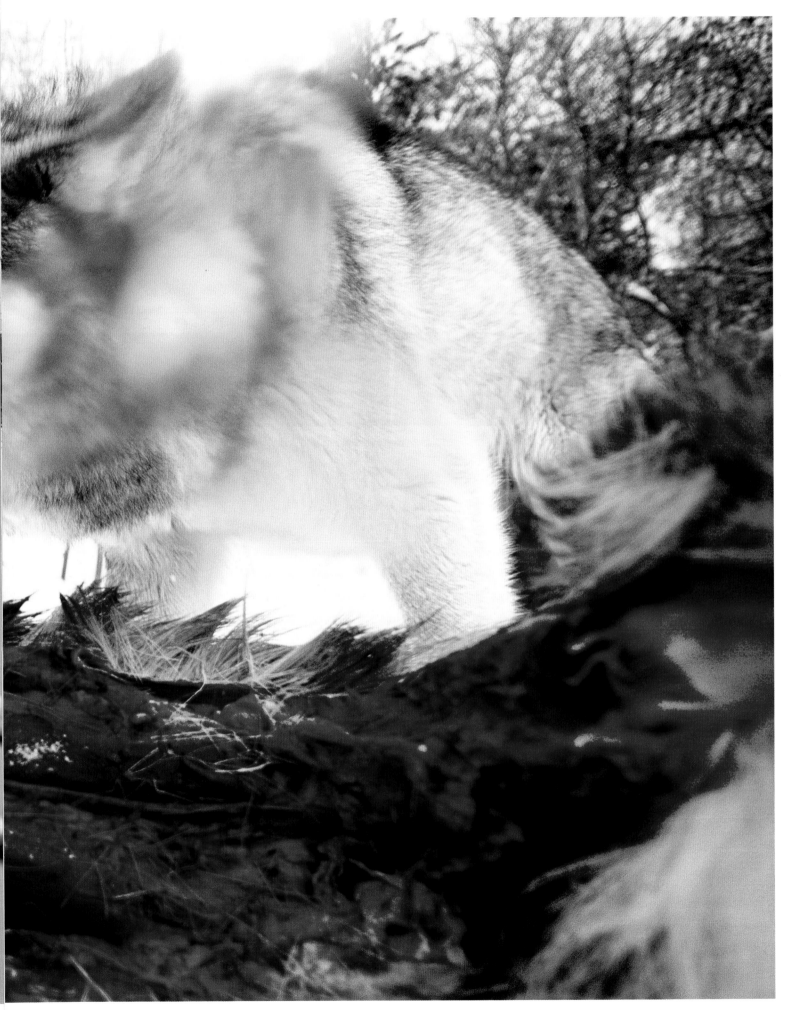

JOEL SARTORE | 1997 | MINNESOTA *Captive wolf, snapped by a remotely triggered camera*

BILL CURTSINGER | 2003 | ALASKA *Starfish bathed in a toxic tide*

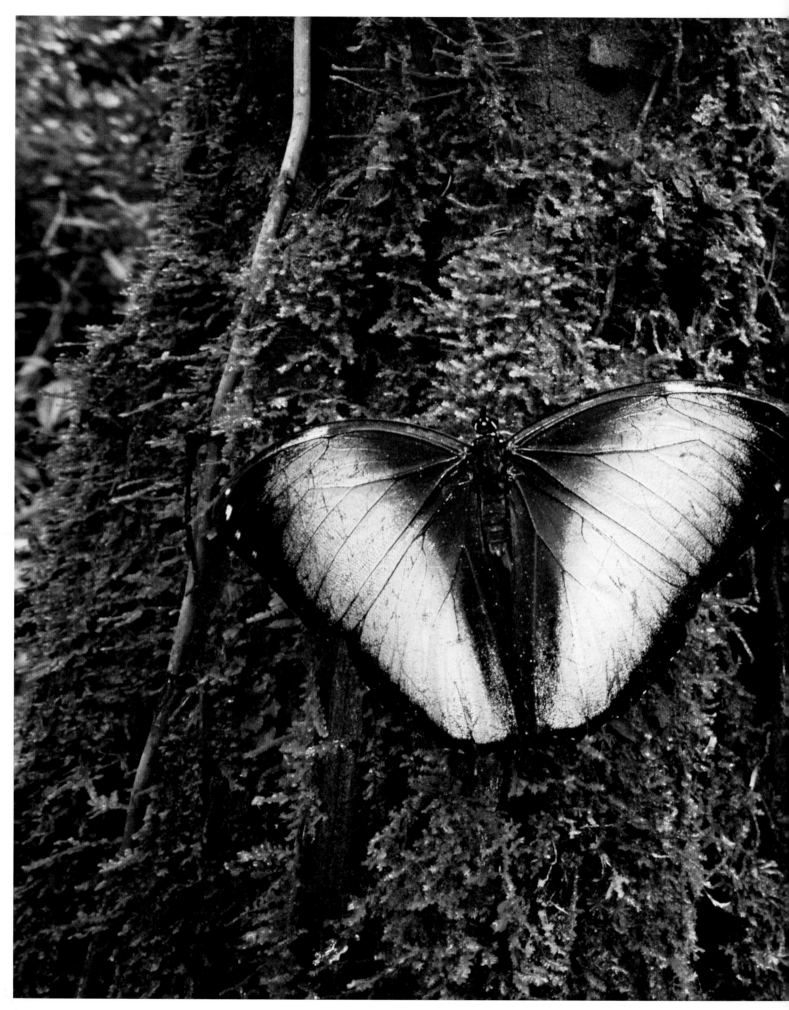

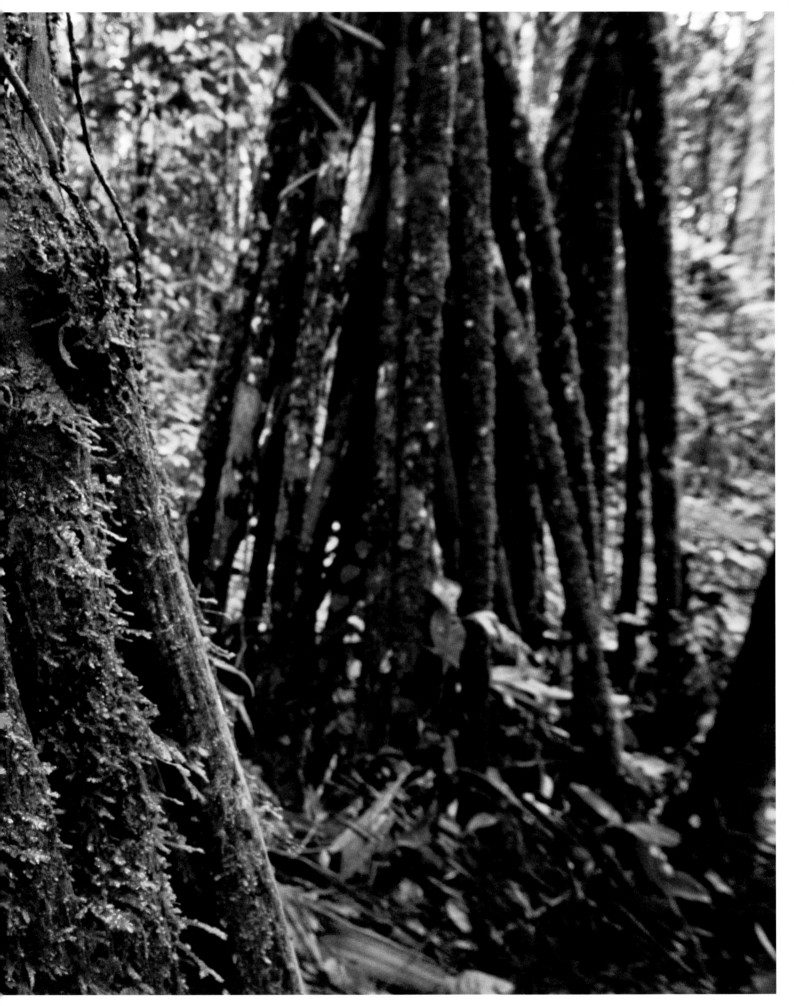

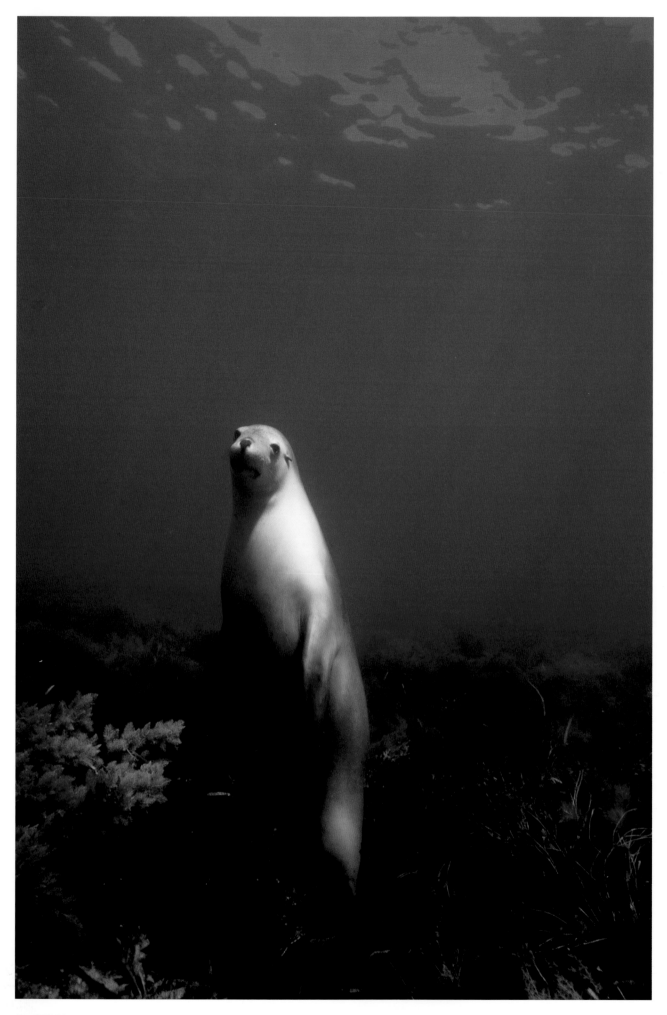

DAVID DOUBILET | 2000 | SOUTH AUSTRALIA *Australian sea lion*

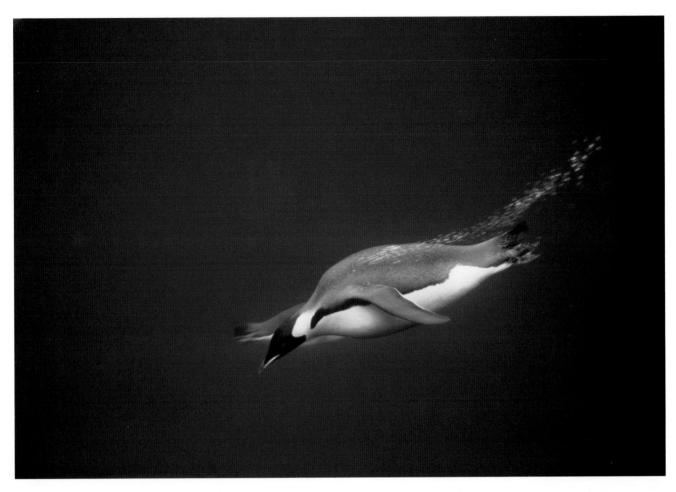

BILL CURTSINGER | 1999 | ANTARCTICA *Emperor penguin*

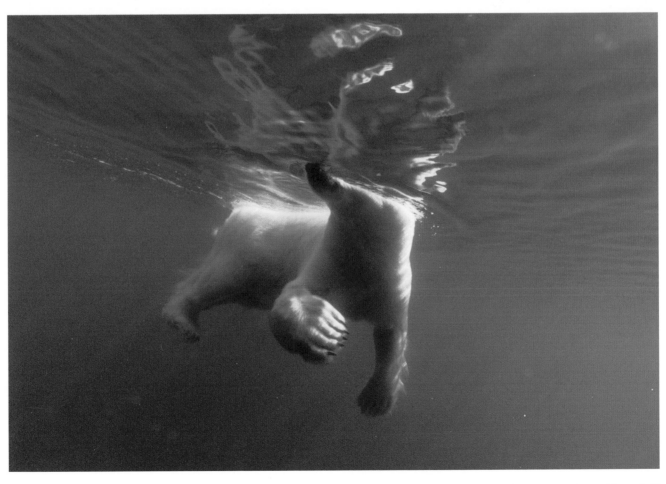

FLIP NICKLIN | 1998 | CANADA *Polar bear*

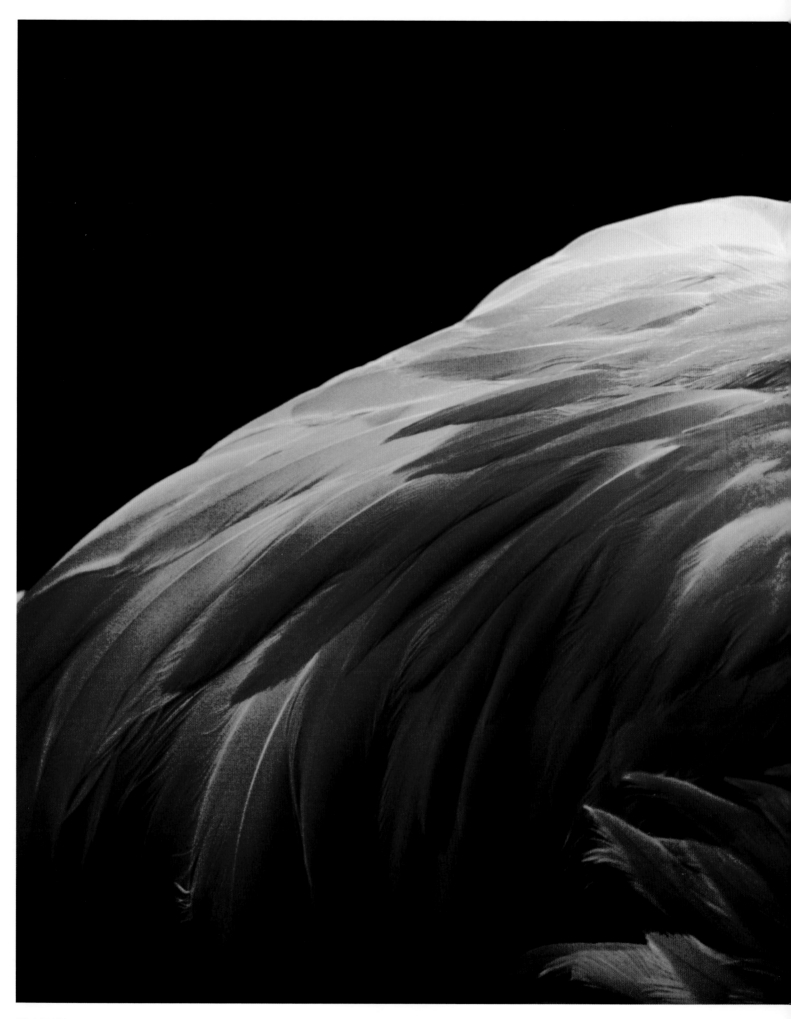

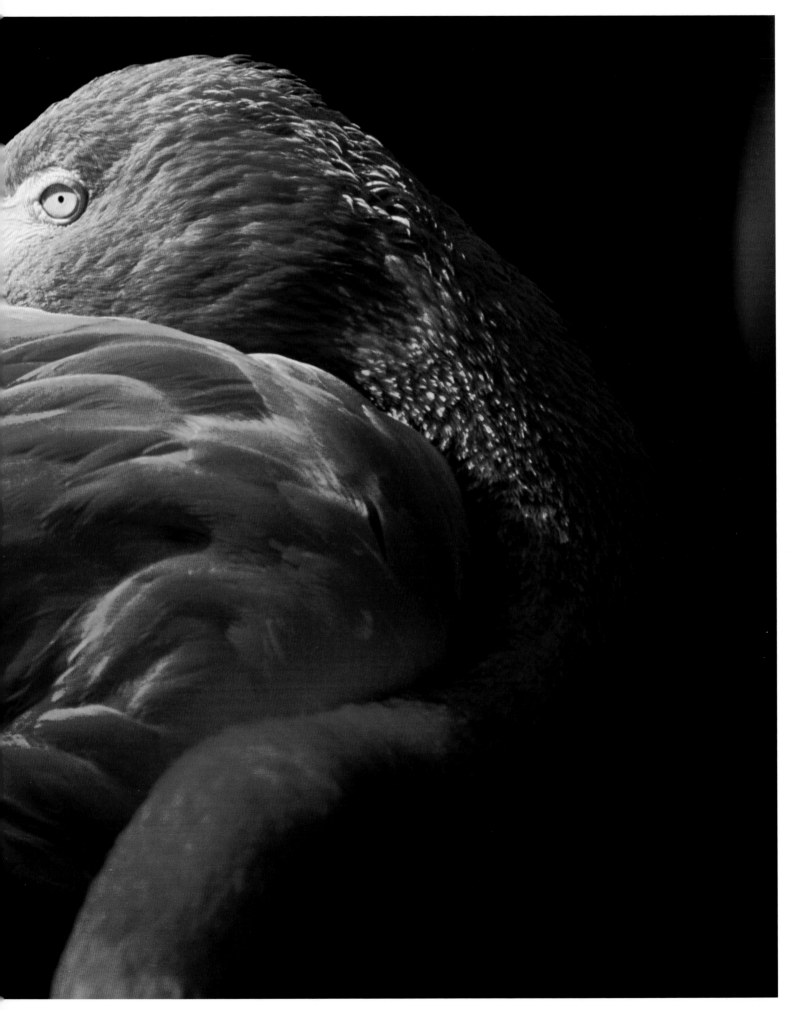

TIM LAMAN | 2001 | AFRICA *A greater flamingo*

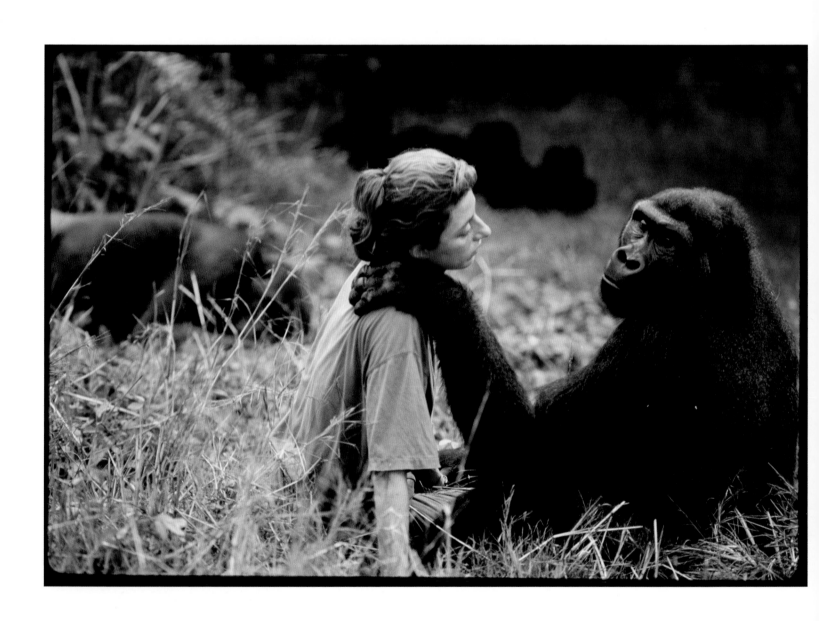

MICHAEL NICHOLS | 2001 | REPUBLIC OF THE CONGO *Rehabilitating orphaned gorillas*

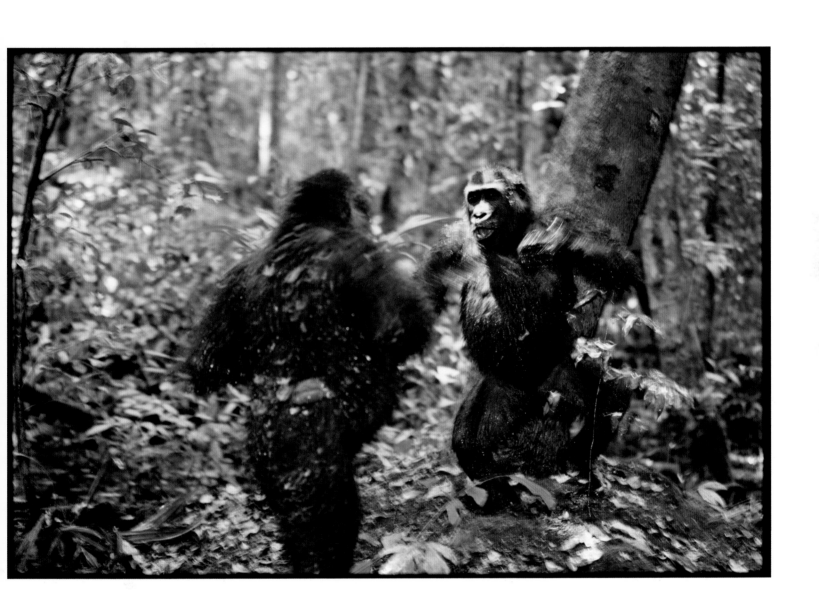

MICHAEL NICHOLS | 2001 | REPUBLIC OF THE CONGO *Young males sparring for dominance*

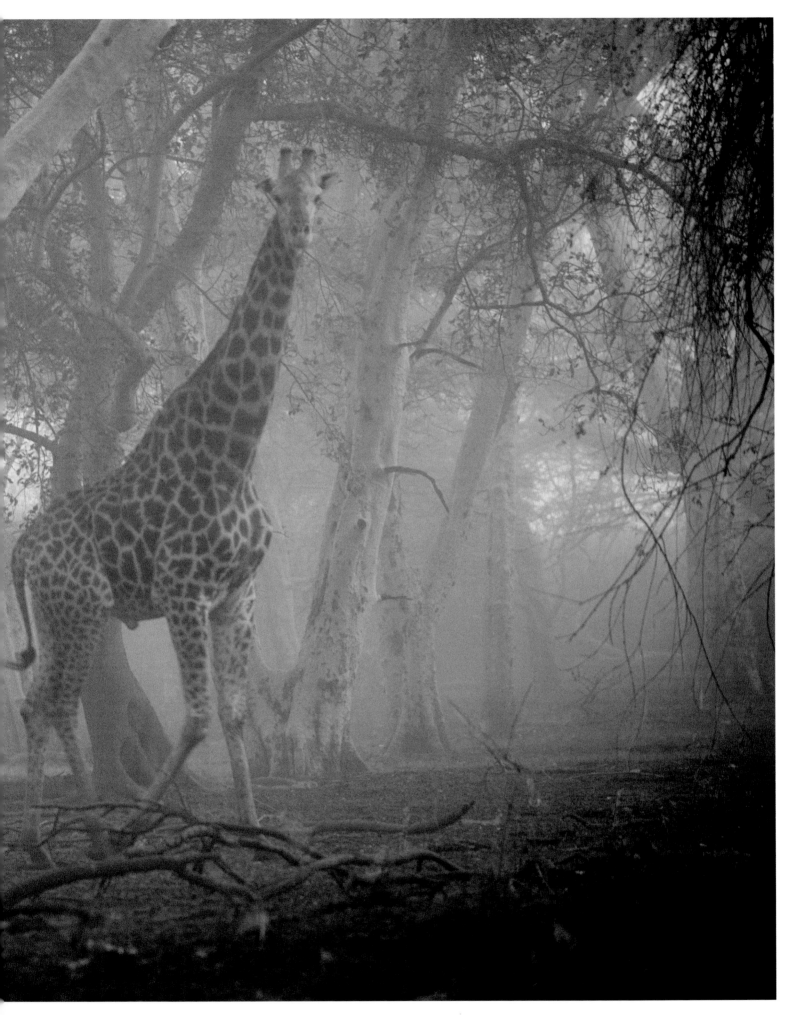

CHRIS JOHNS | 2001 | SOUTH AFRICA *Giraffe in the mist*

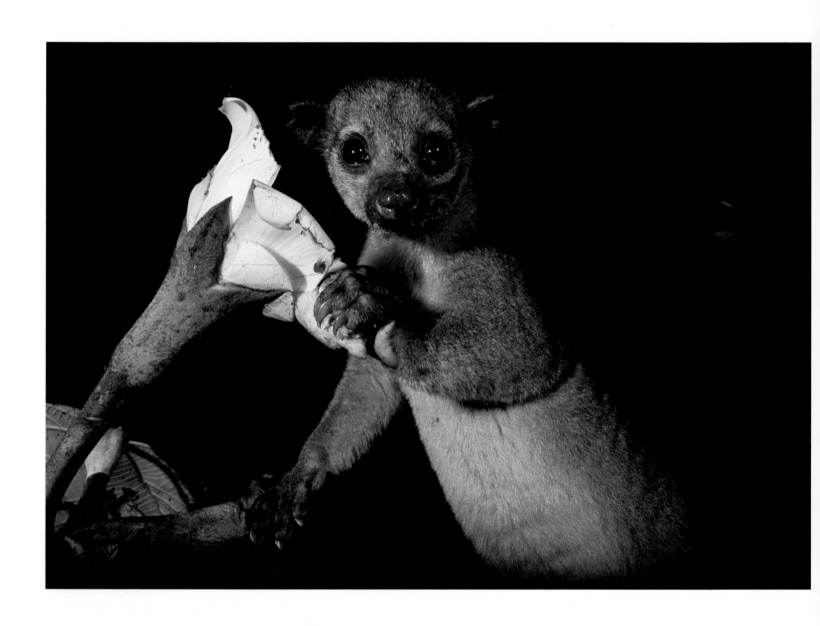

MATTIAS KLUM | 2003 | PANAMA *Kinkajou with a balsa blossom*

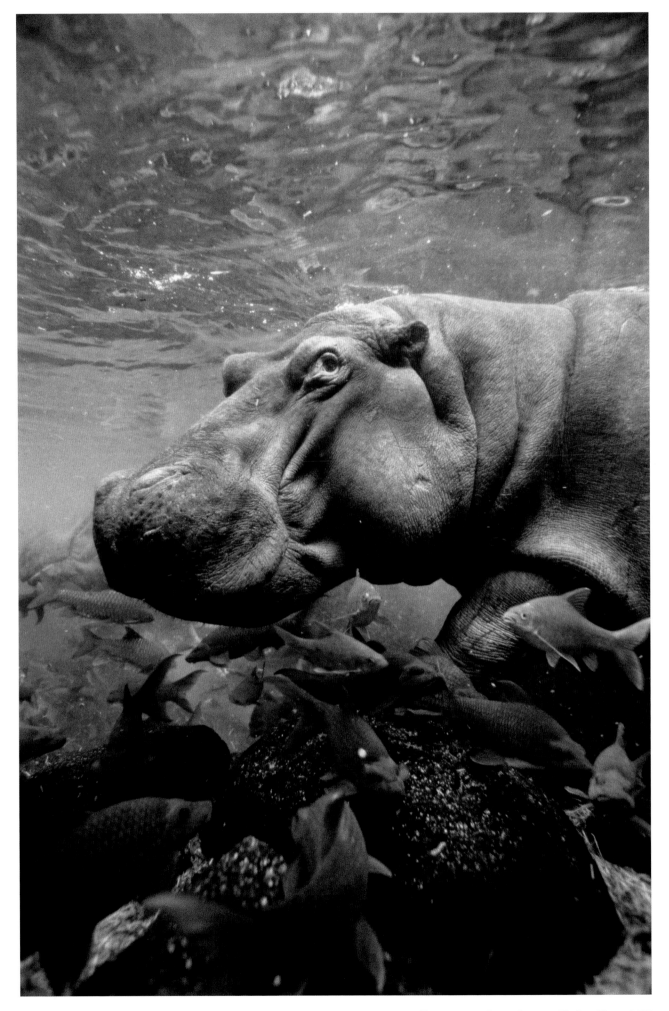

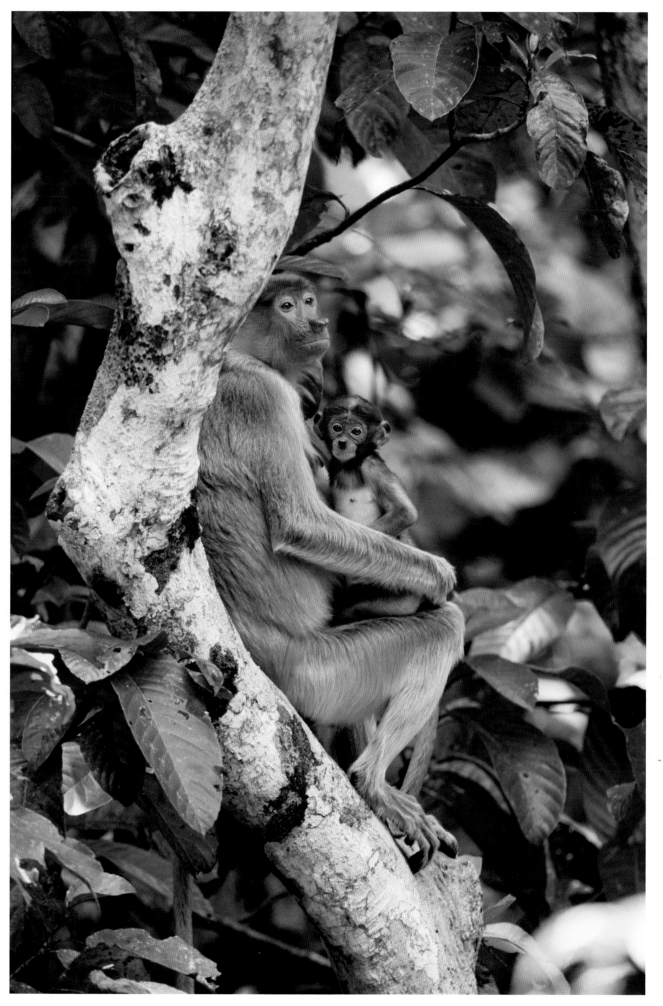

TIM LAMAN | 2002 | BORNEO *Proboscis monkey and her baby*

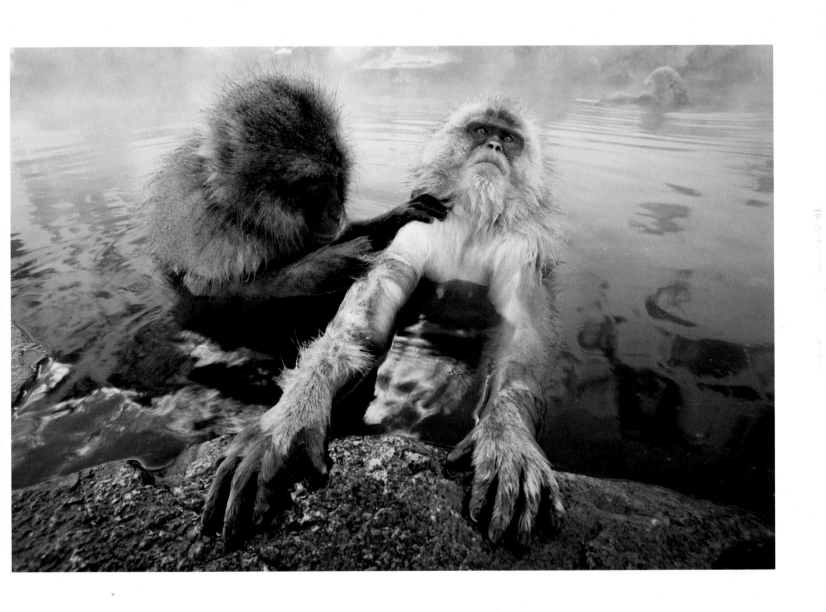

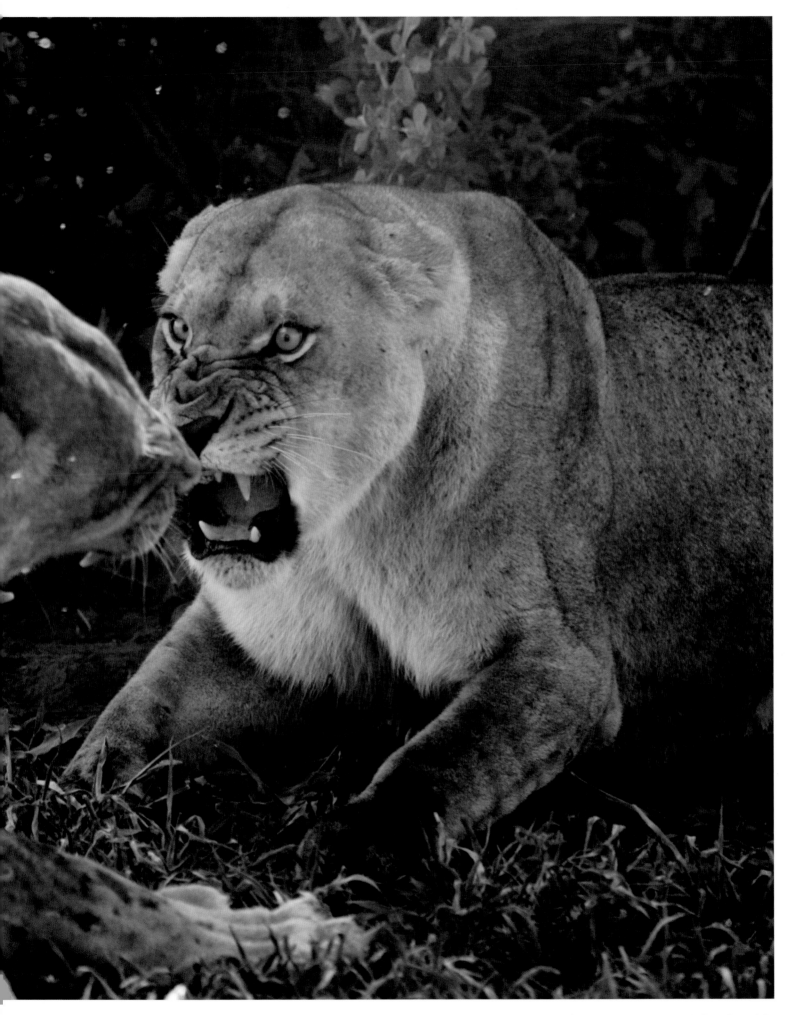

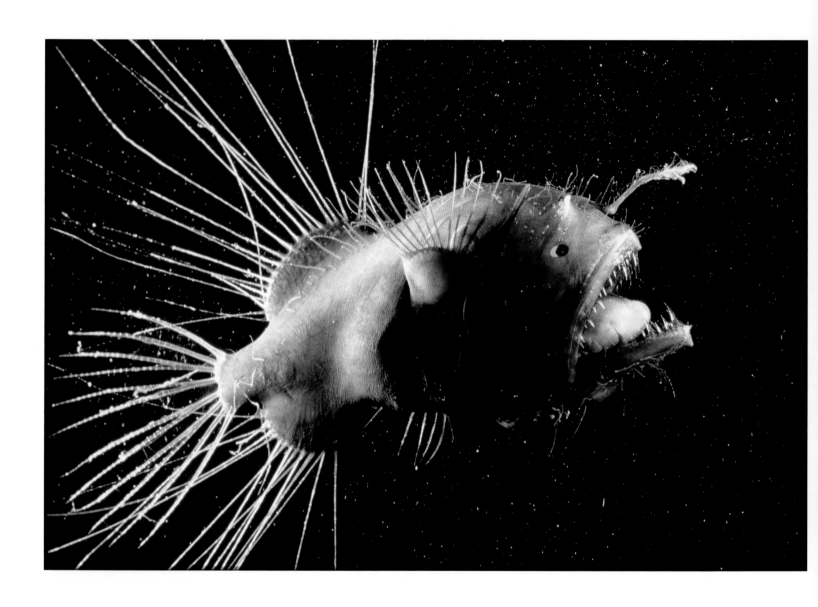

BRUCE H. ROBISON | 2004 | CALIFORNIA *Fanfin anglerfish*

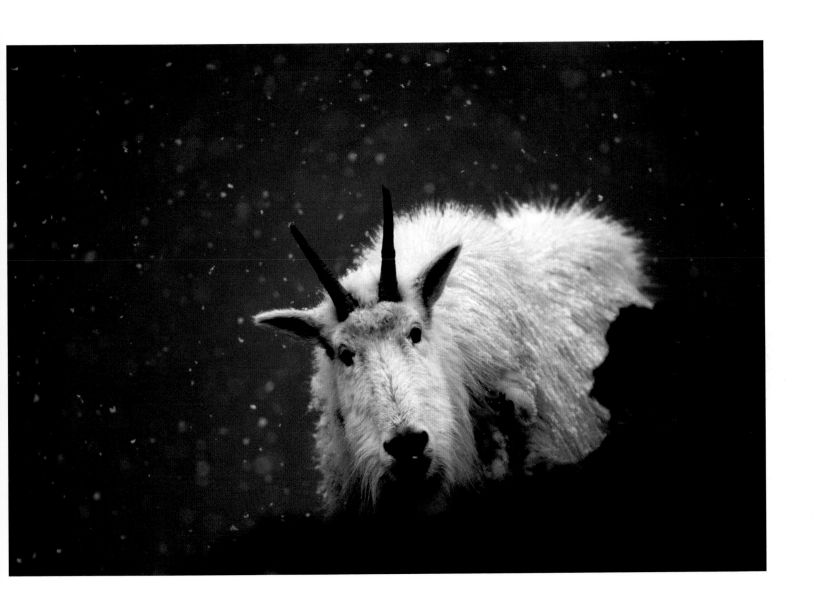

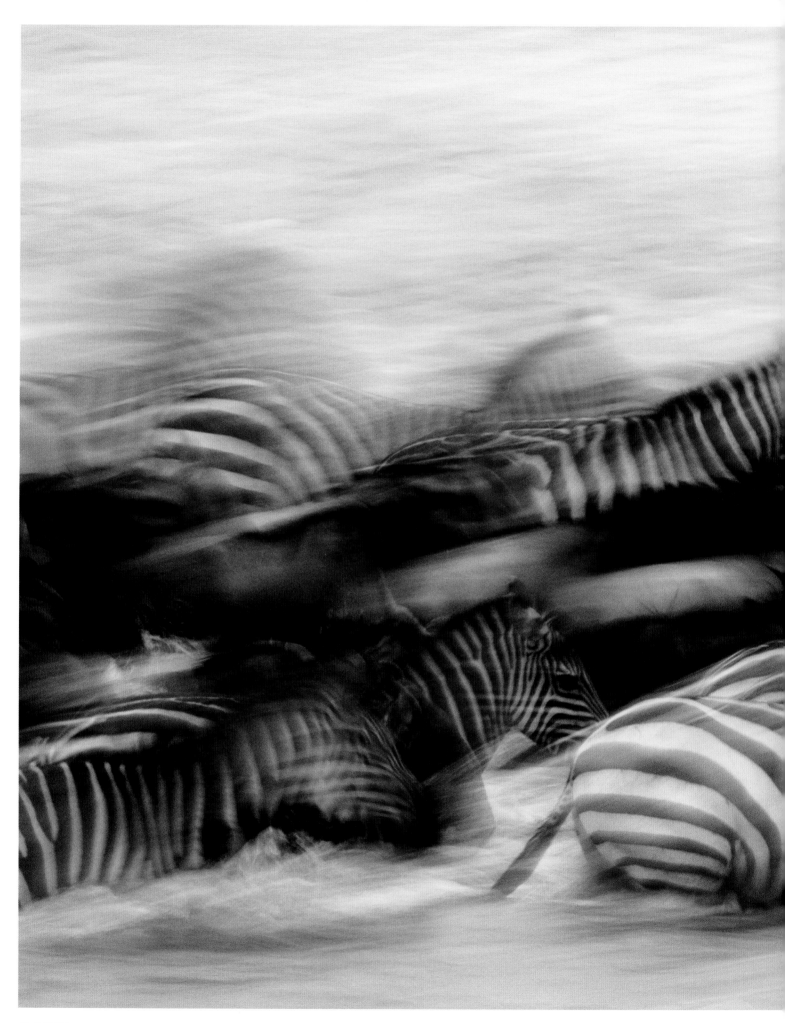

ANUP AND MANOJ SHAH | 2003 | KENYA *Zebras fording a crocodile-filled river*

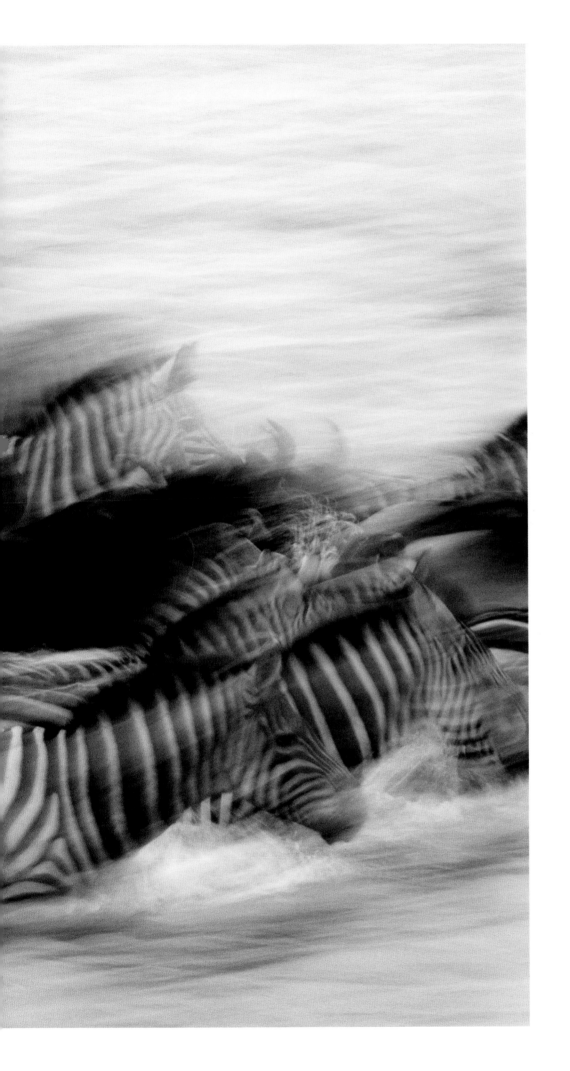

"With zebras," photographer Anup Shah observes, "you just point the camera at the fantastic view." Fantastic, spectacular—and poignant, as the graceful animals are a favorite prey of some of Africa's most feared carnivores.

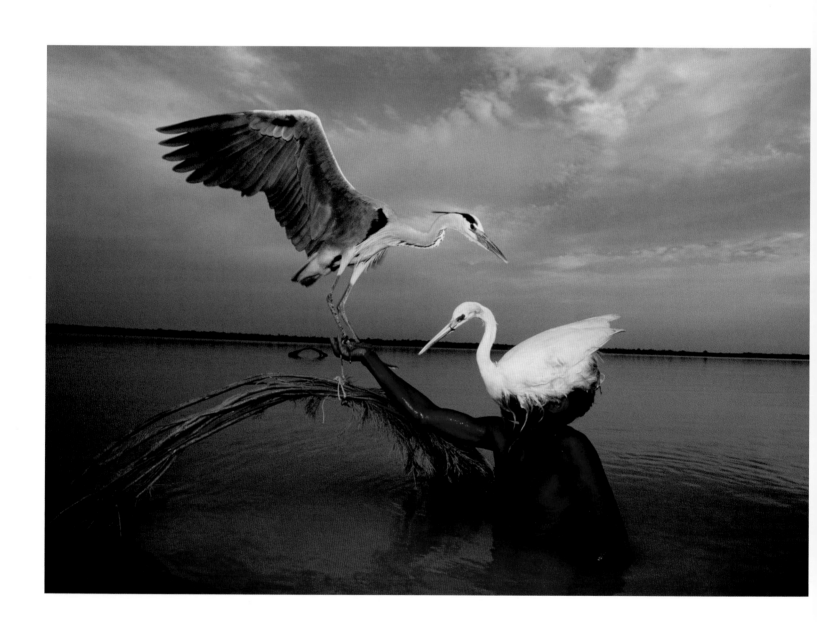

RANDY OLSON | 2007 | PAKISTAN *Decoying herons the Indus River way*

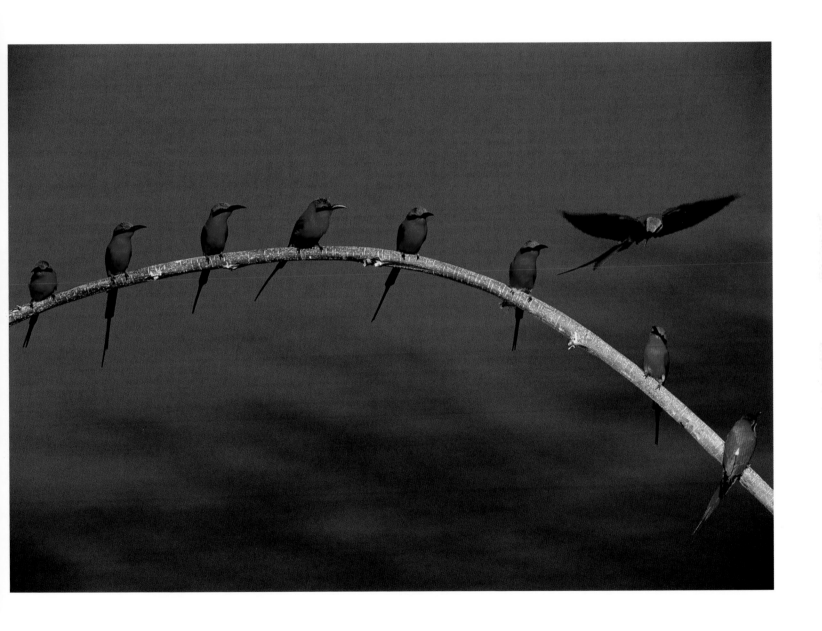

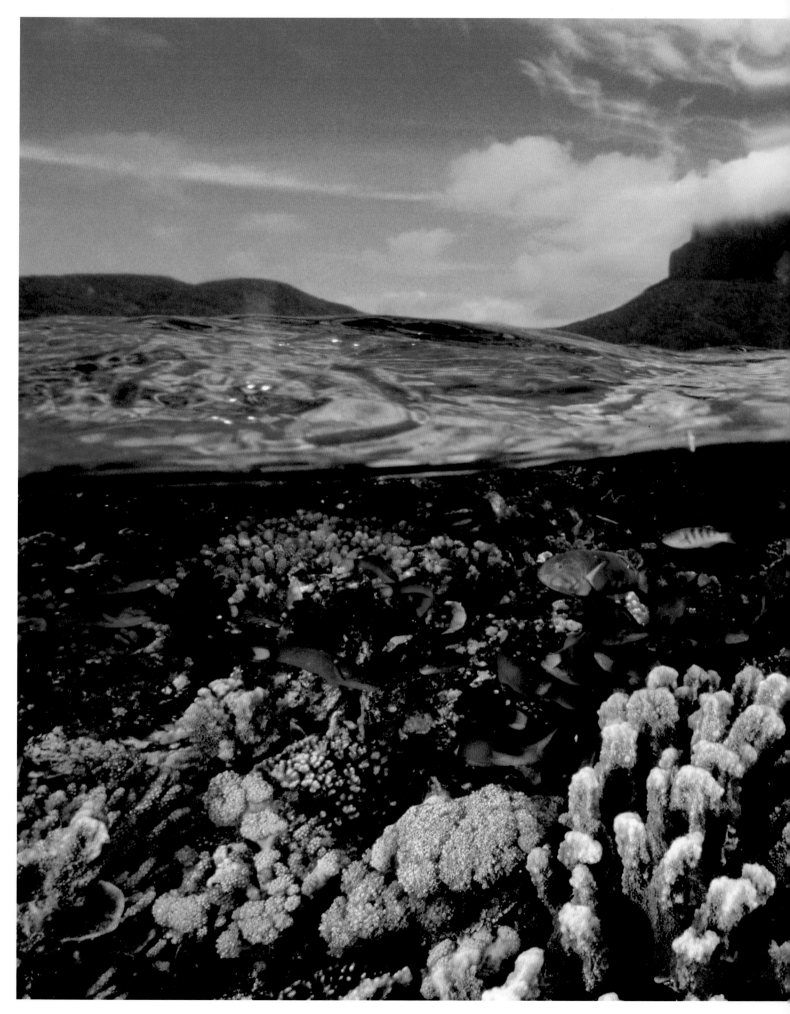

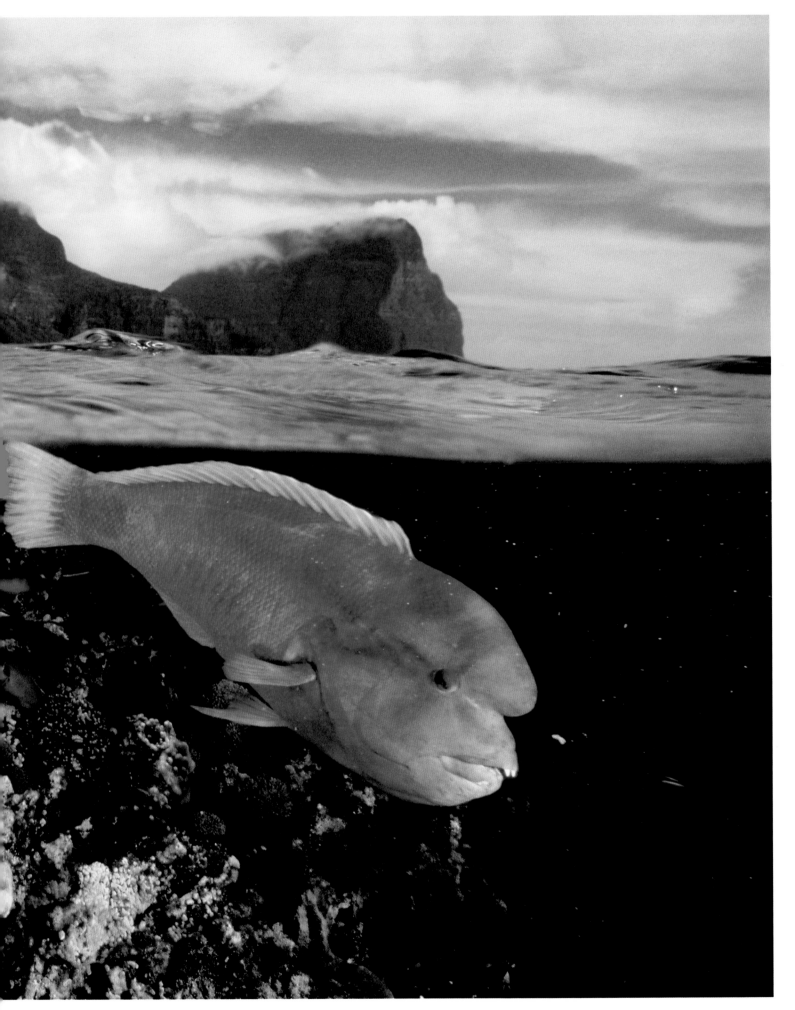

DAVID DOUBILET **|** 2007 **|** AUSTRALIA *Humphead wrasse and coral reef*

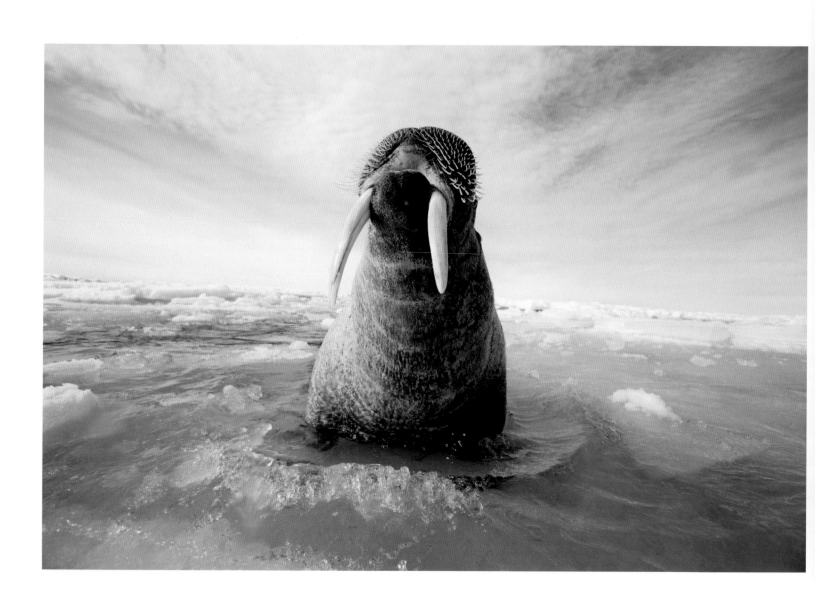

PAUL NICKLEN | 2006 | CANADA *Walrus*

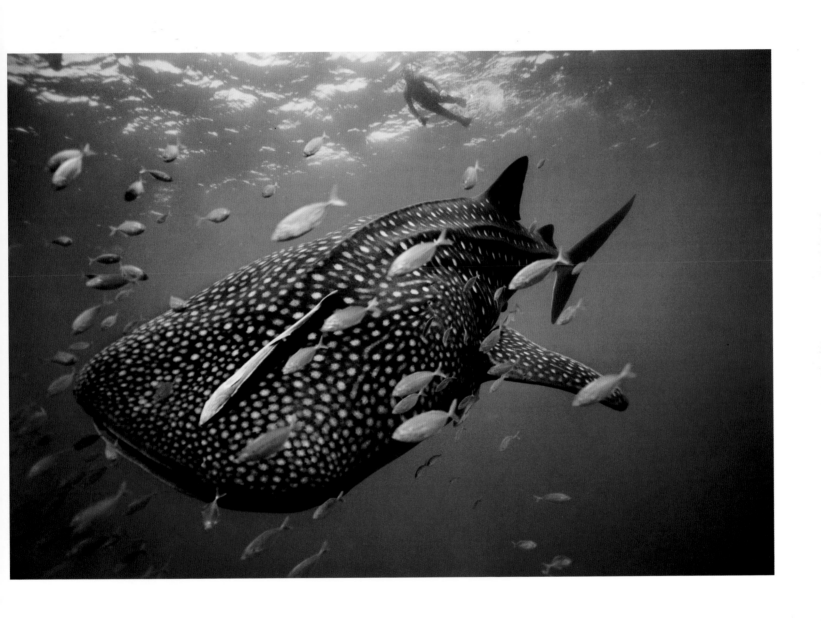

When dusk fell on the Himalaya, writer Doug Chadwick could easily imagine a snow leopard coming down the slopes: "It flows low to the ground, with huge gold eyes and a coat the color of dappled moonlight on frost."

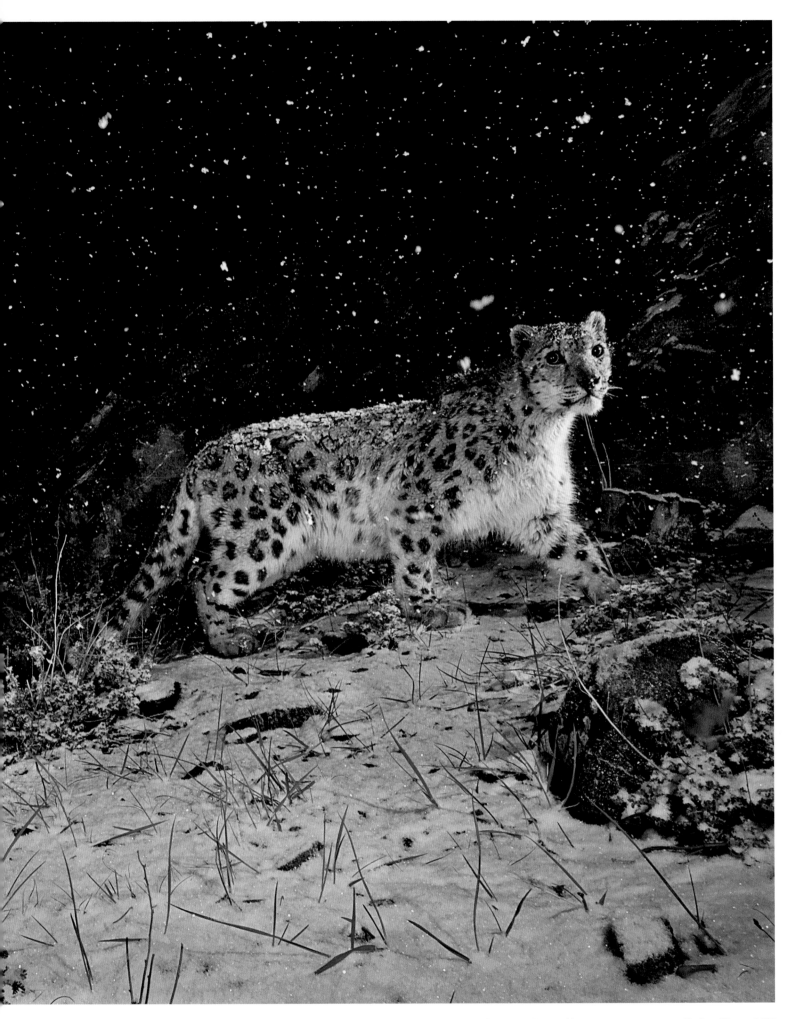

STEVE WINTER | 2008 | INDIA *Snow leopard snapped by a remote camera*

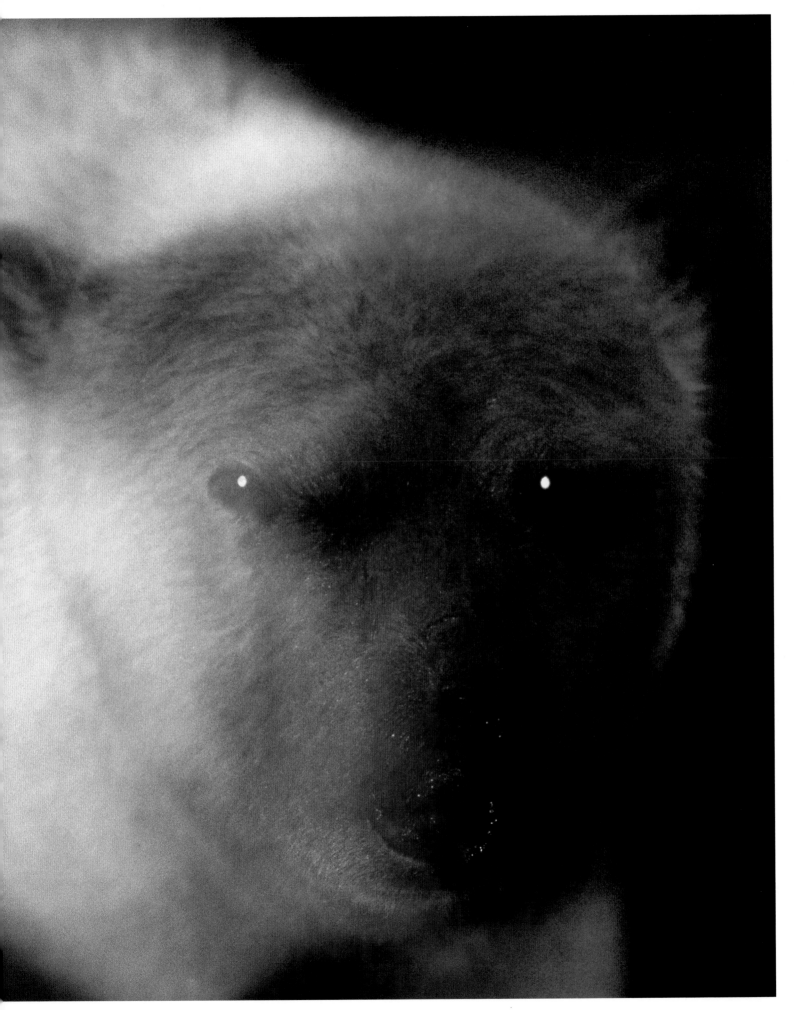

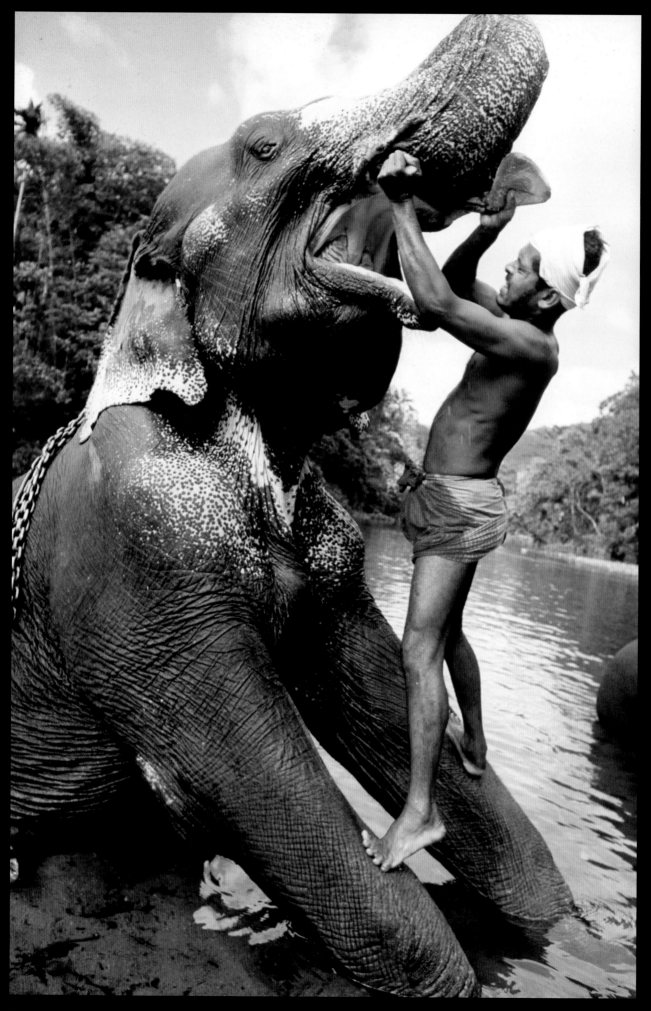

GILBERT M. GROSVENOR | 1966 | CEYLON *A mahout brushing his elephant's teeth*

elephants up close

ONCE, IF YOU WERE CLOSE ENOUGH to see the yellow of their eyes, you were probably too close, as many a hunter discovered only too late. Today, however, some of our best photographers have been bringing us ever nearer to wild elephants, gradually unmasking one of Earth's most fascinating, as well as formidable, inhabitants.

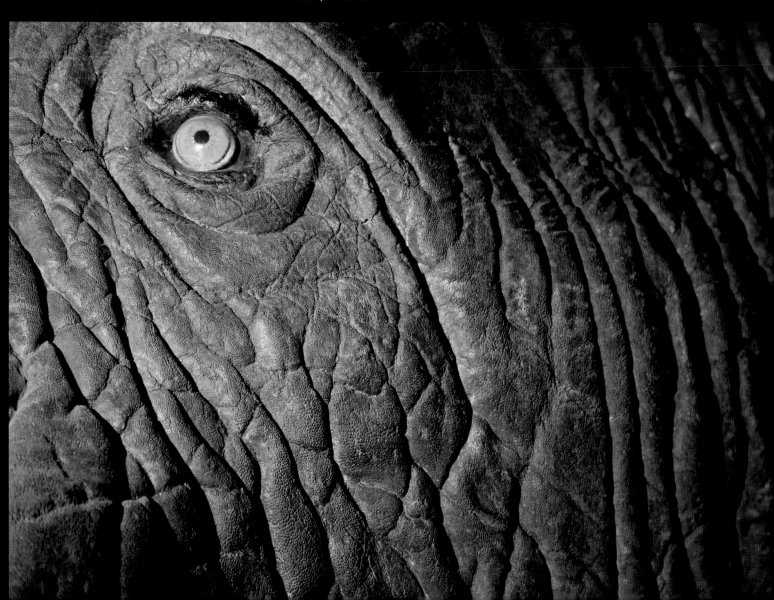

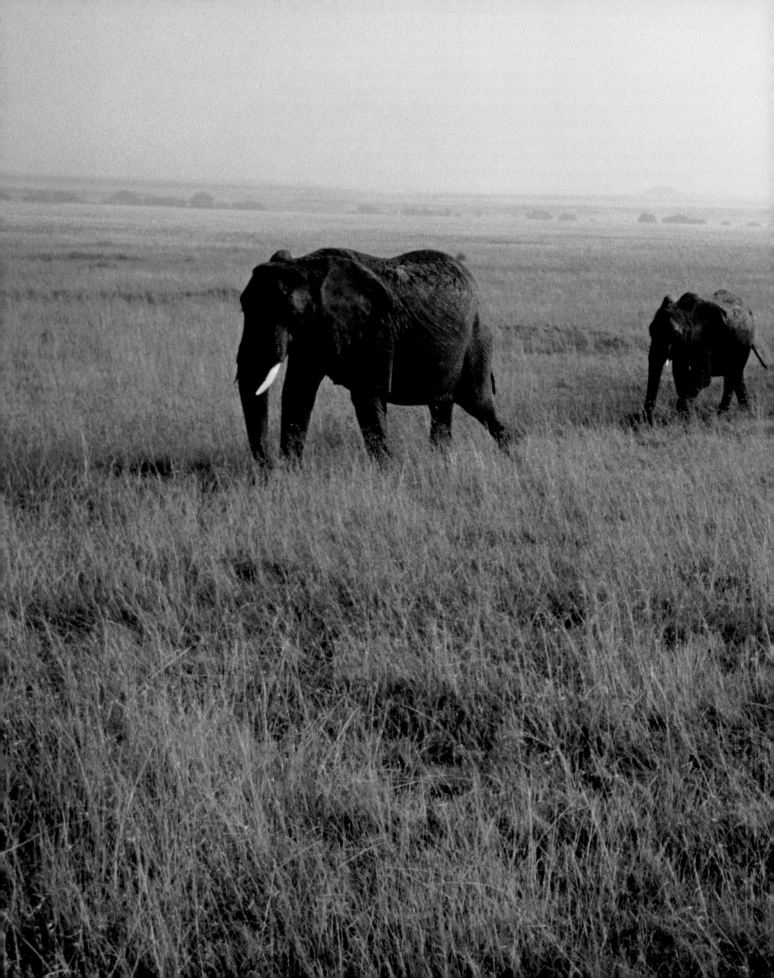

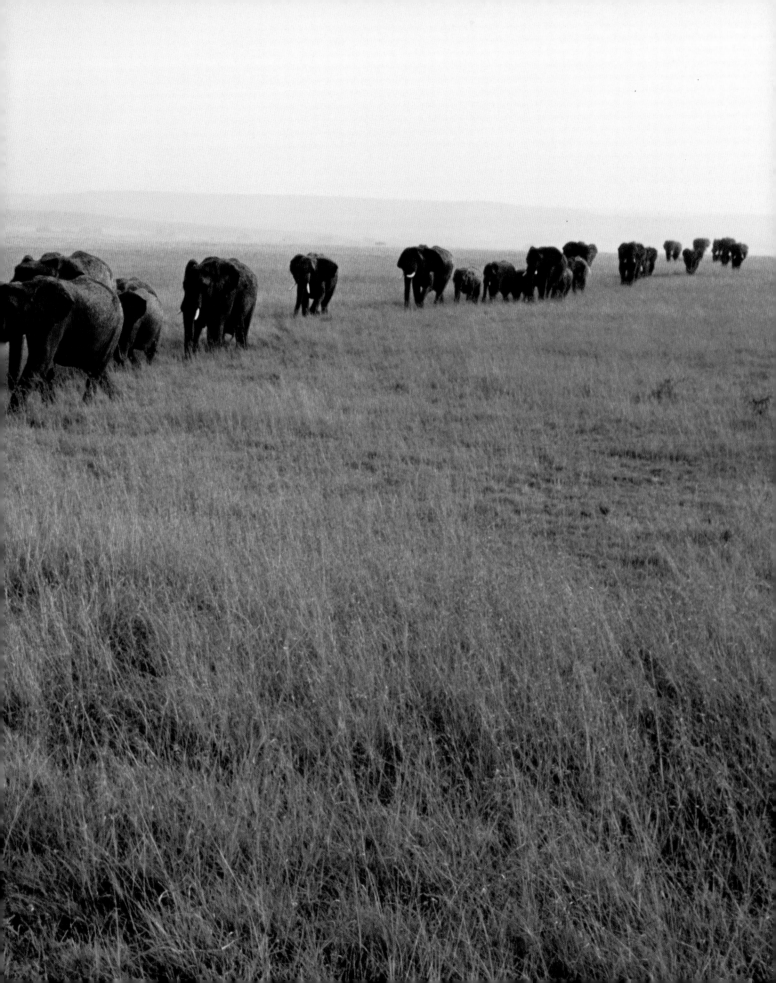

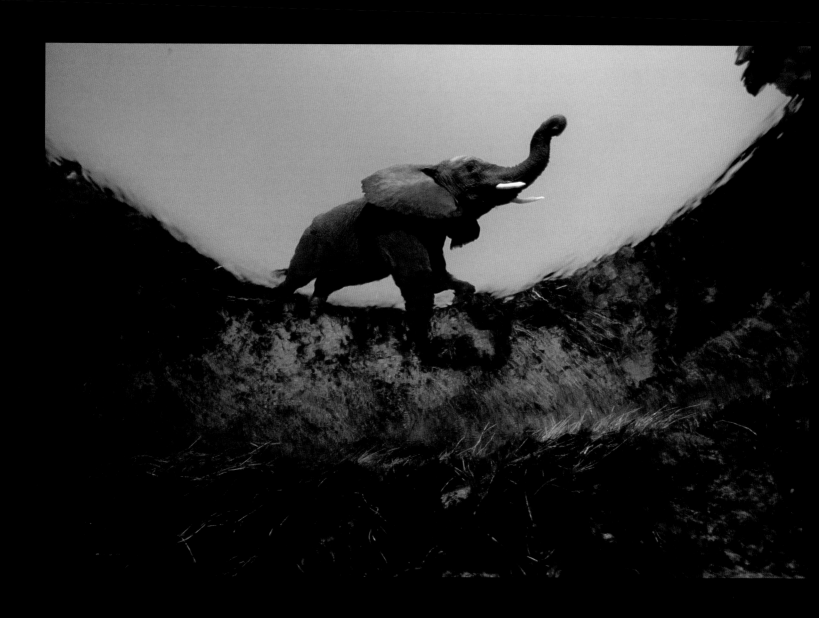

DAVID DOUBILET | 2004 | BOTSWANA *Elephant seen from under water*

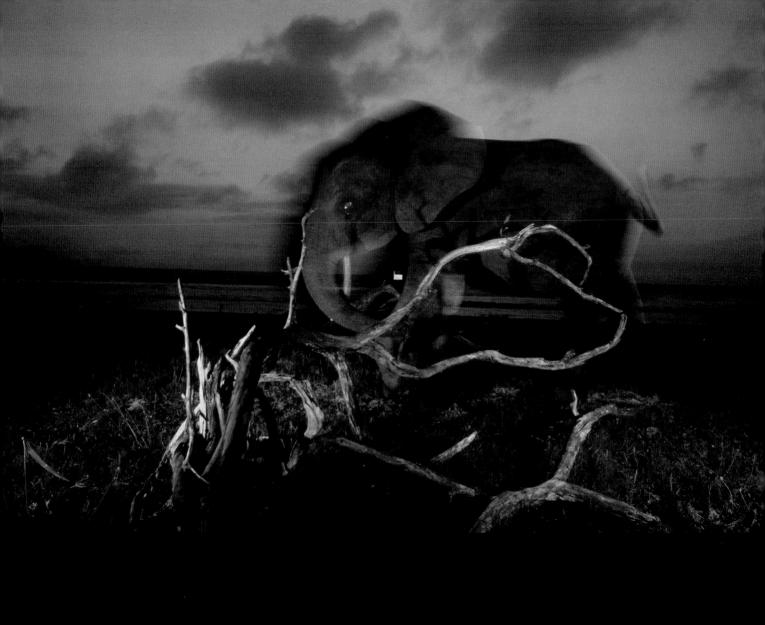

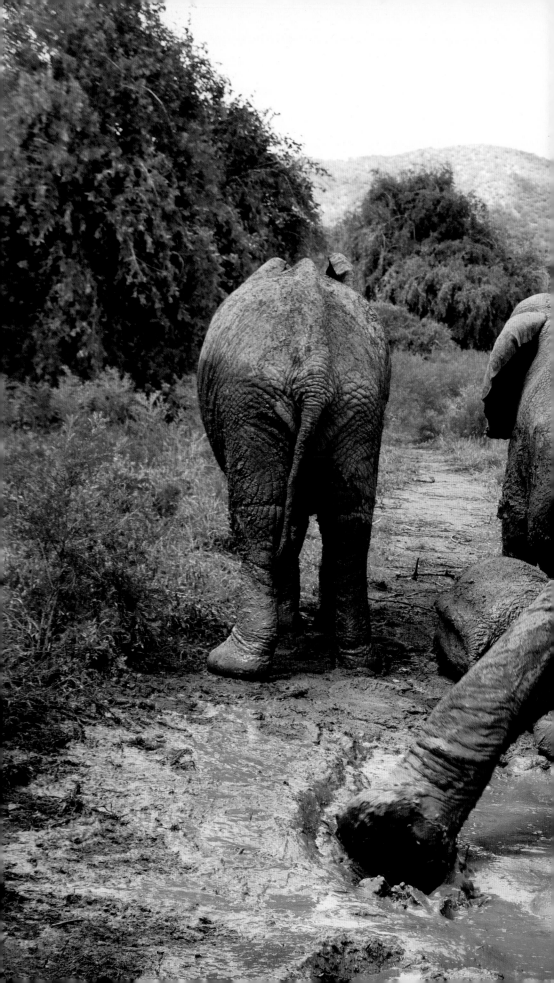

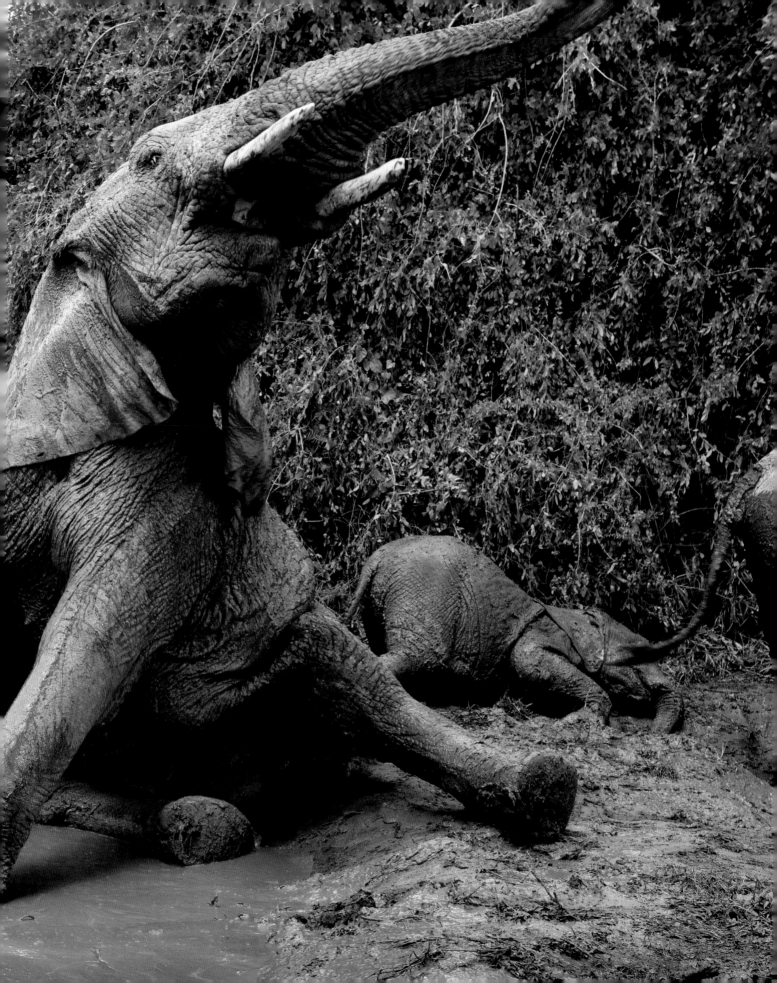

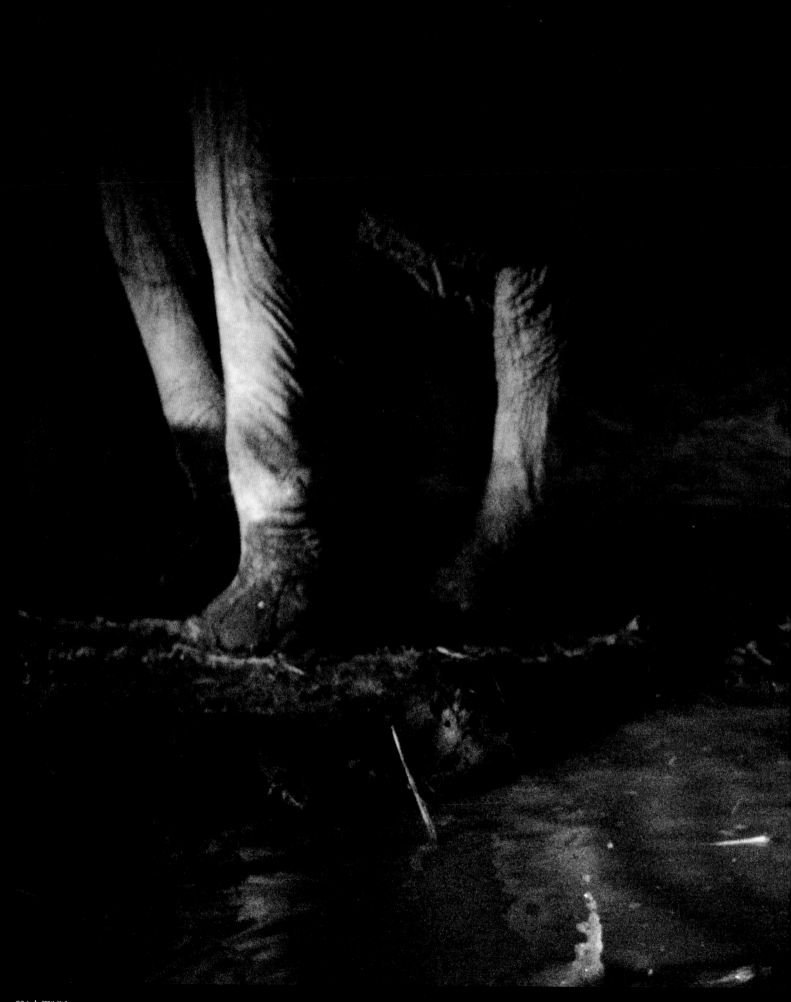

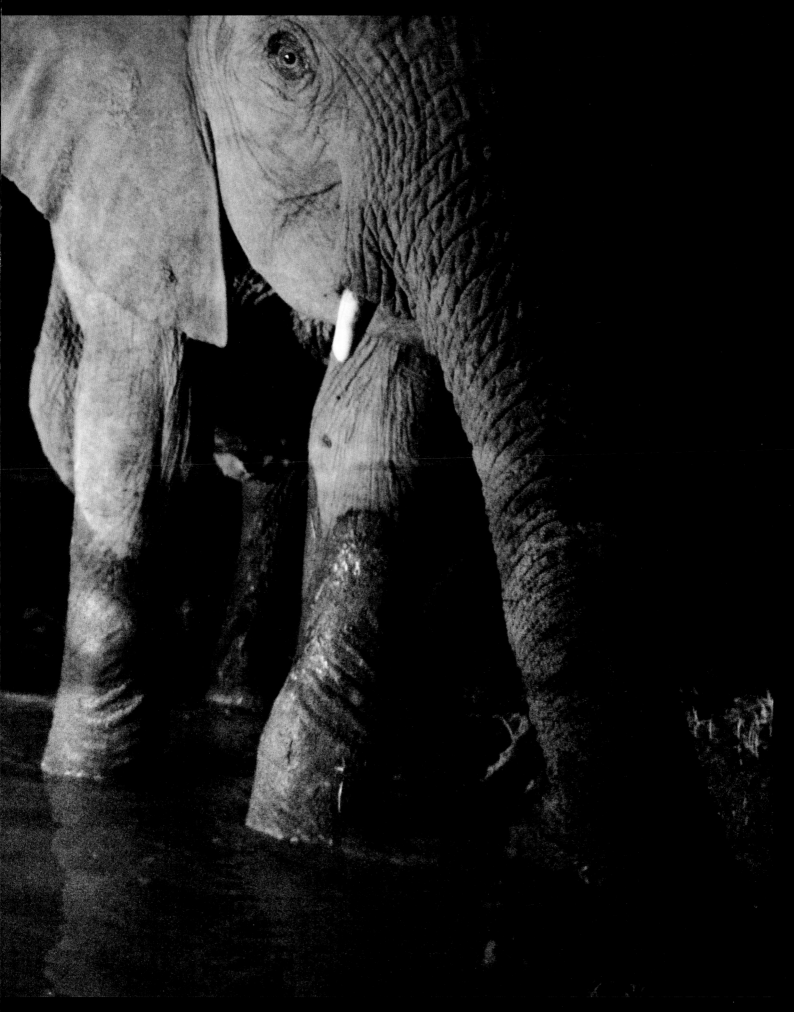

PEOPLE &

CULTURE

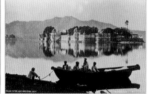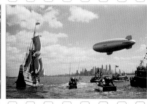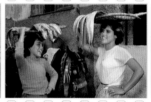

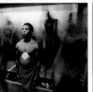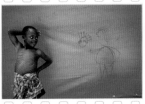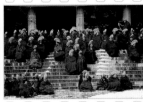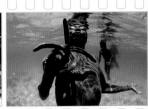

NESTLED DEEP IN THE SOCIETY'S VAULTS is a small case, the size of a cigar box, its plain red-brown cover embossed with Cyrillic characters. Open it—carefully—and inside are 50 stiff-backed black-and-white photographs of Lhasa, which in 1904, when that case arrived at National Geographic headquarters, gift of the Imperial Russian Geographical Society, ranked among the most mysterious cities in the world. Otherwise unremarkable today, these now-fading pictures of the once legendary capital of Tibet were perhaps the first ever captured on film. So when a selection of them was printed in the January 1905 *National Geographic*, the Society's membership surged as people flocked to join an organization that could provide them with photographs from the far corners of the globe.

Thus began the deliberate pursuit of pictorial exoticism that issued in the long procession of painted and plumed, costumed and turbaned humanity that once paraded through the magazine's pages. Postcard views of faraway cities and portraits of "genuine natives" were assiduously collected from every conceivable source, some purchased in bulk from overseas whereas others were dispatched by an assortment of journalists, diplomats, professors, military men, and wealthy vagabonds who lived, worked, or traveled abroad. Exquisite glass-plate Autochromes arrived by the trunkful from a roaming corps of itinerant professional cameramen.

"Humanized geography," this depiction of the world through its peoples and cultures was called, and on its foundations successive generations of versatile staff and freelance photographers have amassed one of the richest collections in the Society's archives. Though exoticism has long given way to photojournalism, this collection remains a kind of time capsule enshrining the world as it has evolved over the past century and more. For whether they pursued the typical subjects demanded by the Kodachrome travelogue, or sought instead to portray the gritty reality of the streets, these photographers crisscrossed each others' paths in time as well as space, documenting the changes the passing years might ring on the way people everywhere lived, worked, plied their trades, celebrated their festivals, or otherwise spun and wove the fabric of their days.

the early photographs

ALTHOUGH THEIR CAMERAS MAY HAVE BEEN HEAVIER, their tripods bulkier, their trunks of glass-plate negatives more burdensome, photographers of the first quarter of the 20th century had one great advantage over those of subsequent generations: The world was still a bigger place, and people wore their cultural distinctiveness quite literally on their sleeves.

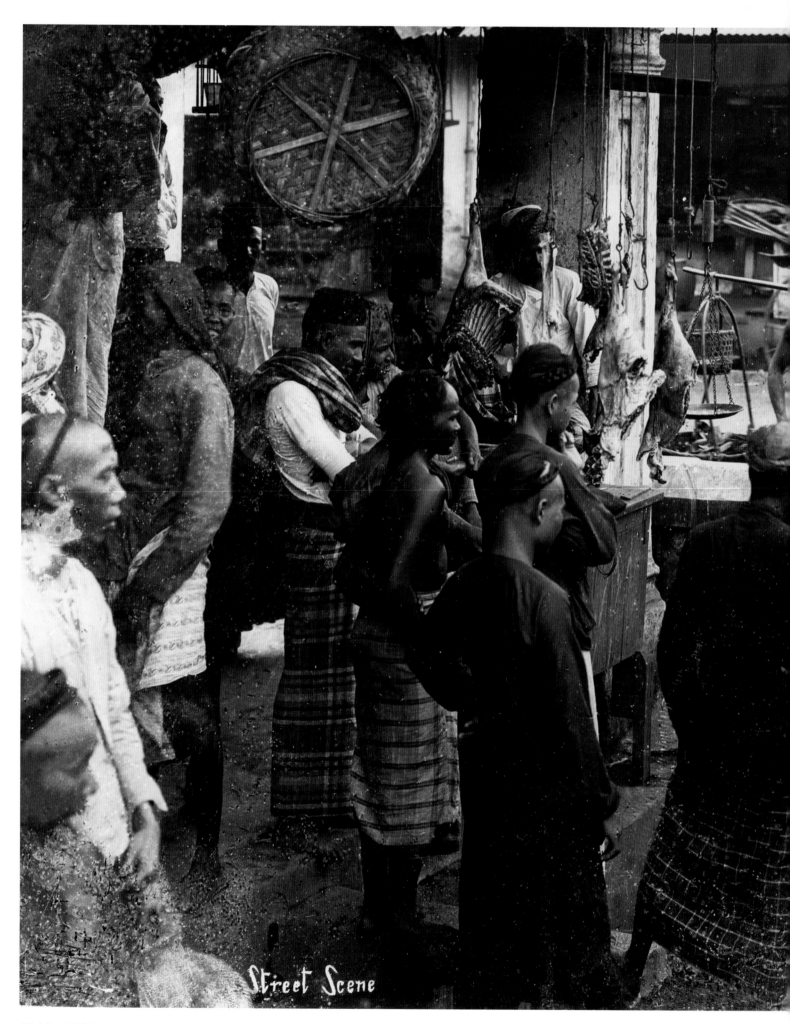

Street Scene

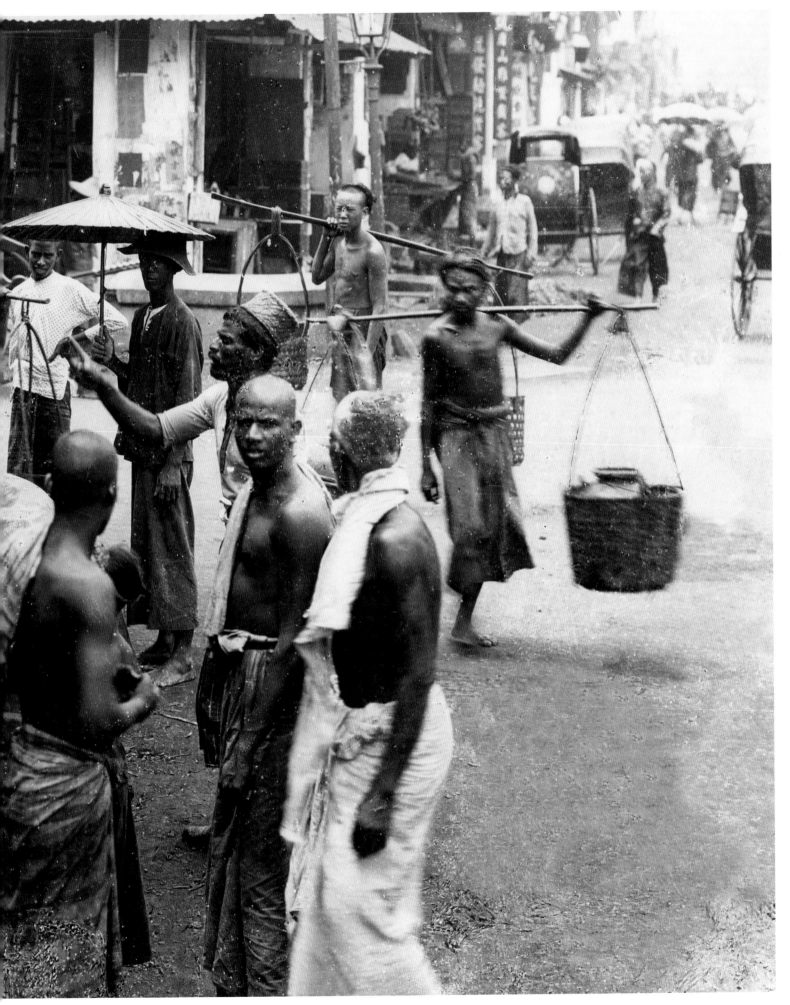

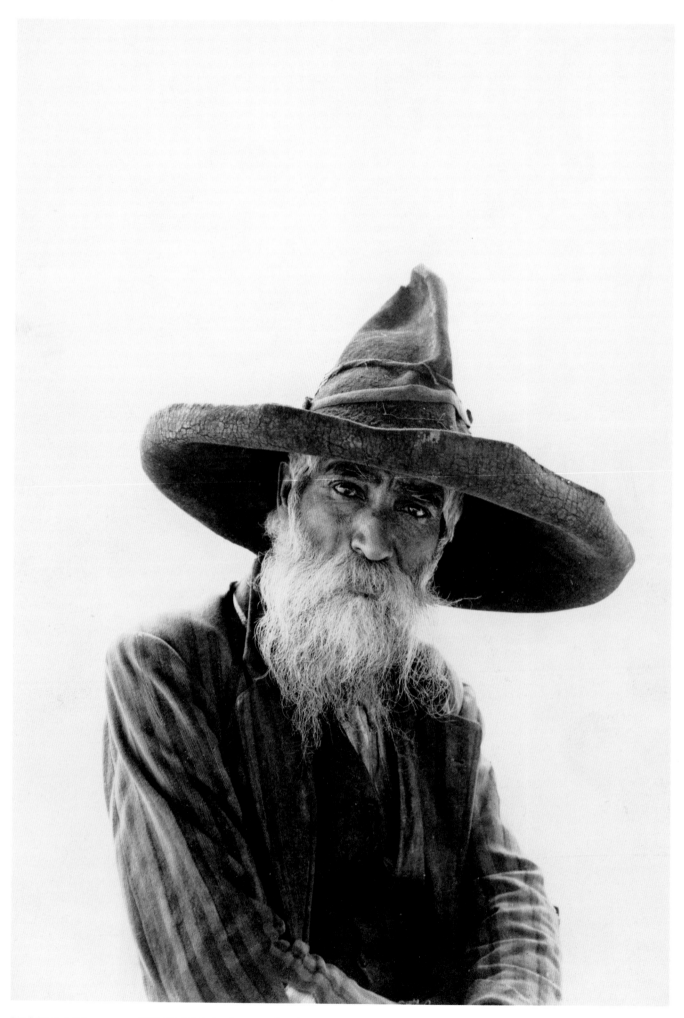

HUGO BREHME | 1916 | MEXICO *Portrait of a peasant*

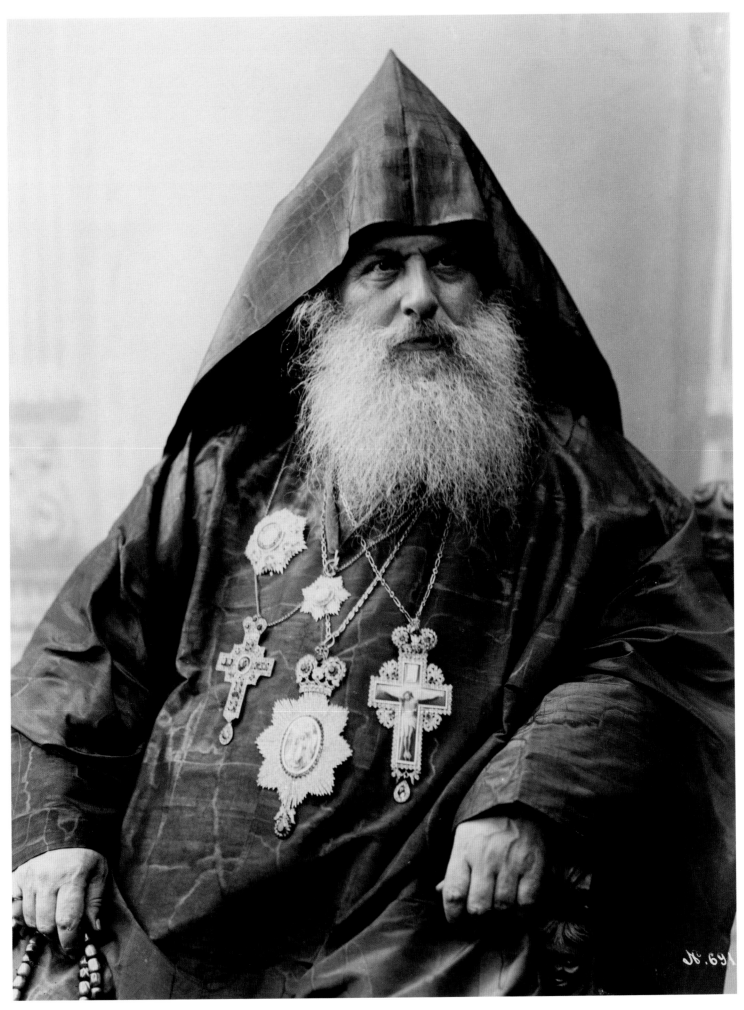

COLBY M. CHESTER | DATE UNKNOWN | PALESTINE *Armenian patriarch of Jerusalem*

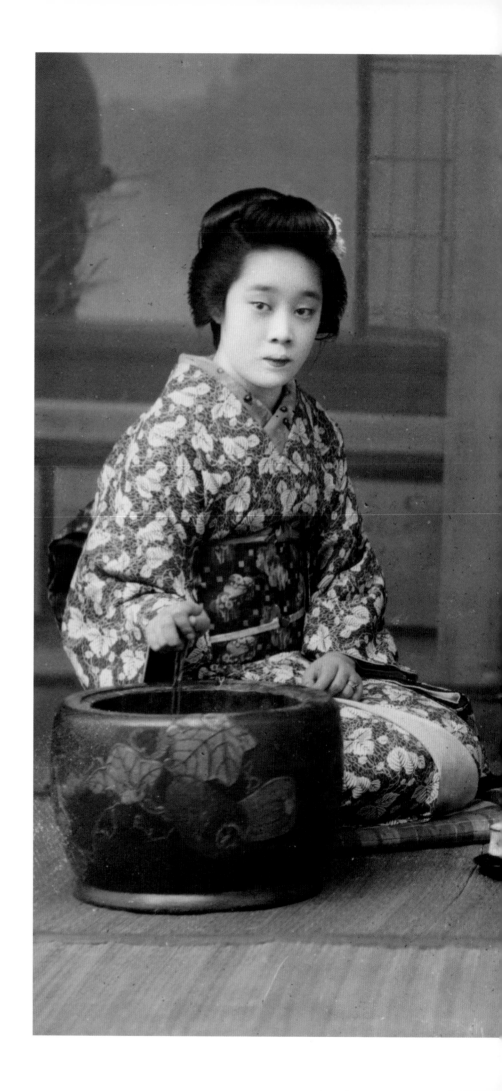

The Japanese tea ceremony so impressed Eliza Scidmore that, having once participated in it, she felt as if she had "slipped out of our century, and almost out of our planet."

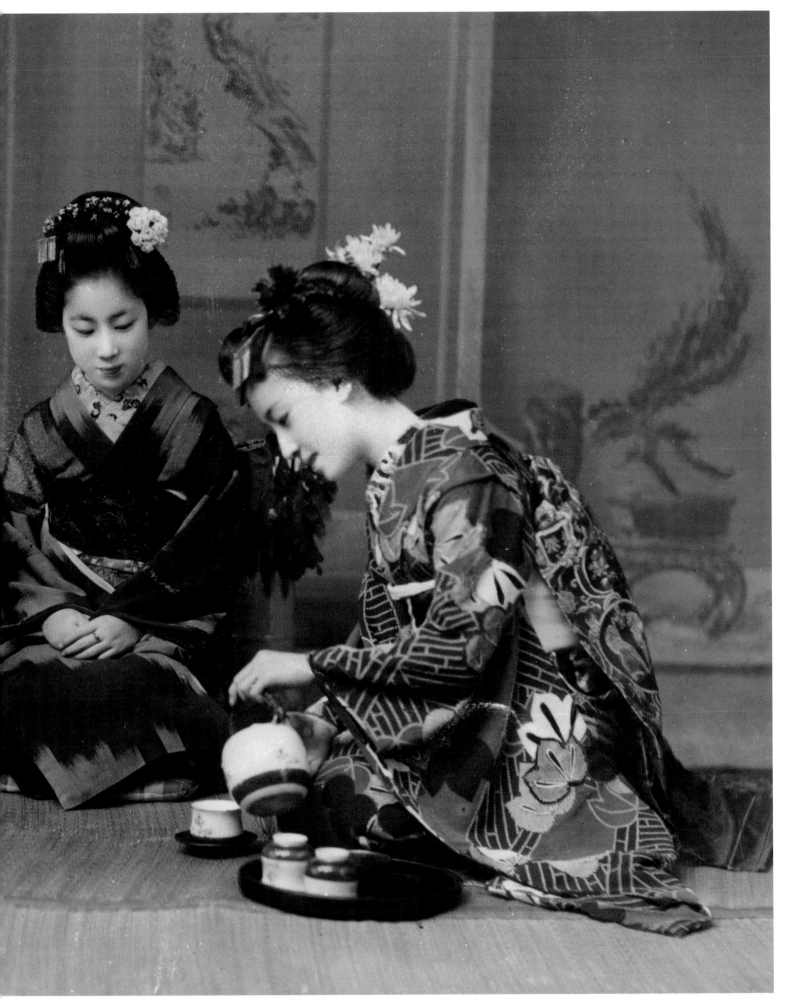

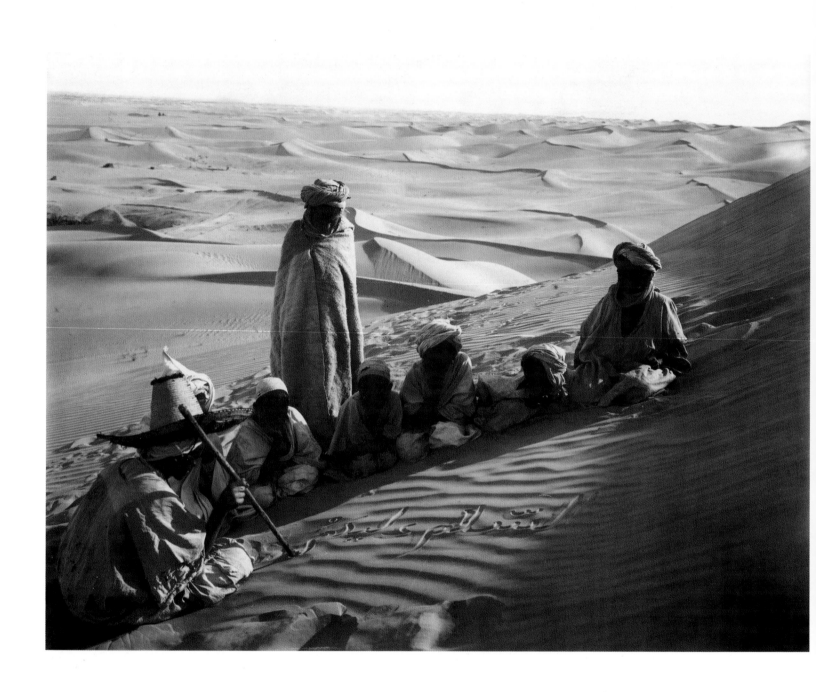

LEHNERT & LANDROCK | 1914 | TUNISIA *A school in the desert*

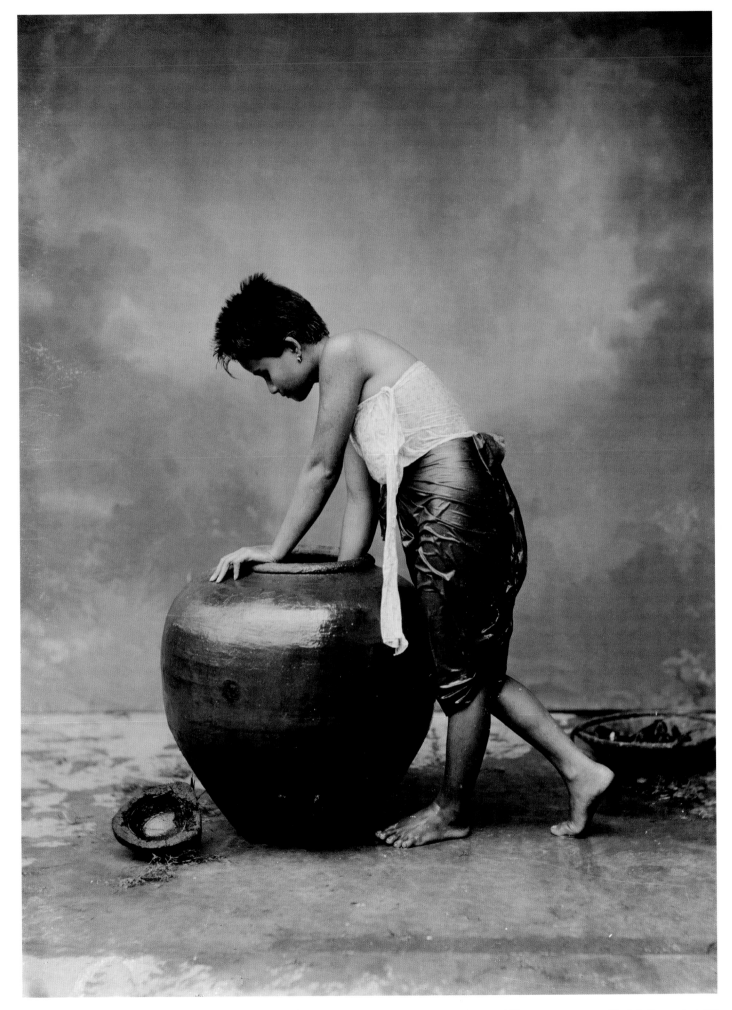

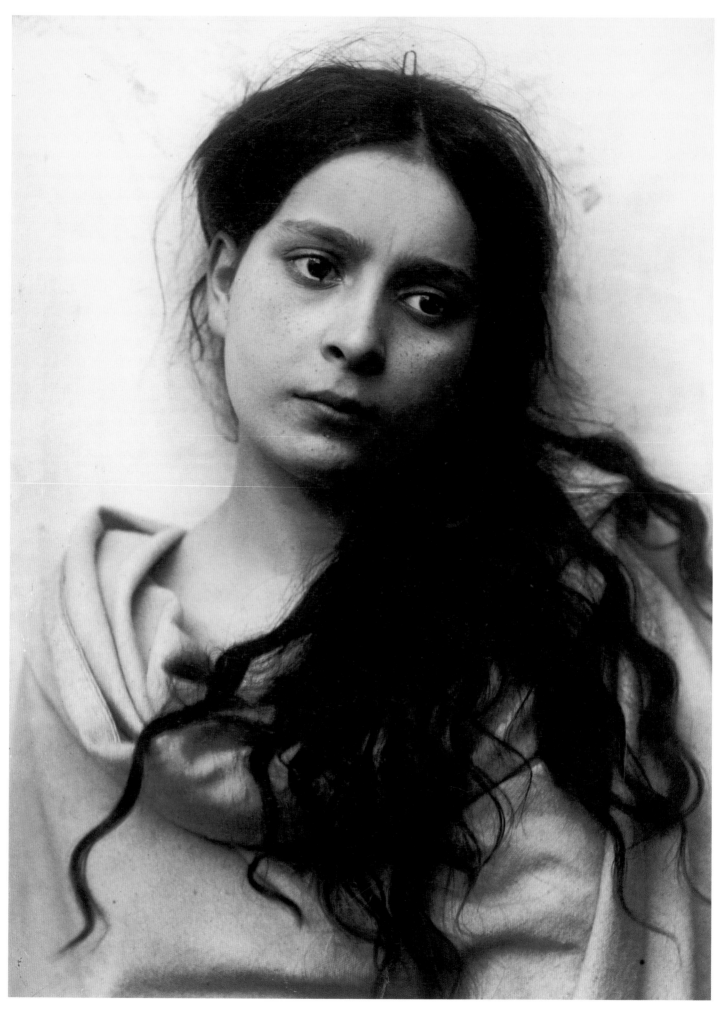

BARON WILHELM VON GLOEDEN **|** 1903 **|** ITALY *A Sicilian girl*

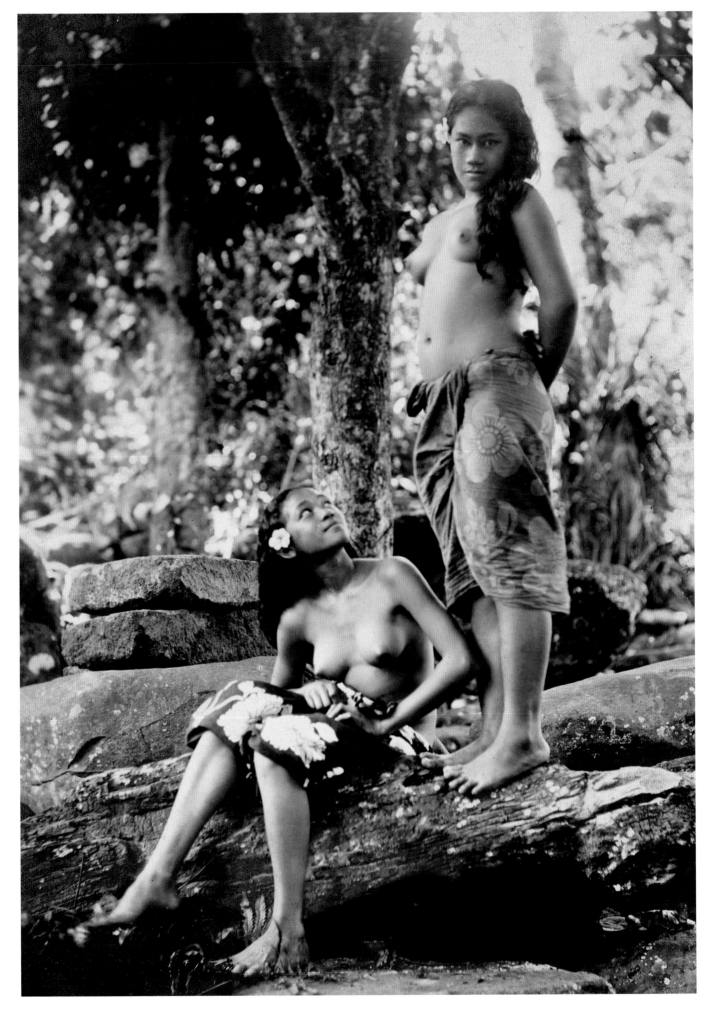

J. W. CHURCH | 1918 | FRENCH POLYNESIA *In the Marquesas Islands*

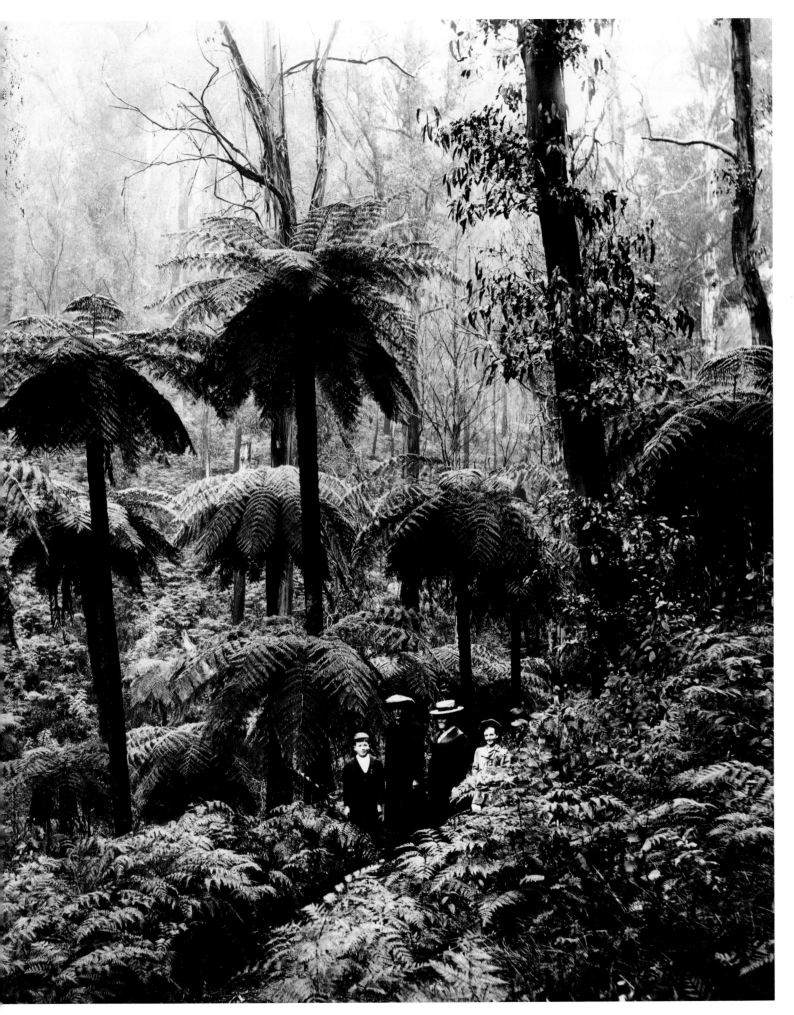

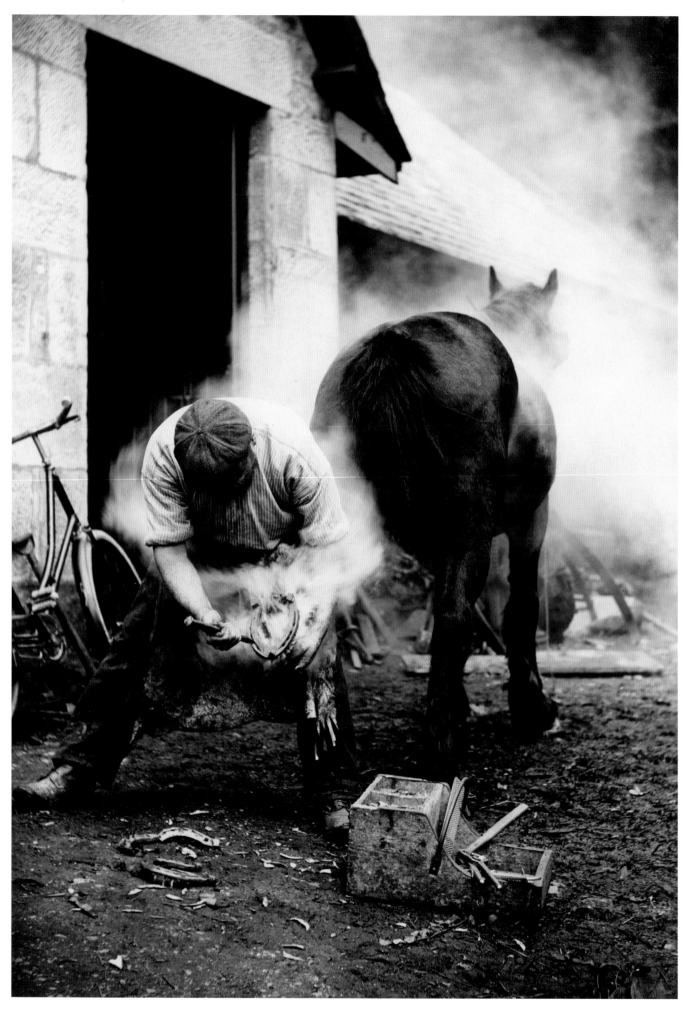

WILLIAM REID | 1921 | SCOTLAND *"Burning the hoof" before shoeing it*

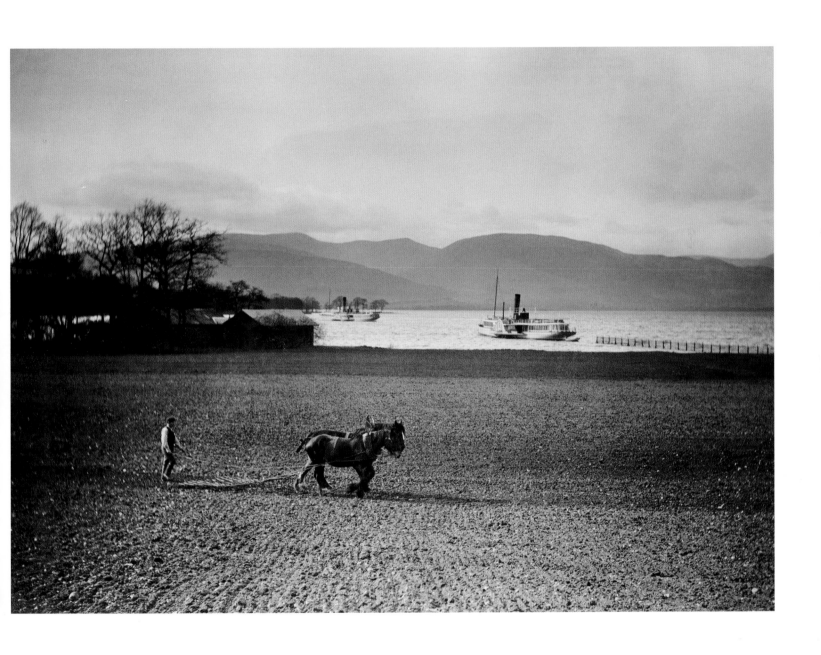

WILLIAM REID | 1921 | SCOTLAND *Figures in a landscape*

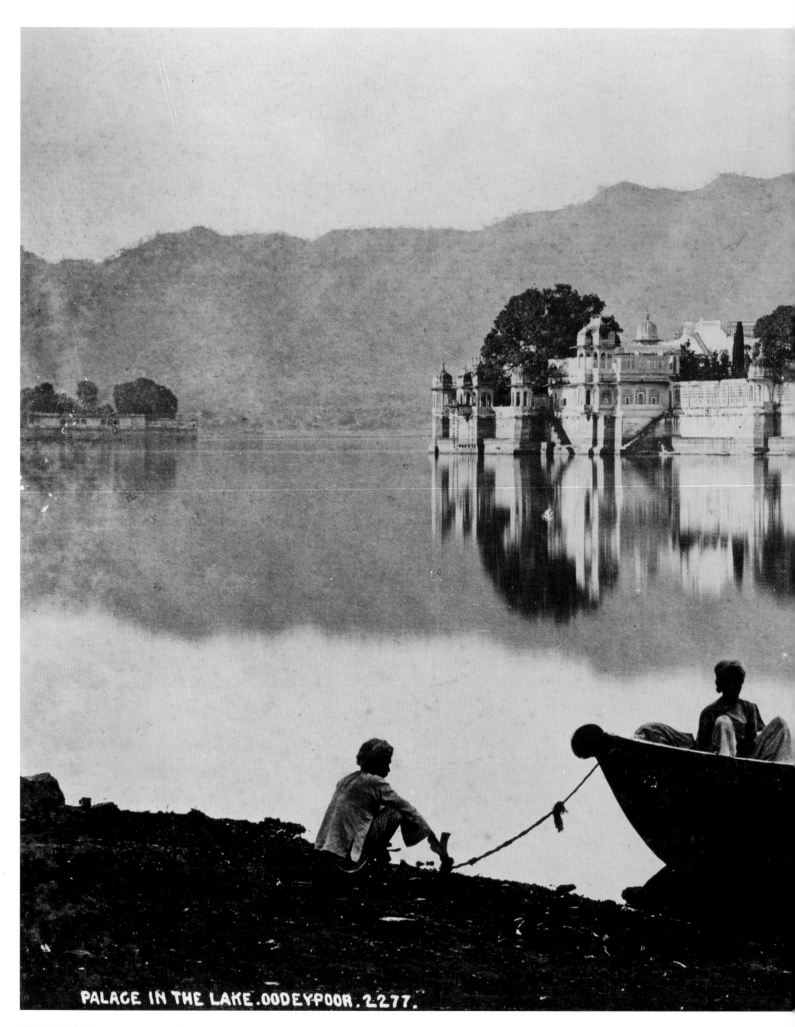

PALACE IN THE LAKE.OODEYPOOR.2277.

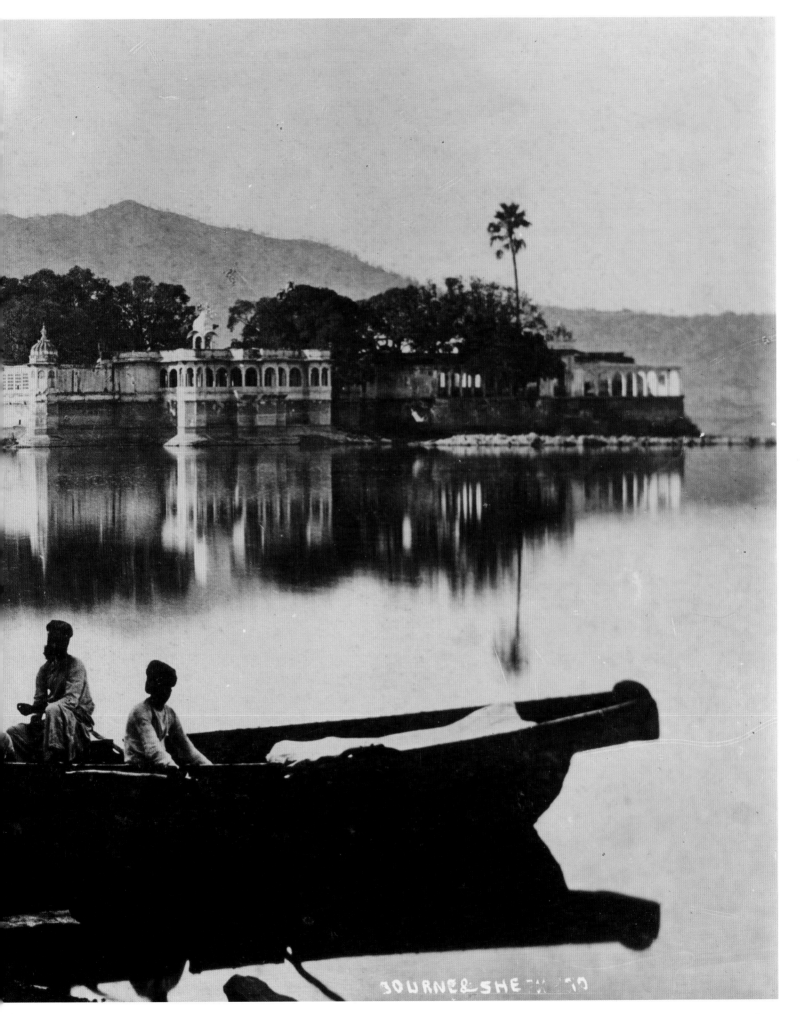

BOURNE AND SHEPHERD | 1877 | INDIA *Palace in Lake Udaipur* The Early Photographs | 257

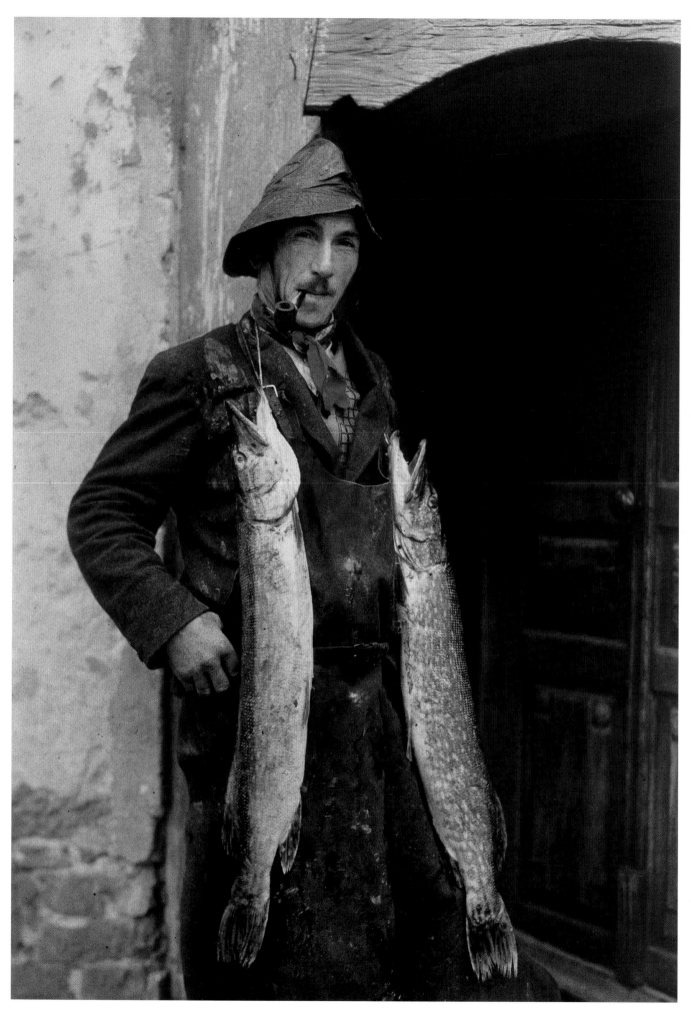

HANS HILDENBRAND | 1932 | SWITZERLAND *Fisherman and pike*

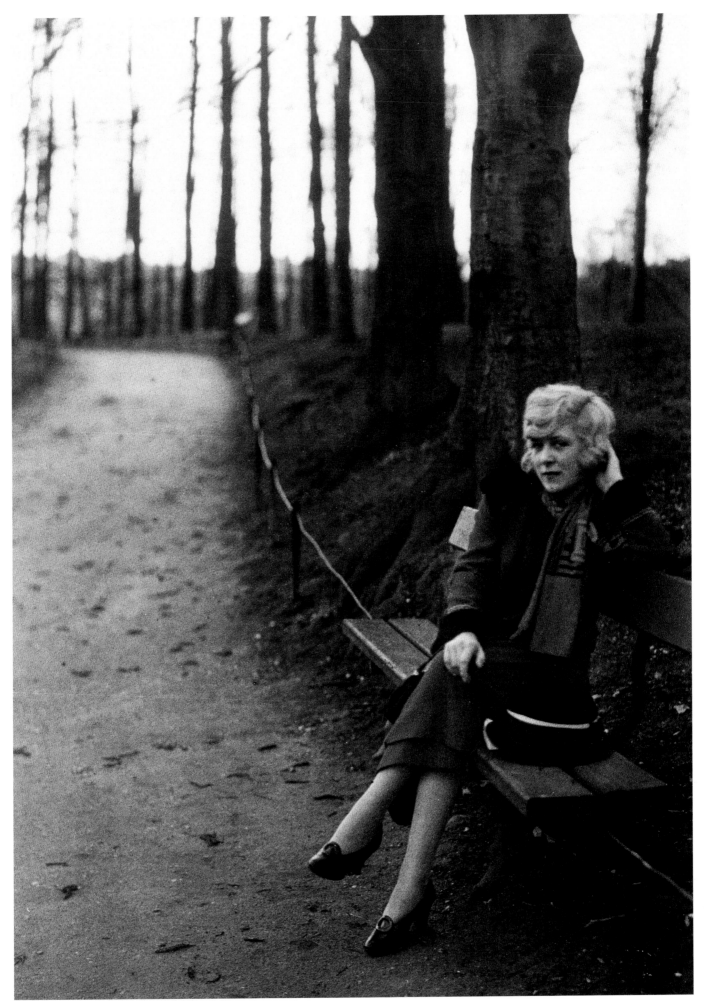

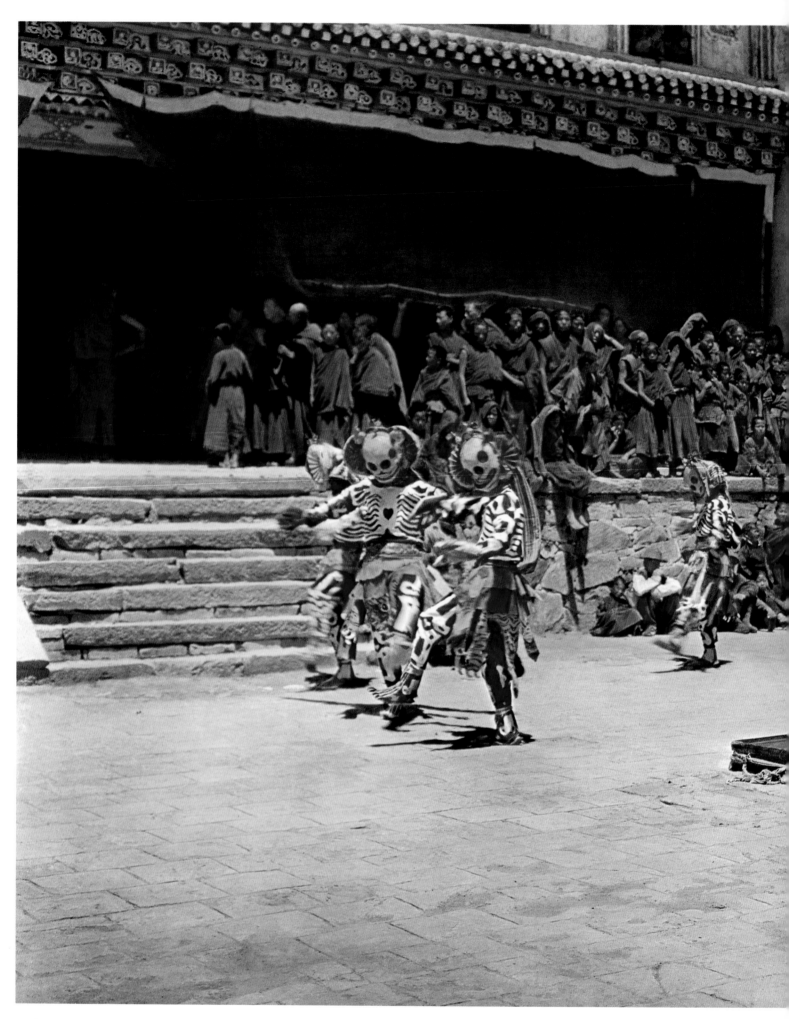

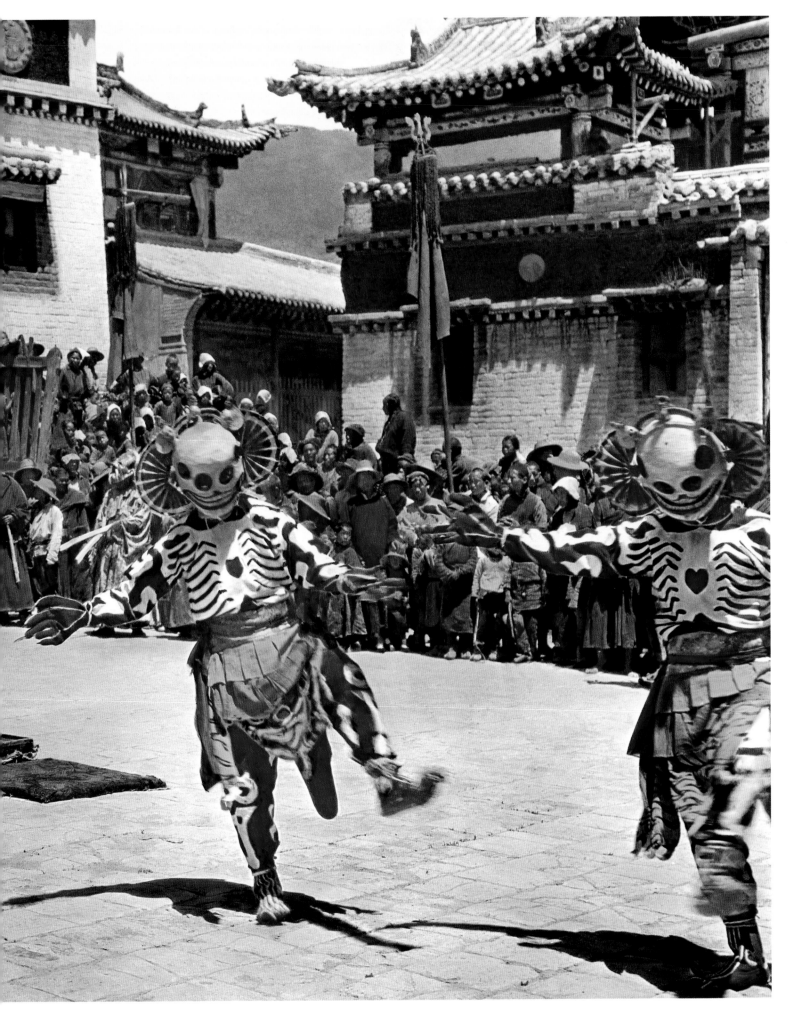

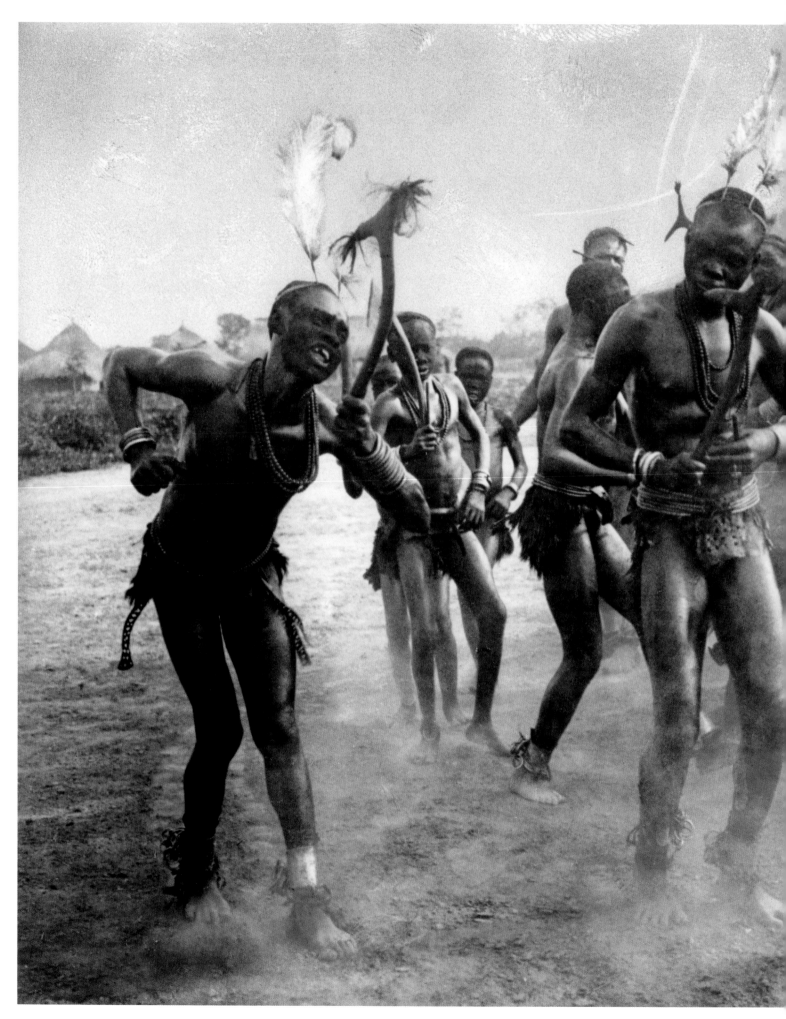

VALERIANO SALAS | 1934 | CHAD *Celebration of the Hyondo sorcerers*

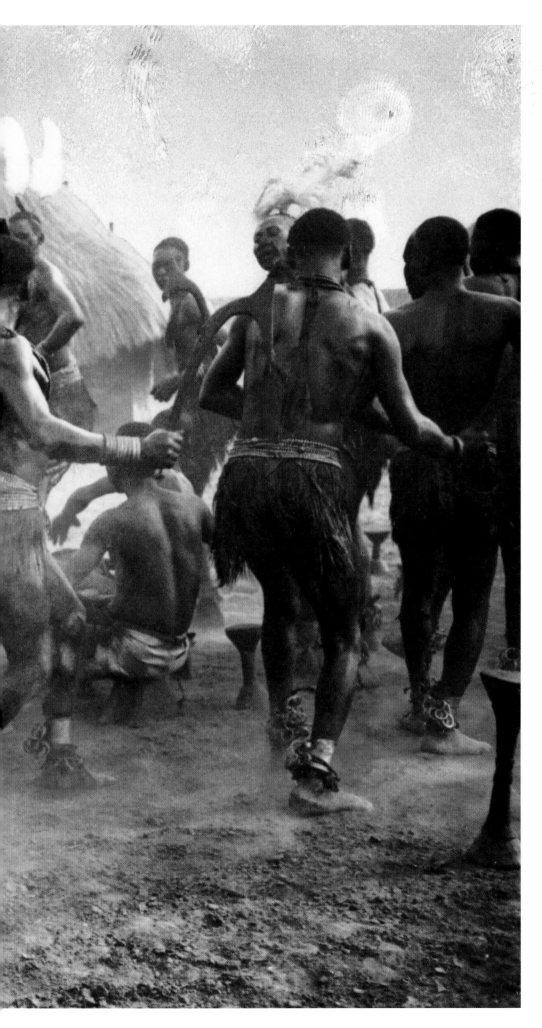

Having completed a grueling initiation in the bush, Hyondo postulants of the Sara tribe hang their shaggy garments on trees and, according to one authority, "give themselves up to hilarious rejoicings."

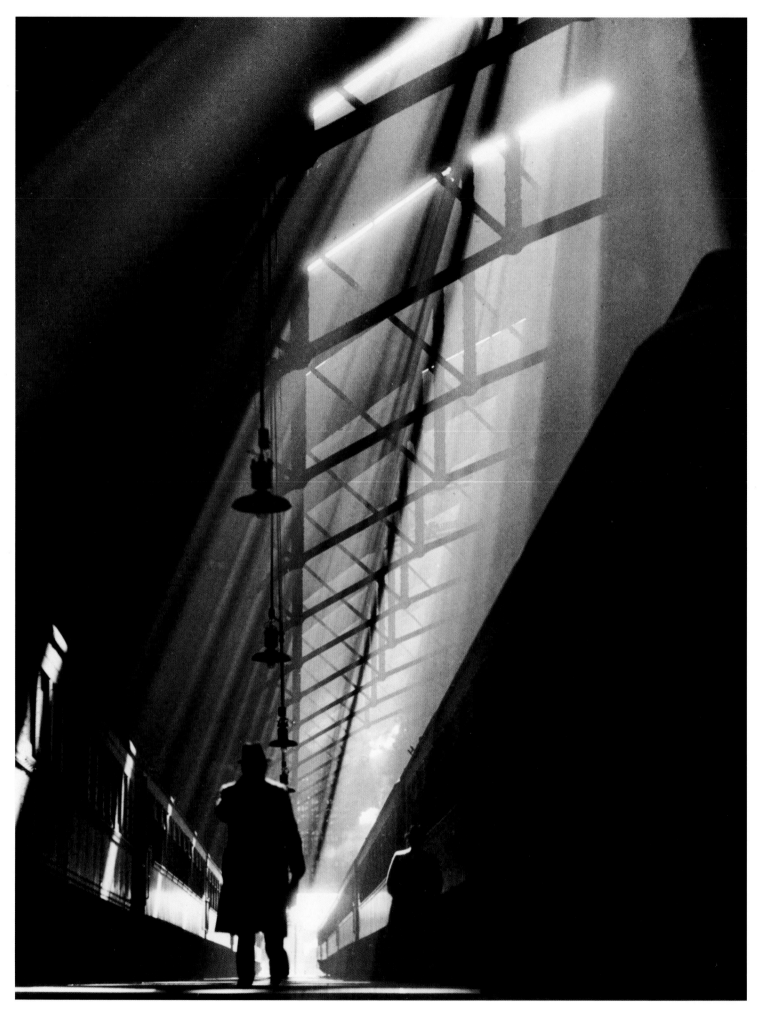

WILLIAM M. RITTASE **|** 1936 **|** ILLINOIS *The fall of light, Chicago*

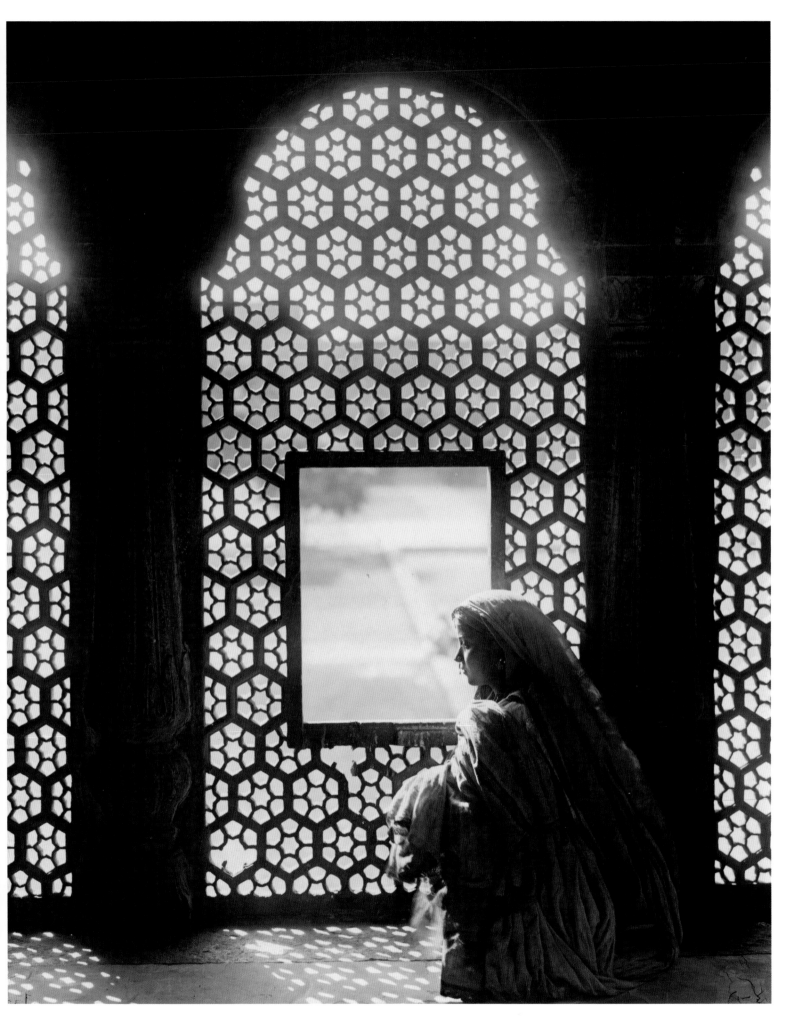

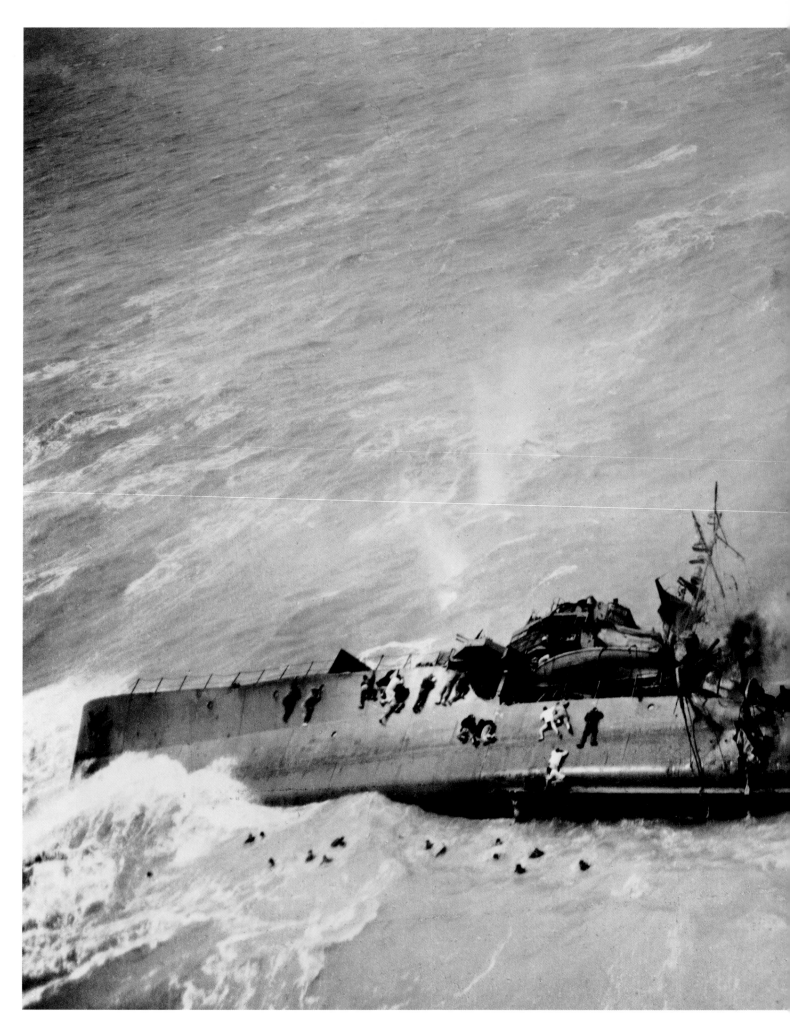

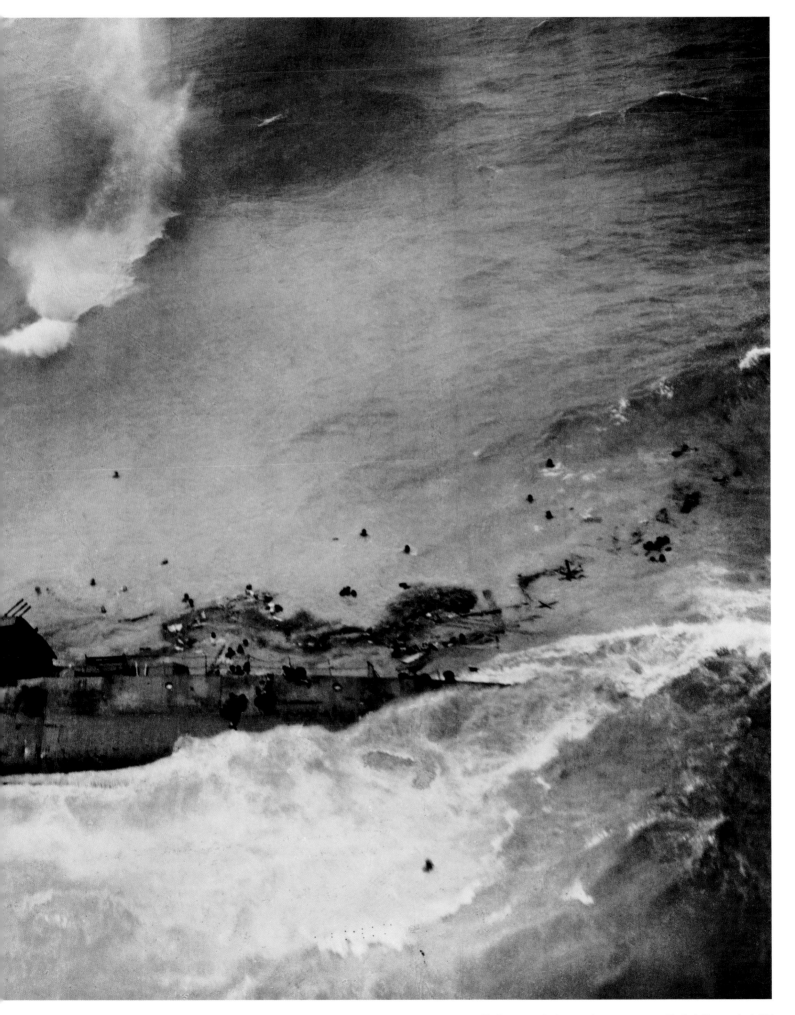

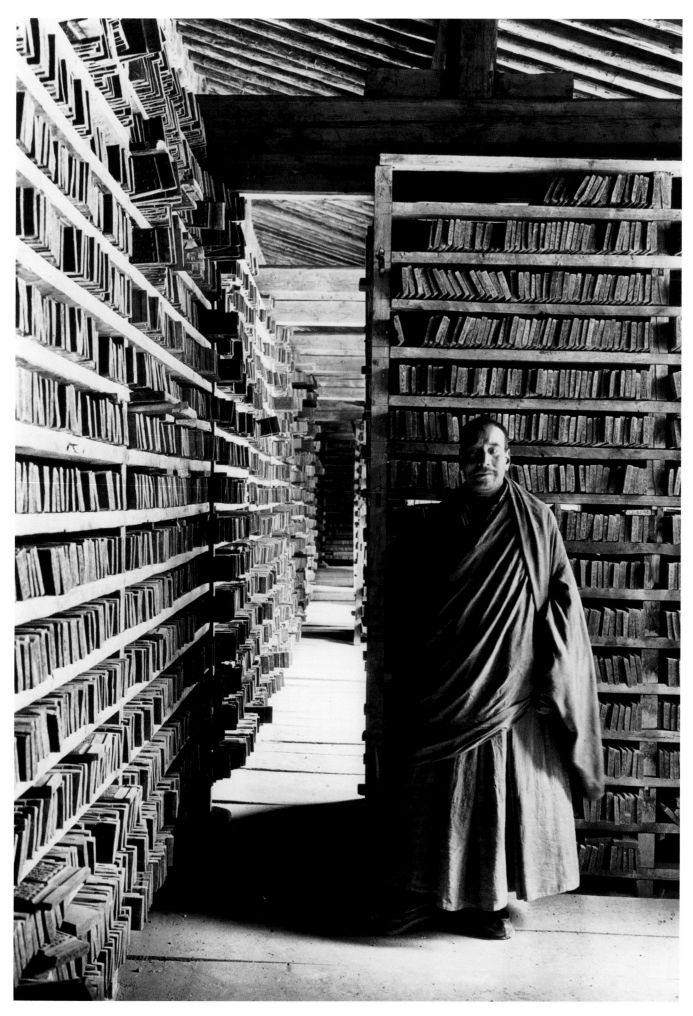

JOSEPH F. ROCK | 1925 | CHINA *One-twelfth of the printing blocks needed to print the Tibetan Buddhist Bible*

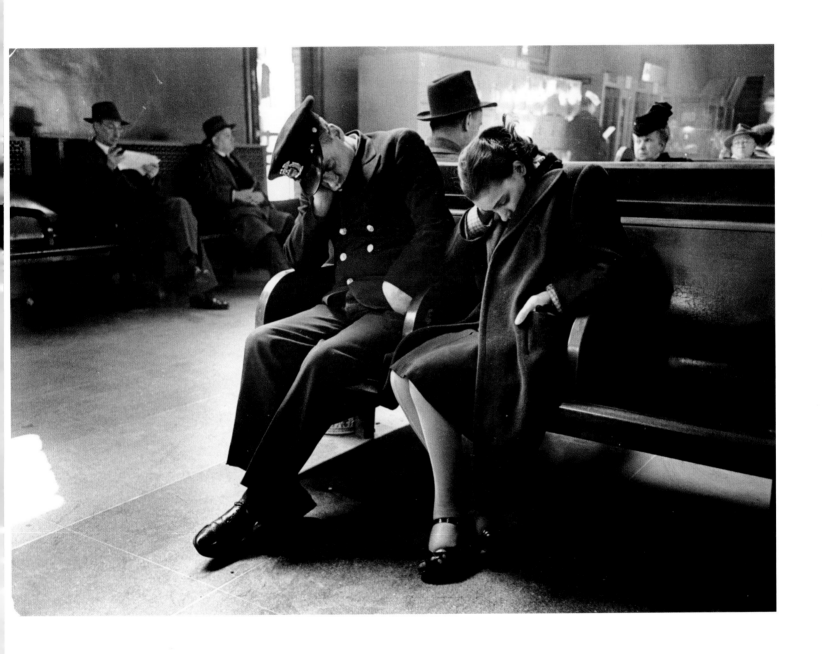

ESTHER BUBLEY ▐ 1949 ▐ U.S.A. *An interminable wait*

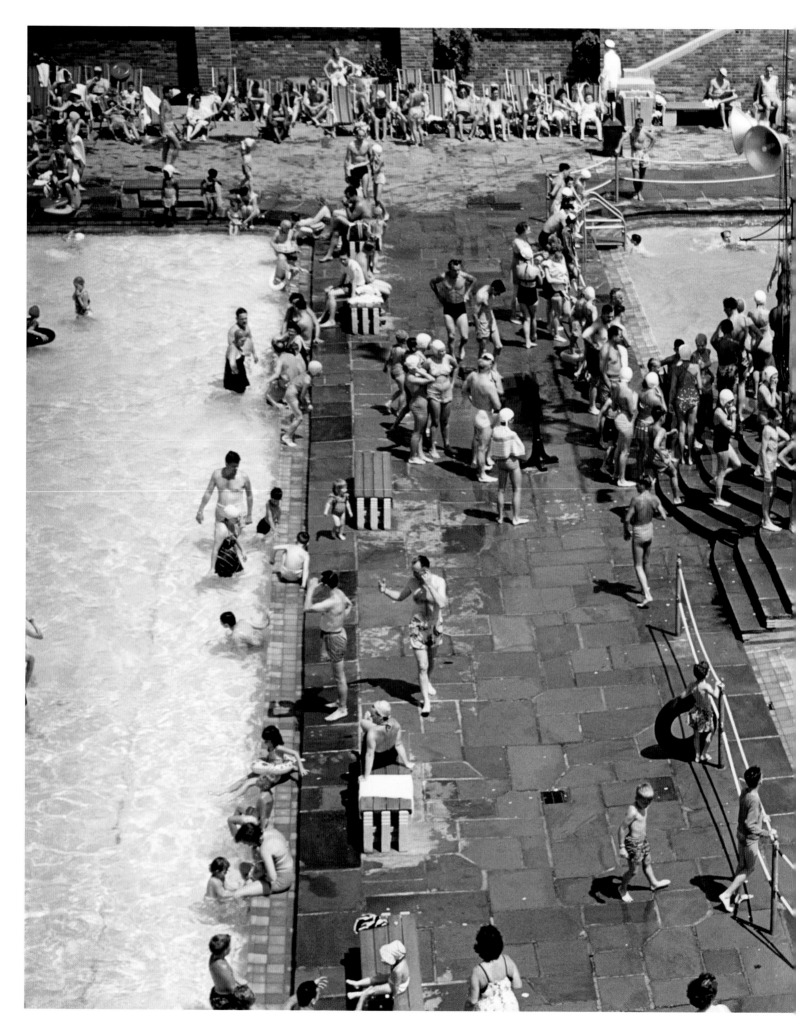

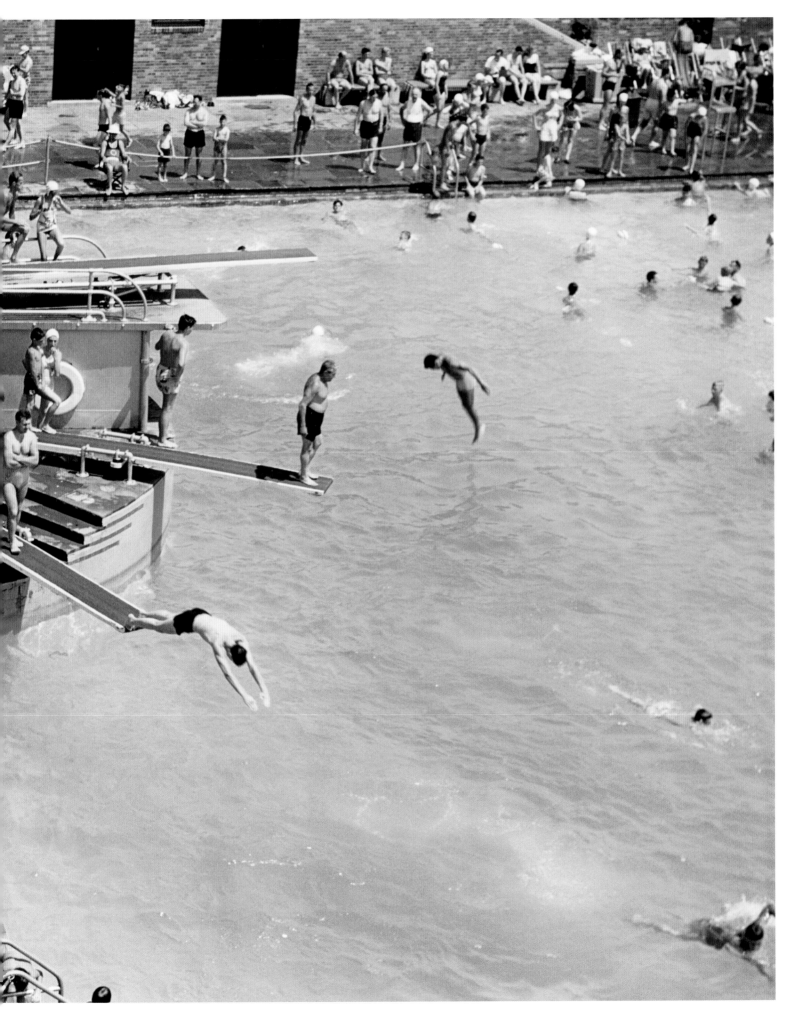

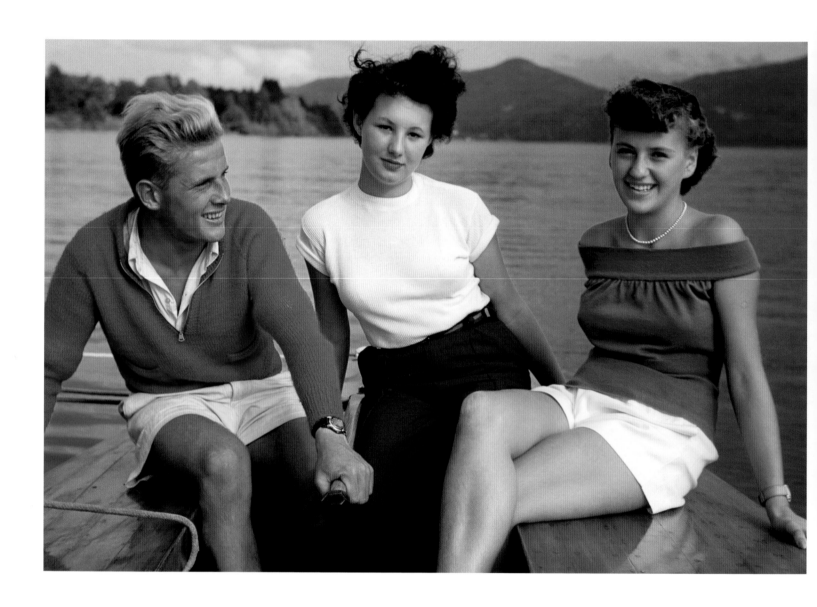

VOLKMAR WENTZEL | 1951 | AUSTRIA *On the Wörthersee*

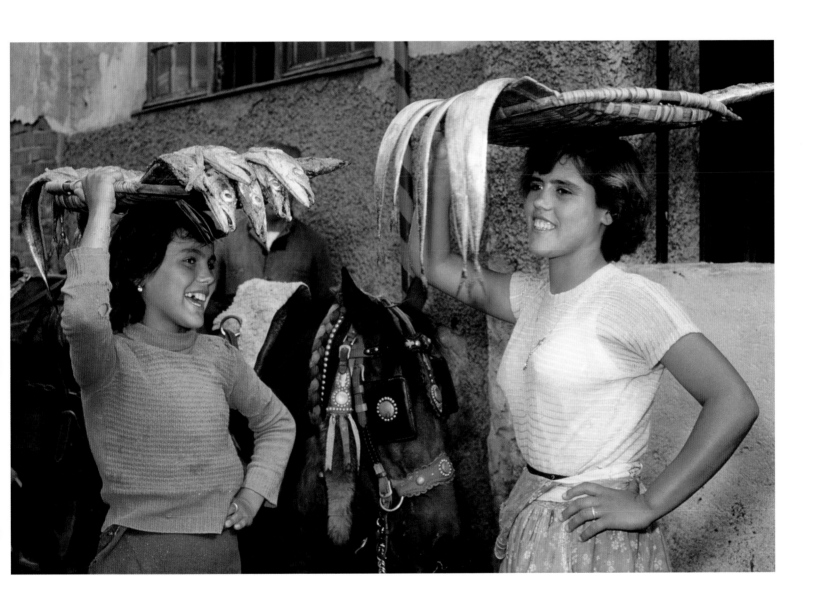

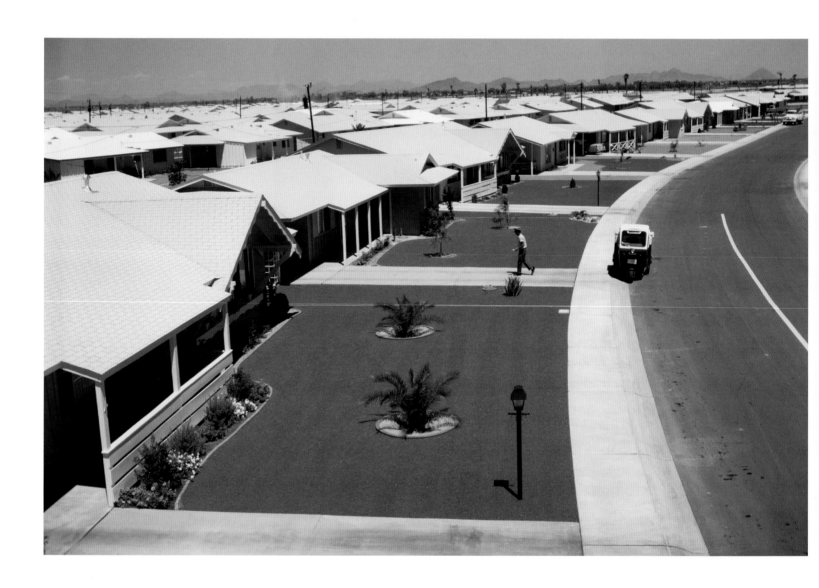

JAMES P. BLAIR | 1963 | ARIZONA *Where even the grass is gravel*

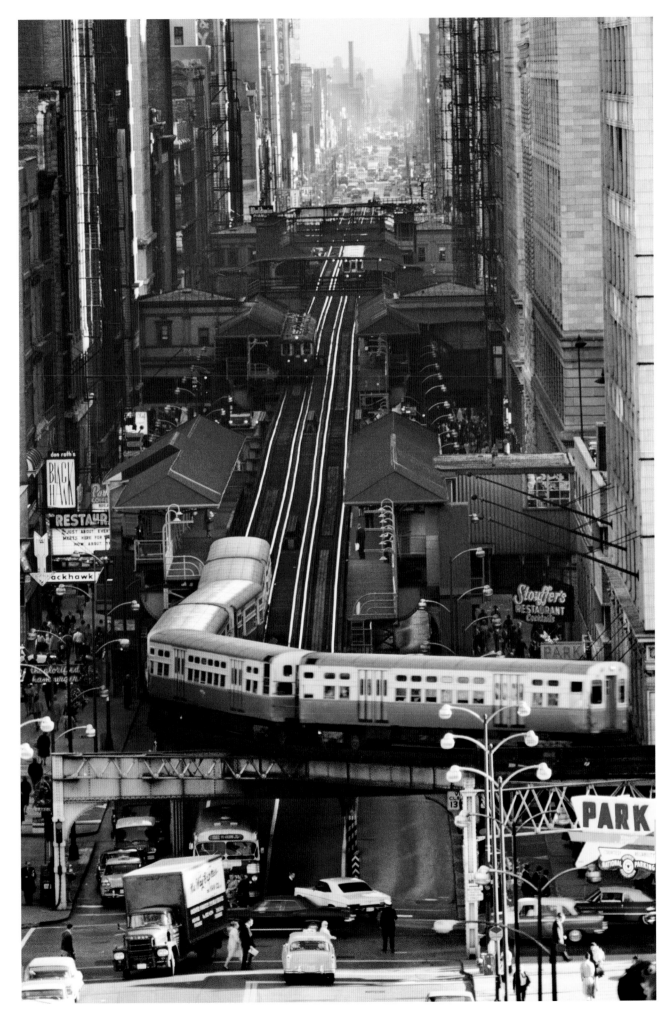

JAMES L. STANFIELD | 1967 | ILLINOIS *The Chicago Loop*

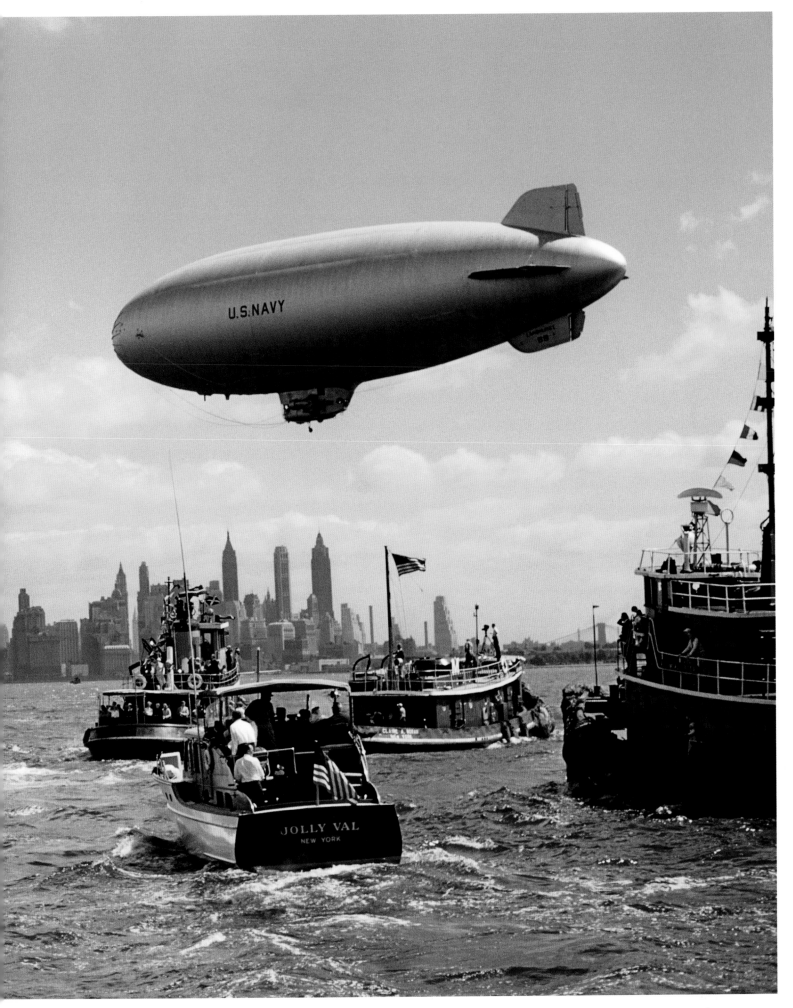

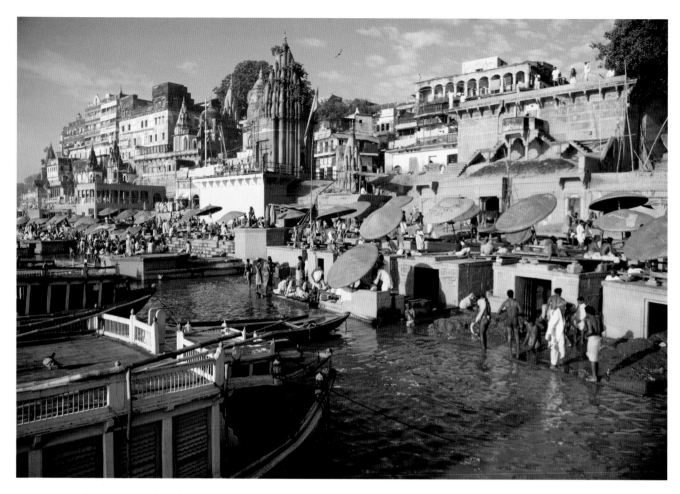

JOHN SCOFIELD | 1963 | INDIA *Mother Ganges*

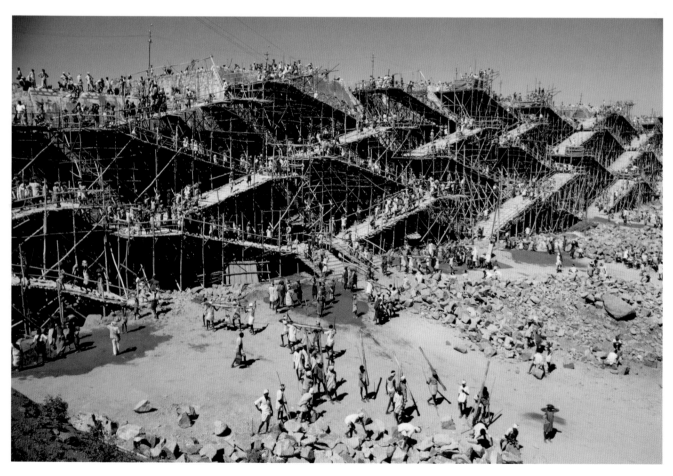

JOHN SCOFIELD | 1963 | INDIA *Building a dam the old-fashioned way*

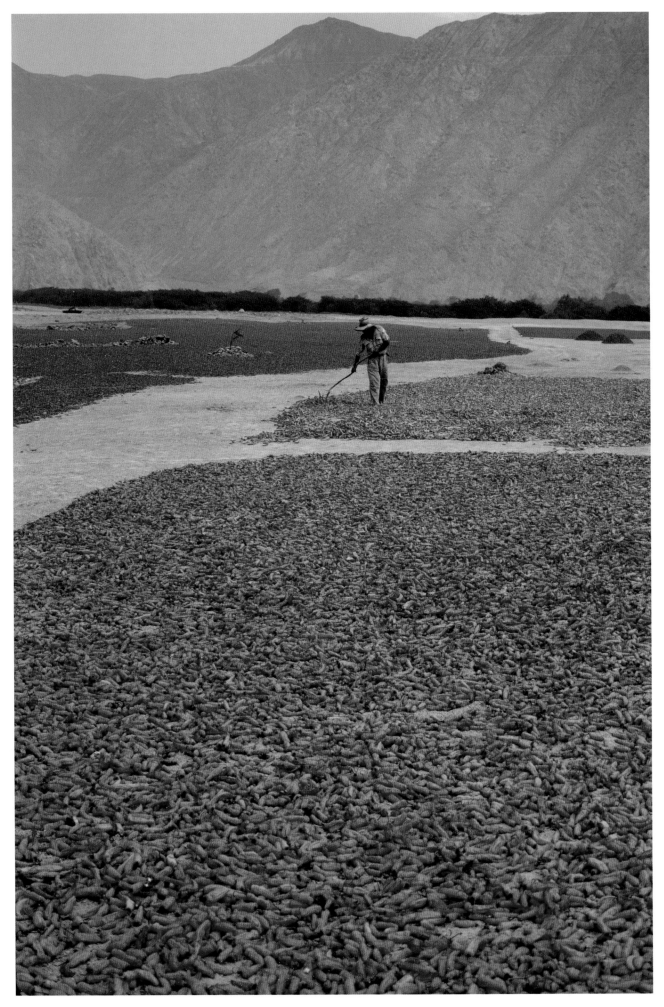

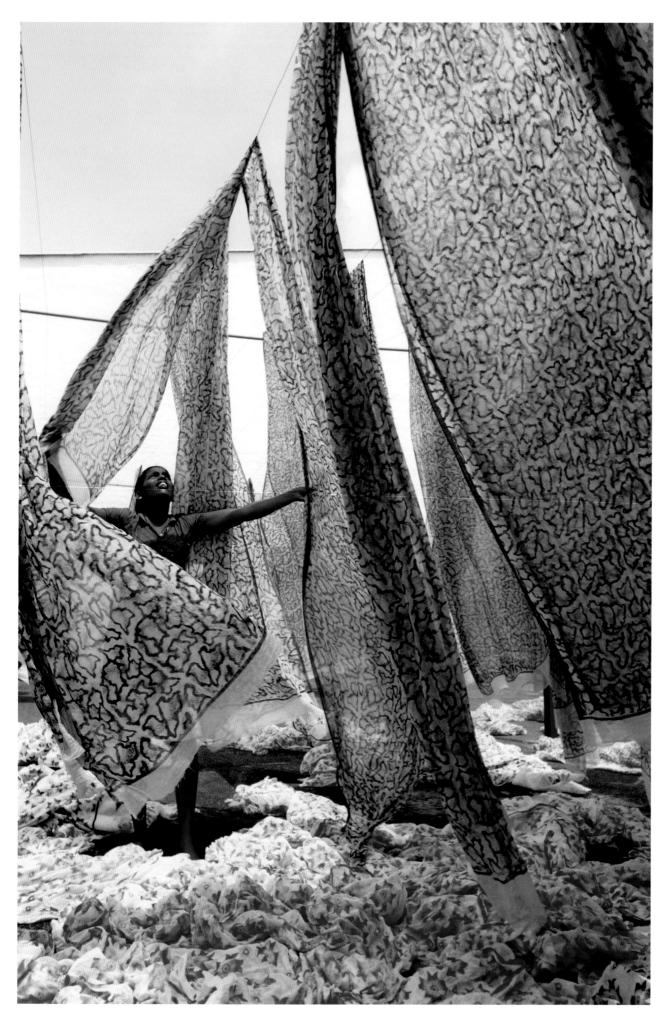

GILBERT M. GROSVENOR | 1966 | CEYLON *Saris on the dry*

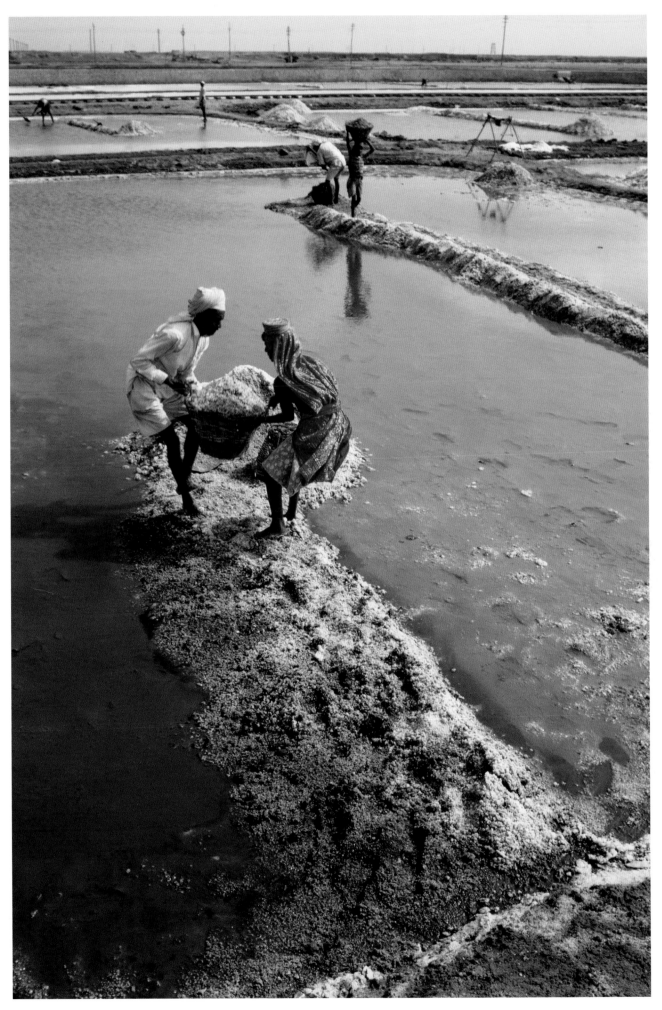

ROBERT F. SISSON | 1967 | INDIA *Making salt*

WILLIAM ALBERT ALLARD | 1967 | COOK ISLANDS *Missed the band and late for church*

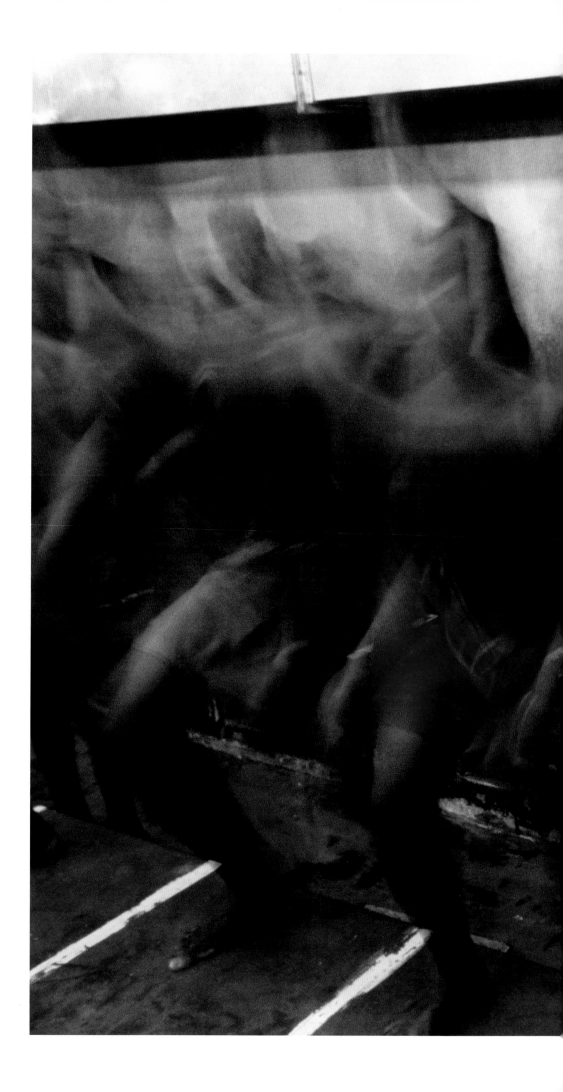

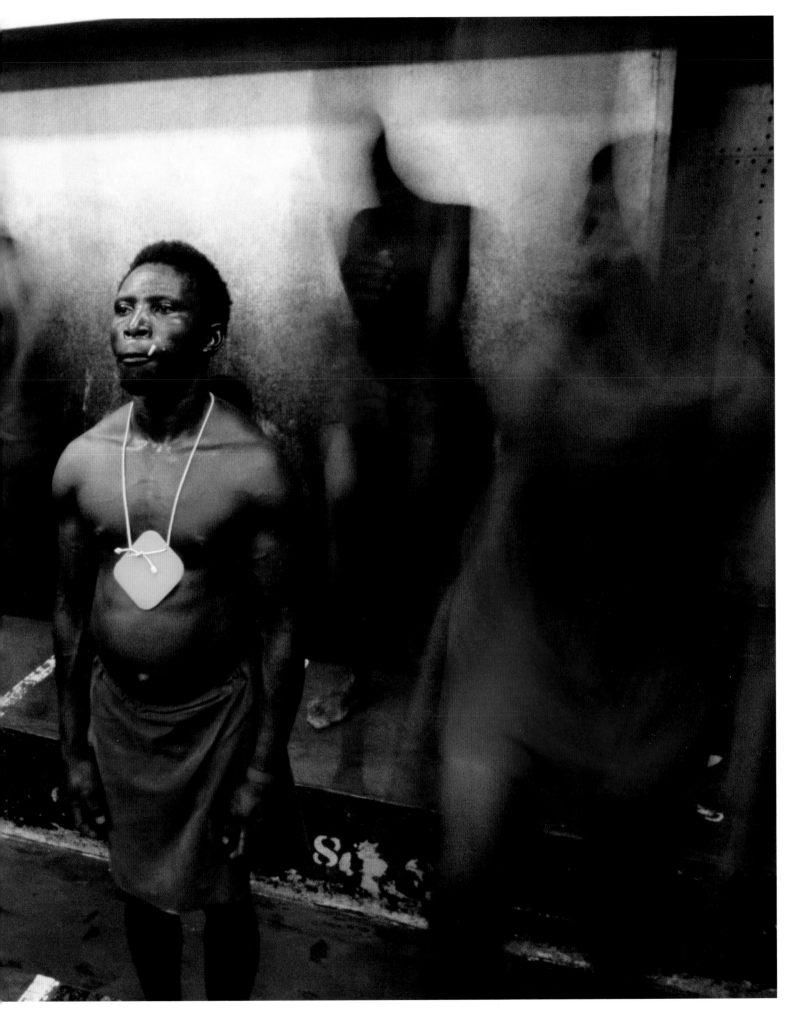

JAMES L. STANFIELD | 1974 | SOUTH AFRICA *Diamond miners in training*

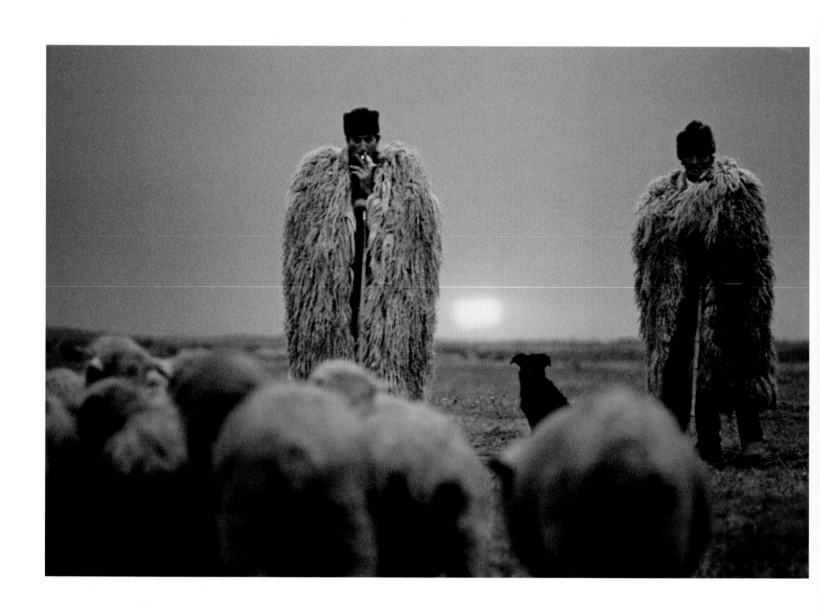

ALBERT MOLDVAY | 1971 | HUNGARY *Shepherds and sheep*

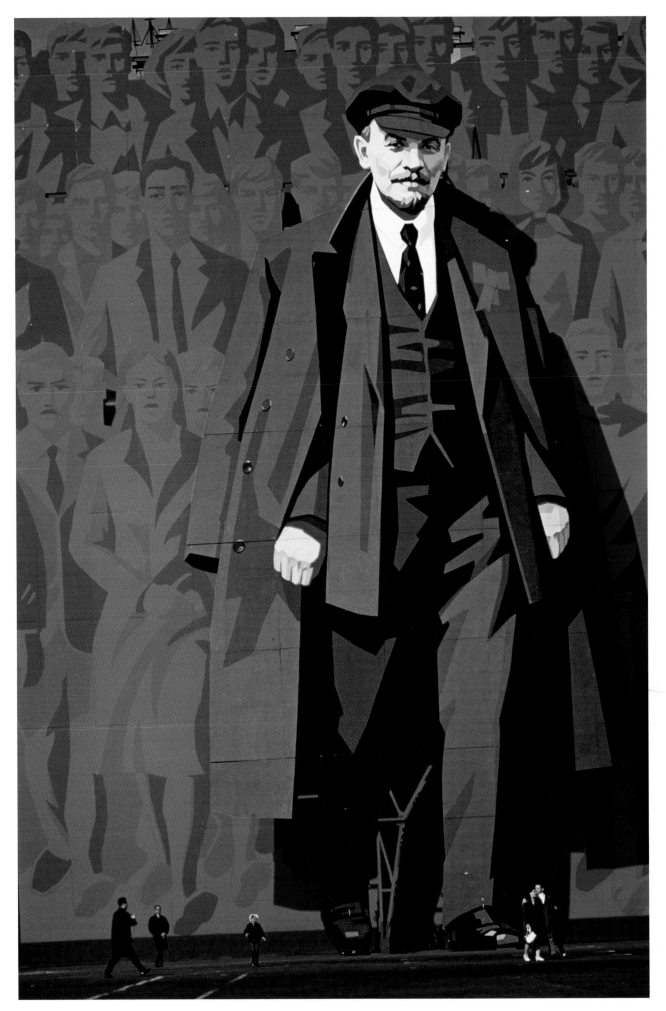

DICK DURRANCE II | 1971 | RUSSIA *Workers' paradise* Documentary Realism | 291

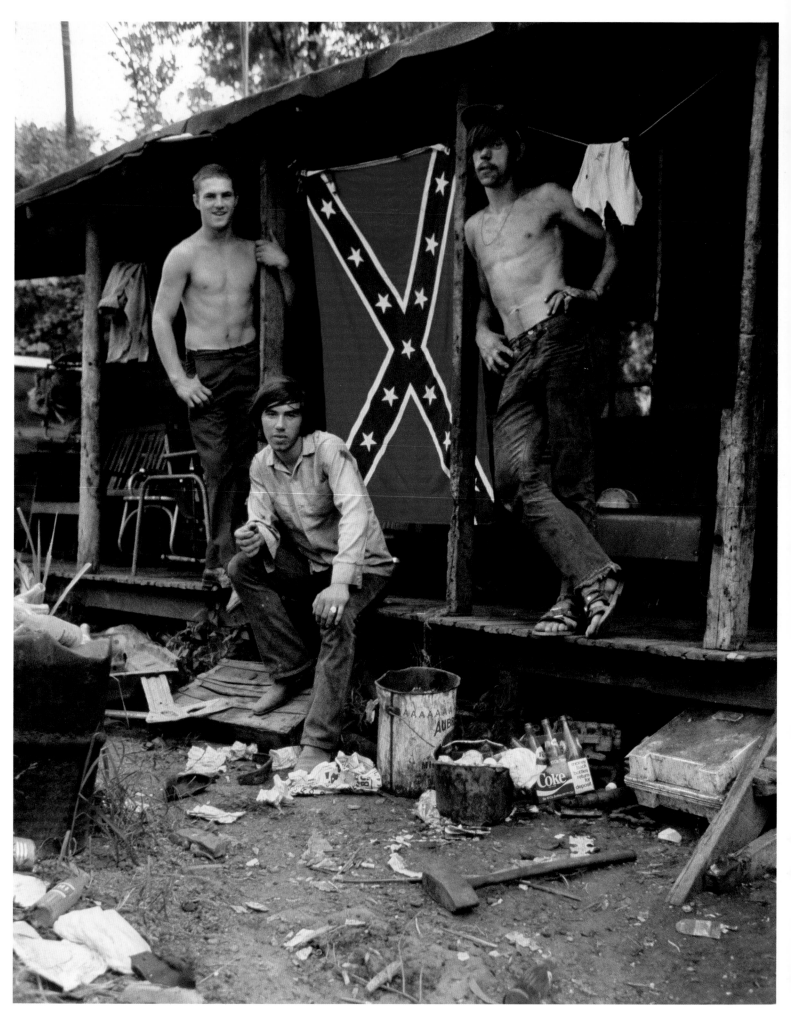

BRUCE DALE | 1973 | KENTUCKY *Mechanics taking a break*

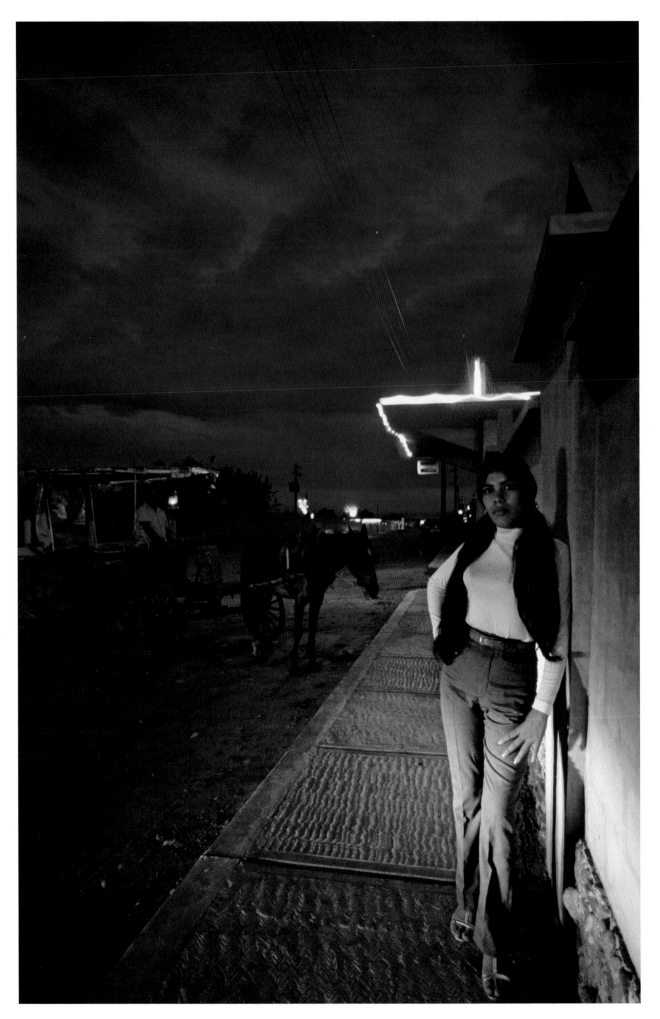

WILLIAM ALBERT ALLARD | 1971 | MEXICO *New to the city*

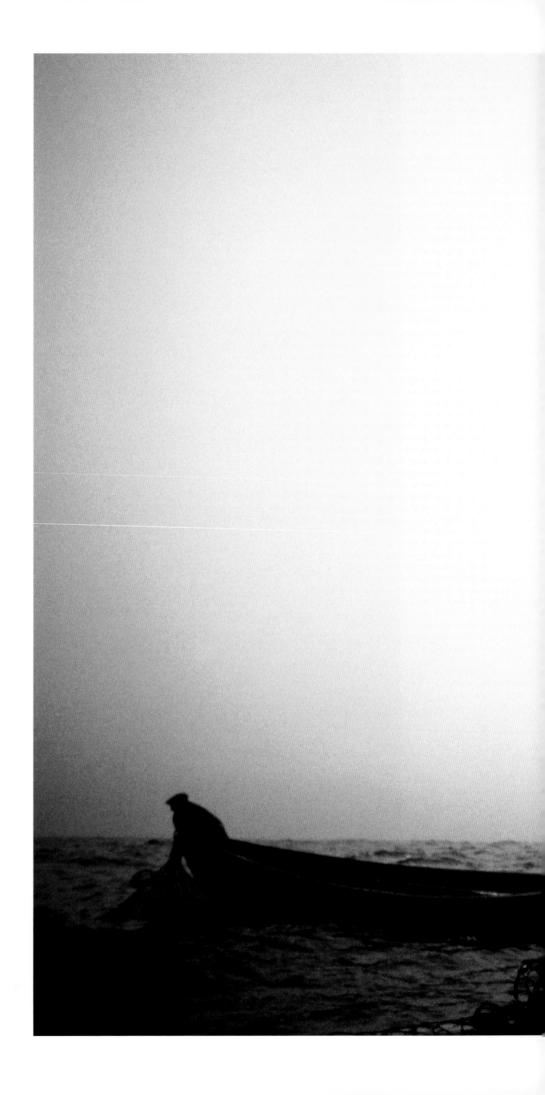

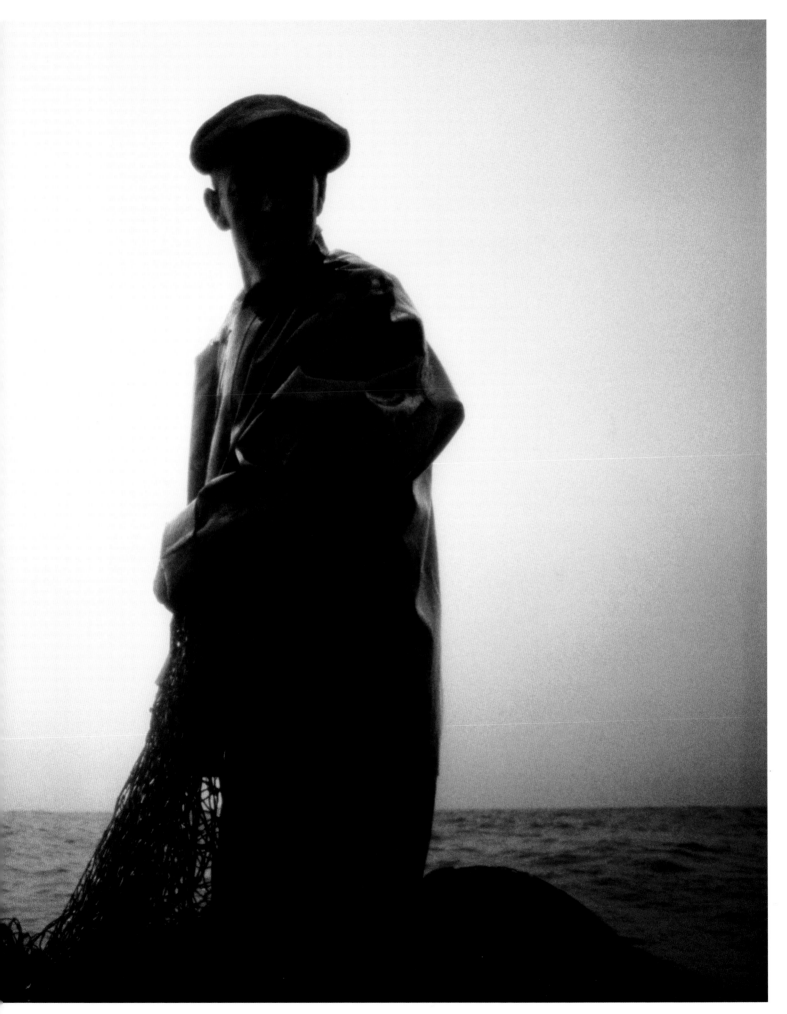

SAM ABELL | 1974 | CANADA *Off the Newfoundland coast*

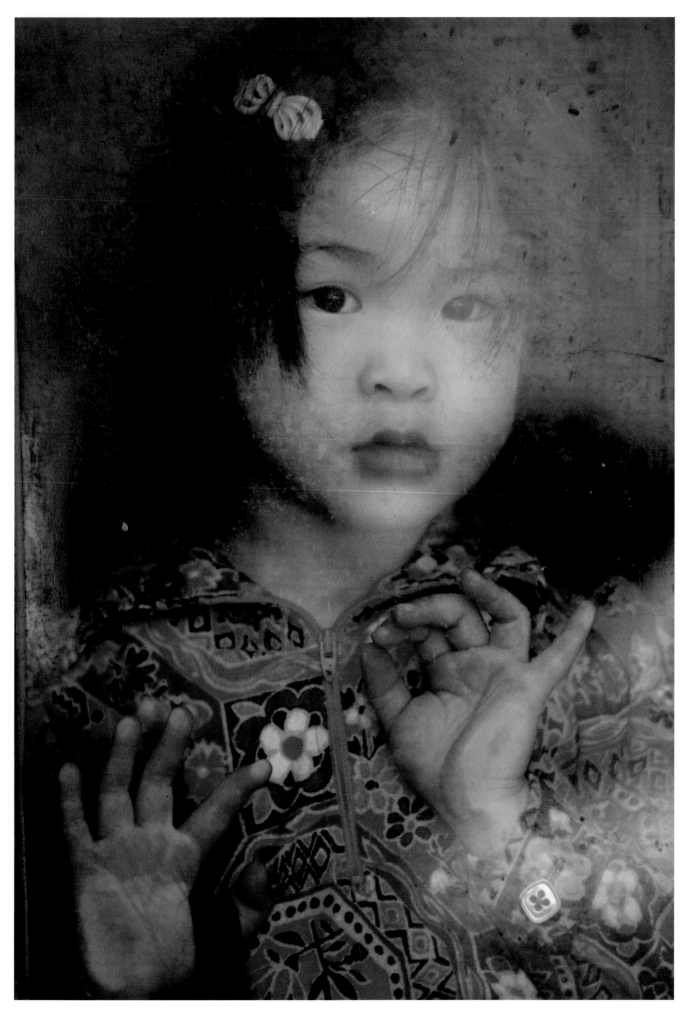

WILLIAM ALBERT ALLARD | 1975 | CALIFORNIA *Chinatown beauty*

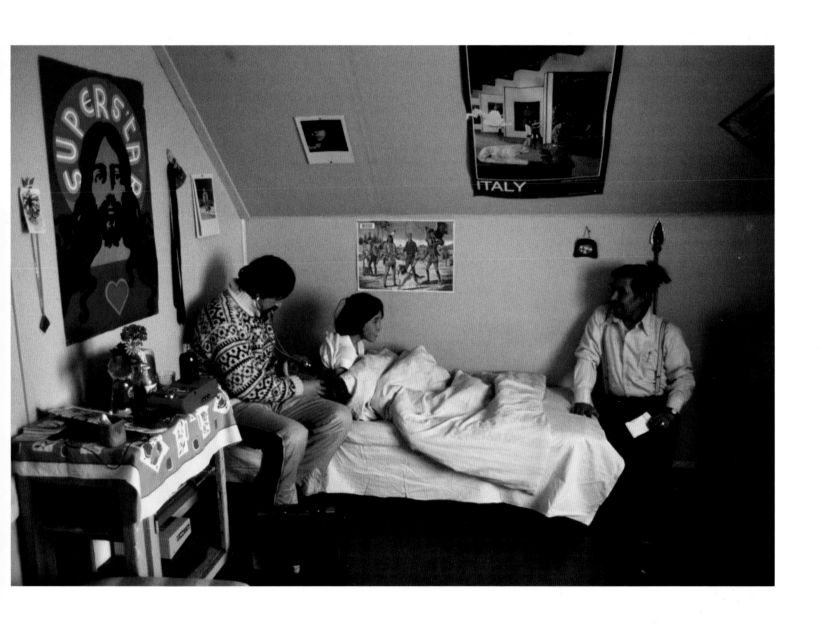

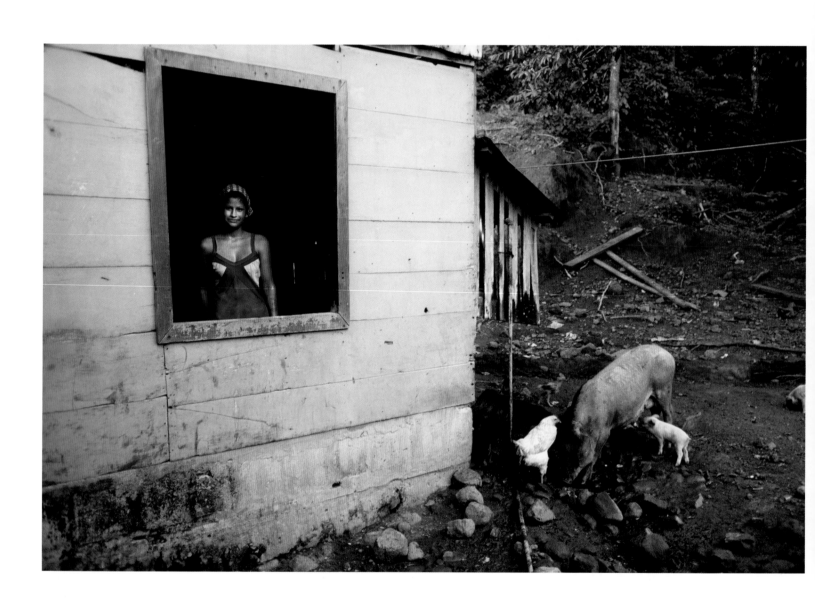

WILLIAM ALBERT ALLARD | 1981 | COSTA RICA *A hardscrabble life*

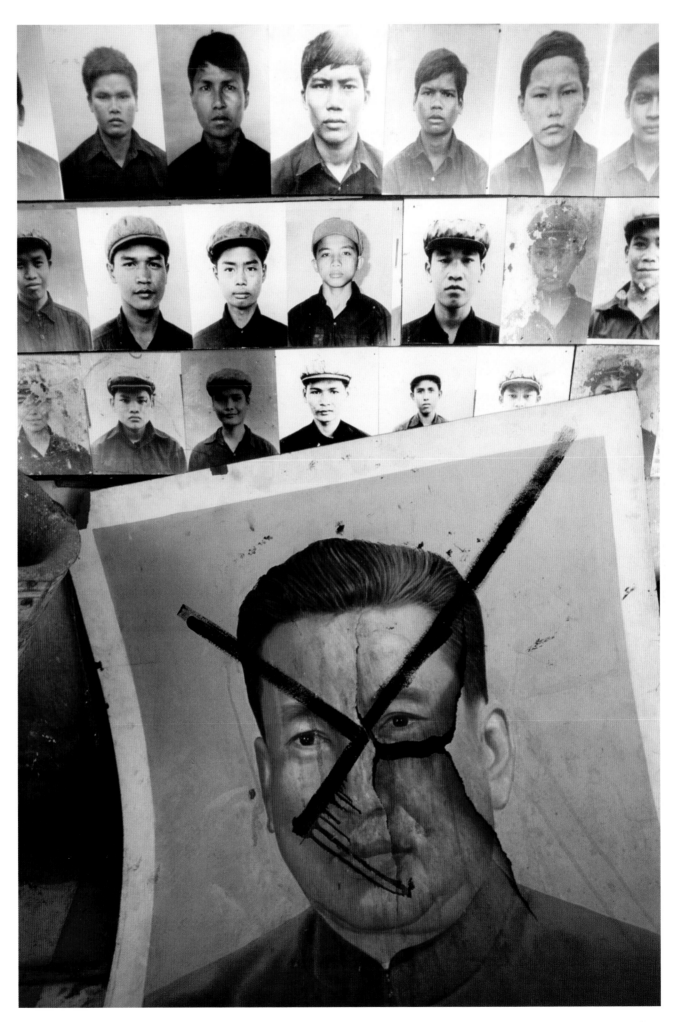

DAVID ALAN HARVEY | 1981 | CAMBODIA *Kids become killers: Pol Pot and Khmer Rouge executioners*

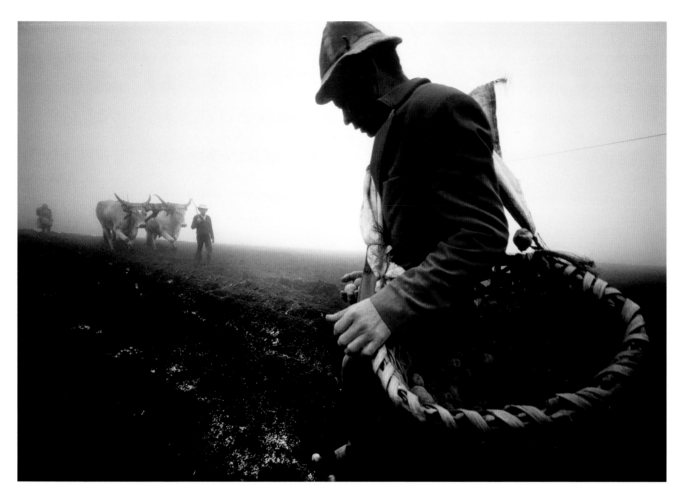

NICHOLAS DEVORE III | 1981 | COSTA RICA *Planting potatoes*

JAMES L. STANFIELD | 1983 | ROMANIA *A mural of the fall of Constantinople to the Turks*

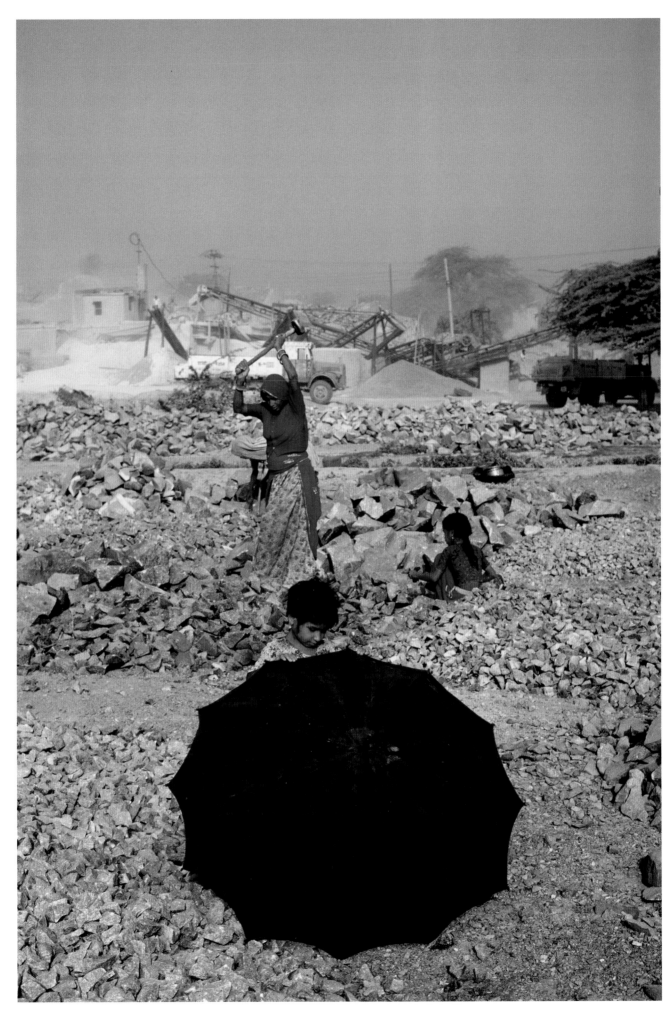

RAGHUBIR SINGH | 1985 | INDIA *The Untouchables* Documentary Realism | 303

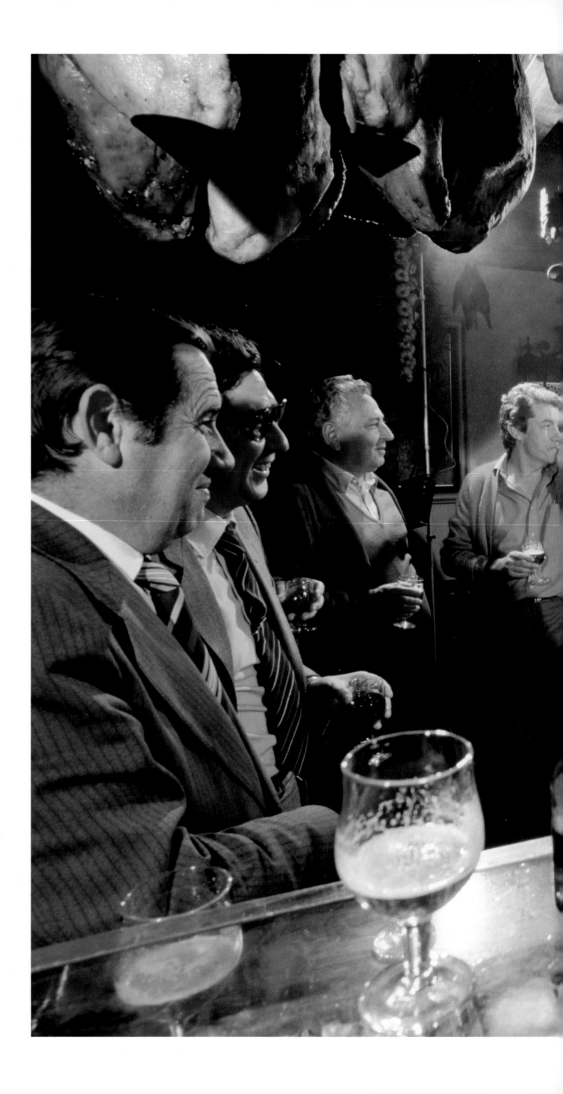

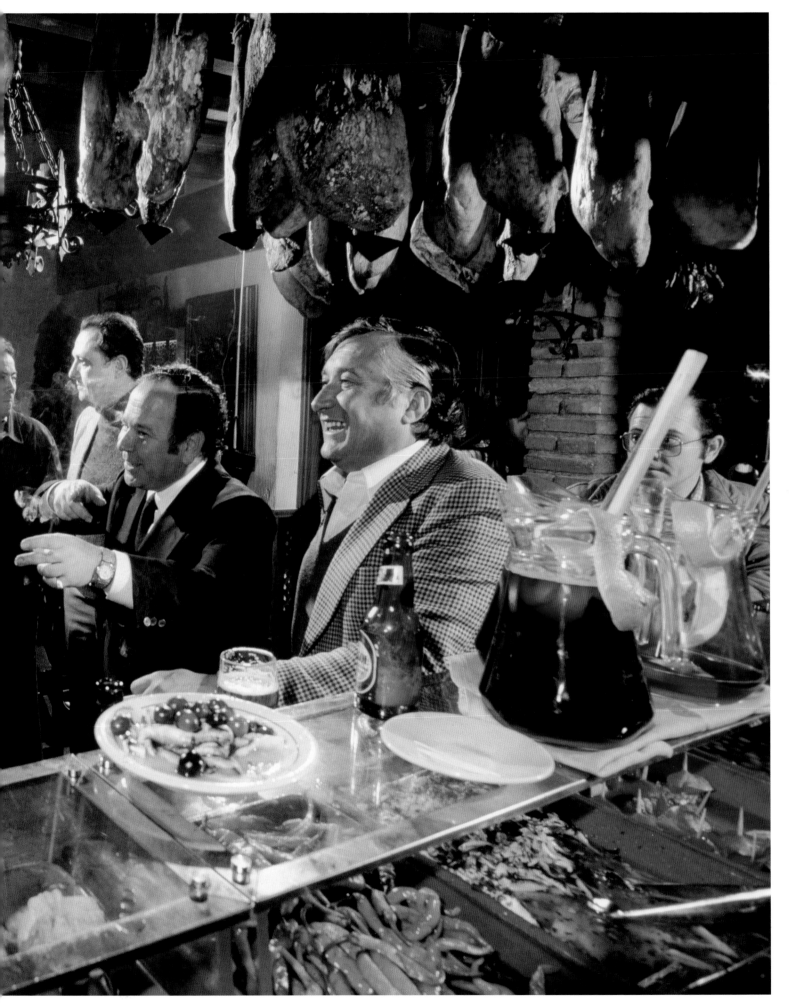

JAMES P. BLAIR | 1982 | SPAIN *Tapas time, magic hour in Toledo*

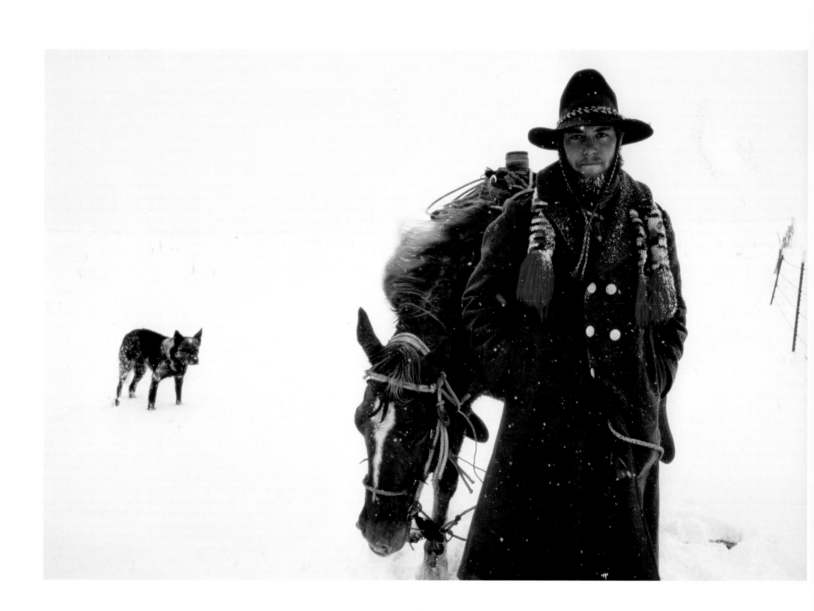

SAM ABELL | 1984 | MONTANA *Portrait of a horse wrangler*

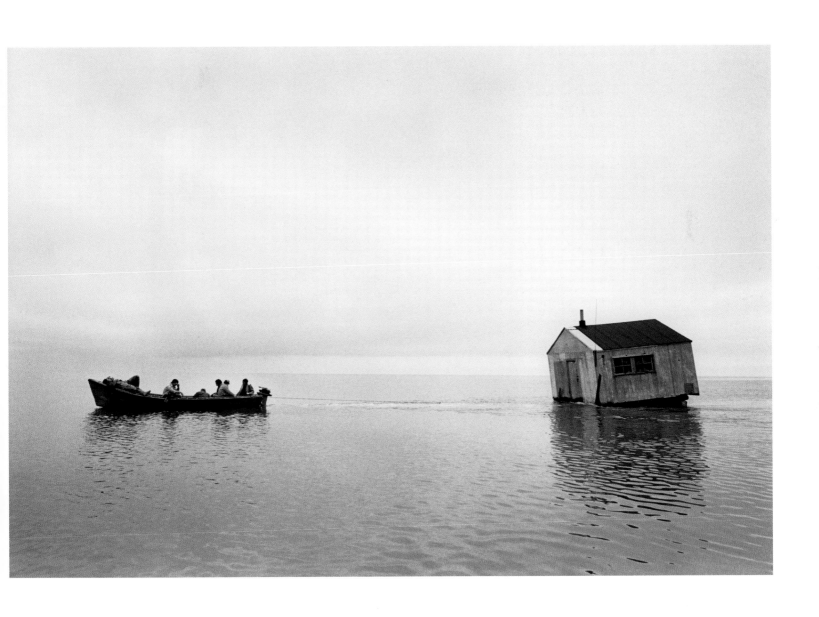

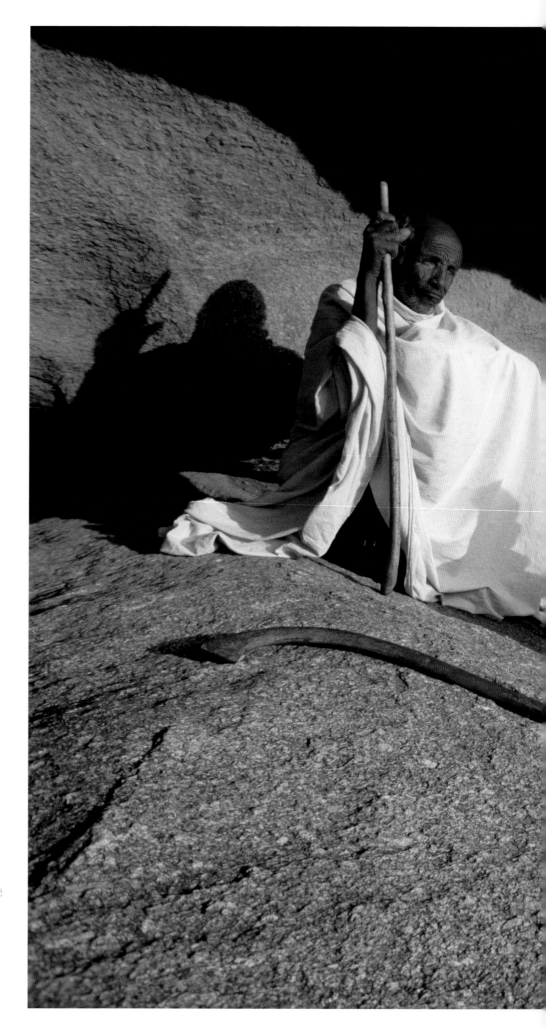

The contribution of elders to societies worldwide lies ultimately in how they practice "the art of being," according to anthropologist Colin Turnbull. "No special skill or training is needed; their age is their qualification."

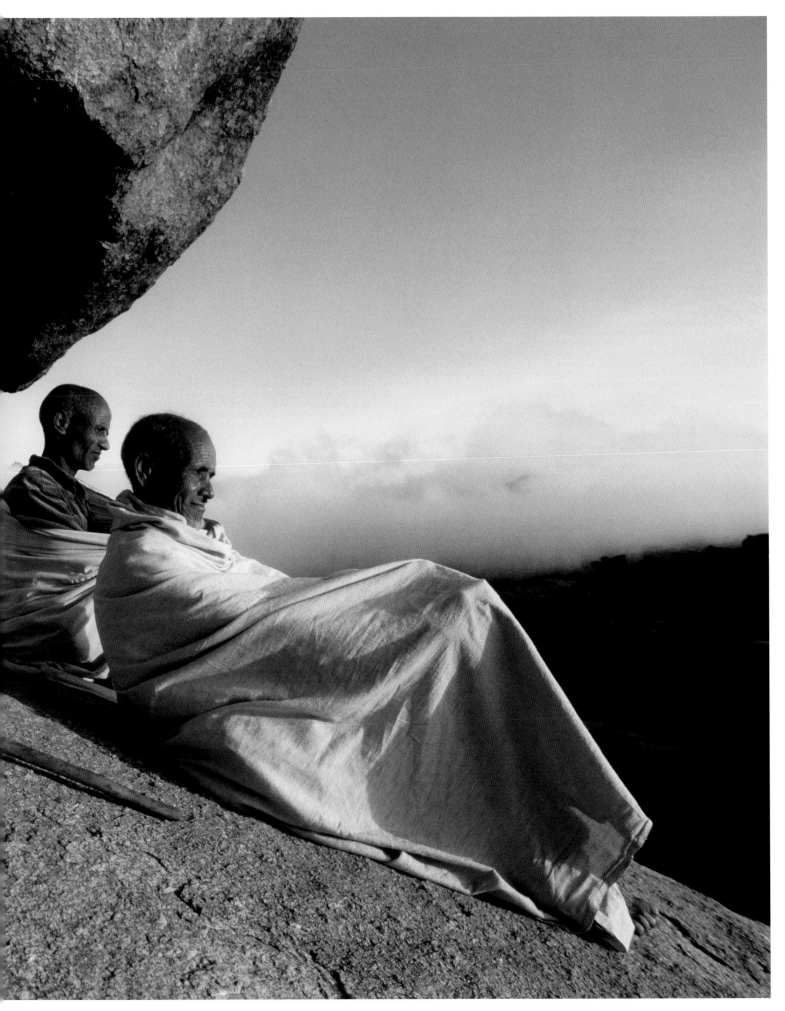

ROBERT CAPUTO | 1996 | ERITREA *Village elders at sunset*

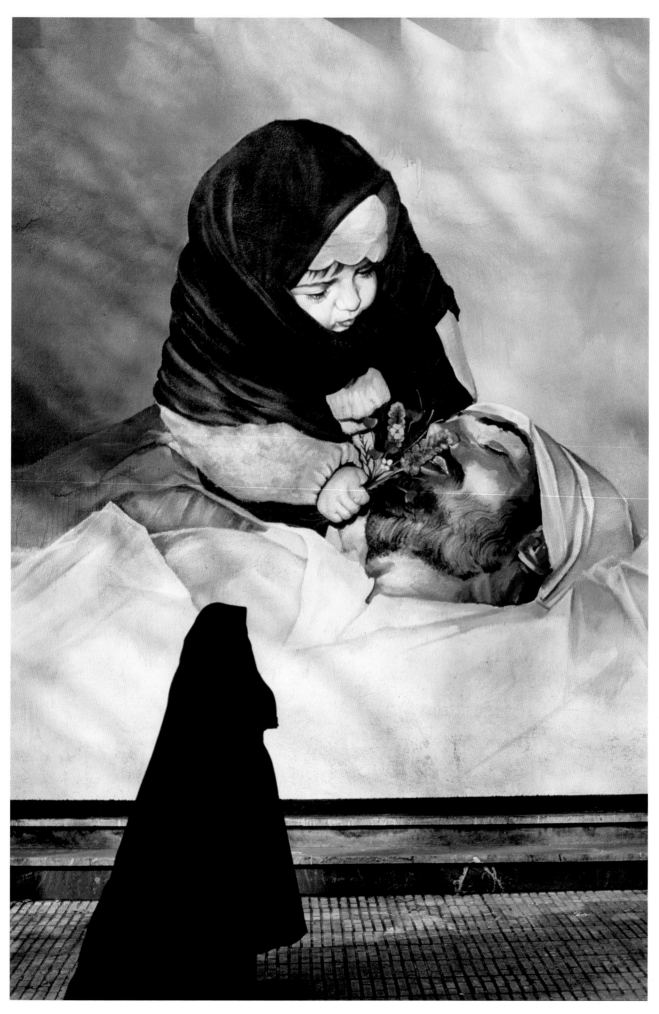

MICHAEL COYNE | 1983 | IRAN *Casualties of war*

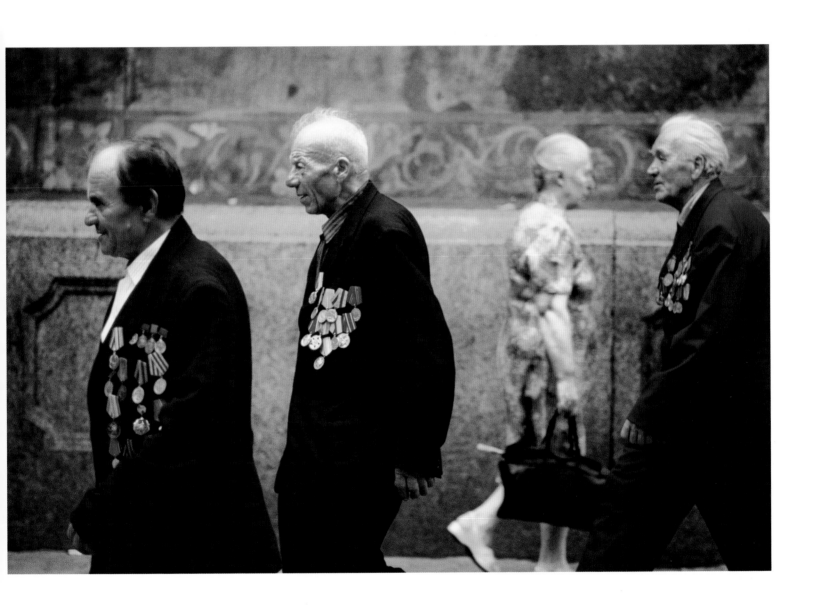

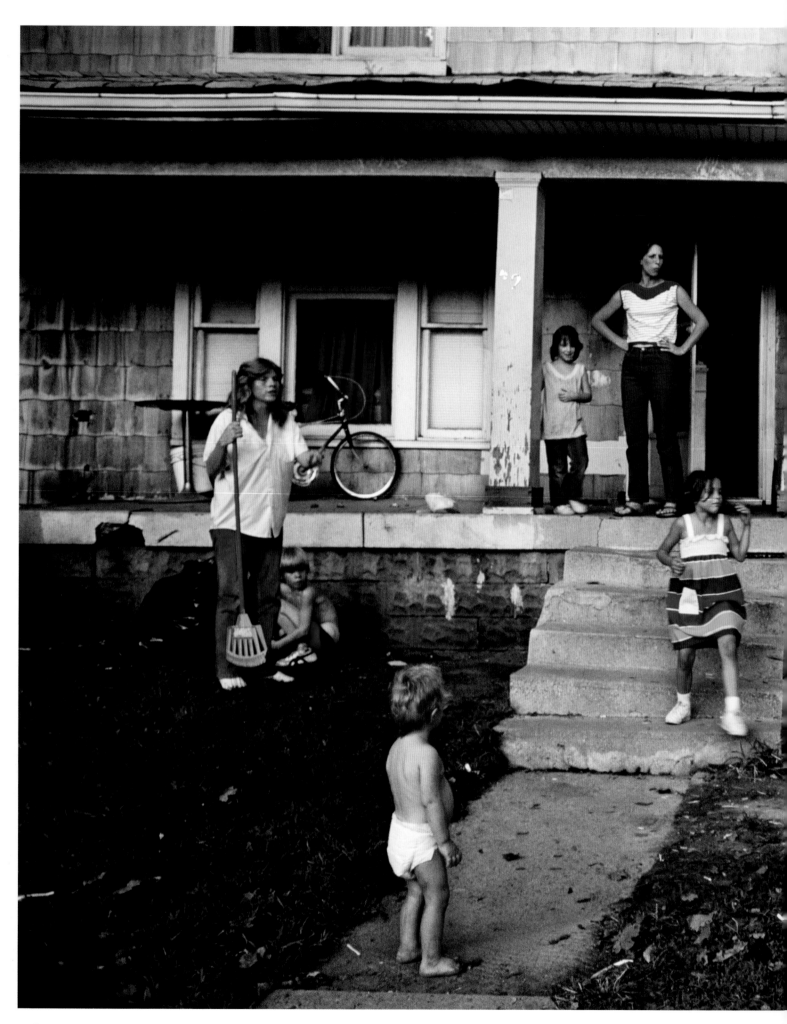

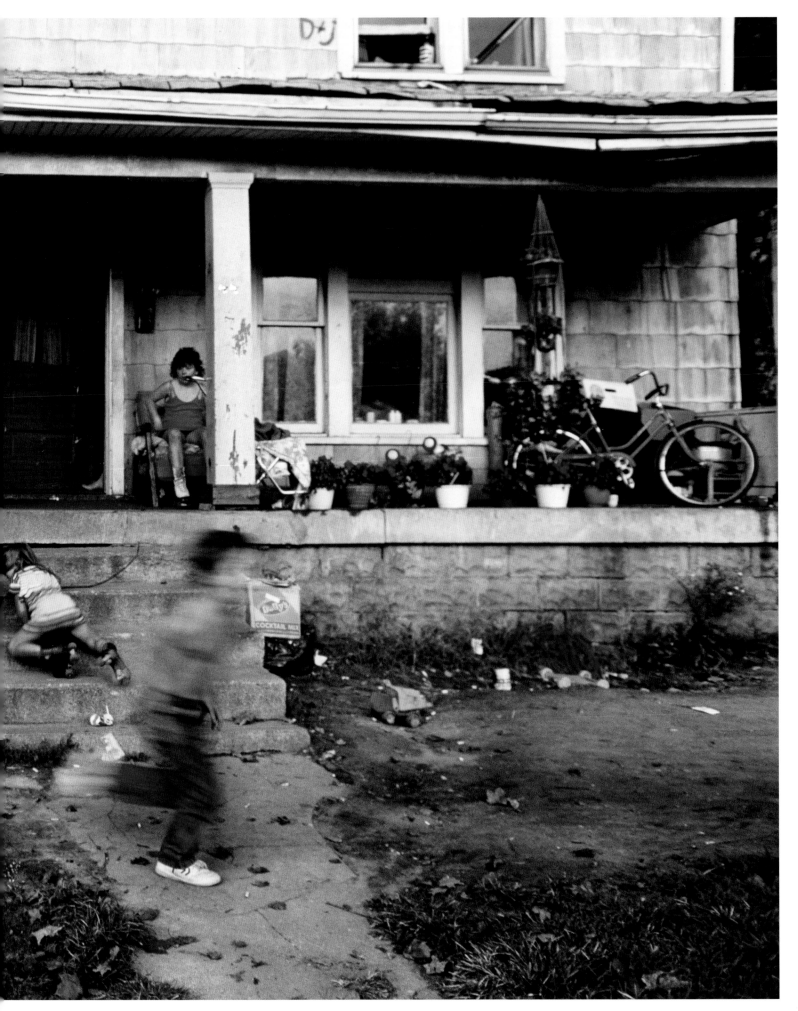

SANDY FELSENTHAL | 1987 | INDIANA *Sweet bird of youth* Documentary Realism | 313

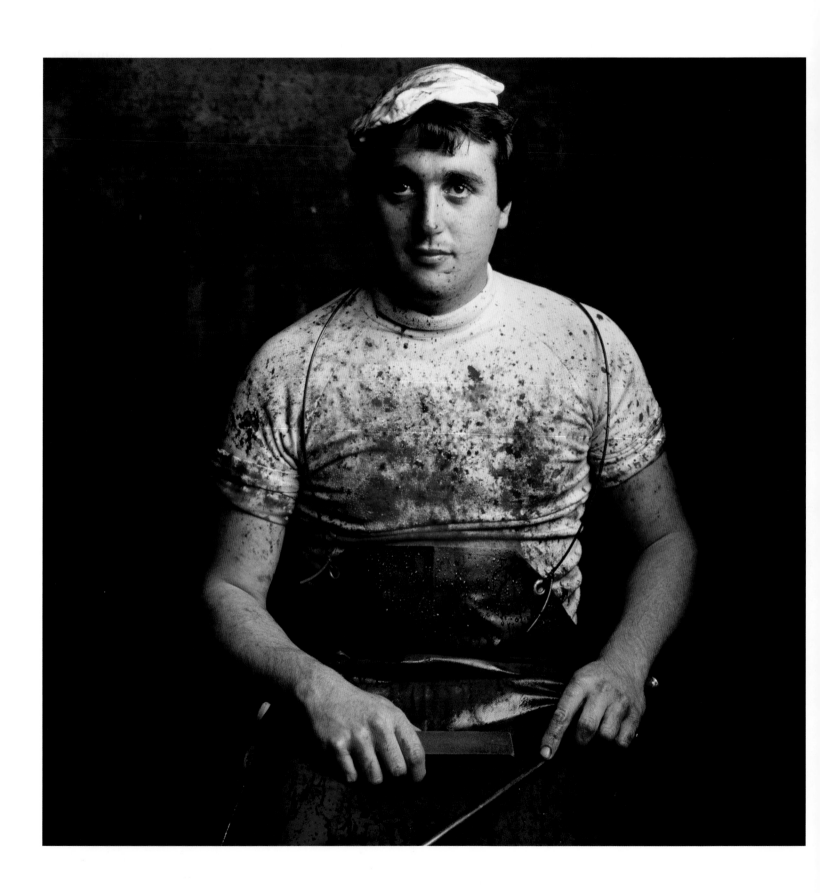

MICHAEL O'BRIEN | 1988 | AUSTRALIA *Portrait of the butcher as a young man*

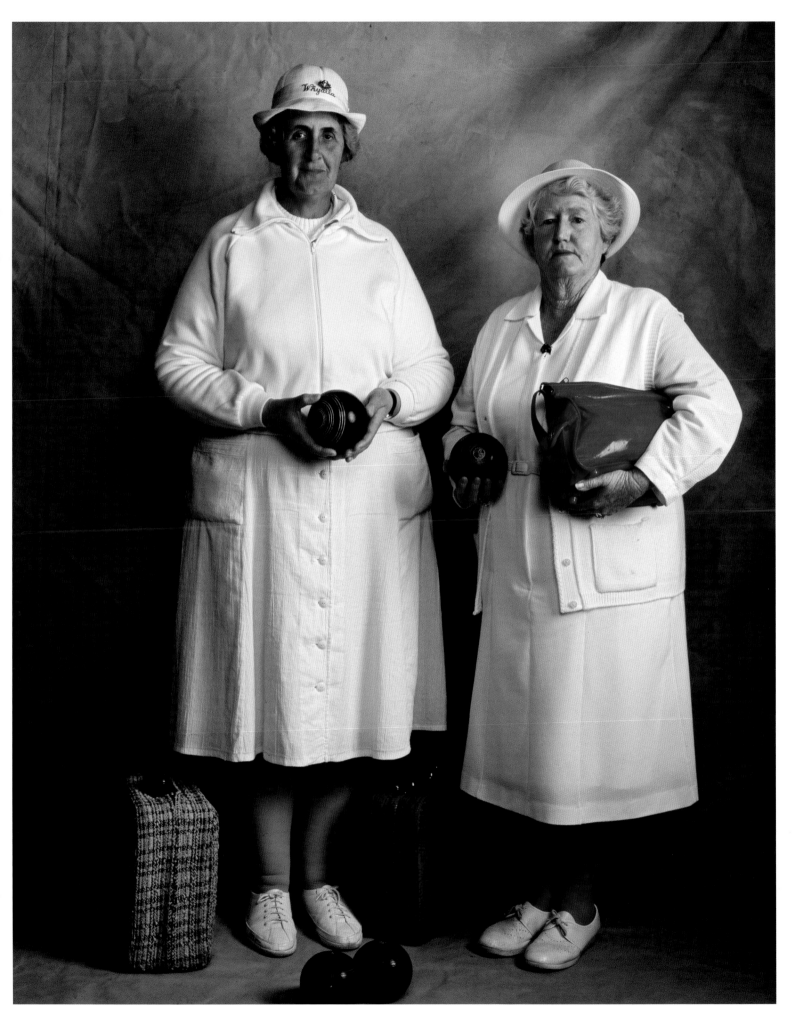

MICHAEL O'BRIEN | 1988 | AUSTRALIA *Lawn bowlers*

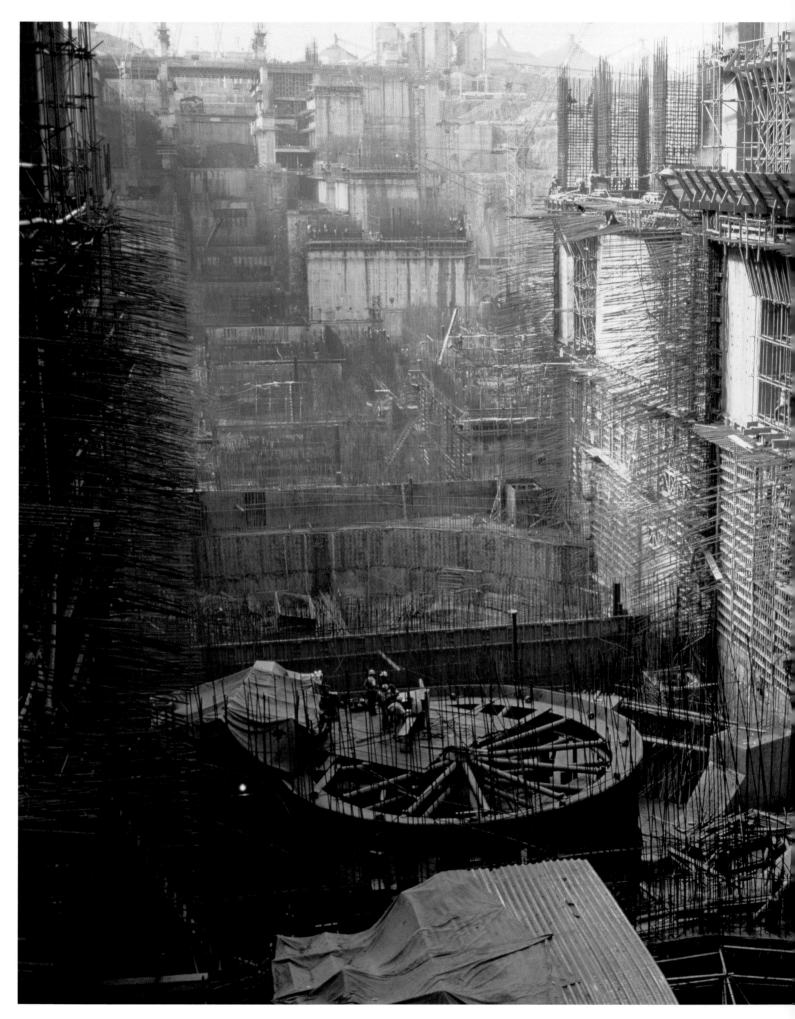

O. LOUIS MAZZATENTA | 1982 | PARAGUAY *Erecting the Itaipú Dam*

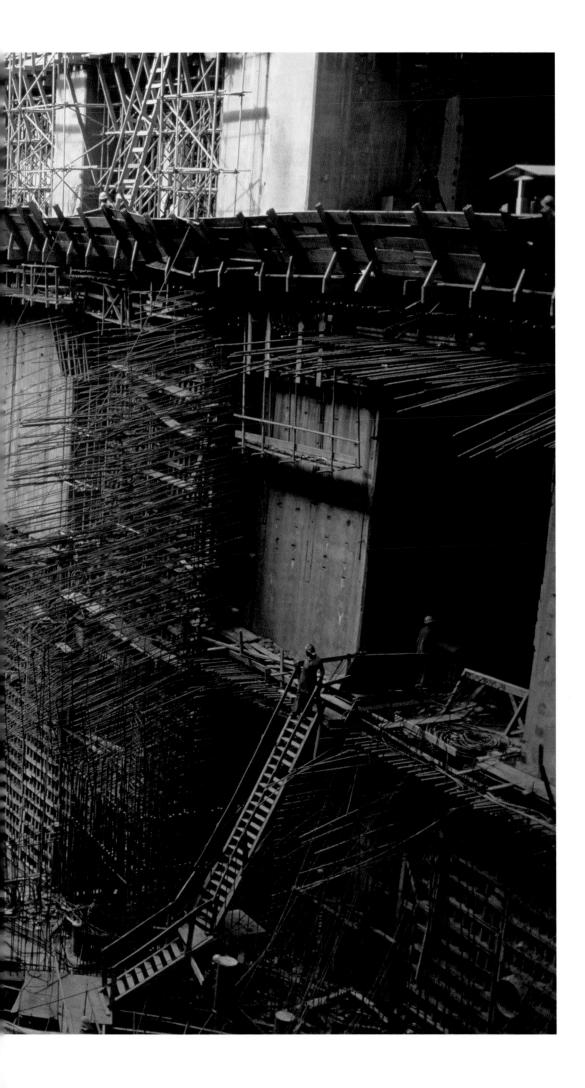

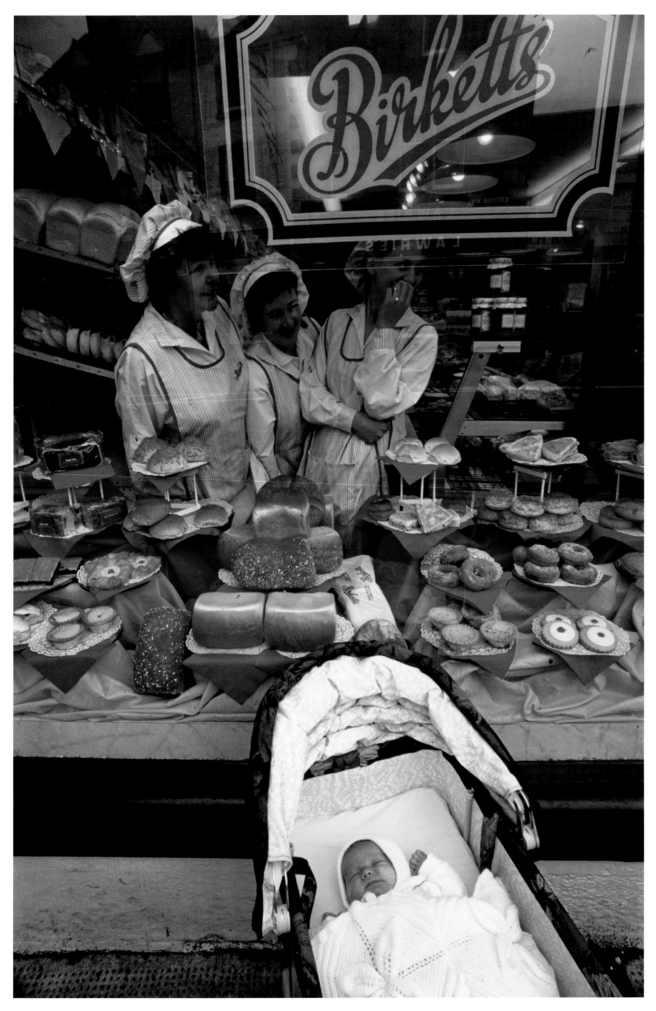

JIM RICHARDSON | 1996 | SCOTLAND *Sweets for the sweet*

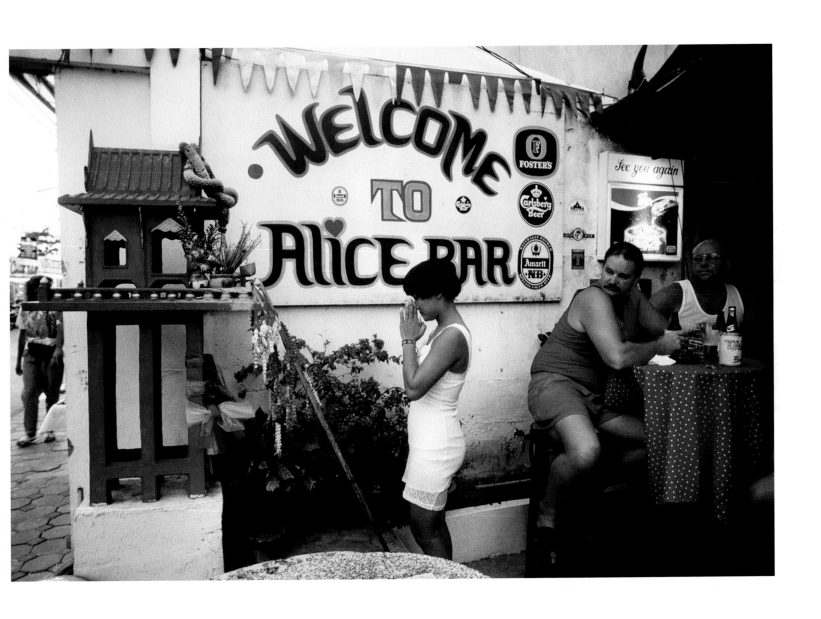

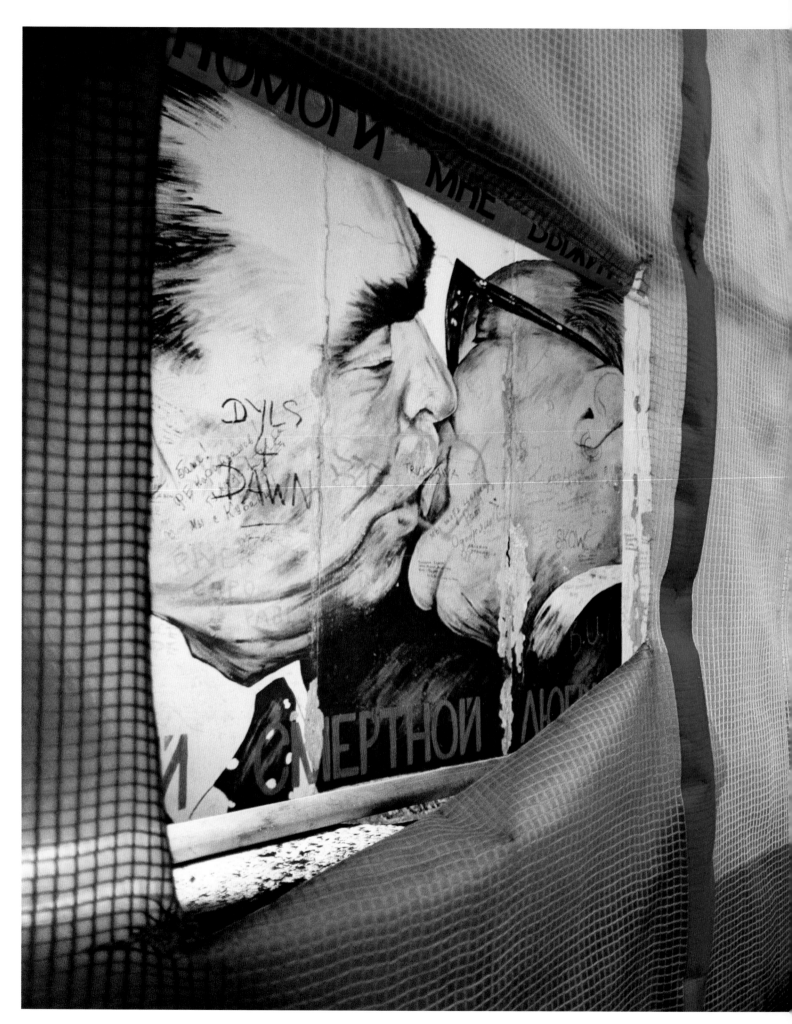

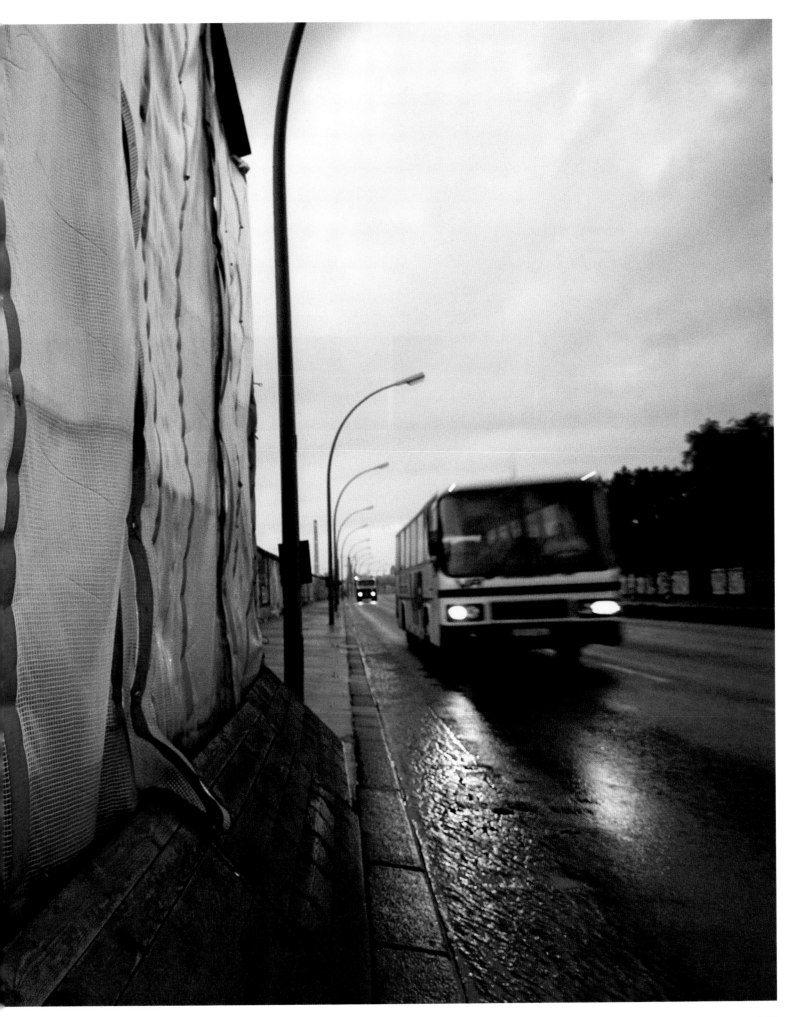

GERD LUDWIG | 1996 | GERMANY *Strange bedfellows* Documentary Realism | 321

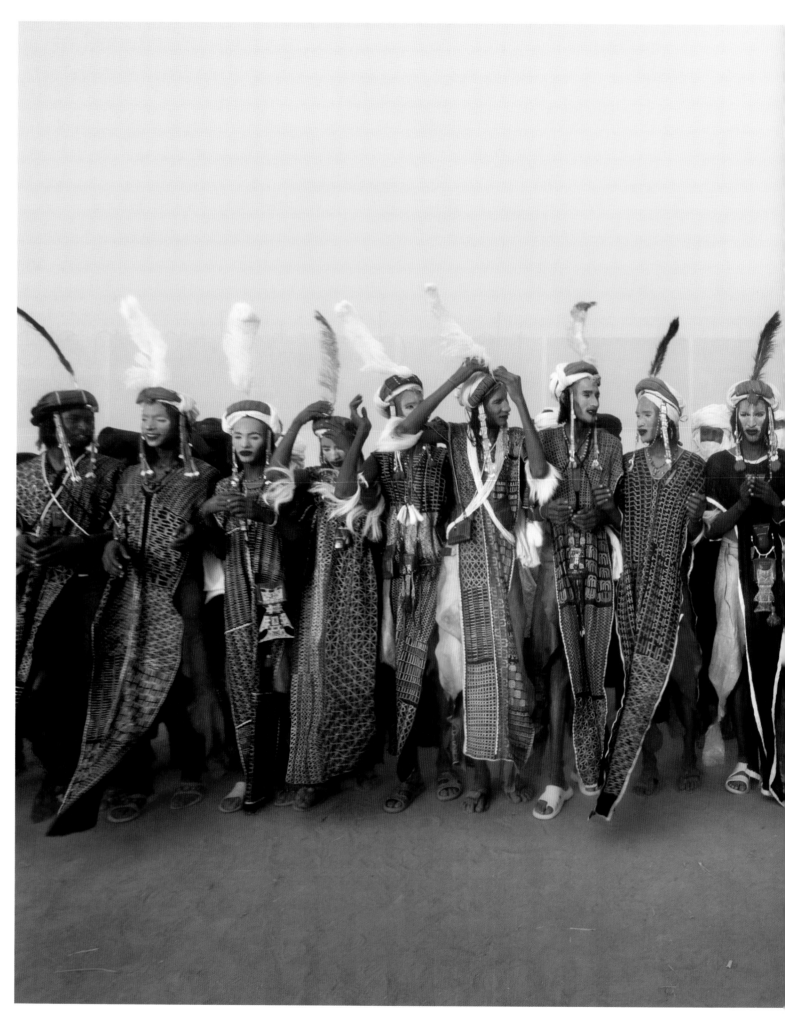

MIKE HETTWER **|** 2008 **|** NIGER *Wodaabe men preening for the ladies*

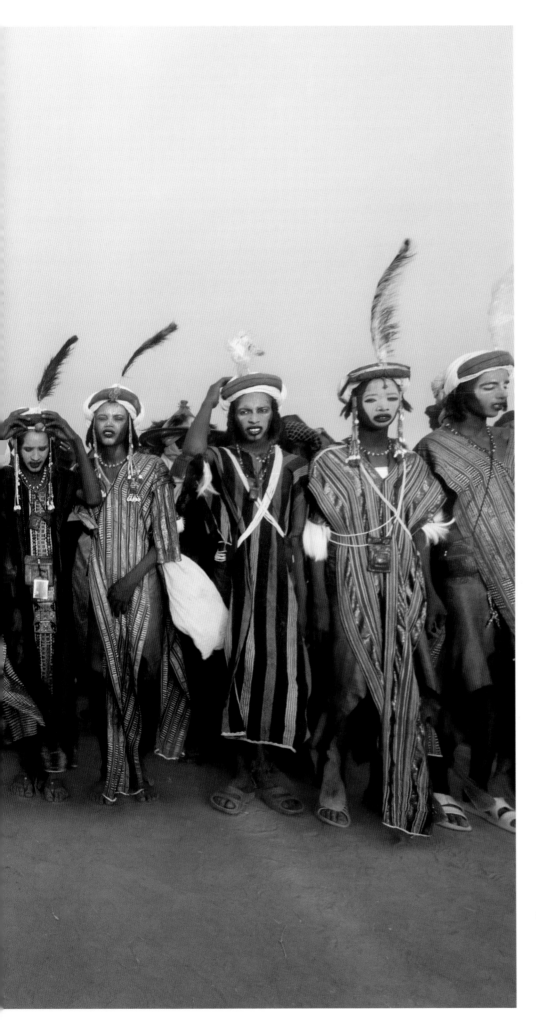

At festivals, Wodaabe men promenade before admiring women who scrutinize their every move. According to anthropologists Carol Beckwith and Angela Fisher, "a man who can hold one eye still and roll the other is considered particularly alluring…"

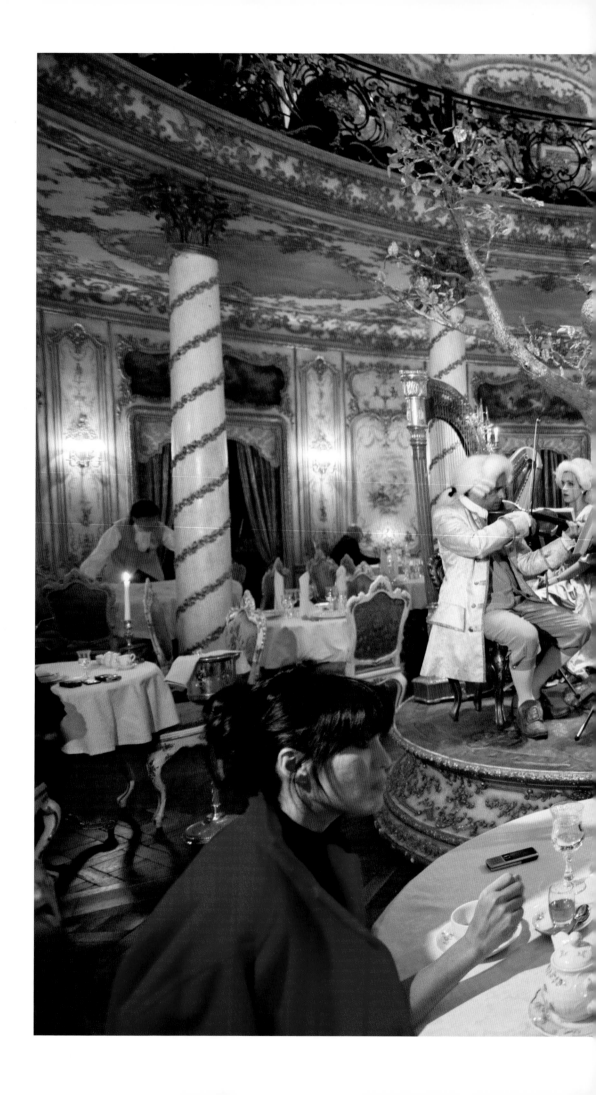

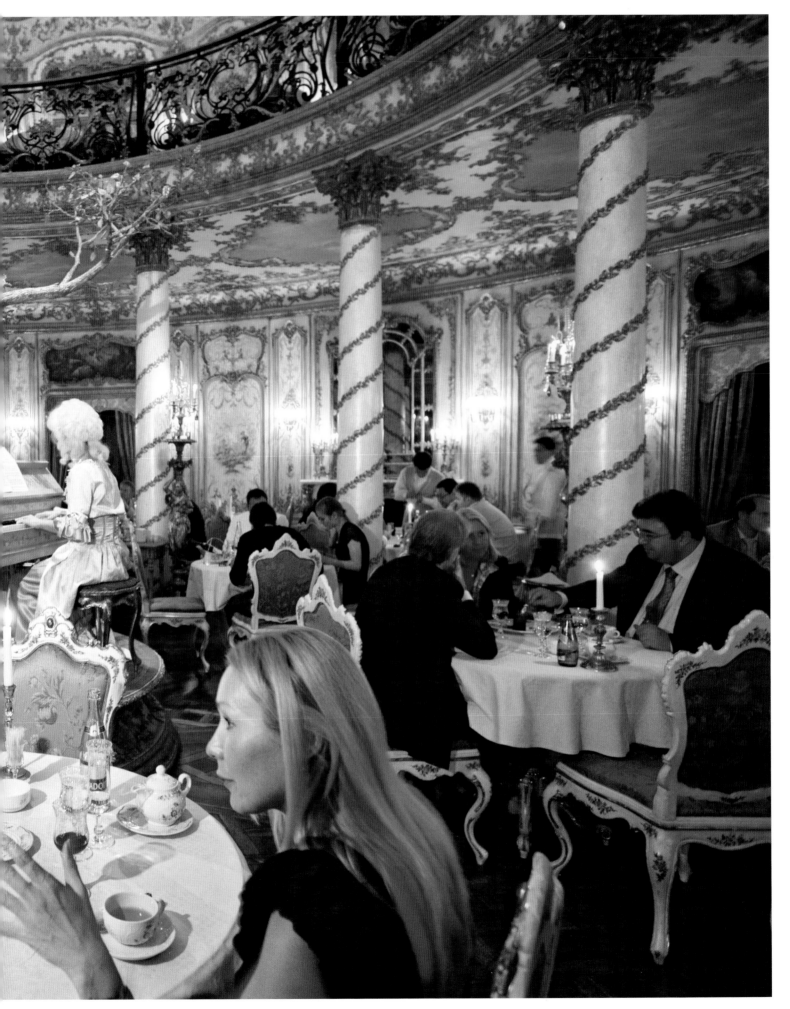

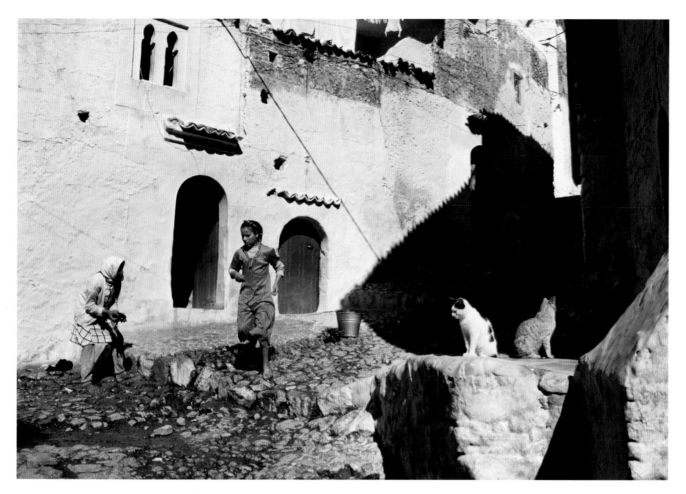

BRUNO BARBEY | 1998 | MOROCCO *In the Rif Mountains*

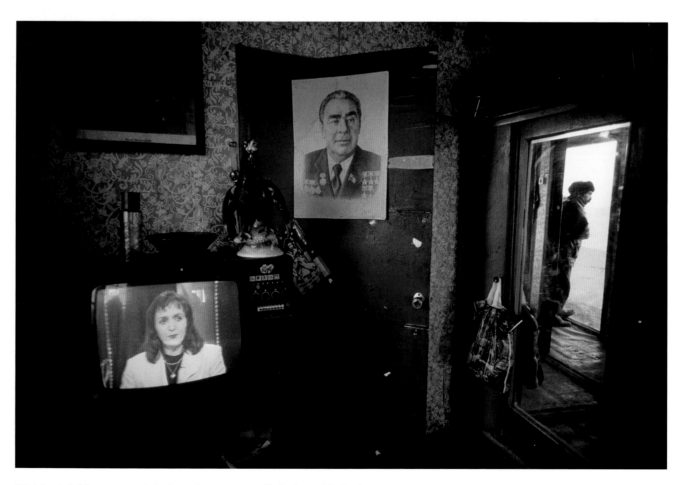

REZA | 1999 | KAZAKHSTAN *On the shores of the Caspian*

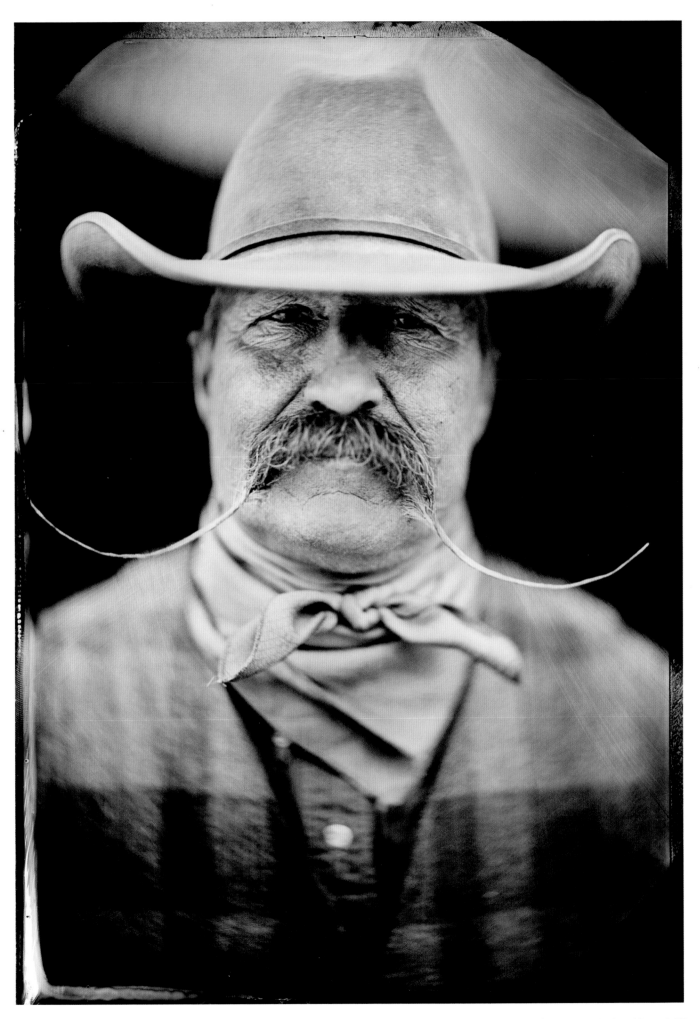

ROBB KENDRICK | 2007 | UTAH *A modern tintype of an old-fashioned cowboy*

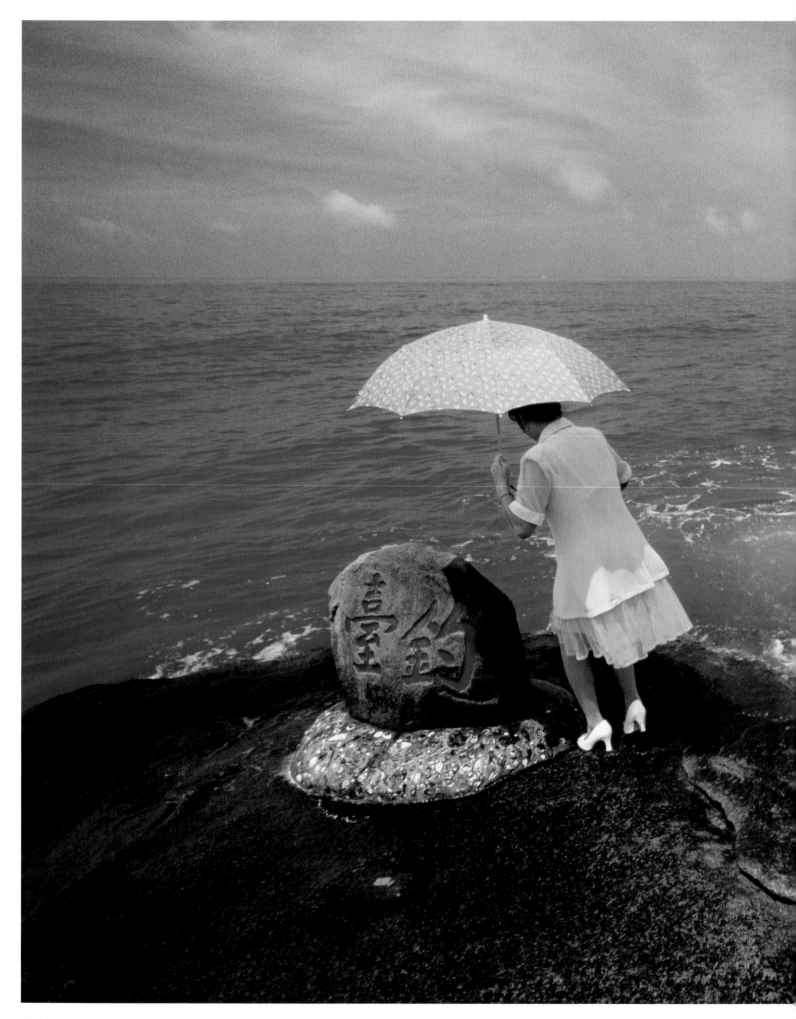

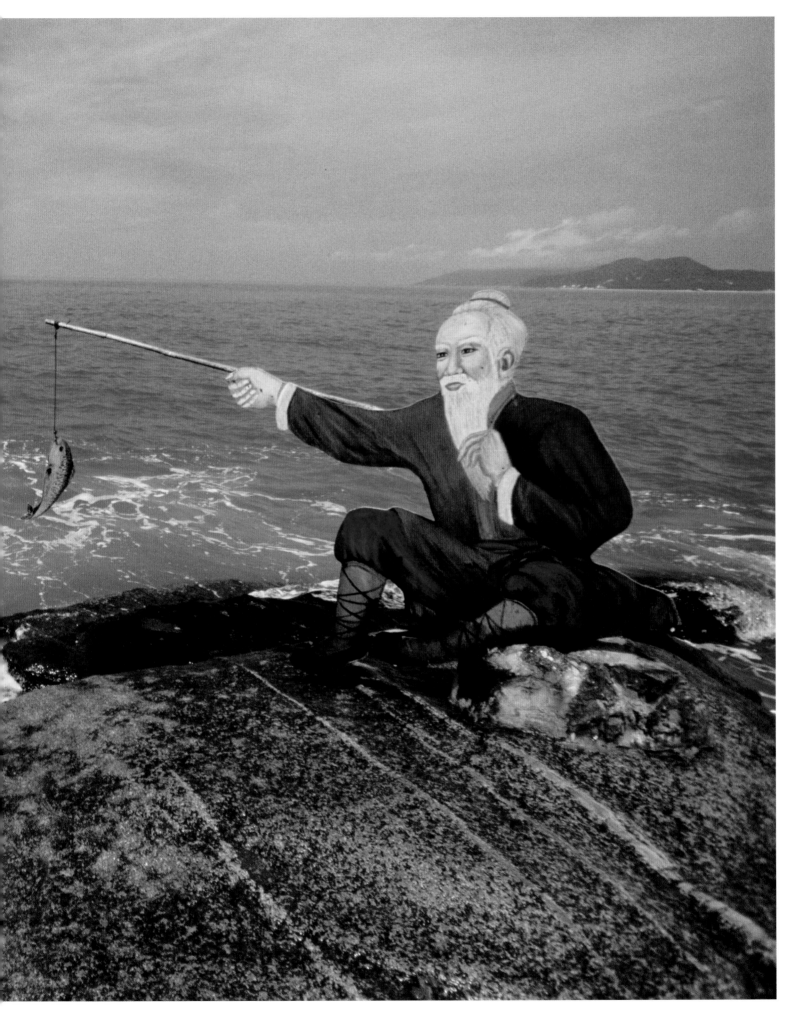

KAREN KASMAUSKI | 1998 | UNKNOWN LOCATION *Study in blue*

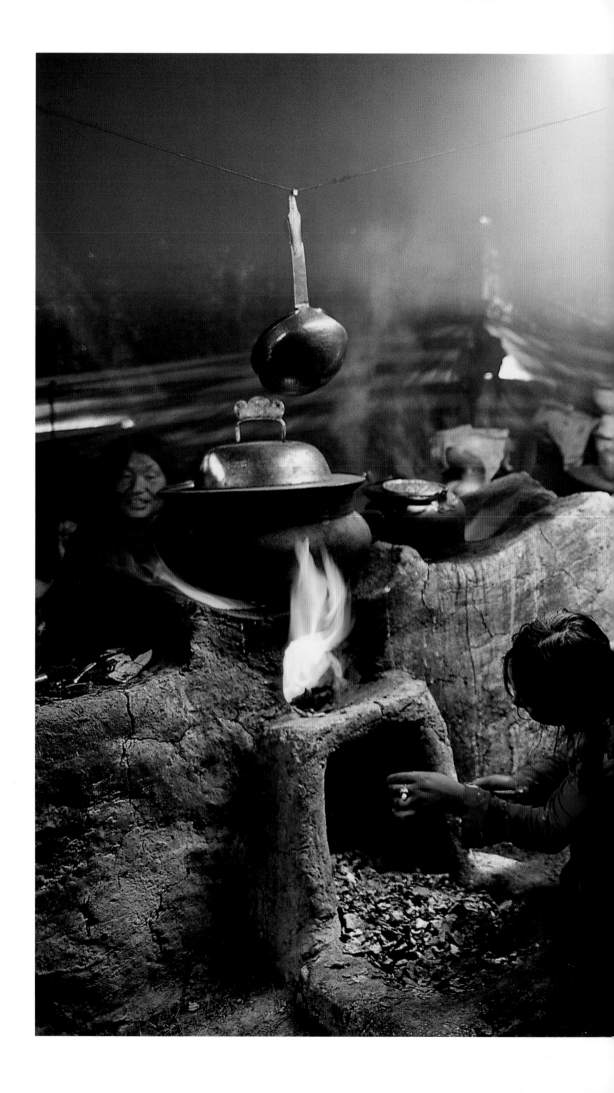

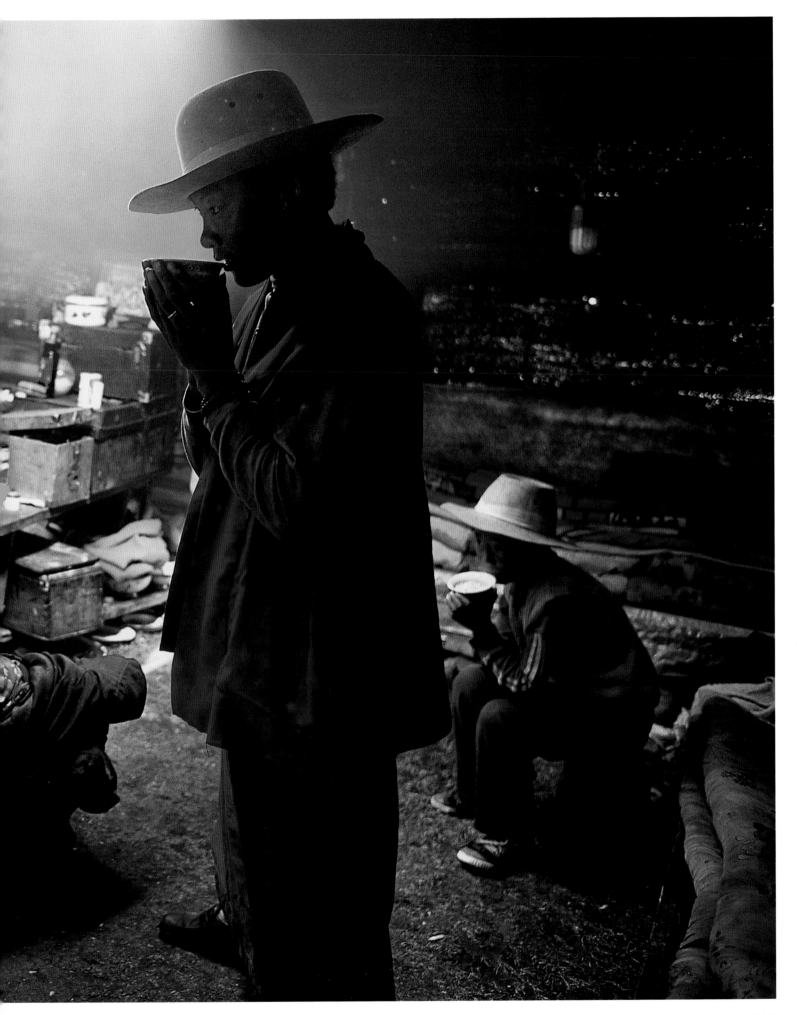

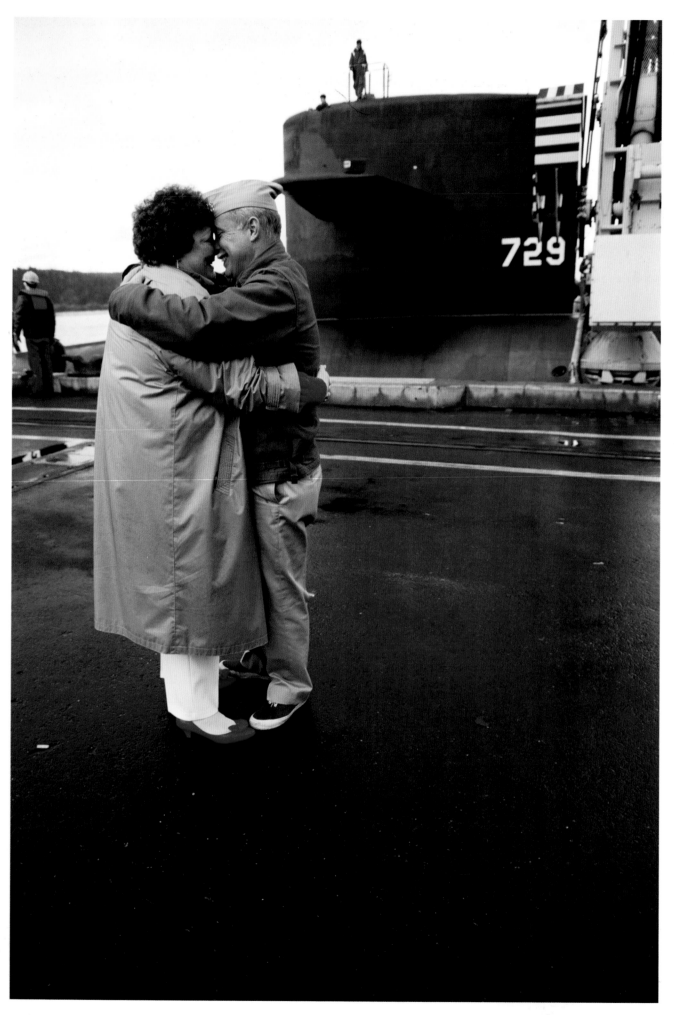

SANDY FELSENTHAL | 2001 | MAINE *Home is the sailor*

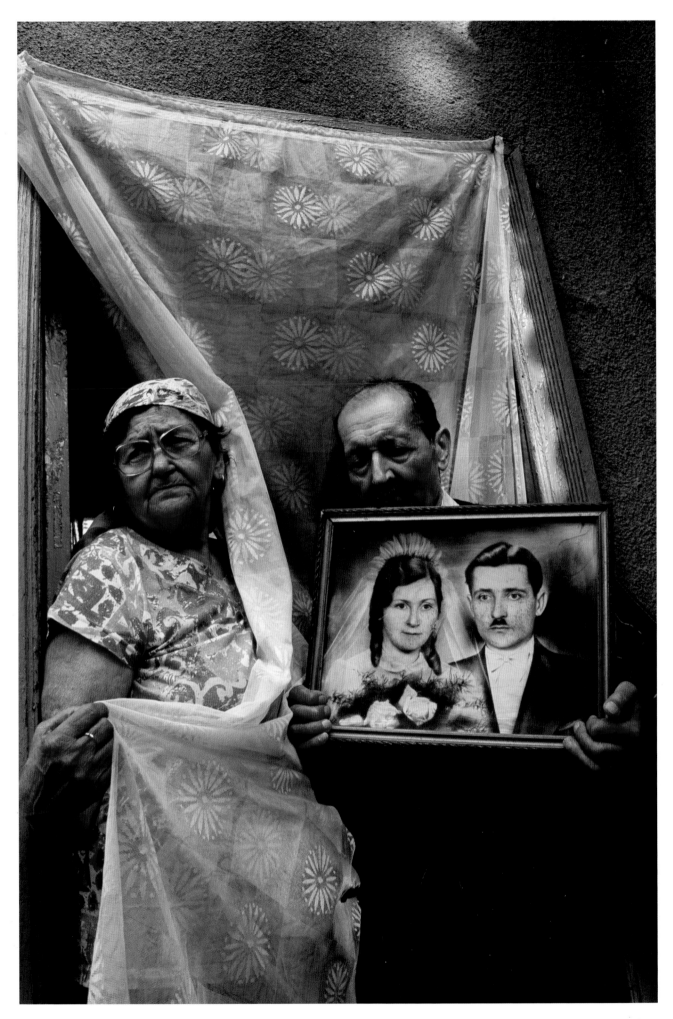

TOMASZ TOMASZEWSKI | 2001 | EASTERN EUROPE *A reminiscing gypsy and his non-gypsy wife*

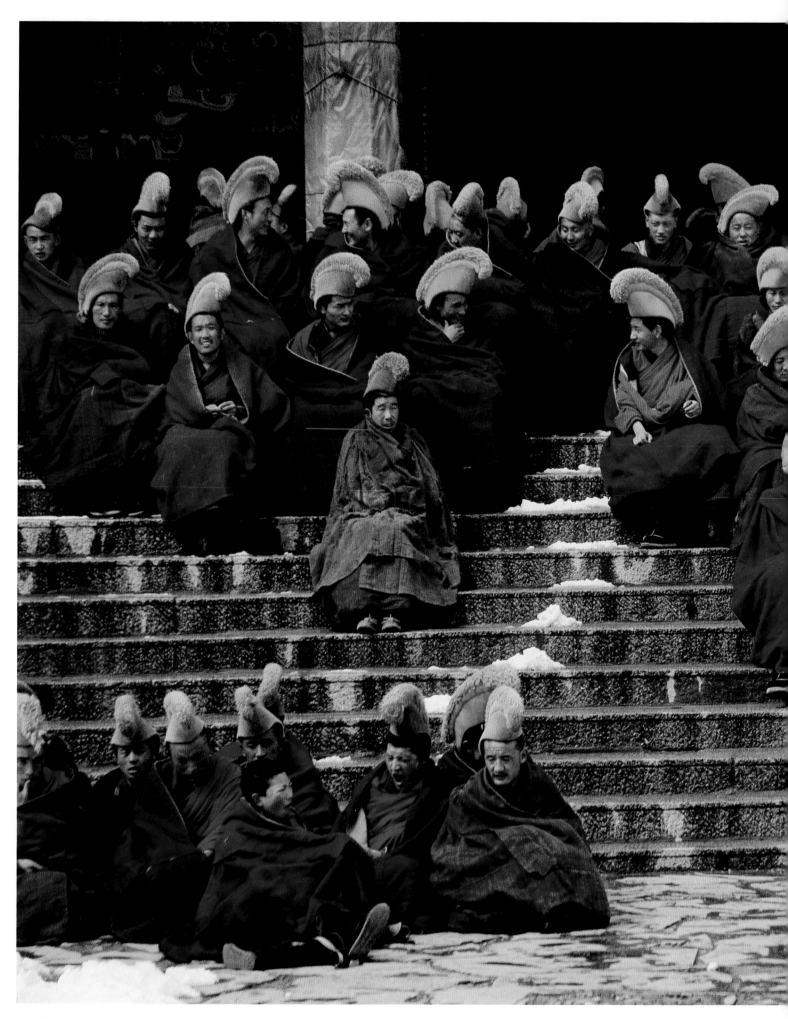

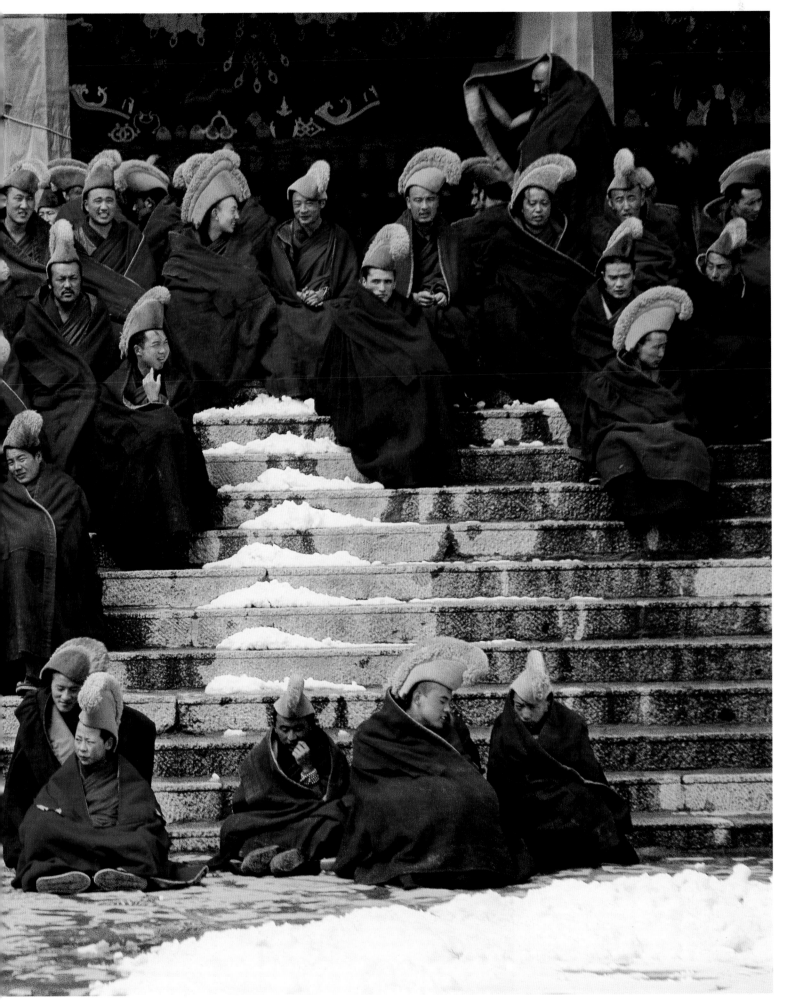

MICHAEL YAMASHITA | 2001 | CHINA *Awaiting morning prayer at Labrang monastery*

According to Nagasaki-born novelist Kazuo Ishiguro, "All children have to be deceived if they are to grow up without trauma."

LYNN JOHNSON **|** 2002 **|** RUSSIA *Teaching second graders how to prepare for a chemical attack*

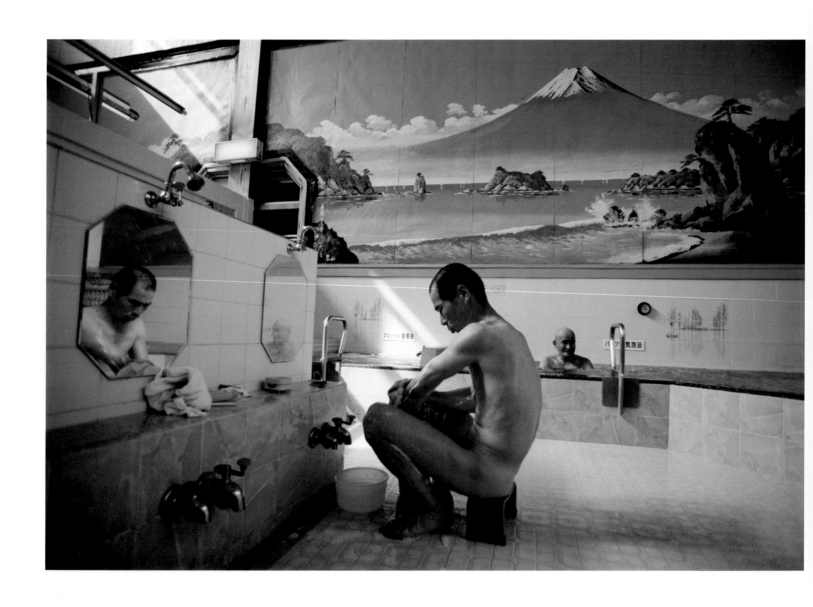

KAREN KASMAUSKI | 2002 | JAPAN *In a Tokyo bathhouse*

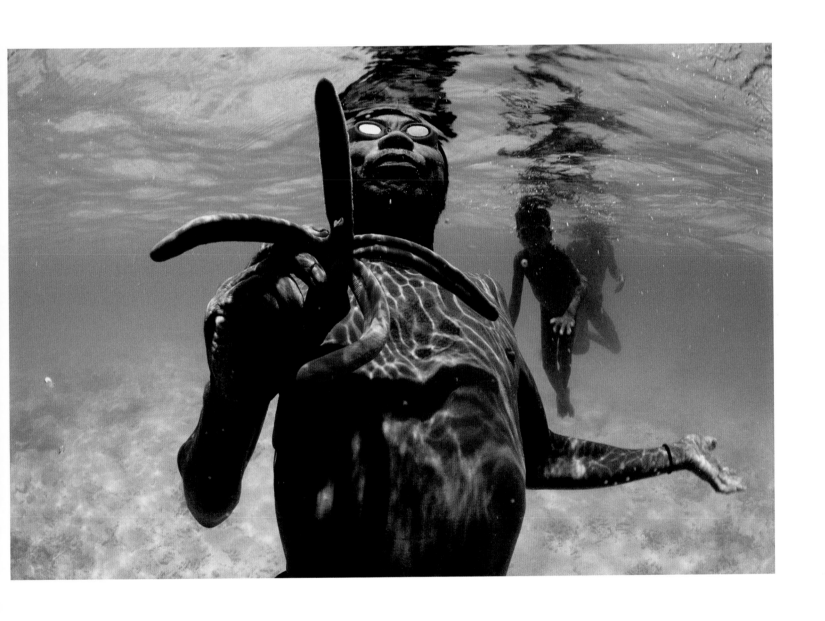

JOHN STANMEYER | 2005 | INDONESIA *As twilight falls*

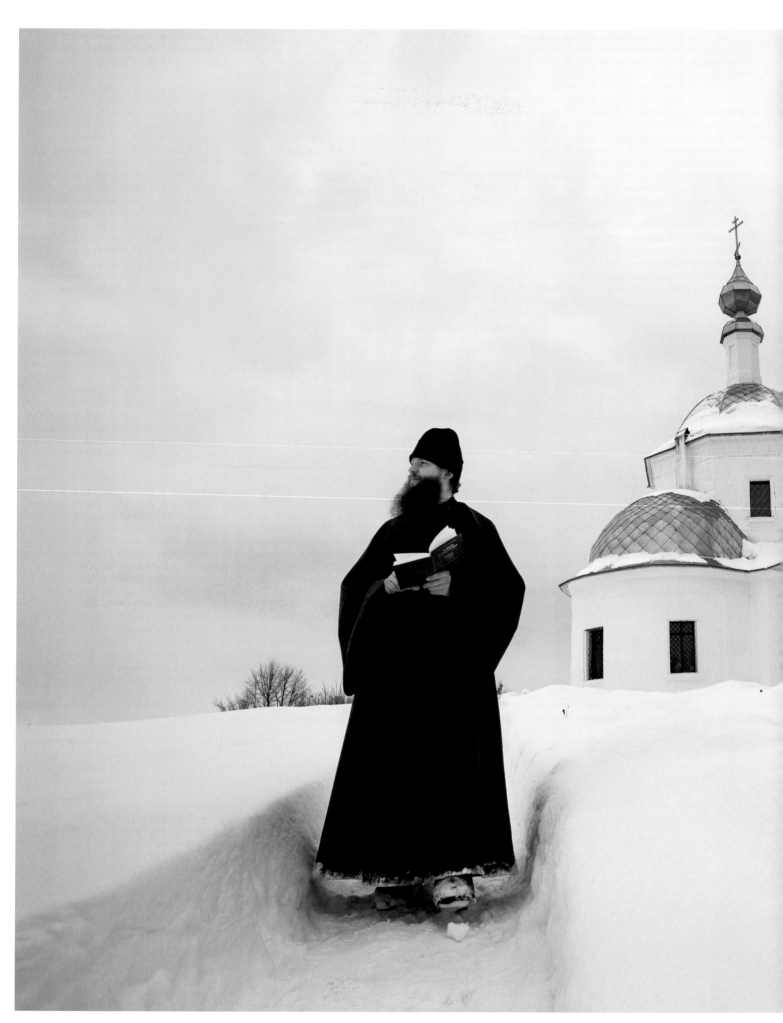

GERD LUDWIG | 2009 | RUSSIA *An Orthodox priest on a meditative stroll*

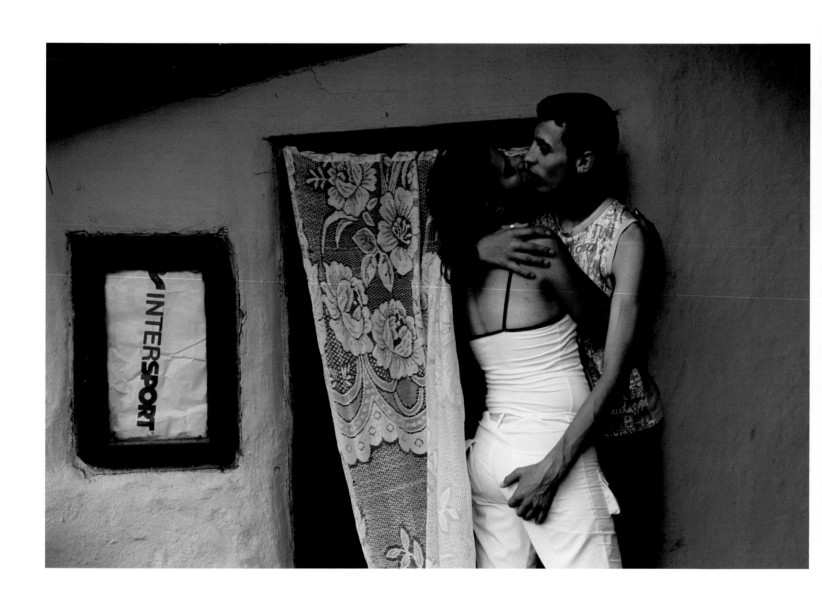

TOMASZ TOMASZEWSKI | 2005 | ROMANIA *Brief encounter*

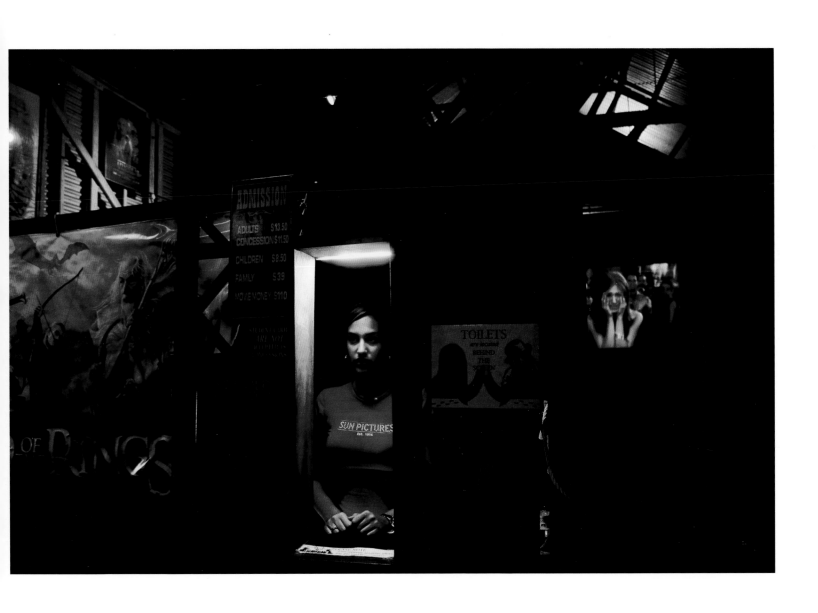

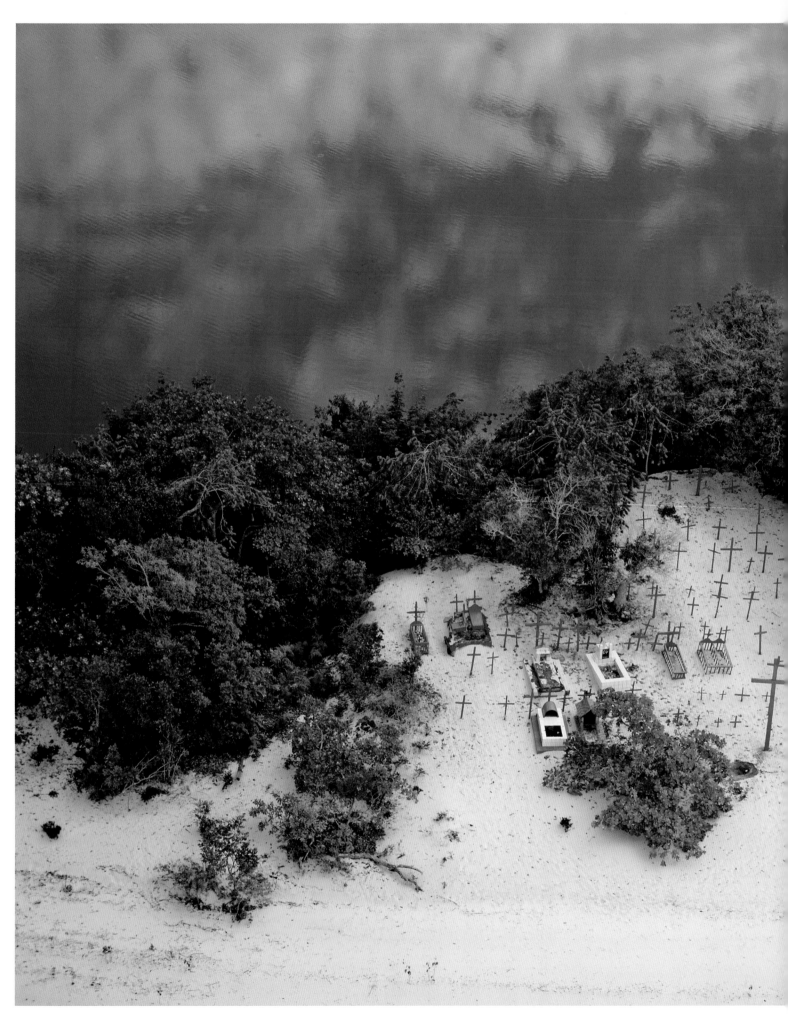

ROBERT HAAS | 2007 | BRAZIL *A beach cemetery beside the Rio Negro*

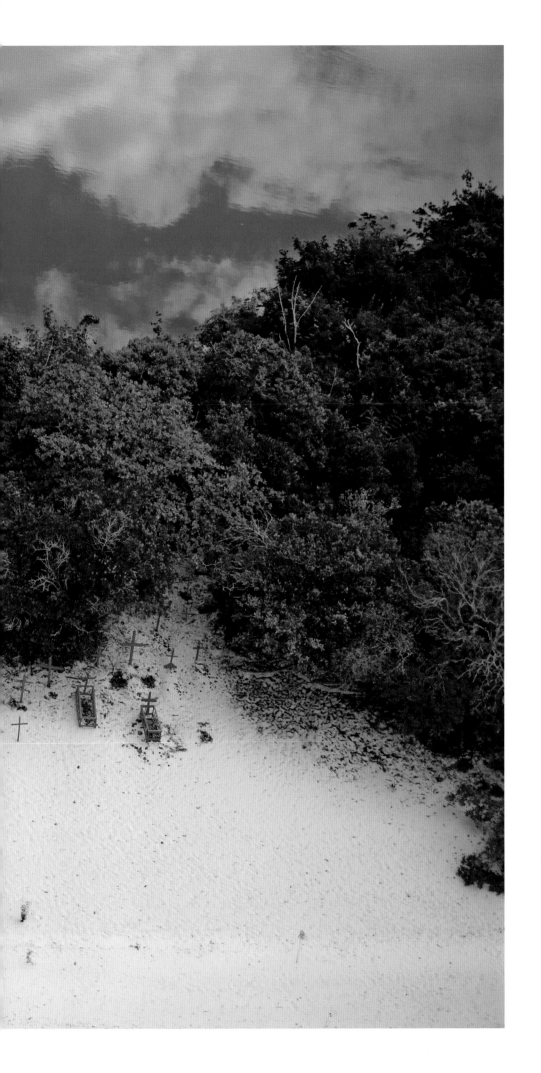

"I realized that it wasn't human history that had drawn Bobby to Latin America," observes writer Marie Arana of aerial photographer Bobby Haas. It was the wonder of the land— "its spectacle and grandeur, its too-often scarred face."

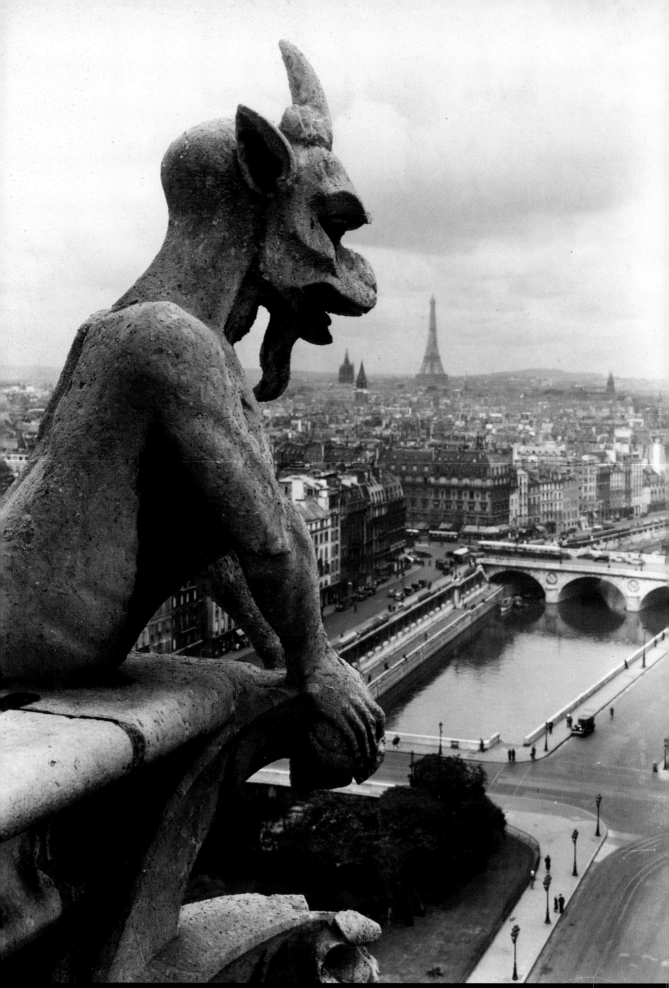

paris in black & white

WHAT IS IT ABOUT PARIS *ENTRE DEUX GUERRES*—between the wars—that makes every image of it so hauntingly evocative? Undoubtedly it has to do with that singular mélange of expatriates, writers, artists, and exiles that crowded its cafés. But just as surely it derives from the photographers who captured its nuanced black-and-white character so memorably.

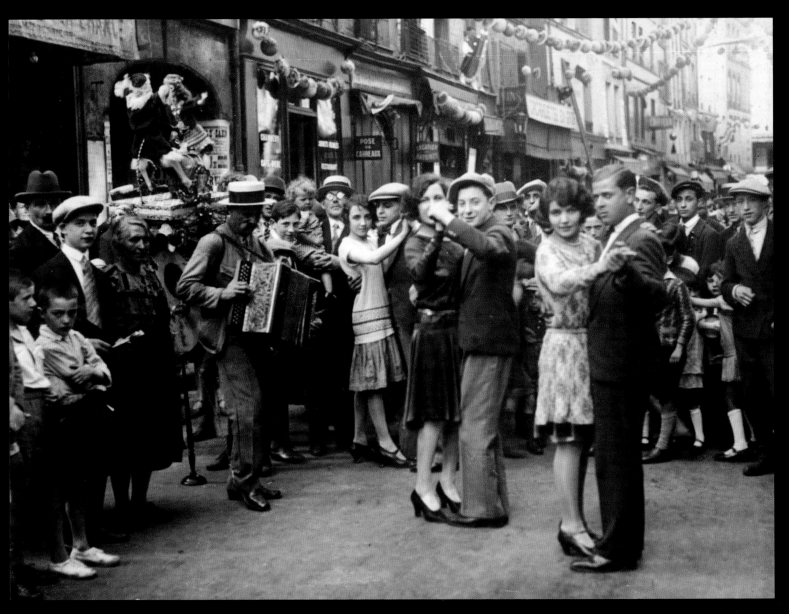

KEYSTONE VIEW CO | 1929 | PARIS *Cutting a caper on Bastille Day*

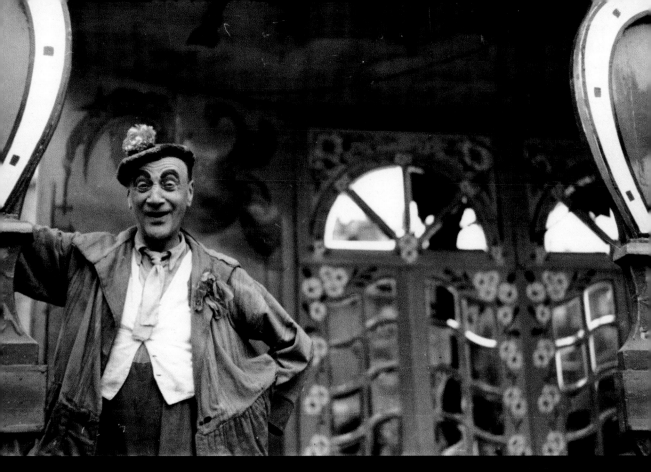

MAYNARD OWEN WILLIAMS | 1930S | PARIS *At the Gingerbread Fair, Place de la Nation*

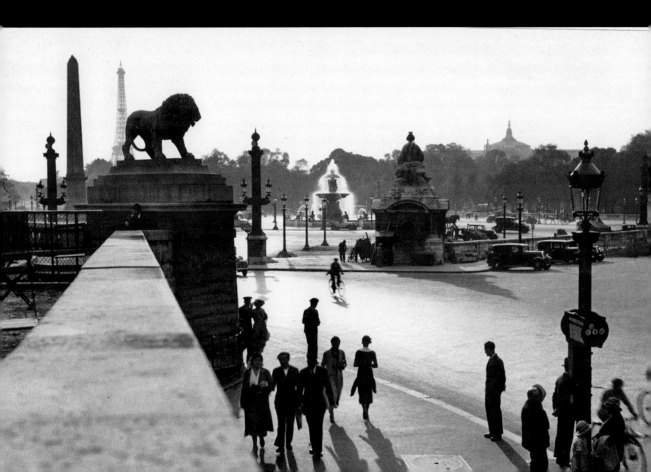

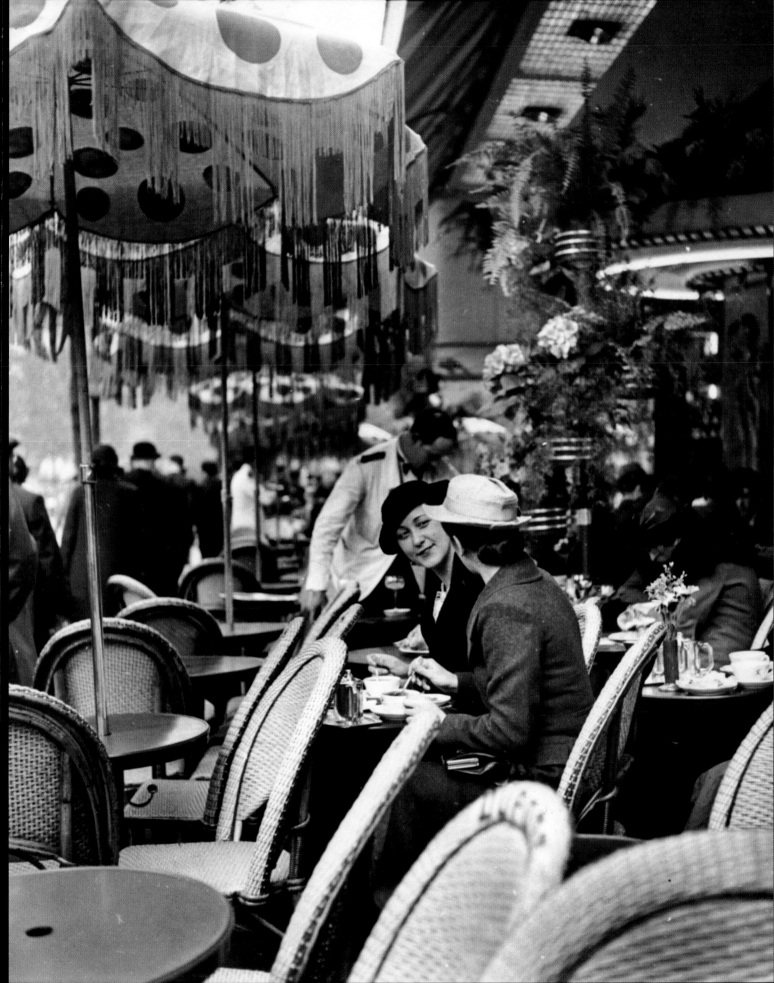

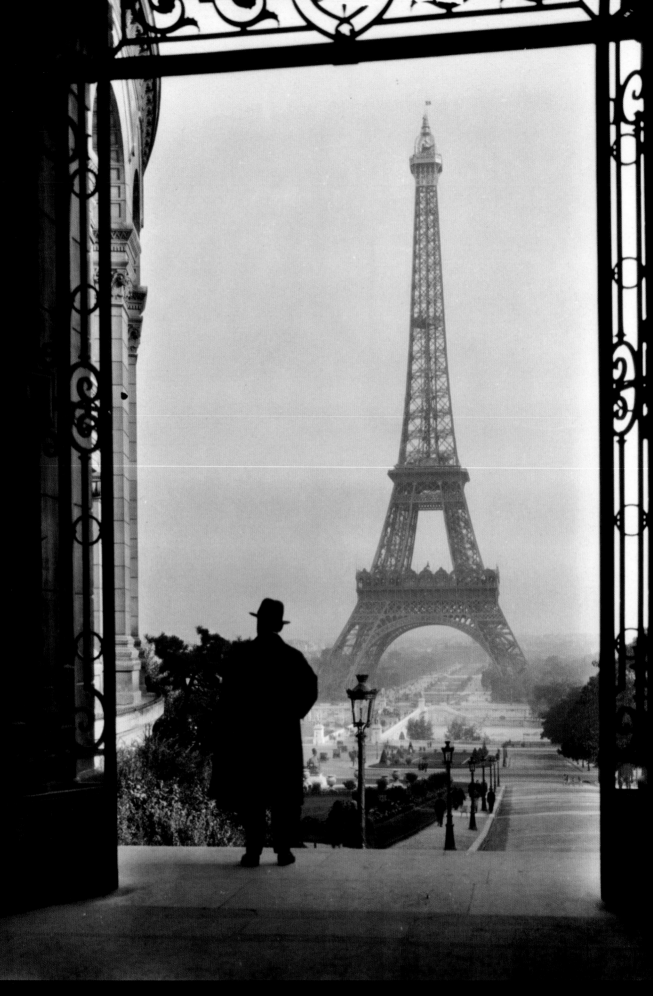

CLIFTON R. ADAMS **|** 1929 **|** PARIS *View from the Palais du Trocadéro*

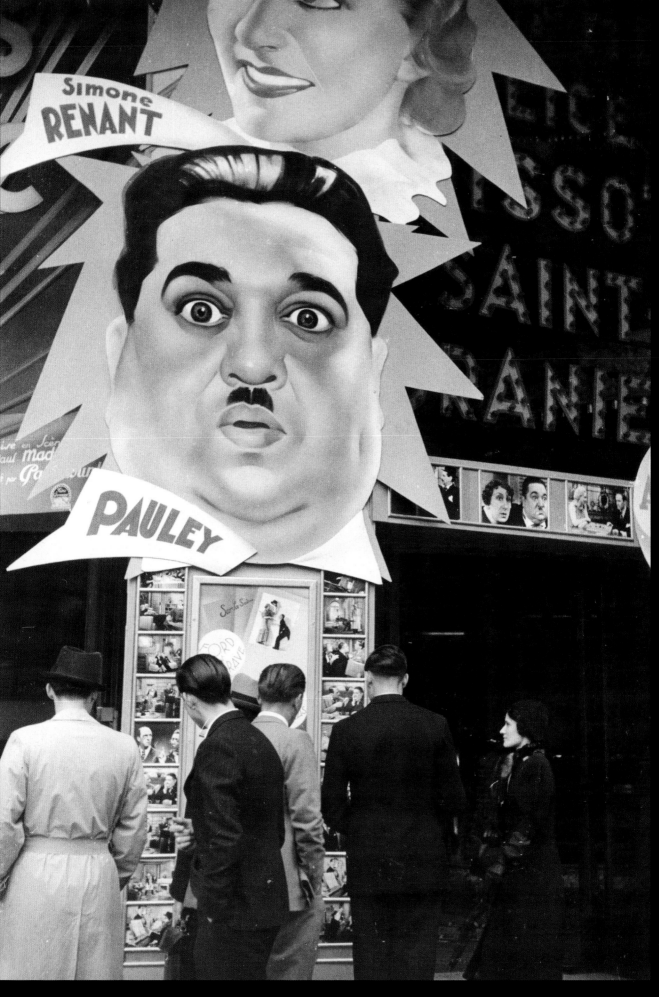

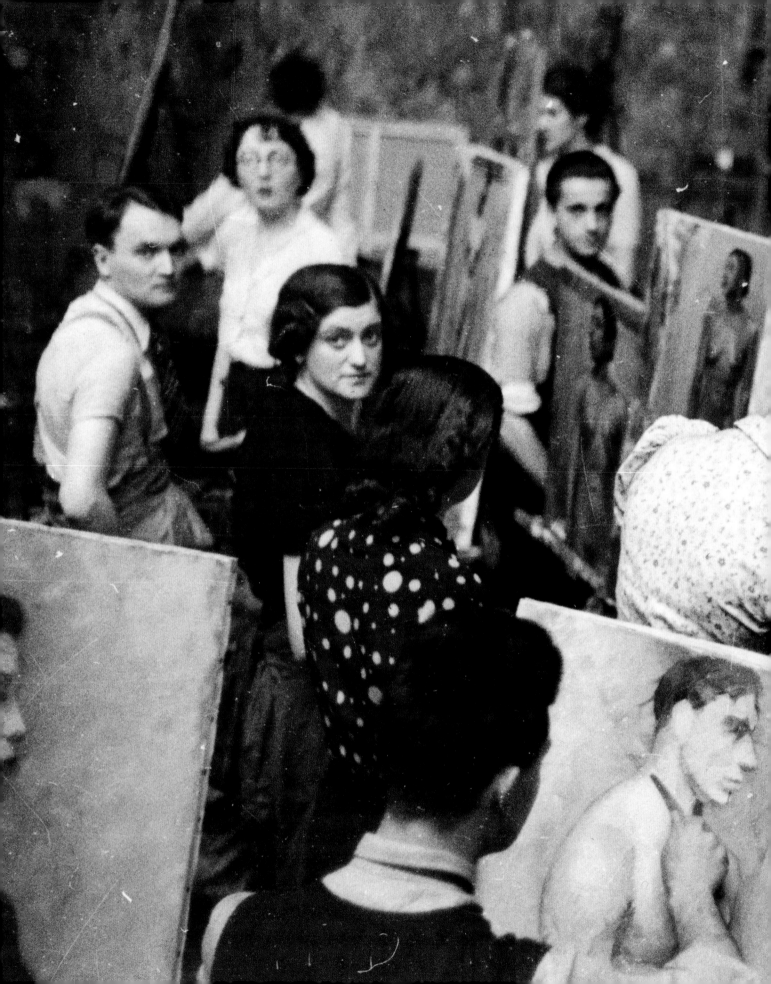

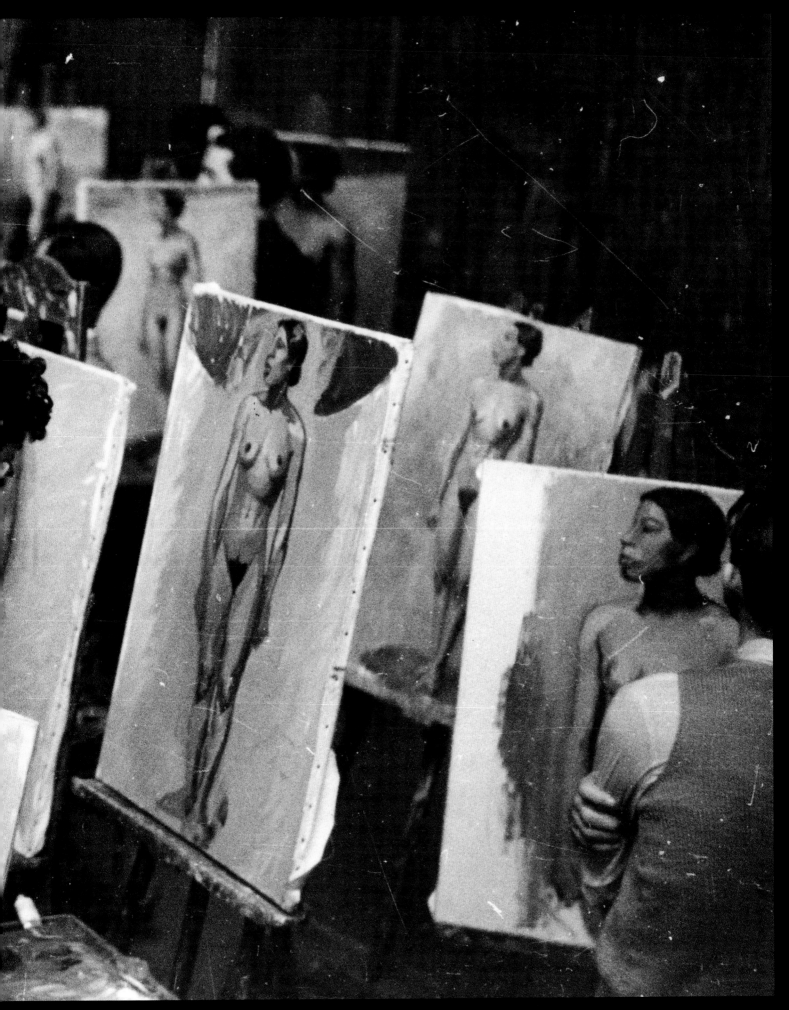

SCIENCE & CL

MATE CHANGE

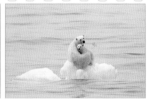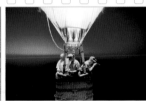

DREAMS AND IMAGINATION—ALEXANDER GRAHAM BELL had plenty of both, but it was imagination that compelled his son-in-law Gilbert H. Grosvenor in 1903 to photograph the inventor's picturesque aerial experiments with tetrahedral kites, and imagination that inspired the young editor, from that point on, to collect or commission for National Geographic further photographs depicting each stage in the conquest of the skies, each new use of harnessed electricity, each notable eclipse, every technological marvel that the hand of man might fabricate or a camera's lens might capture.

There was, after all, a romance about those robots and rockets springing from the dreams of madcap geniuses that could not help but entrance photographers. Many of the images resulting from their carefully contrived setups still possess a quirky, retro appeal, as if all those dials and gauges, levers and vacuum tubes—bathed in that unearthly, pulsating electronic glow—were but aspects of one colossal machine, a machine existing in some fabricated, sci-fi dimension undergirding our daily lives and divorced from the natural world. That it might fail was unimaginable; a cheering and cheerful vision epitomized by the title of one 1950s *Geographic* article: "Man's New Servant, the Friendly Atom."

Yet there had always been a dark side to technology. Those coiled cords and snaking cables might appear monstrous and alien, while men in prophylactic suits easily suggested a dystopian rather than utopian vision. Destruction, after all, rained from those machines, and the fruit of their hideous seed was the mushroom cloud. Thus subsequent generations of photographers have approached scientific or technological assignments in a more nuanced, balanced, realistic, and occasionally ironic manner. They have brought the workaday aspect of research back into their images, but above all, have retrieved the natural world, which not only exceeds in beauty and complexity the fabricated one but will surely determine its destiny. Photographs of melting glaciers or hurricane floodwaters suggest ecosystems increasingly out of balance. These photographs are persuasive witnesses to the growing extent of human-induced climate change, evidence that our technological dreams may be spawning a global nightmare.

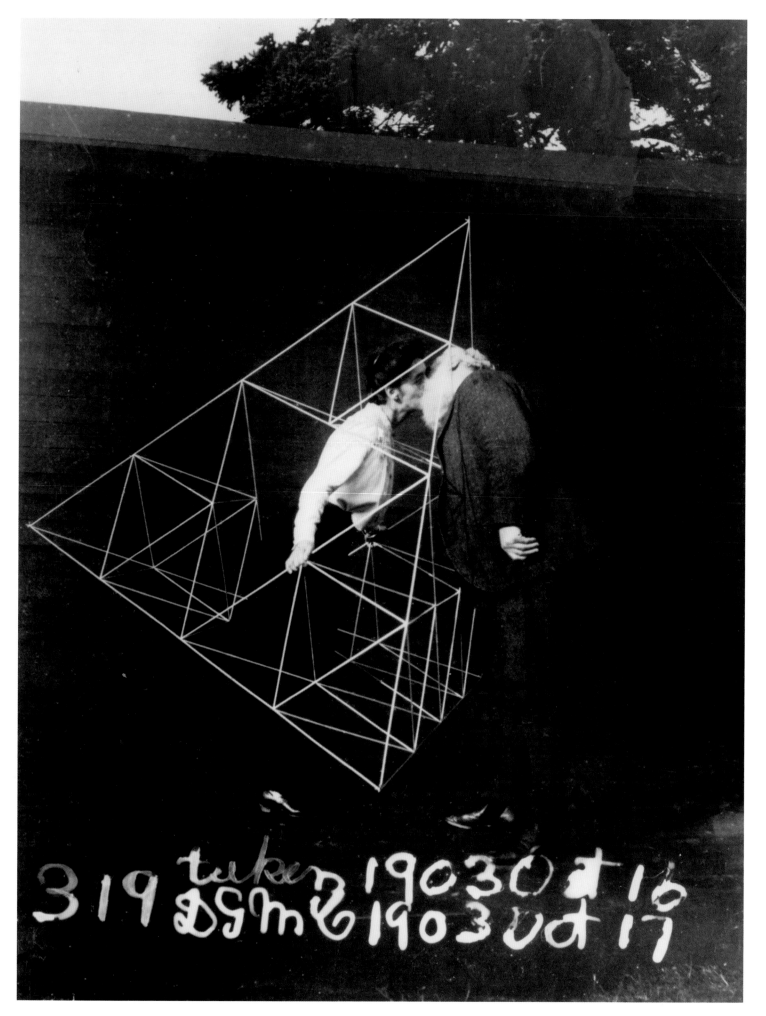

GILBERT H. GROSVENOR | 1903 | CANADA *Mabel and Alexander Graham Bell framed in a tetrahedral kite*

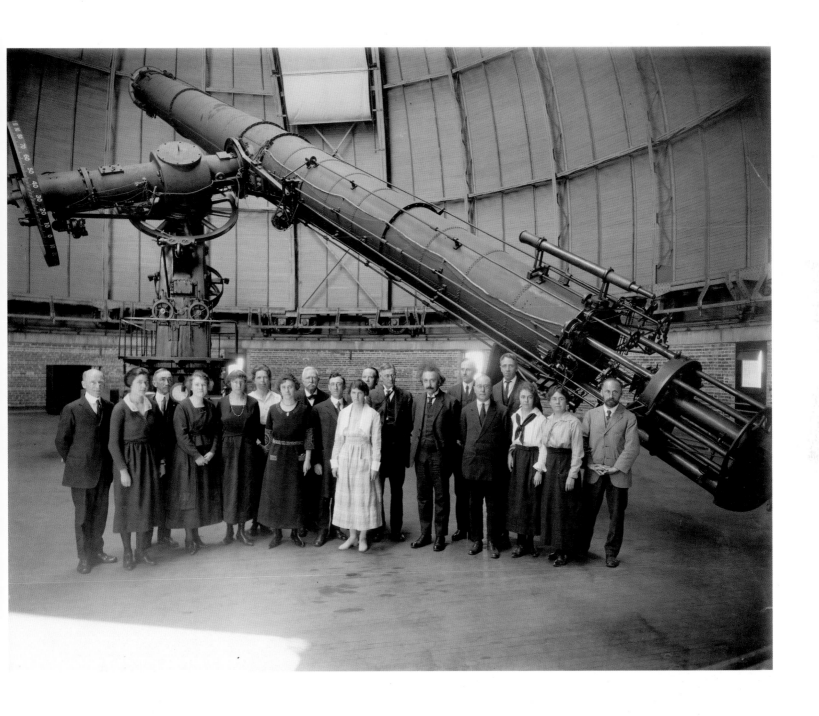

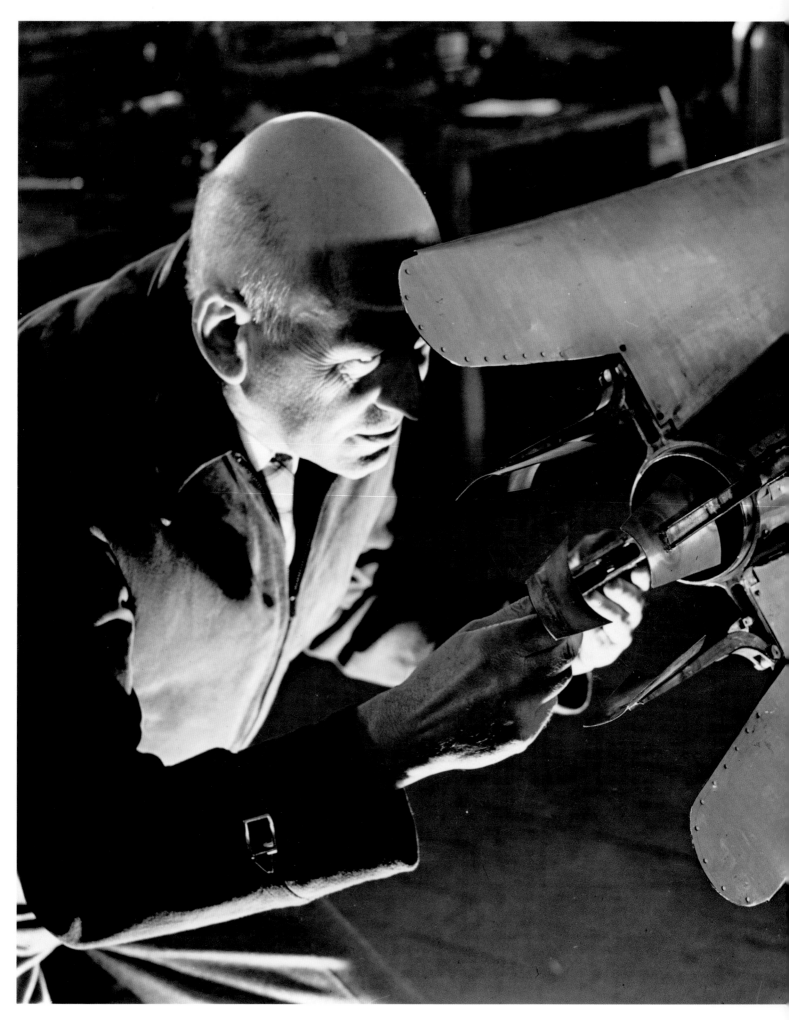

B. ANTHONY STEWART | 1940 | ARIZONA *Robert Goddard adjusting a steering vane*

"I would say he was probably the most conventional human being I have ever known," recalled one friend of rocket pioneer Robert Goddard; "highly conservative in everything except his wild interstellar obsession."

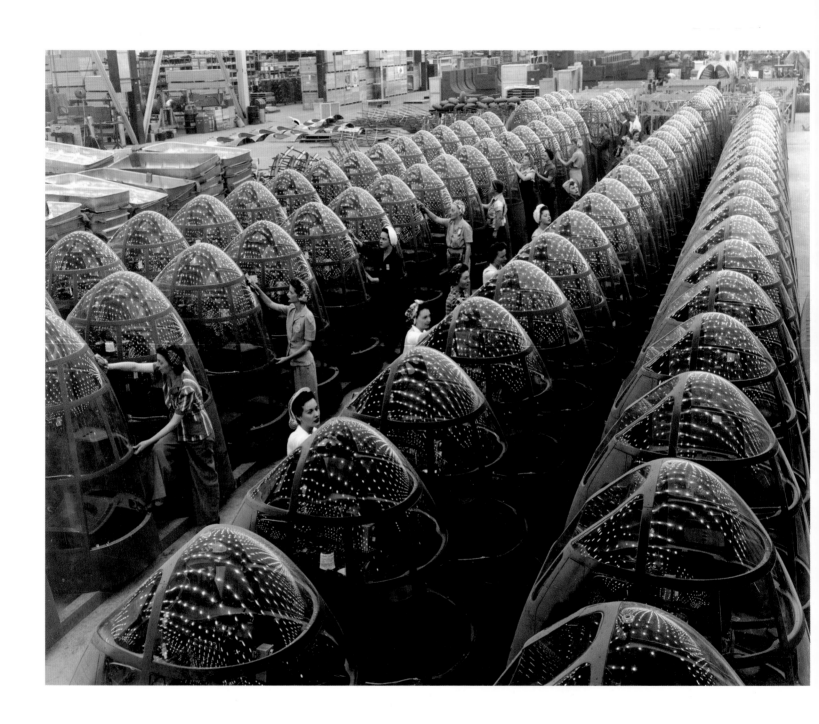

DOUGLAS AIRCRAFT COMPANY | 1942 | CALIFORNIA *Nose assemblies for Douglas A-20 attack bombers*

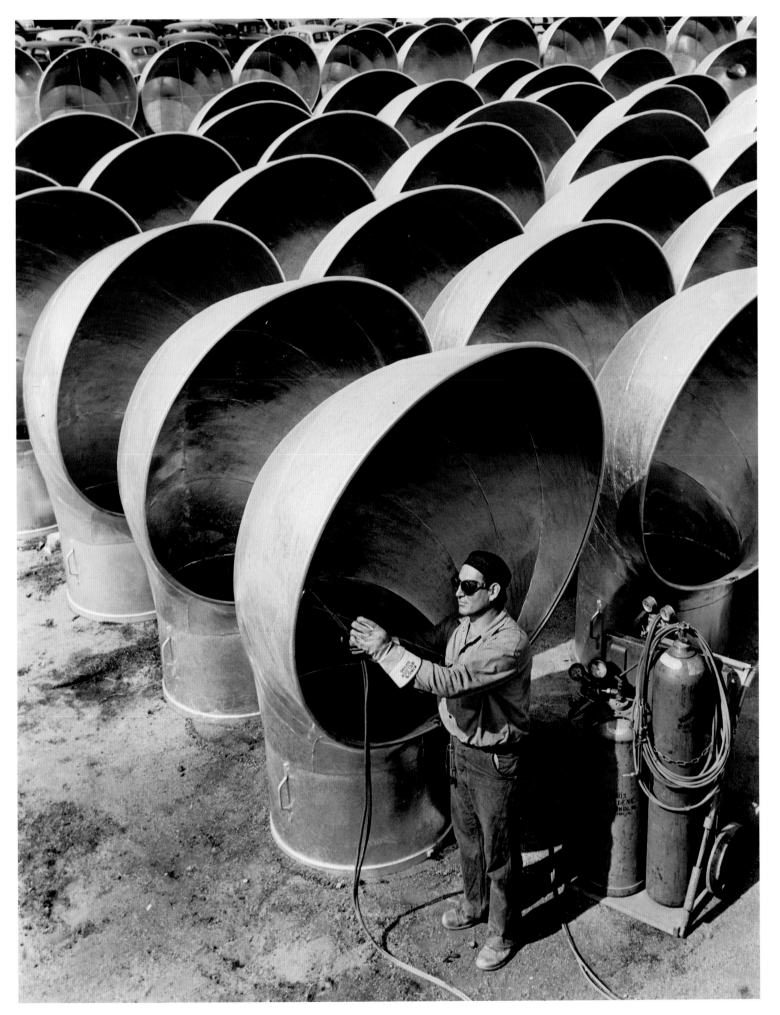

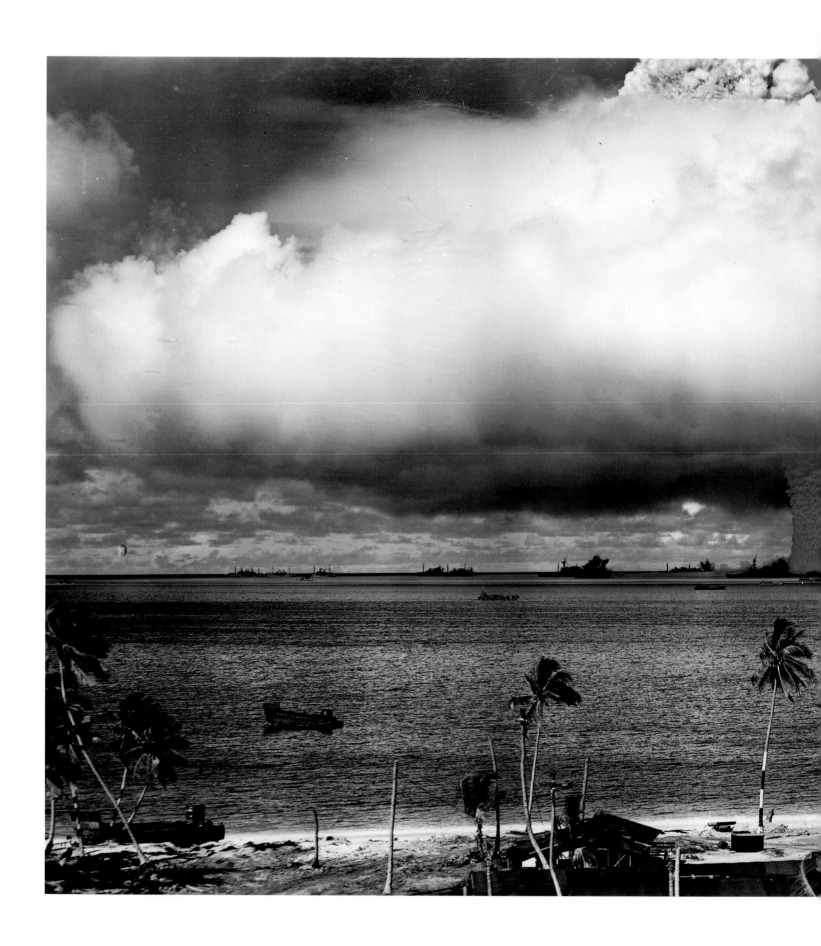

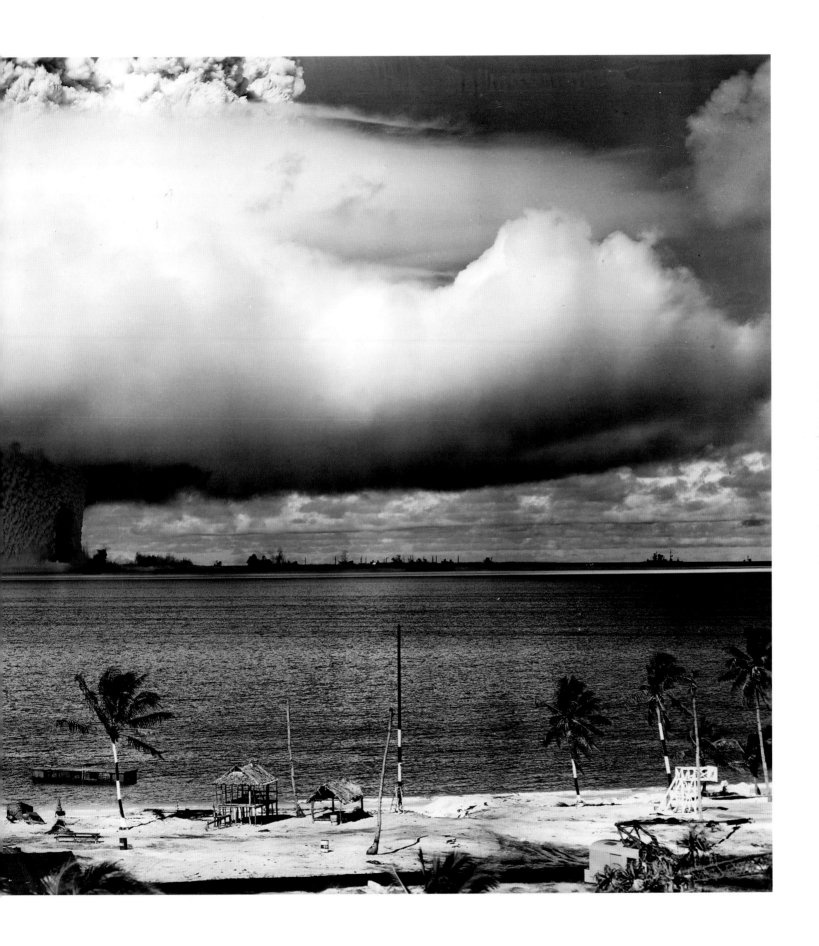

WILLARD CULVER | 1946 | NEW YORK *Testing early television equipment*

WILLARD CULVER | 1947 | NEW JERSEY *Designing a better pay phone at Bell Labs*

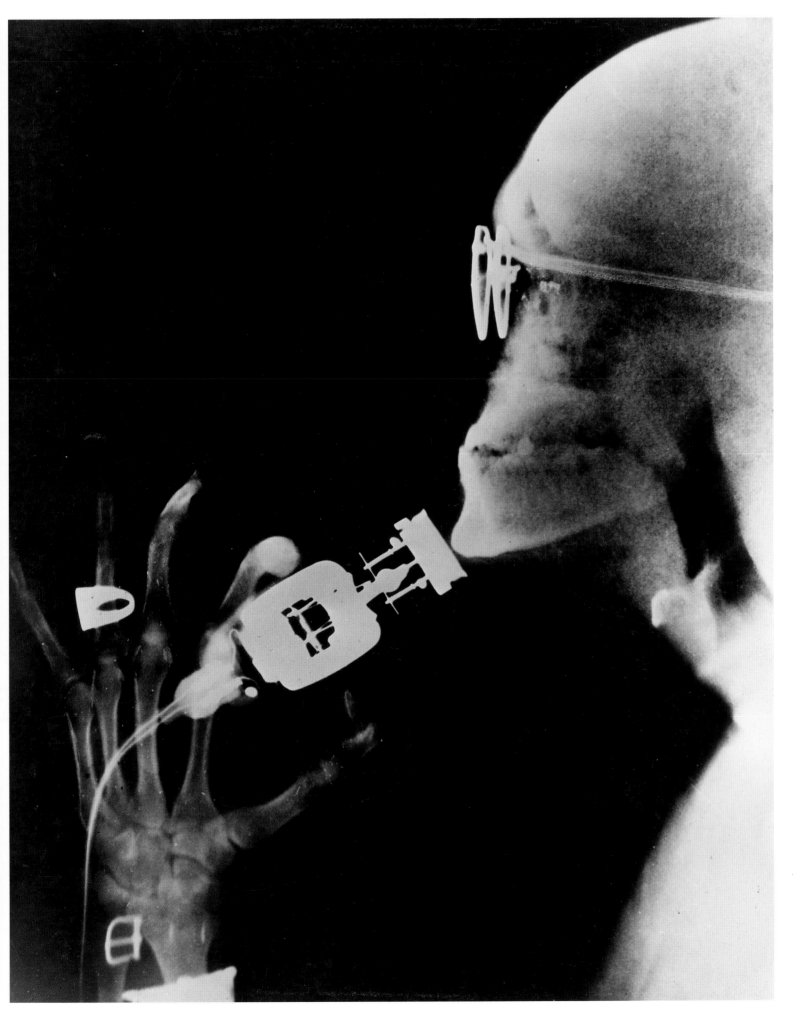

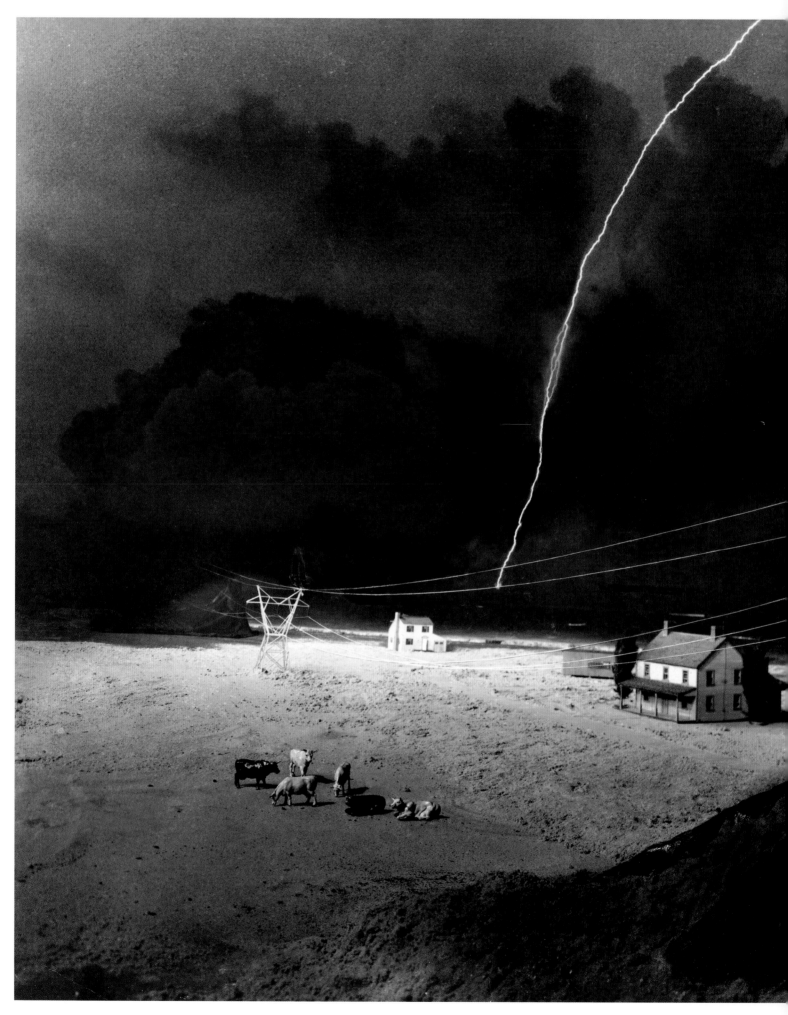

WESTINGHOUSE ELECTRIC CORP | 1950 | NEW JERSEY *How electrical wires detour a lightning stroke harmlessly to the ground*

"Even the cows are man-made," states the original caption to this picture of a tiny model farmstead built for lightning research. "Westinghouse engineers use this miniature system for tests."

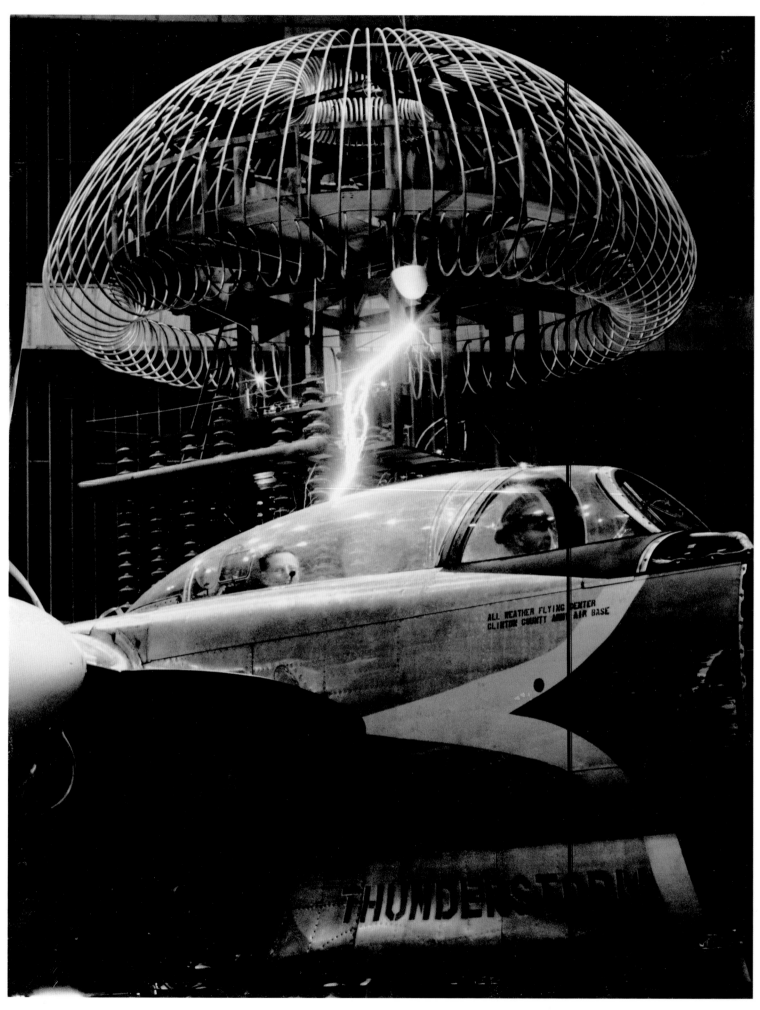

U.S. AIR FORCE | 1950 | OHIO *How metal planes shed lightning*

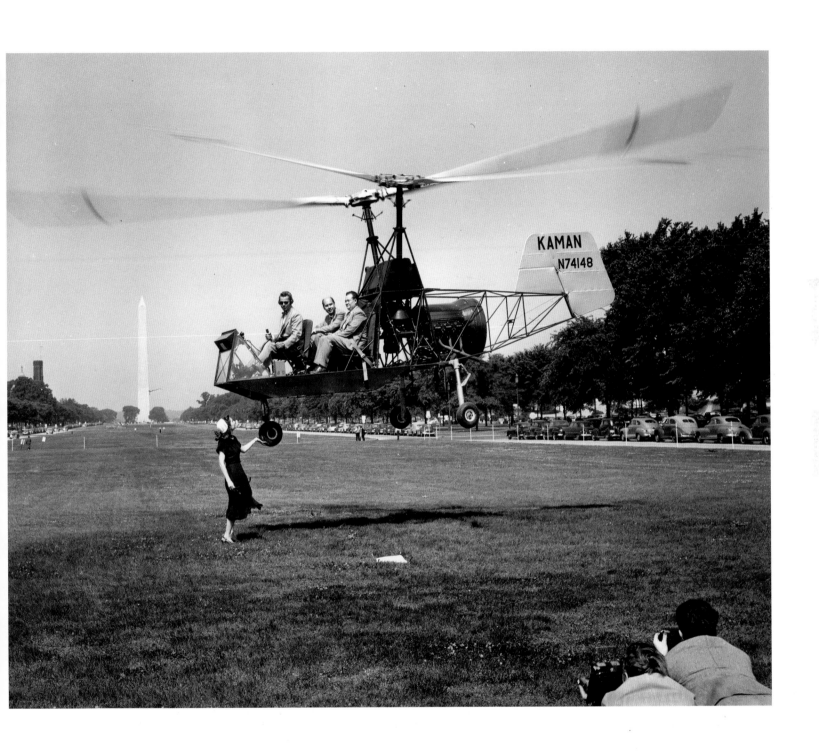

ERNEST J. COTTRELL | 1950 | WASHINGTON, D.C. *Demonstrating a twin-rotor helicopter to congressmen*

"If the jet plane, guided missile, or rocket plane is not perfect," wrote Dr. Heinz Haber, it can be redesigned. "The same cannot be said for man. He is the most important link ... and he cannot be redesigned."

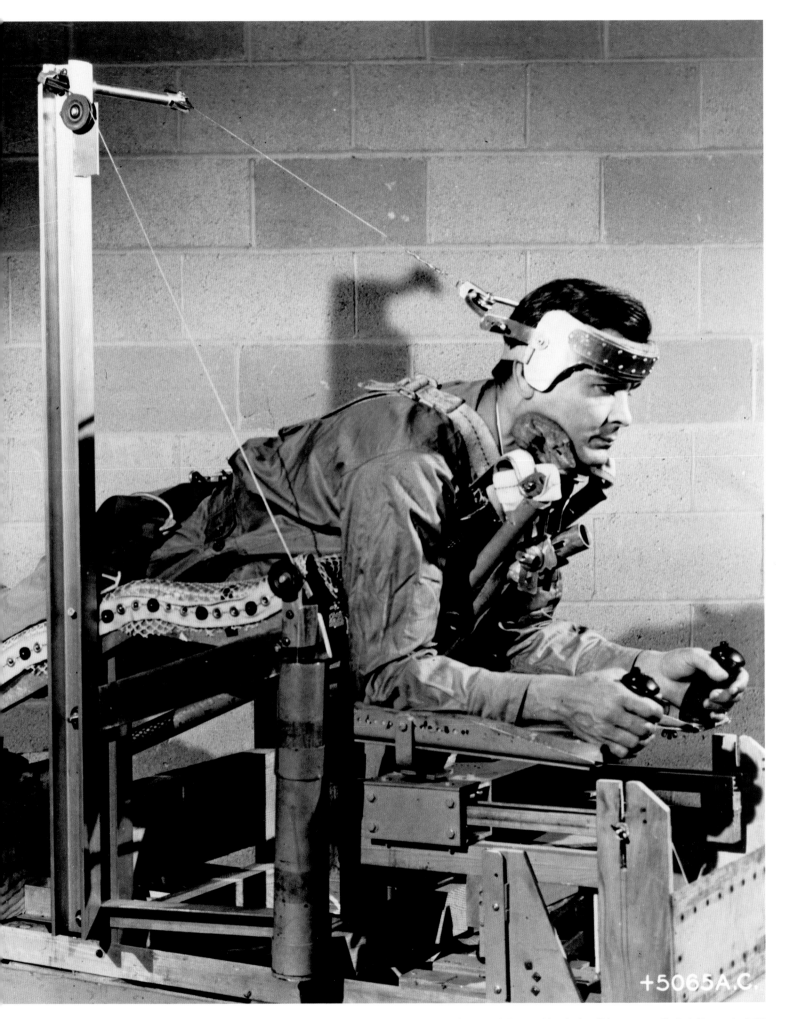

+5065A.C.

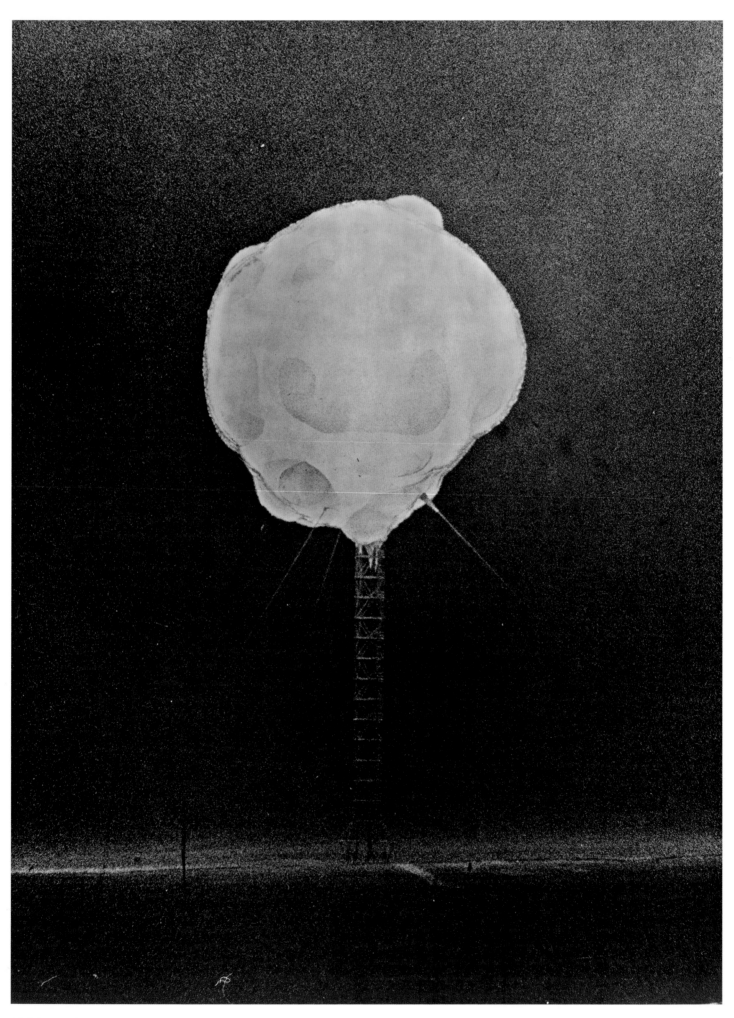

EDGERTON GERMESHAUSEN AND GRIER | 1953 | NEVADA *Fiery flower from a nuclear stem*

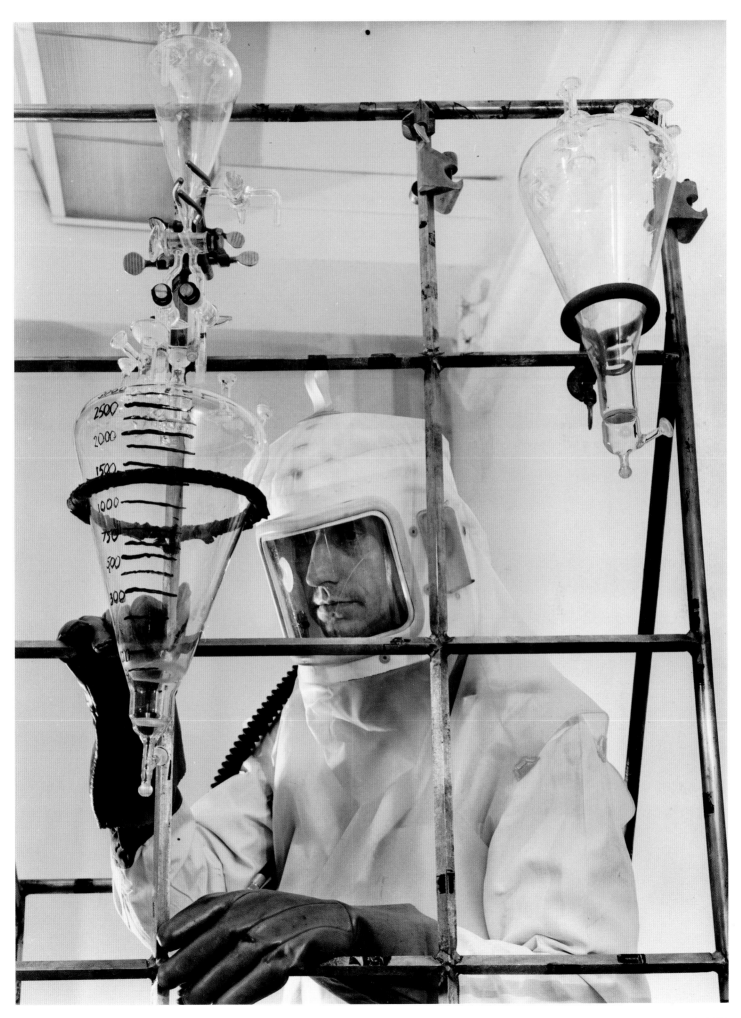

VOLKMAR WENTZEL | 1953 | NEW YORK *Better living through chemistry*

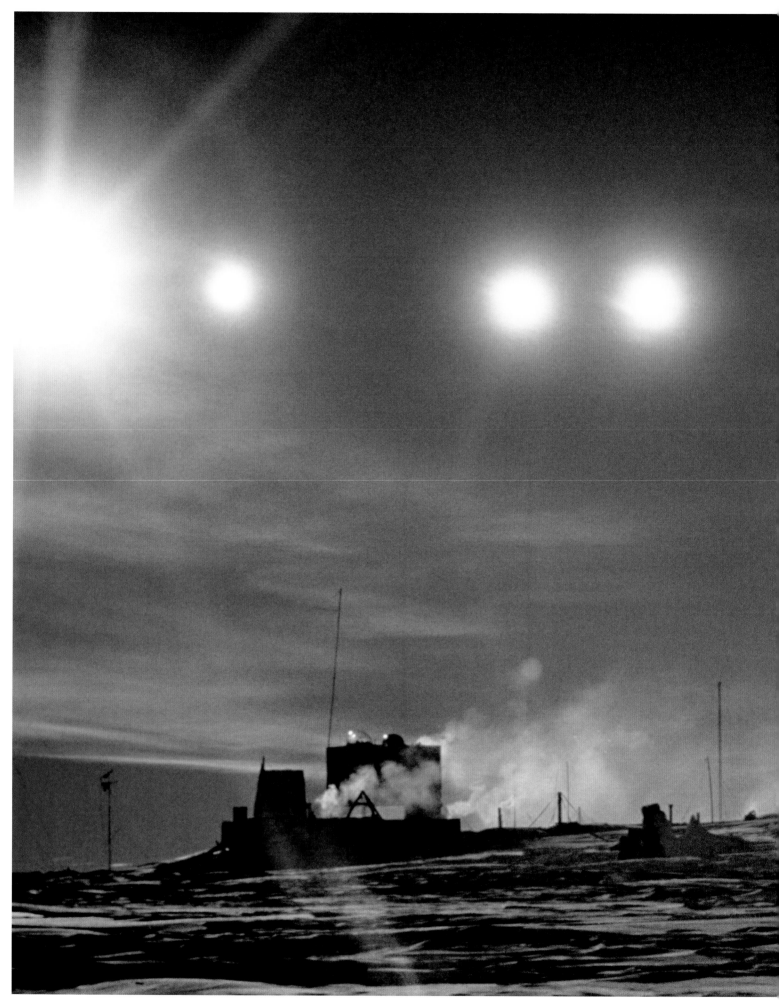

THOMAS J. ABERCROMBIE | 1957 | ANTARCTICA *Time exposure of the sun circling the South Pole*

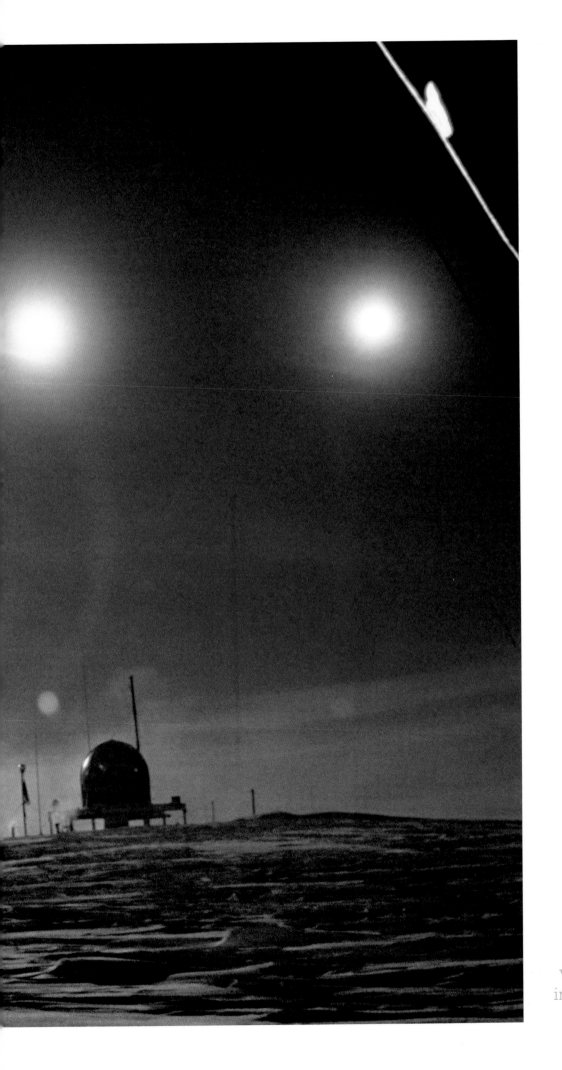

The vanishing of the sun during the Antarctic autumn deeply impressed explorer Ernest Shackleton. "The very clouds at this time were iridescent with rainbow hues. The sunsets were poems."

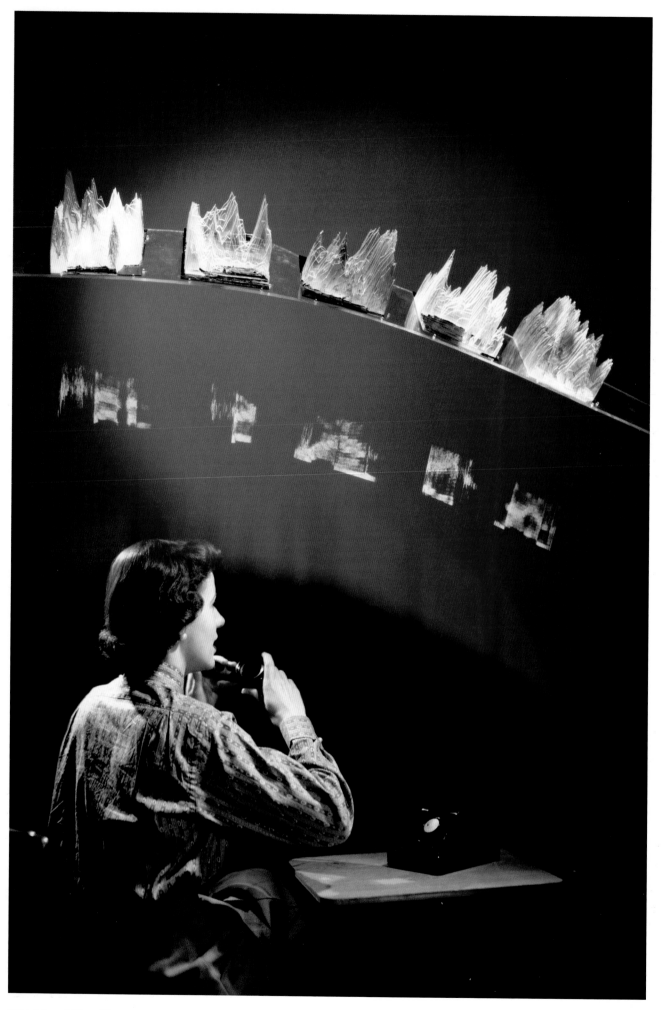

WILLARD CULVER | 1954 | WASHINGTON, D.C. *Speech made visible in plastic analogues of spoken words*

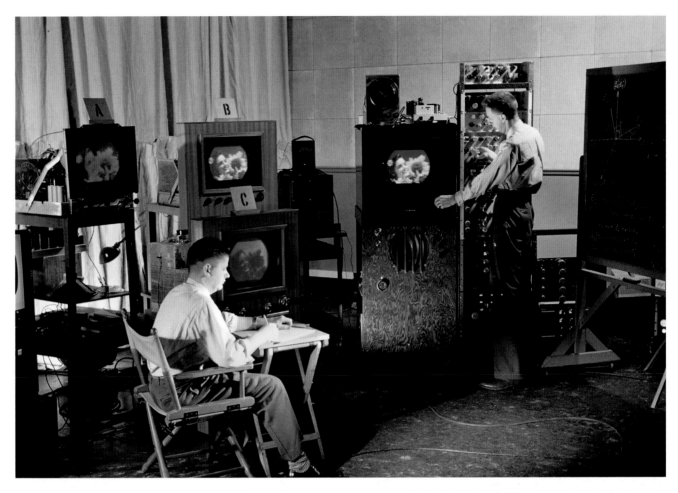

WILLARD CULVER | 1954 | NEW JERSEY *Adjusting the balance on RCA Laboratories' prototype color television*

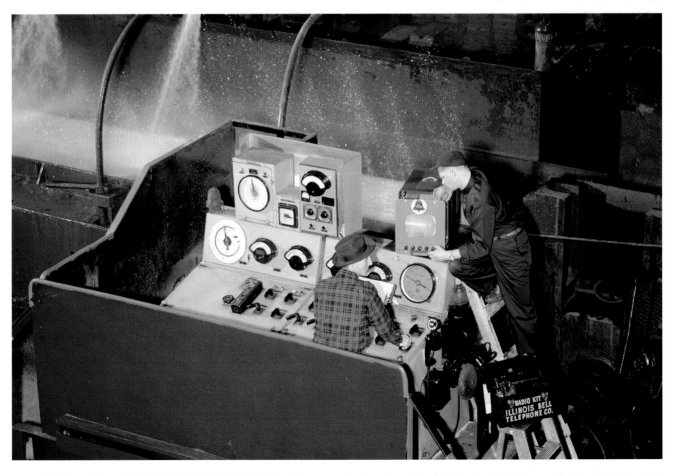

JOHN E. FLETCHER AND DONALD MCBAIN | 1954 | INDIANA *Television-monitored quality control on a U.S. Steel production line*

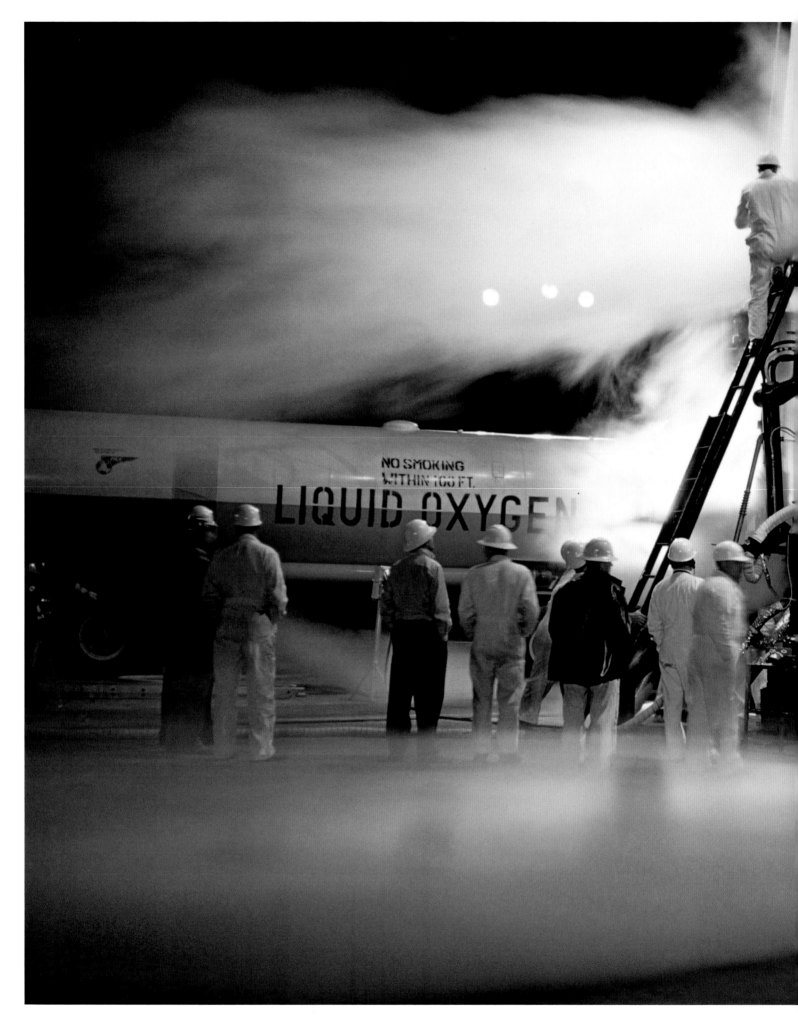

LUIS MARDEN | 1959 | FLORIDA *Pumping liquid oxygen into the Pioneer IV booster*

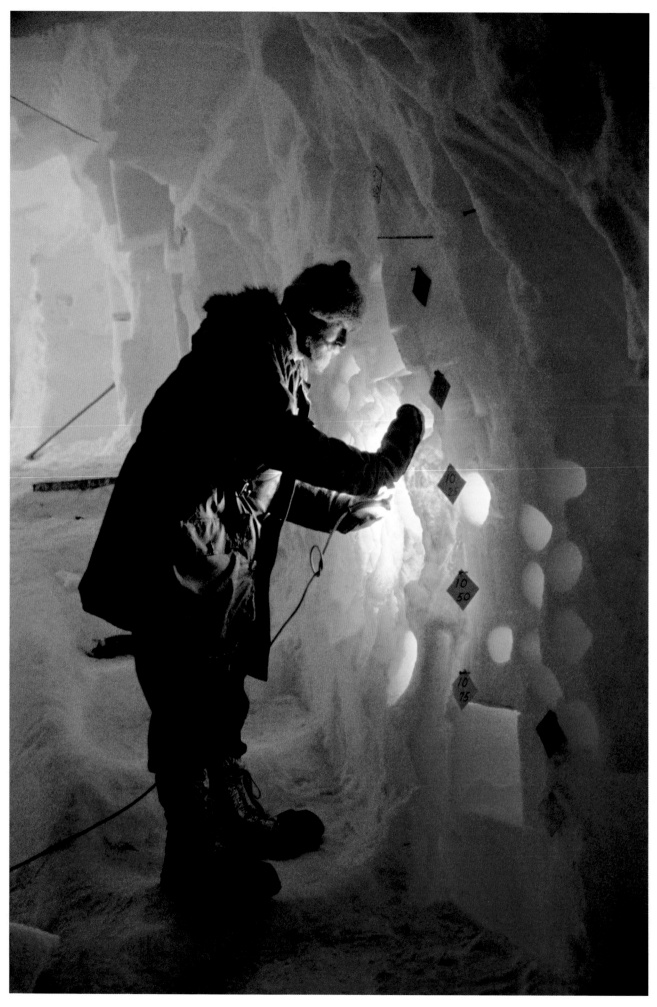

ALBERT MOLDVAY **|** 1963 **|** ANTARCTICA *Retrieving ice cores from 90 feet beneath the South Pole*

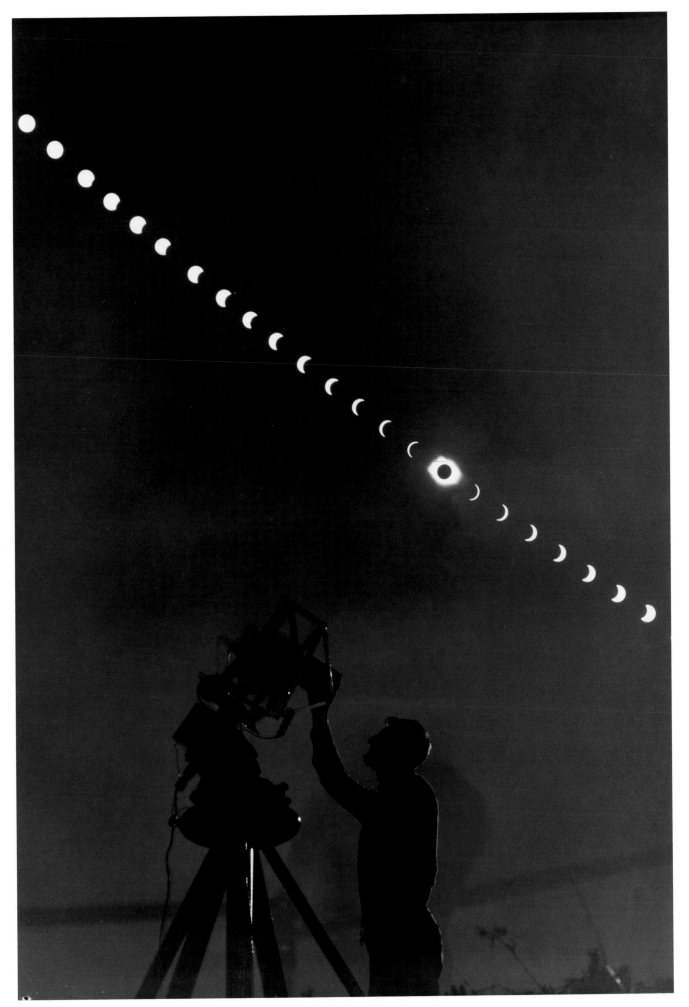

LAIRD BROWN **|** 1963 **|** CANADA *Progress of an eclipse*

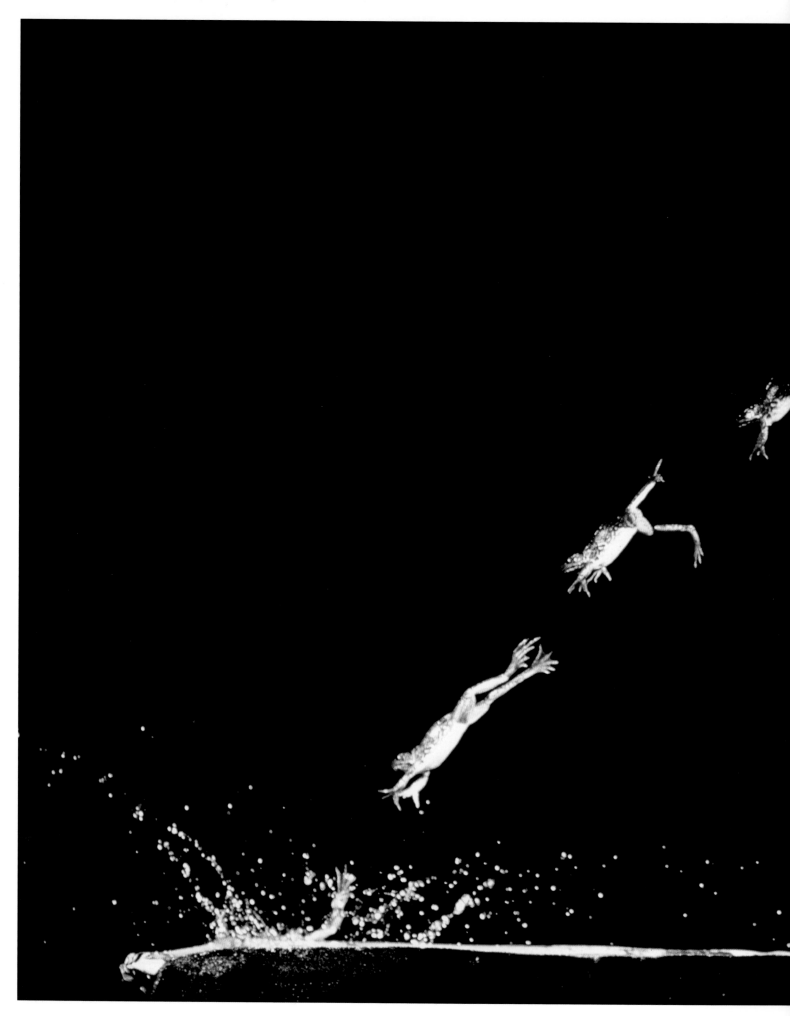

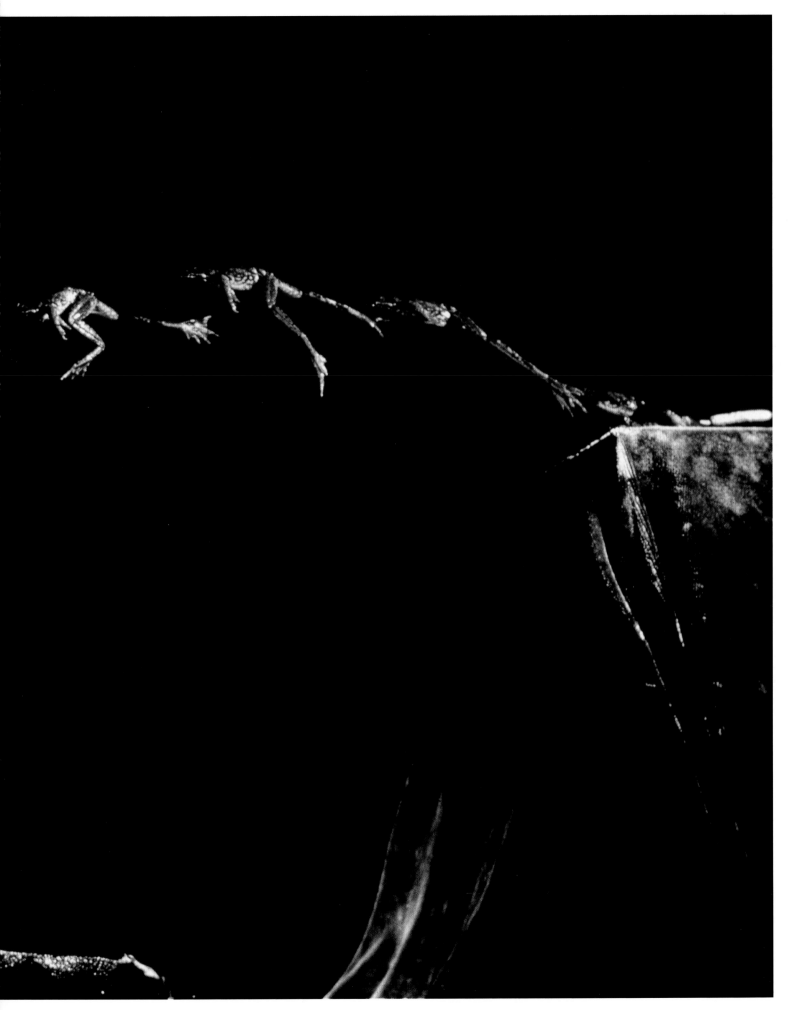

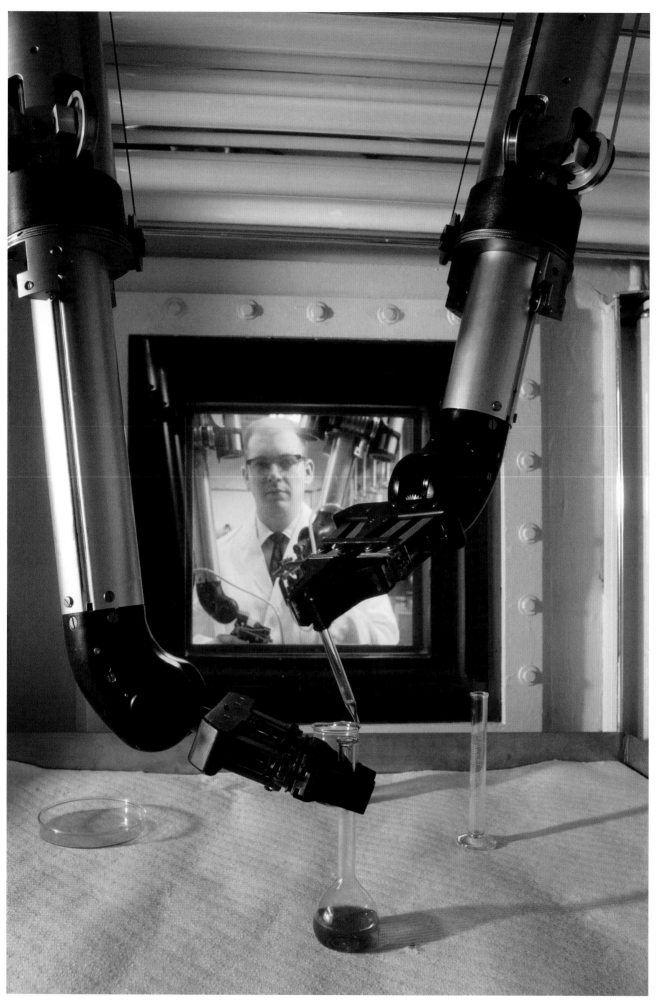

WINFIELD PARKS | 1963 | FLORIDA *Manipulating radioactive substances*

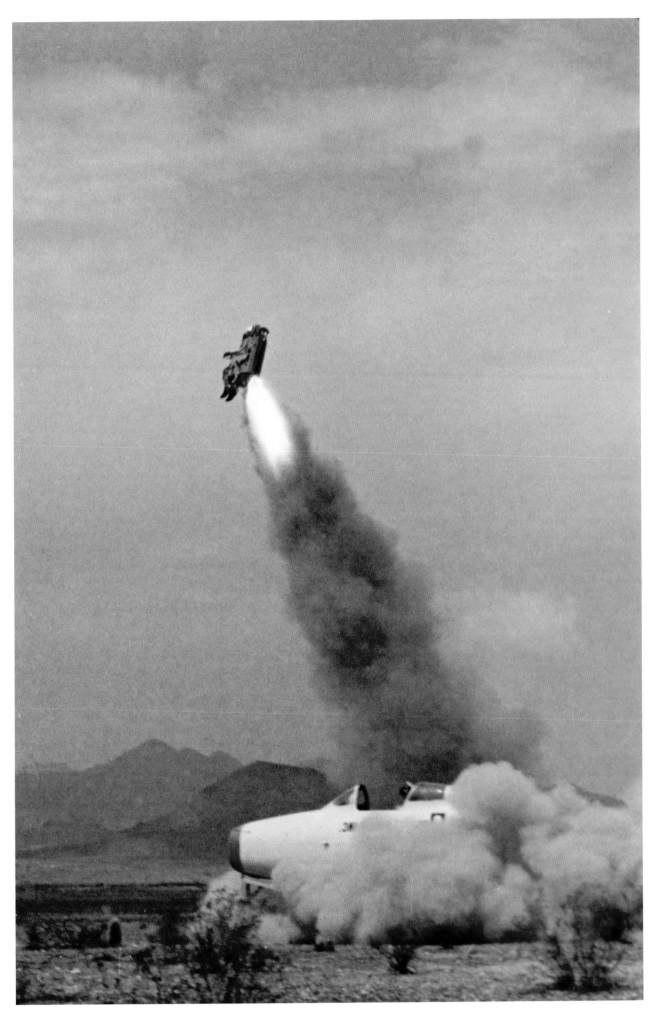

ROBERT F. SISSON | 1963 | ARIZONA *Testing a rocket-powered ejection system*

JAMES P. BLAIR **|** 1968 **|** WASHINGTON STATE *Dwarfed by the monolithic Ross Dam*

"In the view of conservationists," wrote journalist John McPhee, "there is something special about dams, something—as conservation problems go—that is disproportionately and metaphysically sinister."

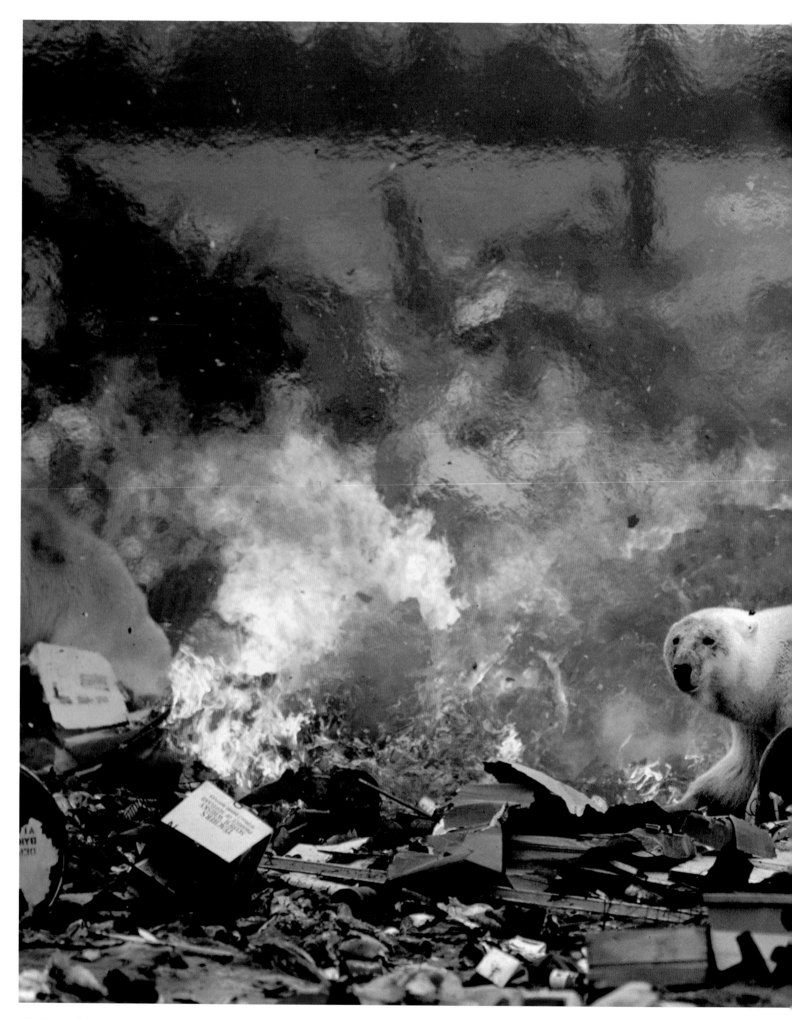

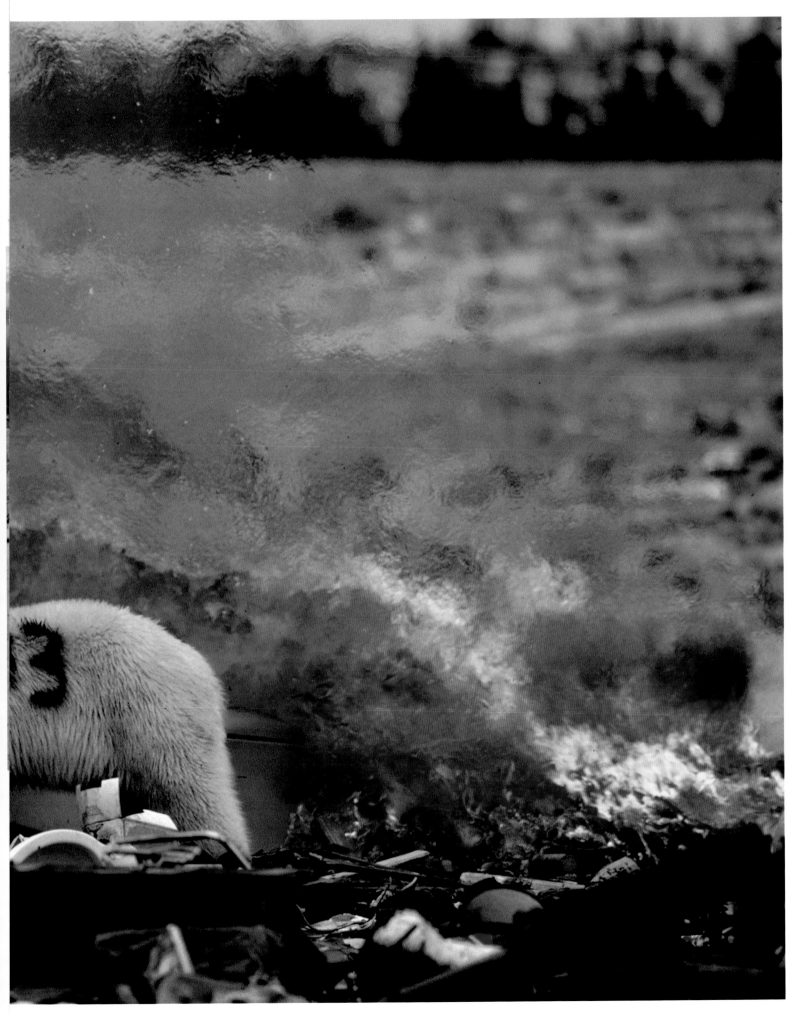

DAVID HISER | 1982 | CANADA *A closely monitored, chronically aggressive polar bear at a Churchill dump*

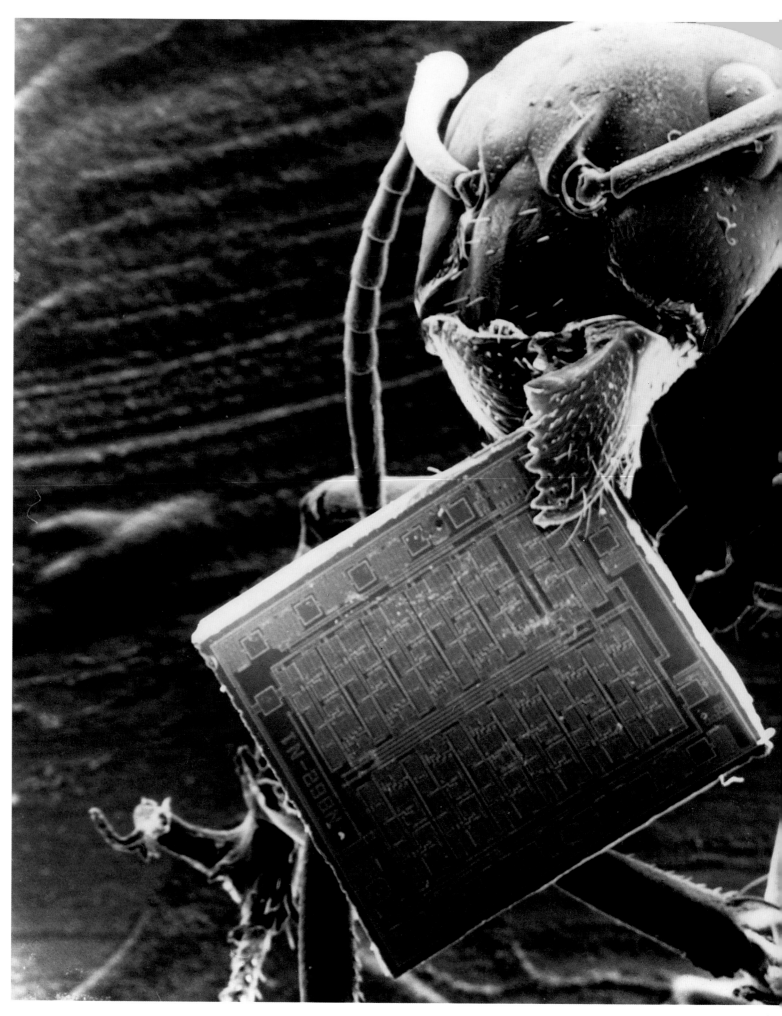

PHILIPS ELECTRONICS COMPANY | 1982 | NETHERLANDS *Ant with microprocessor*

Writer H. G. Wells once imagined ants having evolved to the point where their engineering feats and "organized and detailed method of record and communication" allow them to overwhelm human civilization.

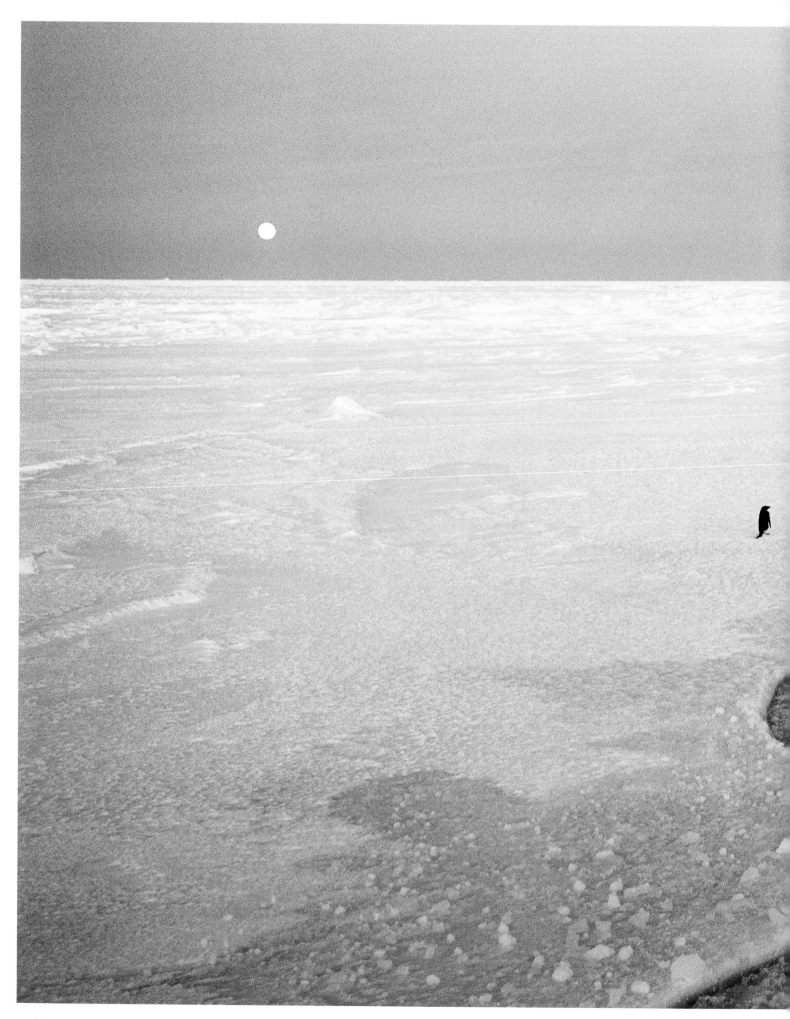

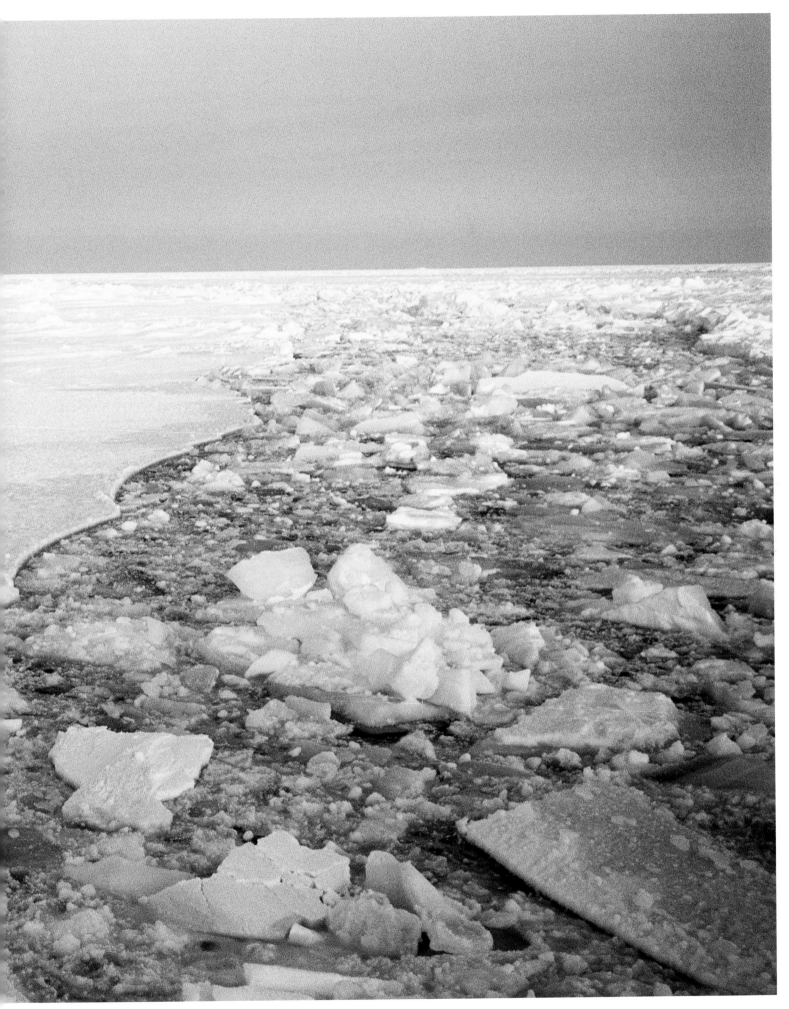

MARIA STENZEL | 1995 | ANTARCTICA *Gazing over the wake of an icebreaker*

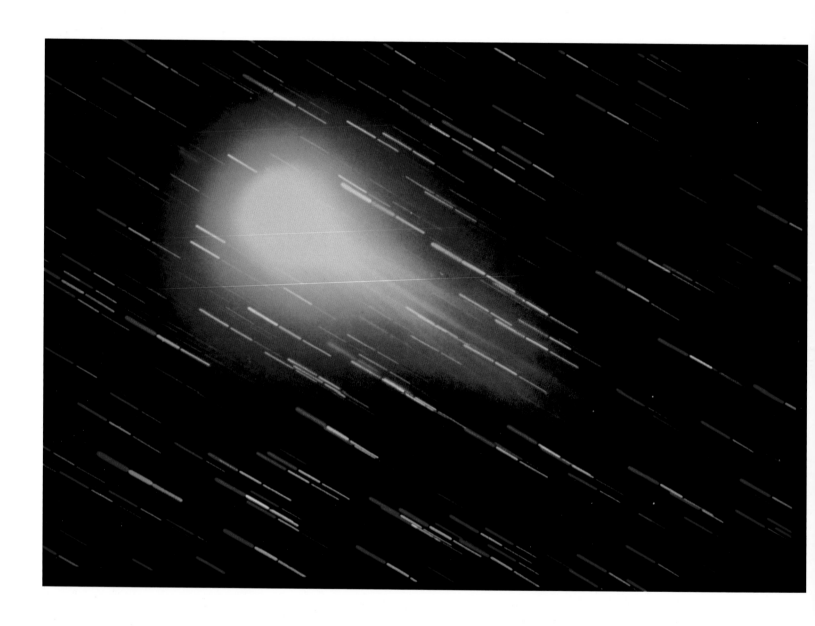

DAVID MALIN, ANGLO-AUSTRALIAN OBSERVATORY | 1986 | AUSTRALIA *Halley's comet*

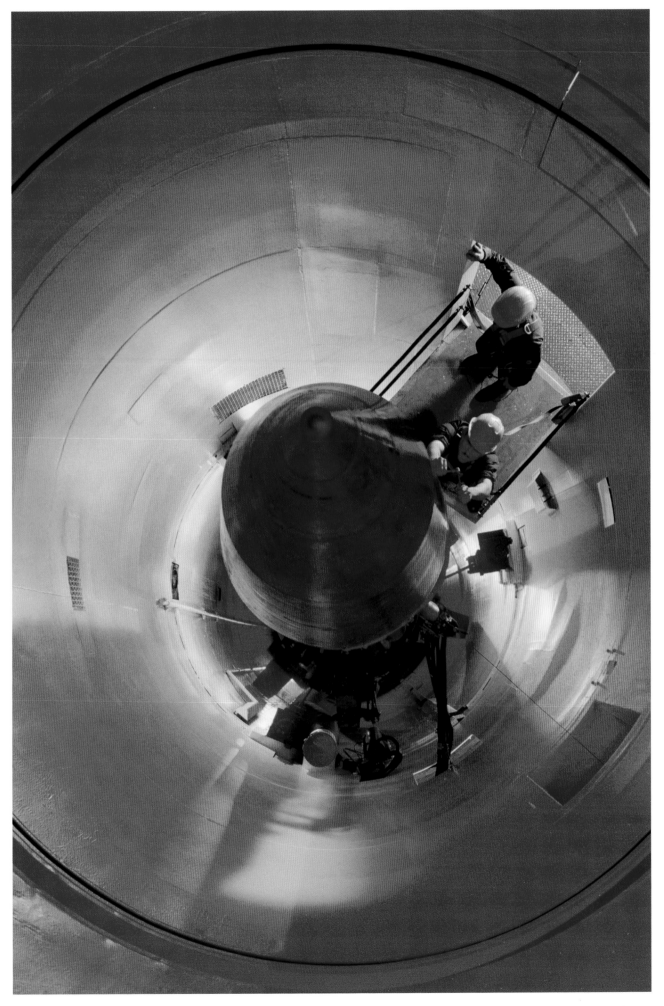

ANNIE GRIFFITHS BELT | 1987 | NORTH DAKOTA *In a Minuteman silo*

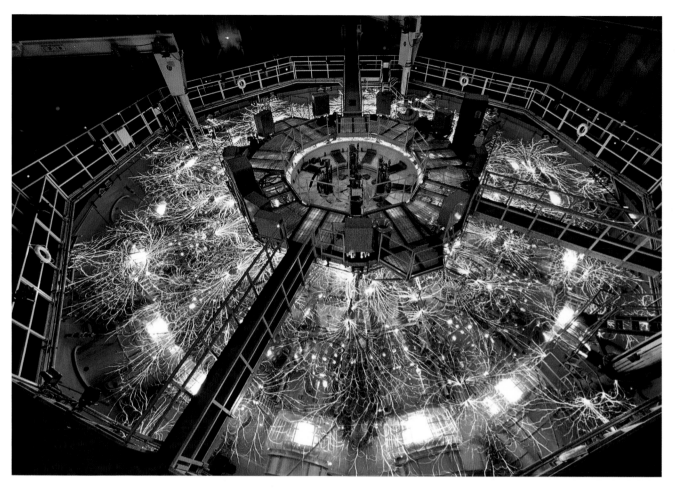

DANNY LEHMAN | 1987 | NEW MEXICO *The Particle Beam Fusion Accelerator II at Sandia National Laboratories*

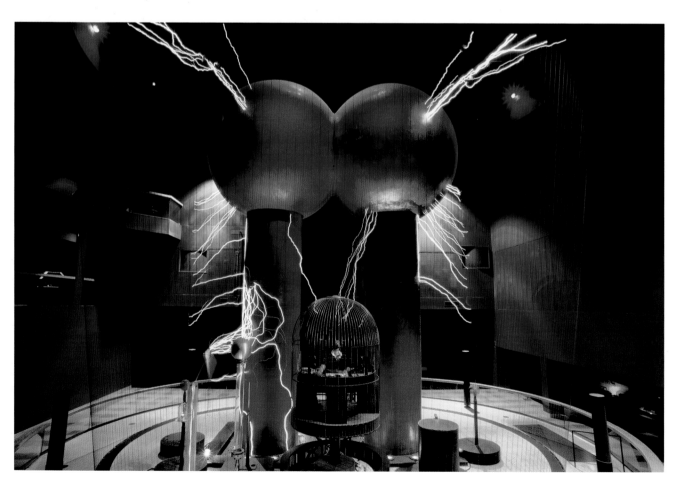

PETER MENZEL | 1993 | MASSACHUSETTS *The 1931 Van de Graaff generator at the Boston Museum of Science*

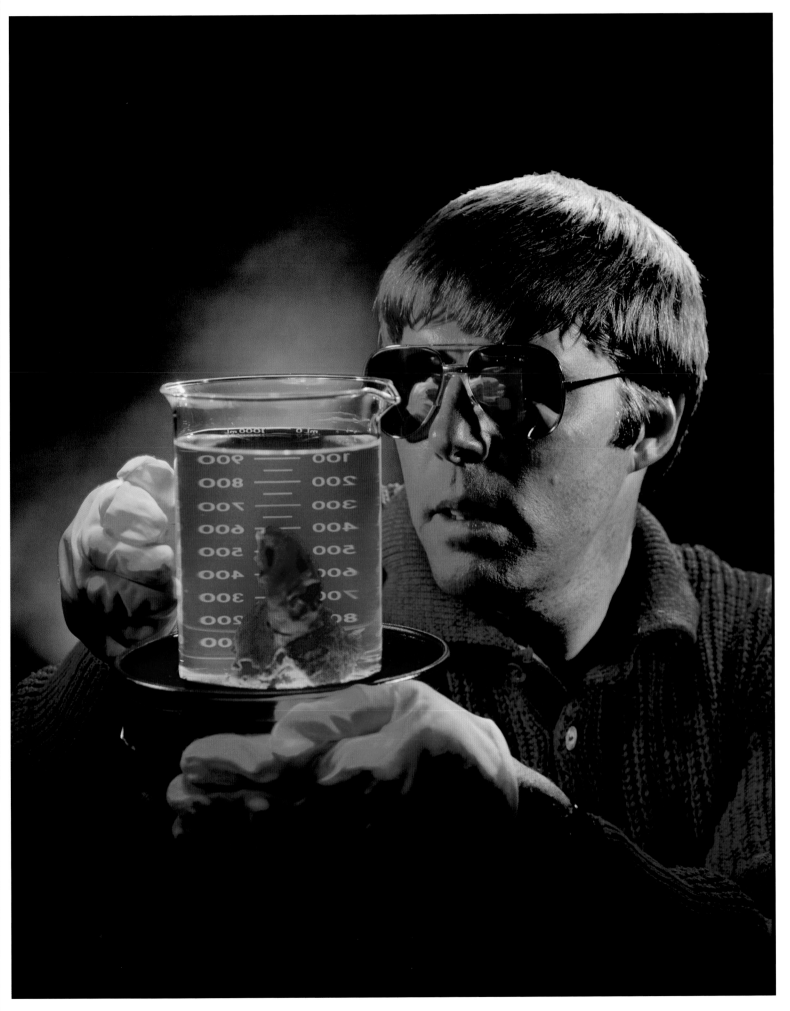

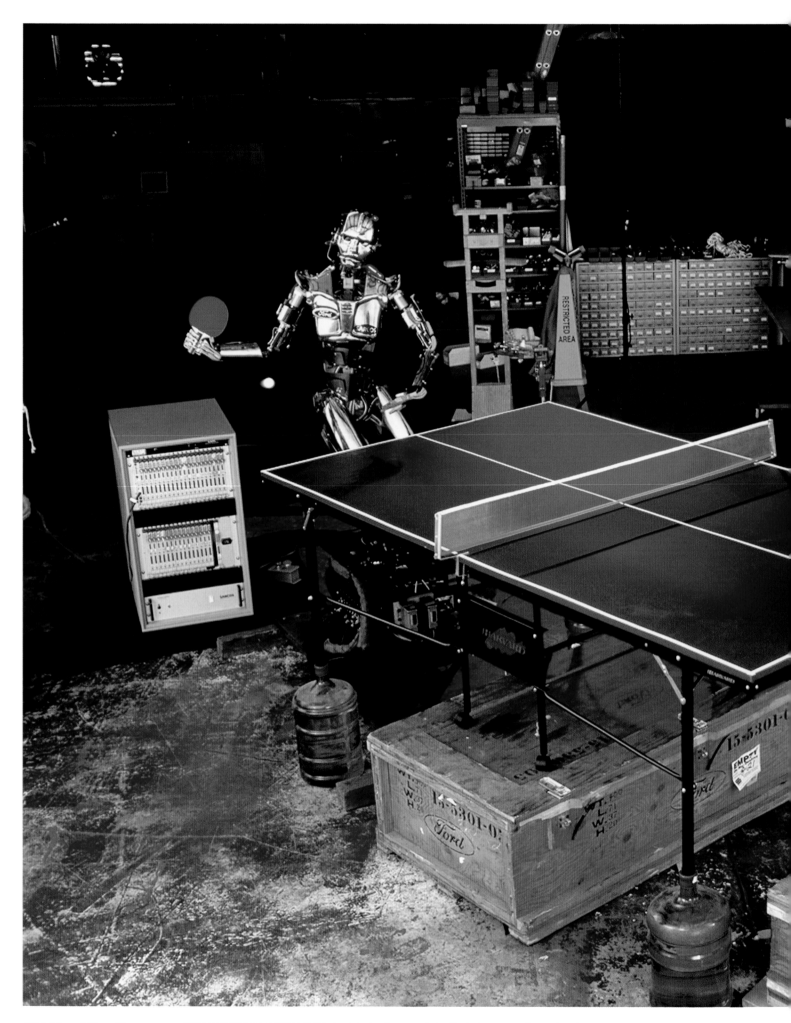

GEORGE STEINMETZ | 1997 | UTAH *A robot mirroring every stroke, thanks to sensors and computer relays*

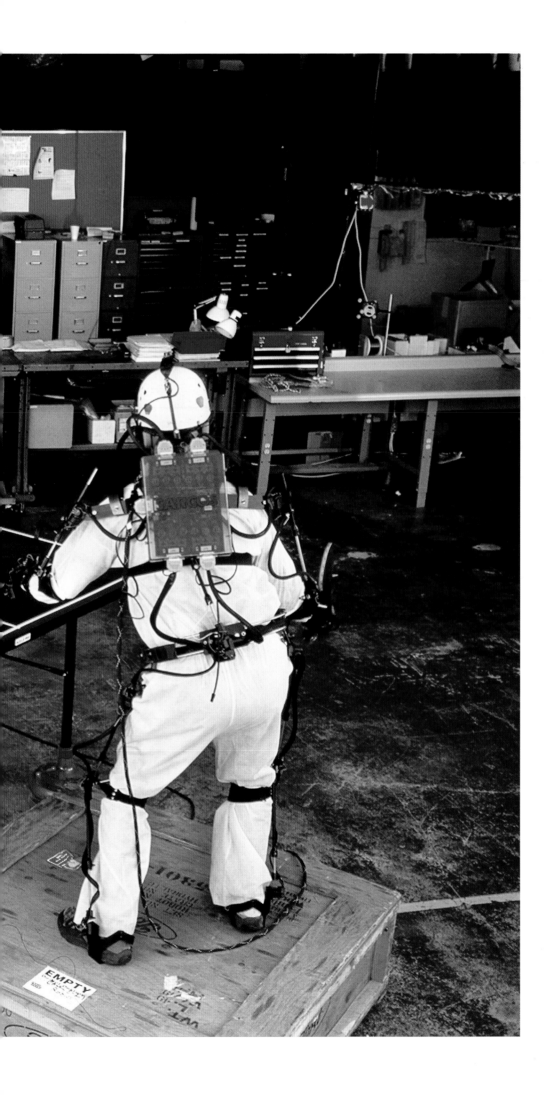

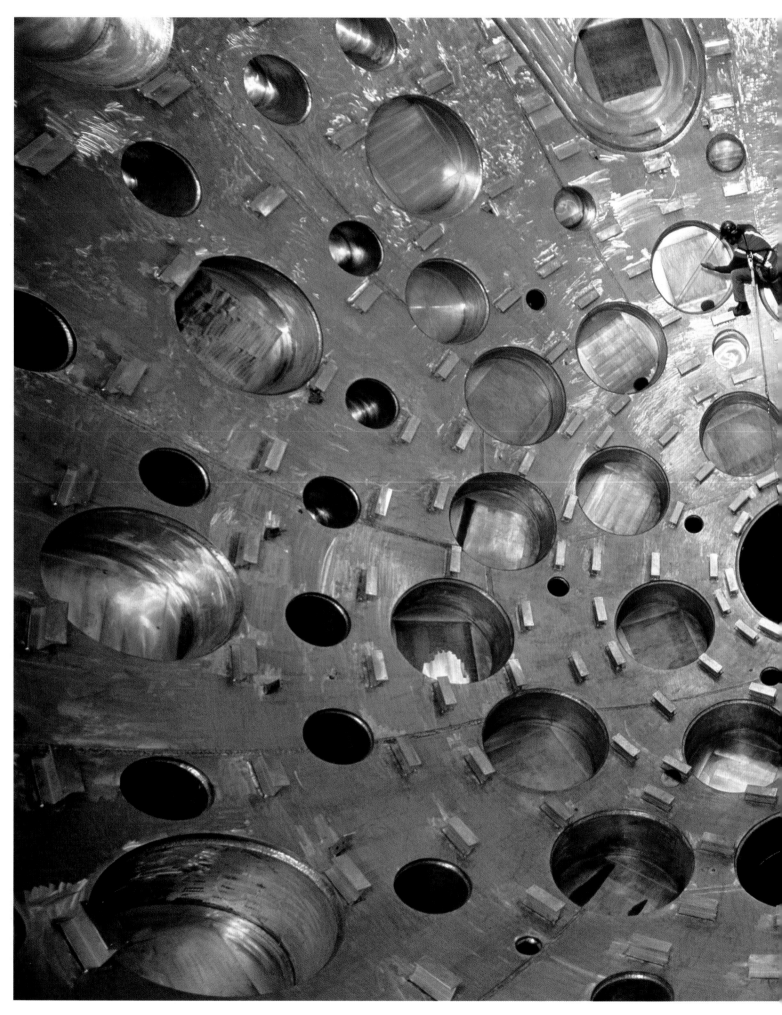

JOE MCNALLY | 2001 | CALIFORNIA *National Ignition Facility's target chamber for light-induced nuclear fusion*

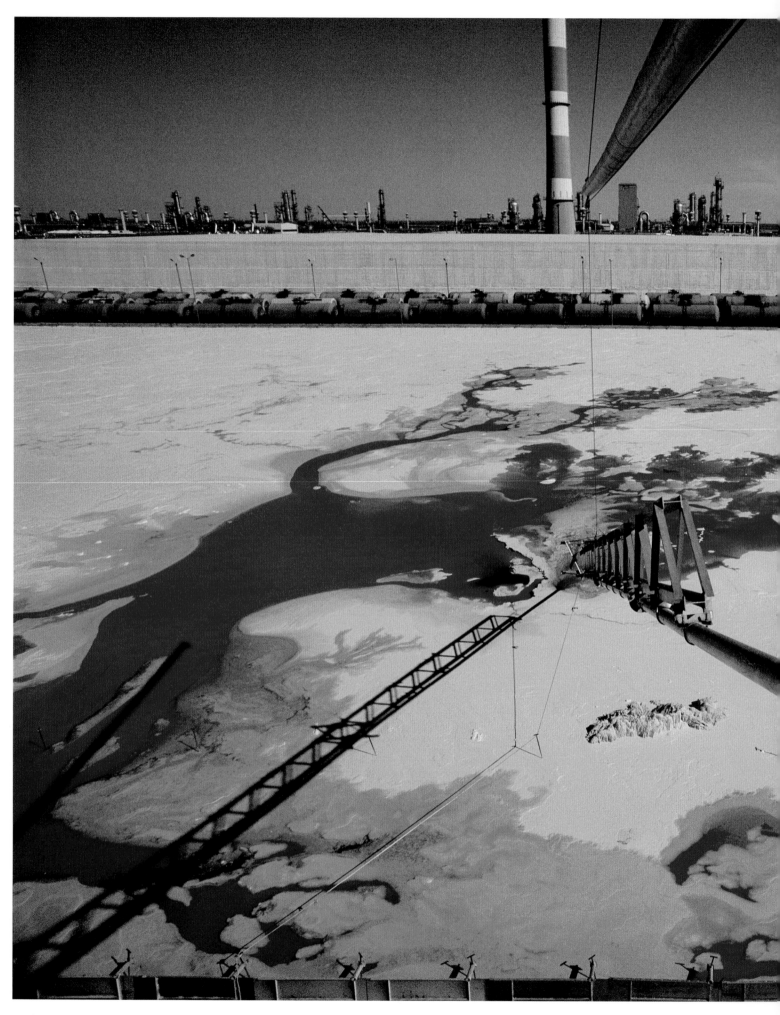

REZA | 1999 | KAZAKHSTAN *Bloody sands, the sulfurous by-product of oil extraction*

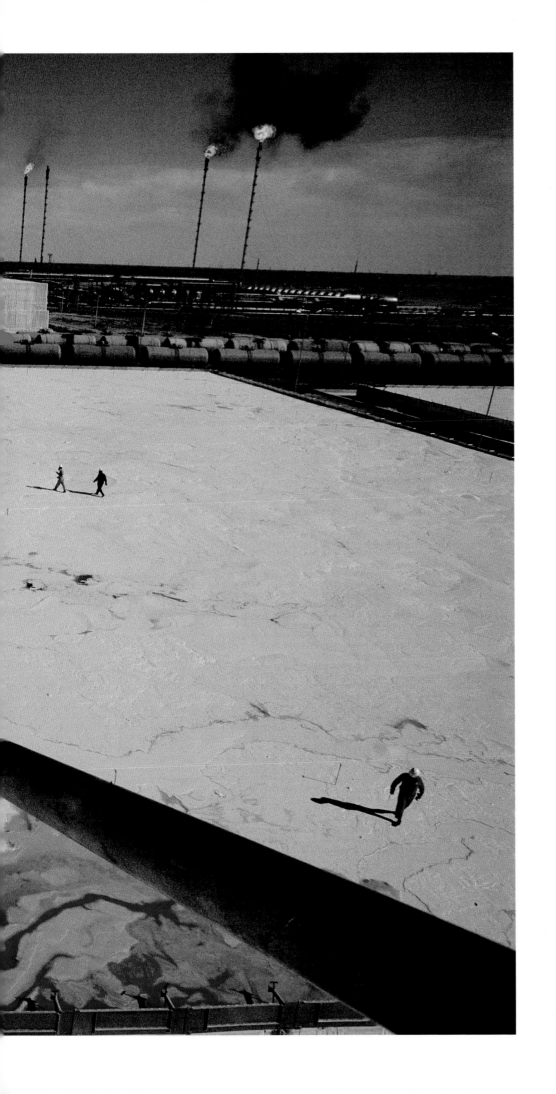

"For the first time in the history of the world," wrote Rachel Carson, "every human being is now subjected to contact with dangerous chemicals, from the moment of conception until death."

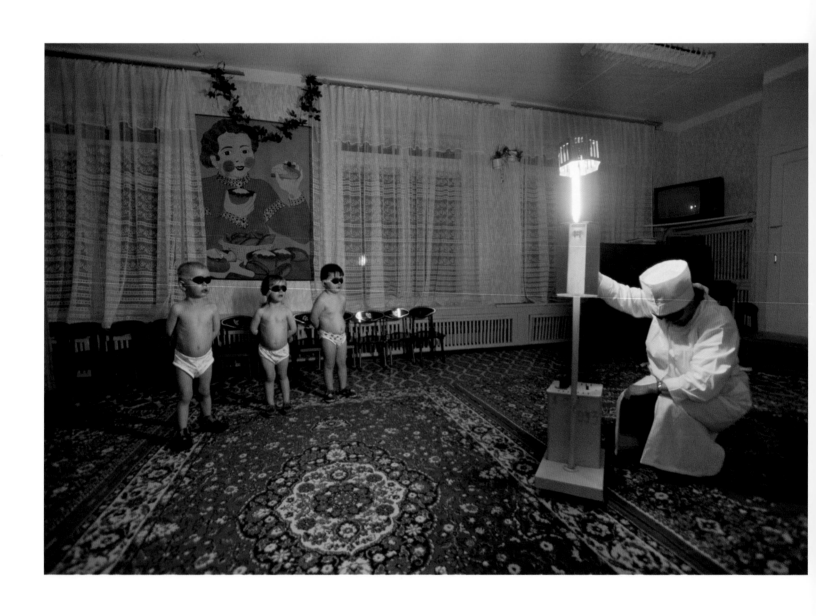

JOE MCNALLY | 2001 | RUSSIA *Vitamin D-rich ultraviolet bath for light-deprived children*

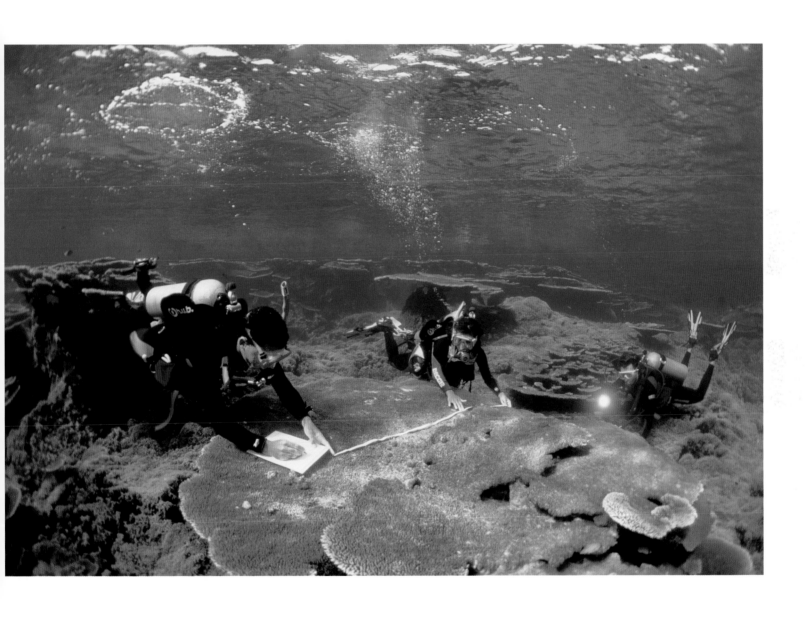

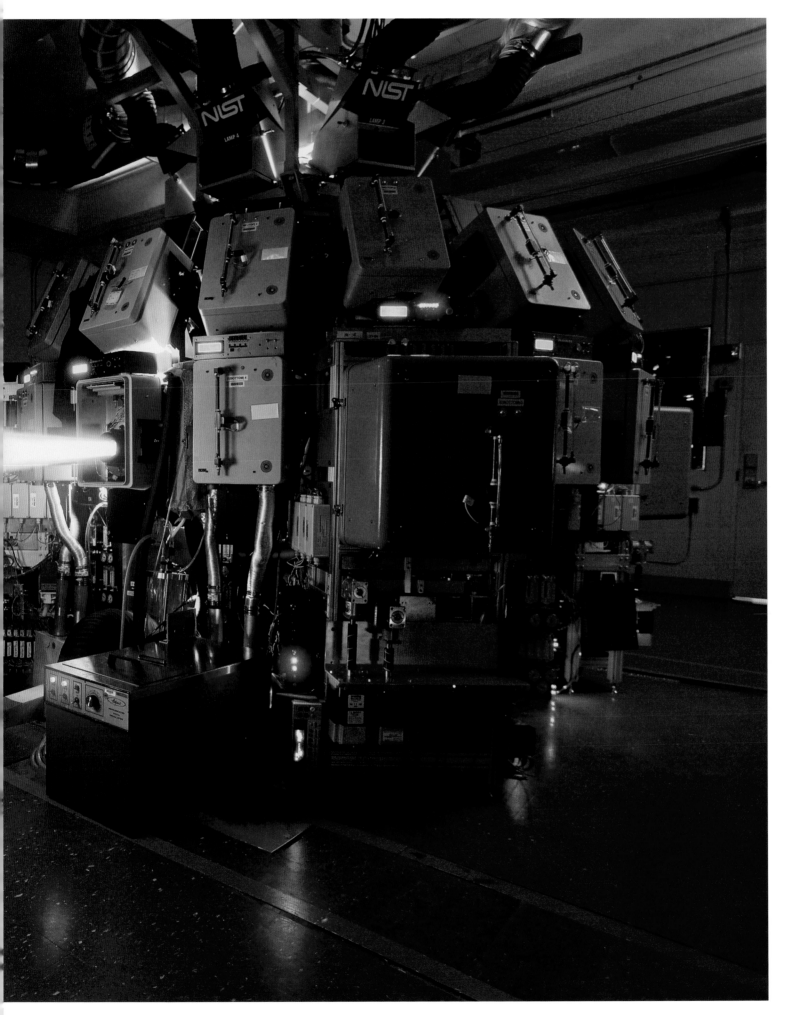

JAY DICKMAN **|** 2002 **|** TEXAS *Bat researchers trying a new approach*

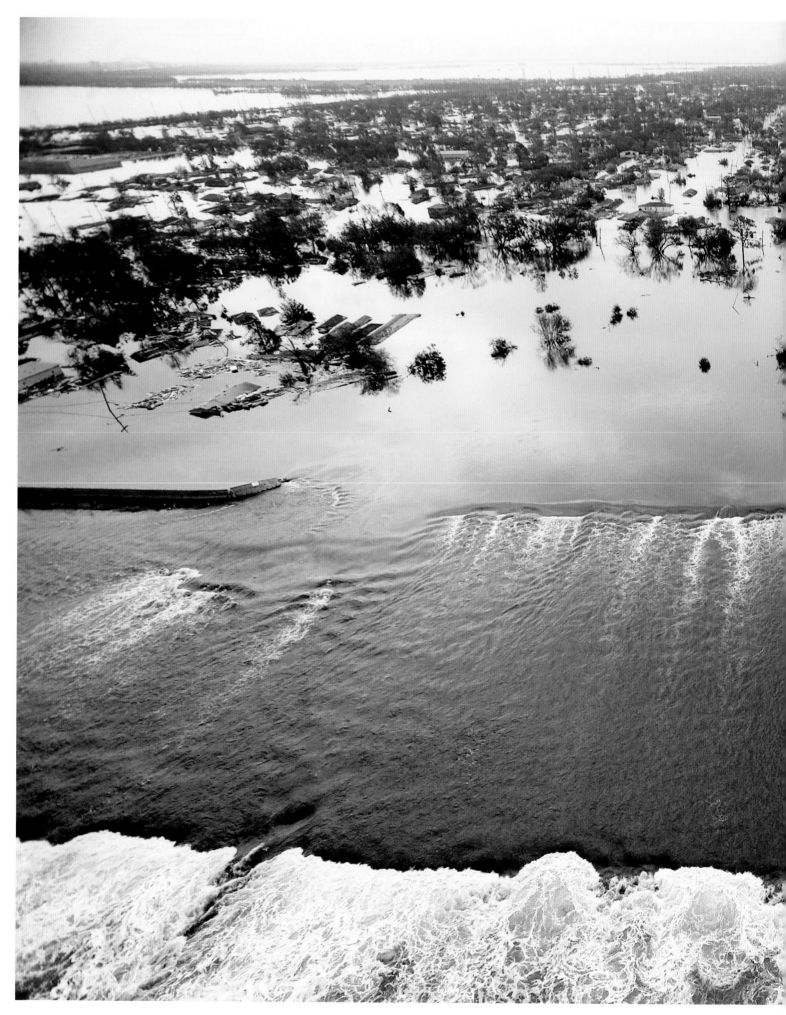

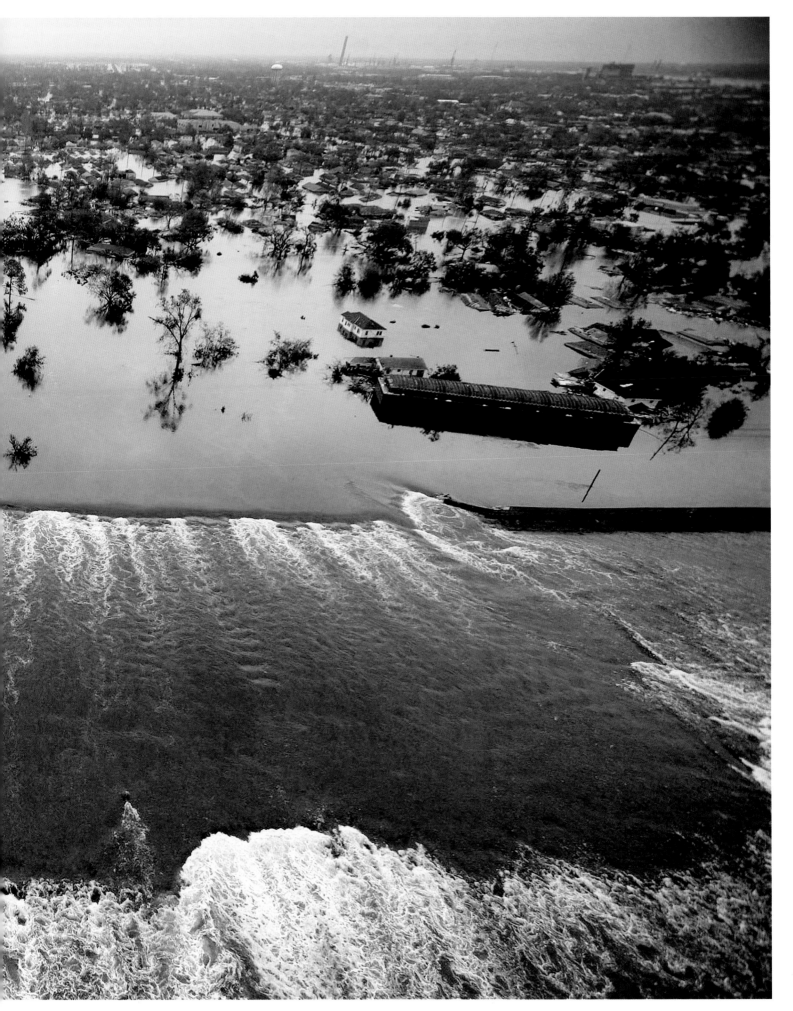

VINCENT LAFORET | 2005 | LOUISIANA *Lower Ninth Ward during Hurricane Katrina*

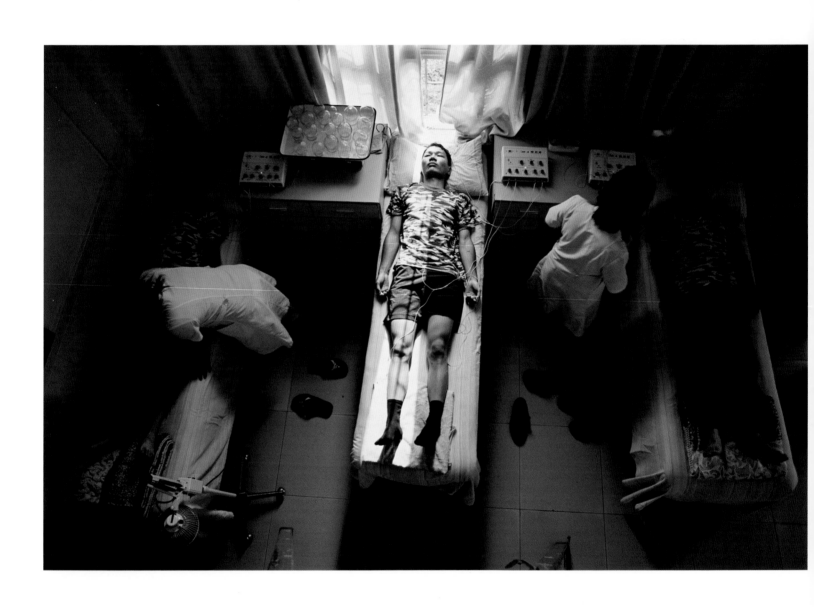

FRITZ HOFFMANN | 2008 | CHINA *Acupuncture to alleviate Internet addiction*

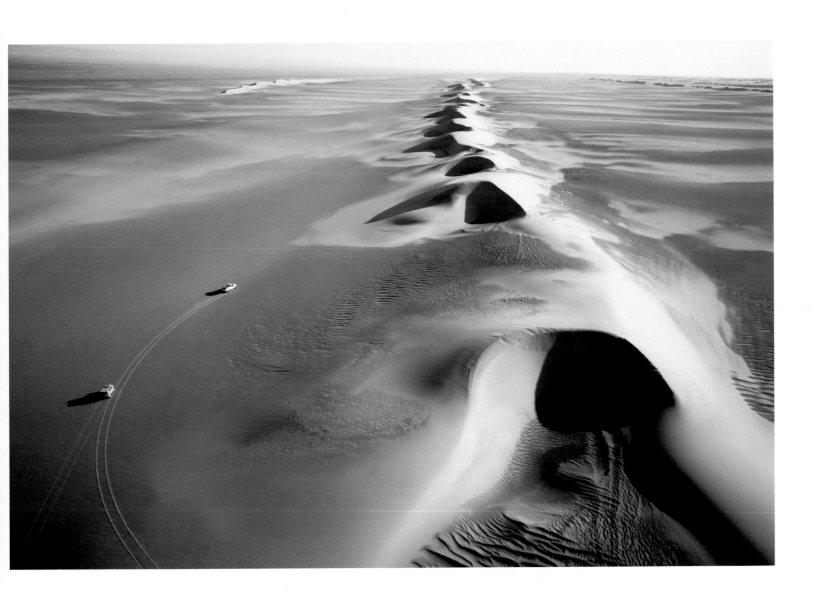

GEORGE STEINMETZ **|** 2008 **|** CHINA *Wind-heaved dunes in the Kumtag Desert*

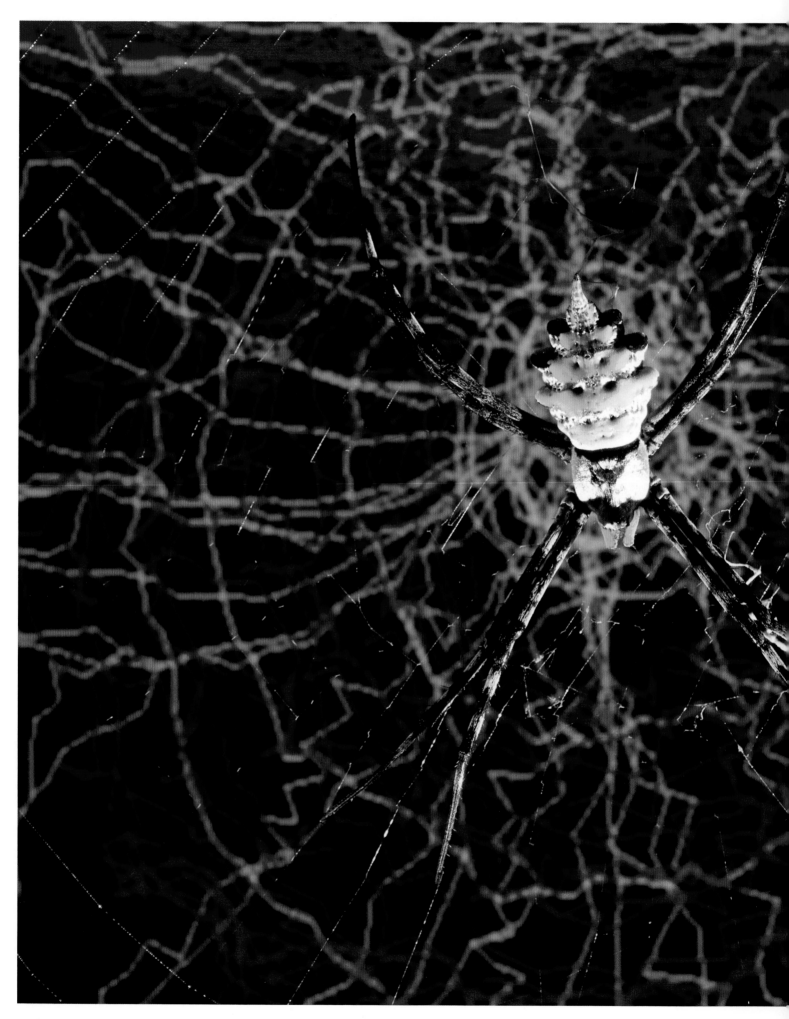

HEIDI AND HANS-JÜRGEN KOCH | 2008 | DENMARK *Patterning how a spider spins its web*

The brain, according to Nobel Prize–winning physiologist Sir Charles Sherrington, is an "enchanted loom" ceaselessly weaving a "dissolving pattern, always a meaningful pattern though never an abiding one; a shifting harmony of subpatterns."

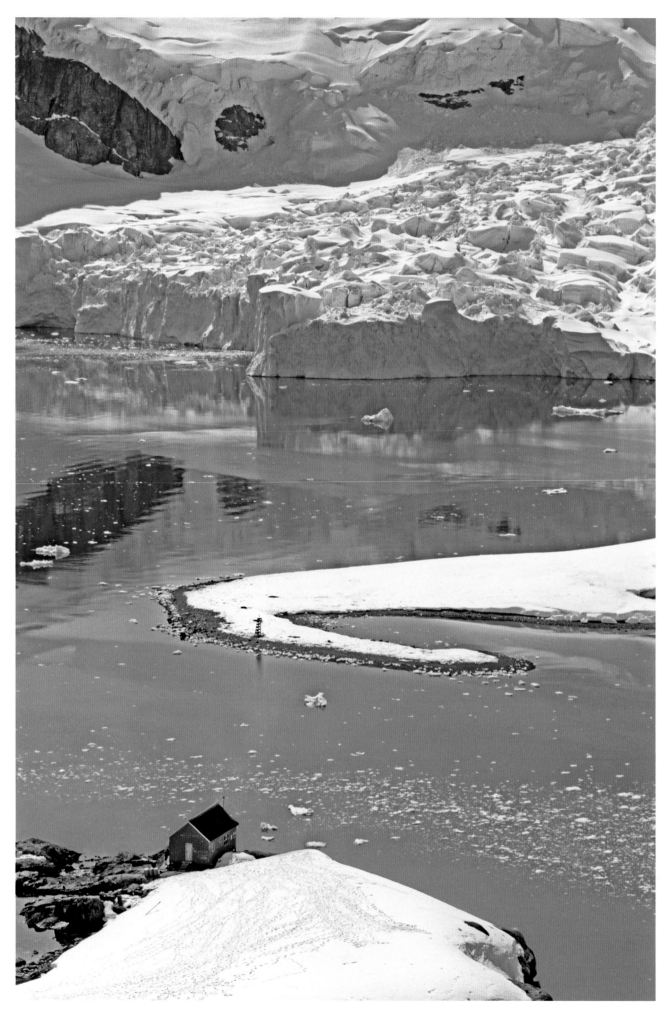

GORDON WILTSIE **|** 2008 **|** ANTARCTICA *Summer melt at Paradise Bay*

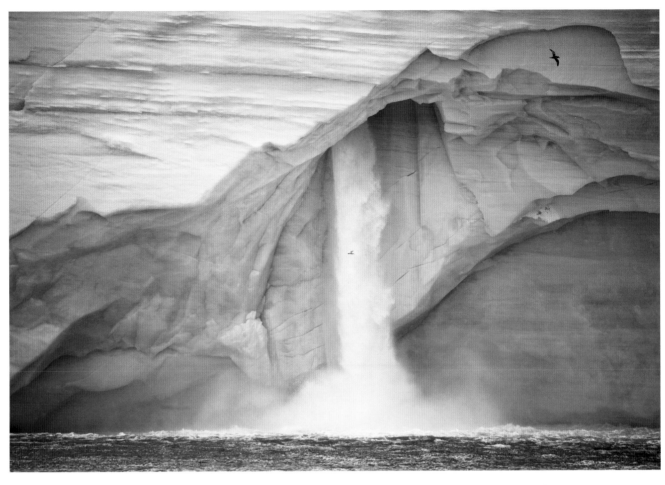

PAUL NICKLEN | 2009 | SVALBARD *Summer melt on the Austfonna Ice Cap*

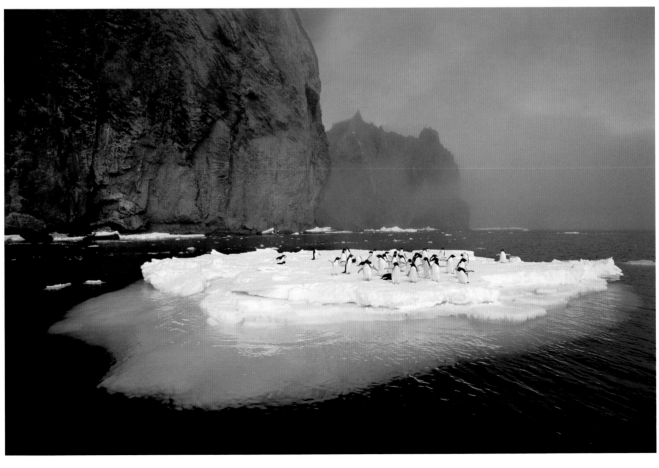

TUI DE ROY | UNKNOWN DATE | ANTARCTICA *Penguins on an ice floe* The Digital Range | 443

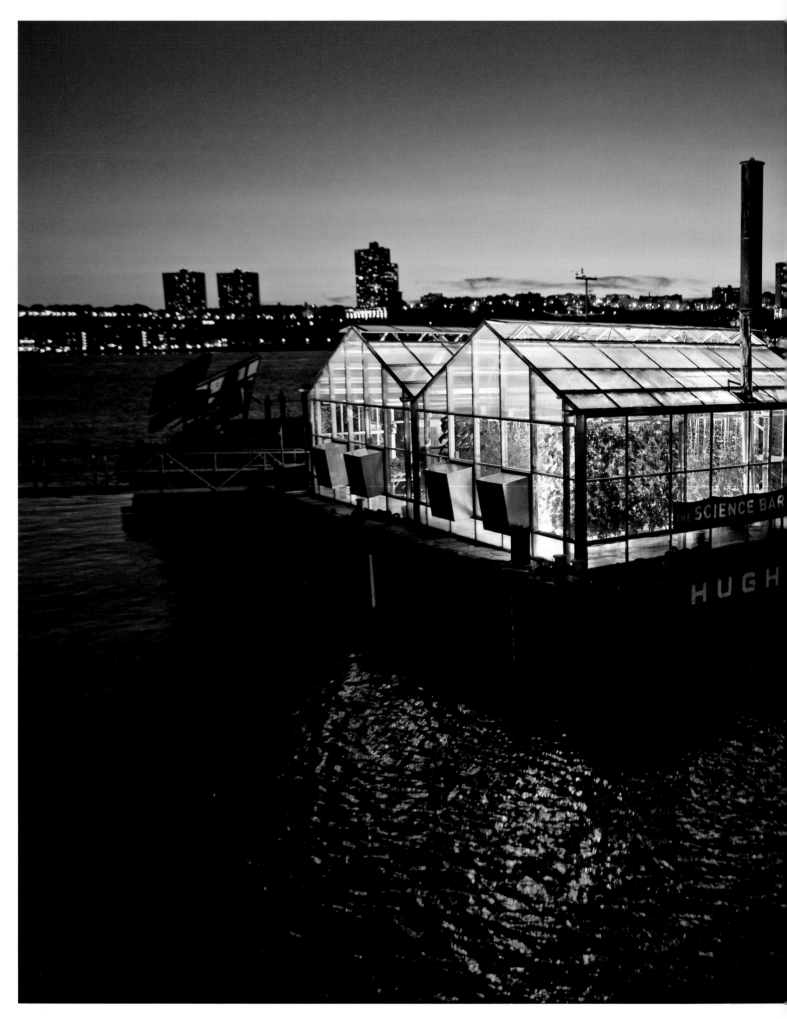

TYRONE TURNER | 2009 | NEW YORK *Twilight falling on the green world*

"Too late," says biologist
E. O. Wilson to those
who dream "in Paleolithic
serenity" of restored
ecosystems. "Put away your
bow and arrow, forget the
harvest of wild berries; the
wilderness has become a
threatened nature reserve."

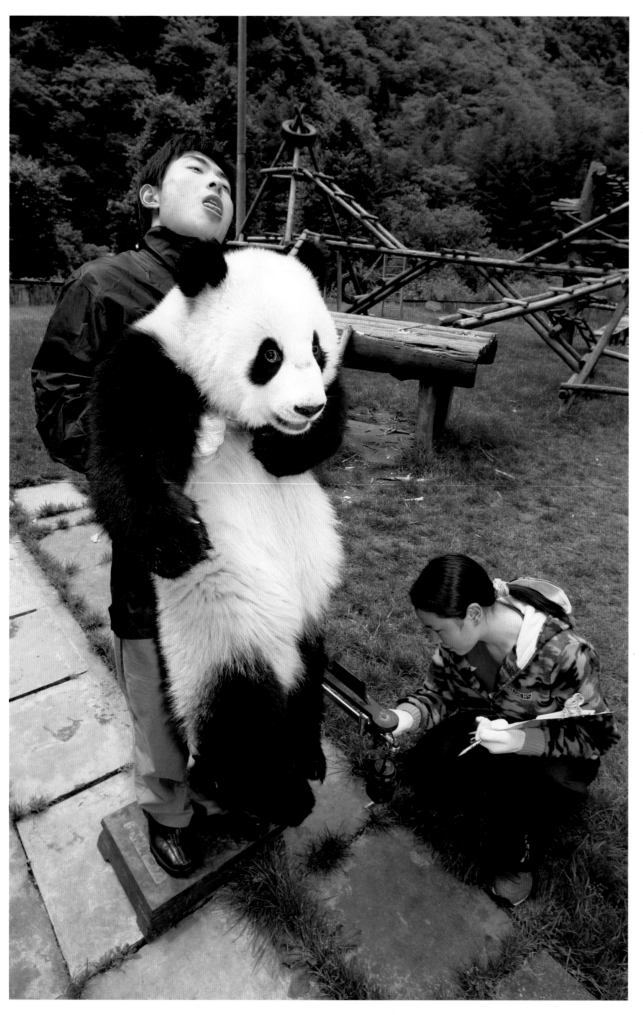

KATHERINE FENG | 2008 | CHINA *Weighing a baby panda*

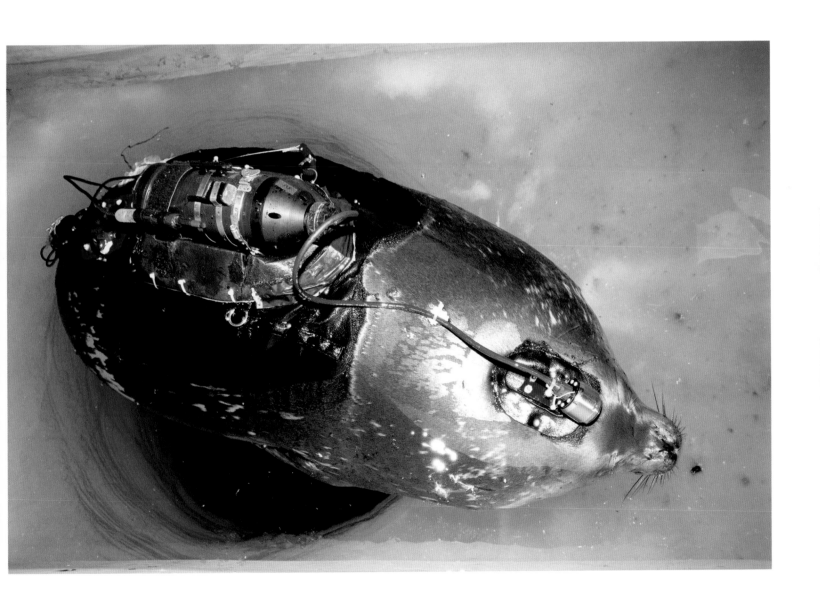

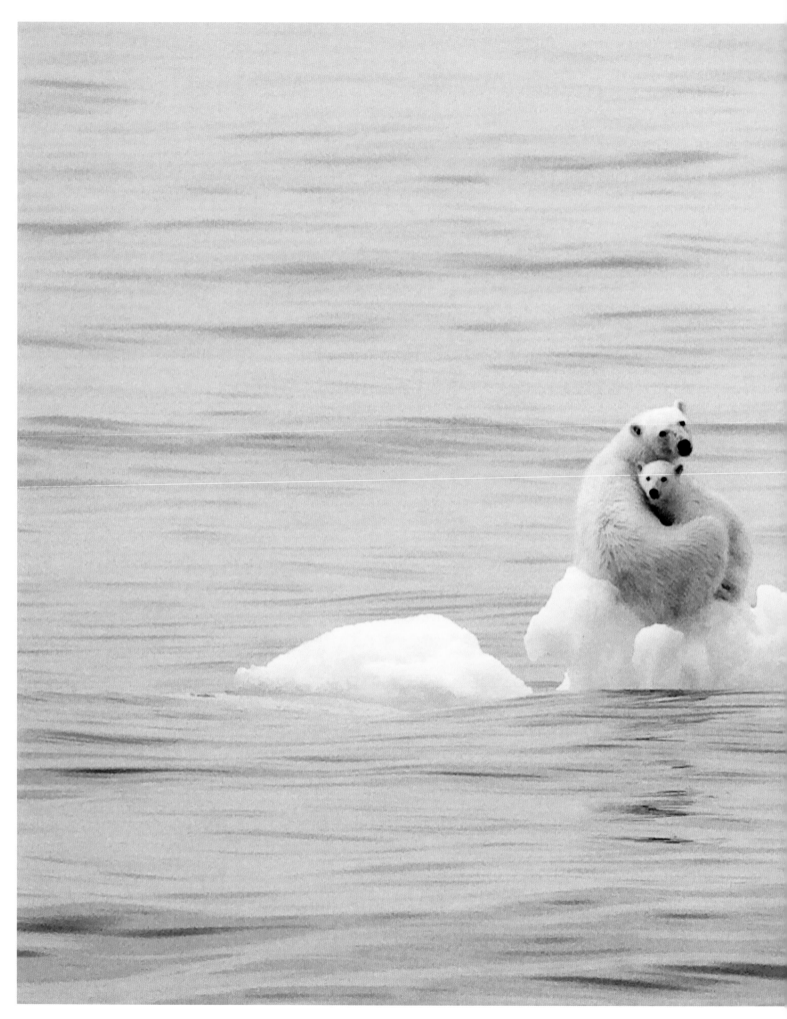

IRA MEYER | 2008 | SVALBARD *Bound to disappear*

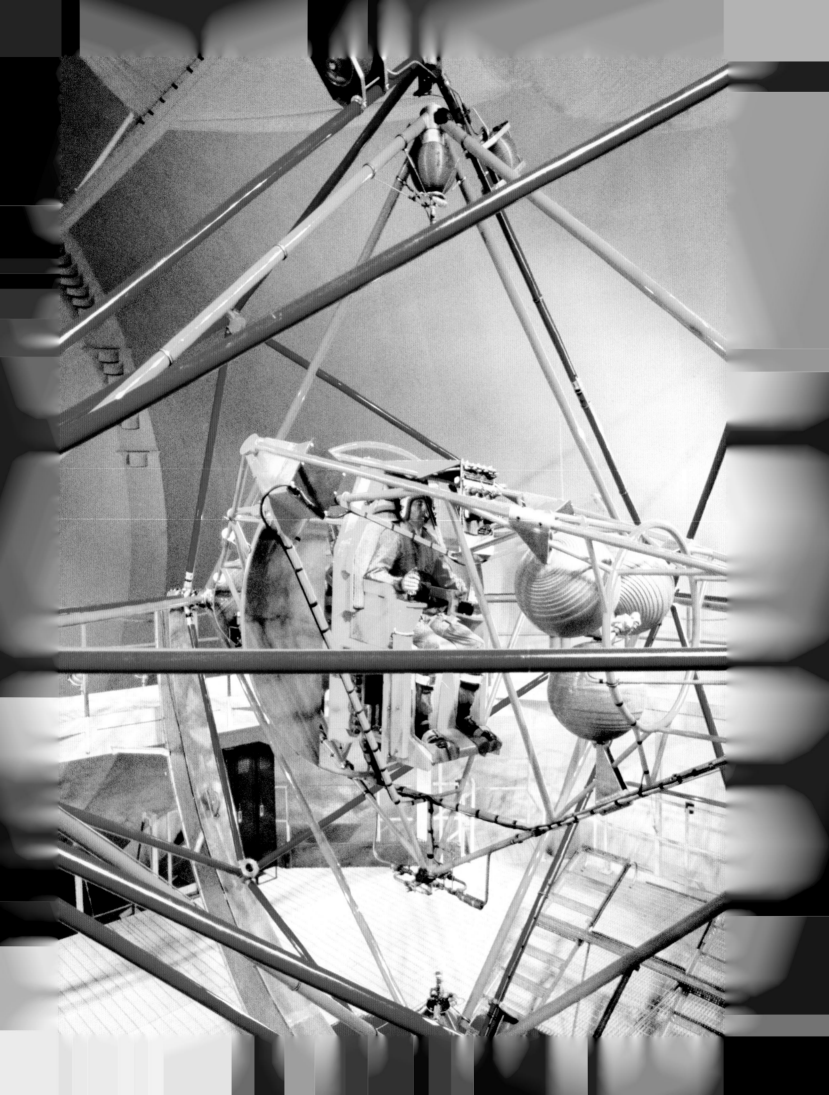

the future of space

THE SPACEFARING DREAM—DEPICTED IN MYTH and story and art and, when we were finally on its threshold, in photographs—that dream, first and last, is what rocket pioneer Willy Ley always said it was, "the story of the idea that we possibly could, and if so should, break away from our planet and go exploring to others..."

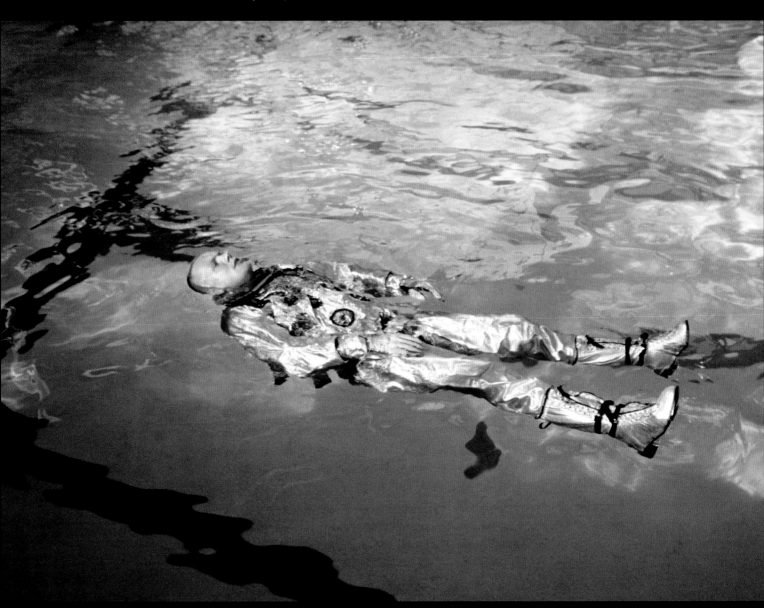

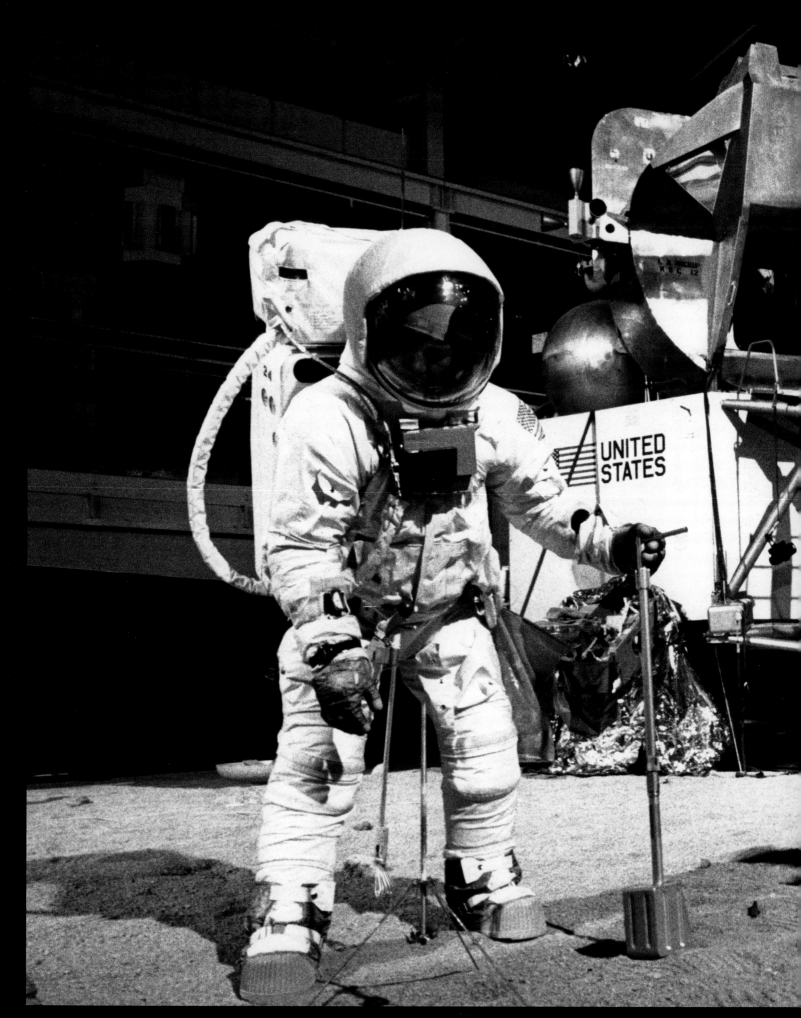

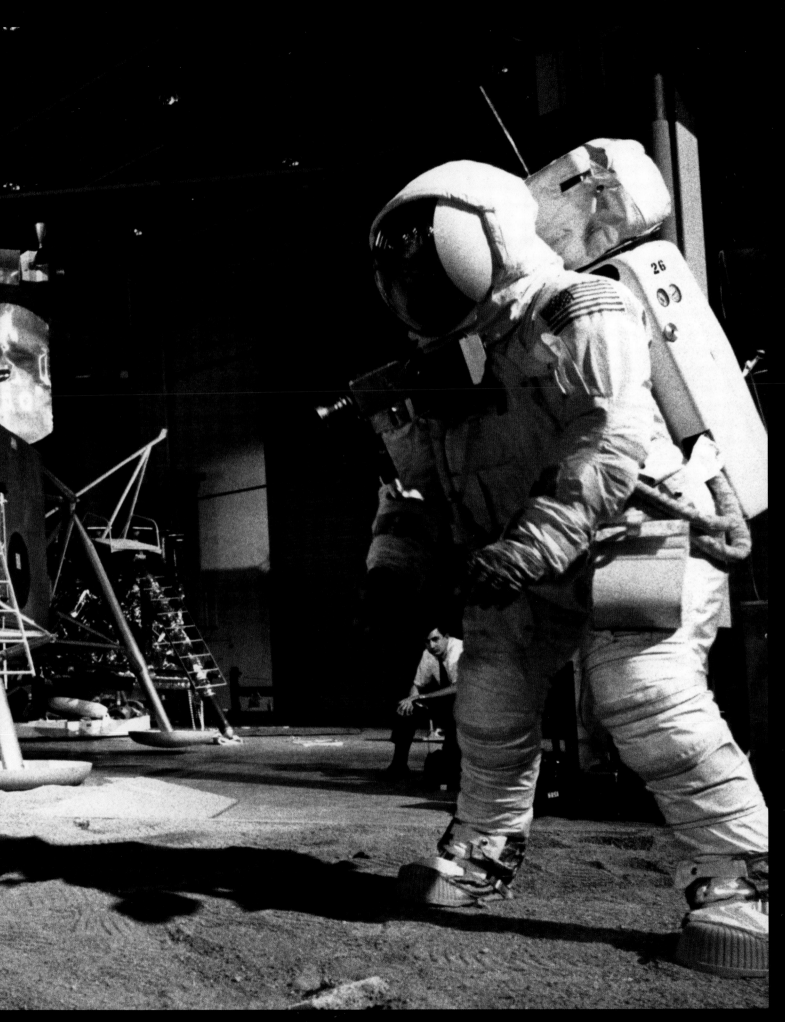

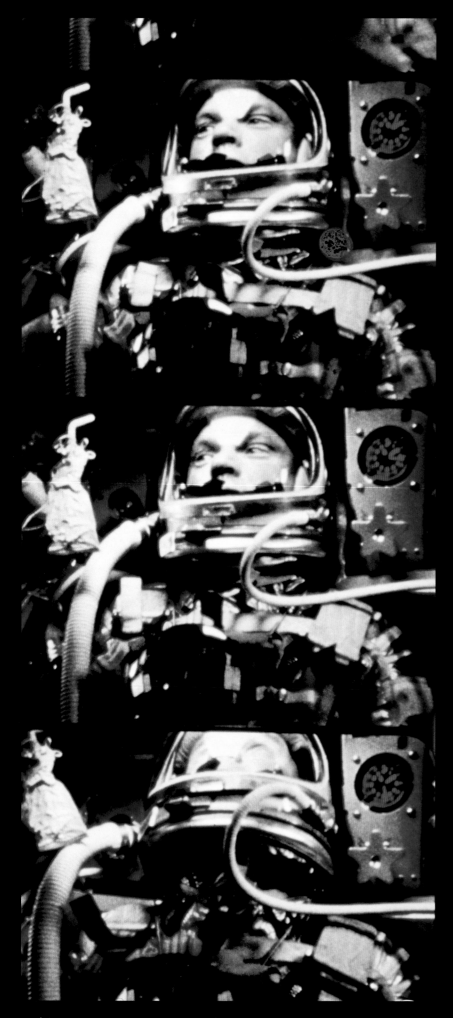

NASA | 1962 | EARTH ORBIT *John Glenn orbiting the Earth*

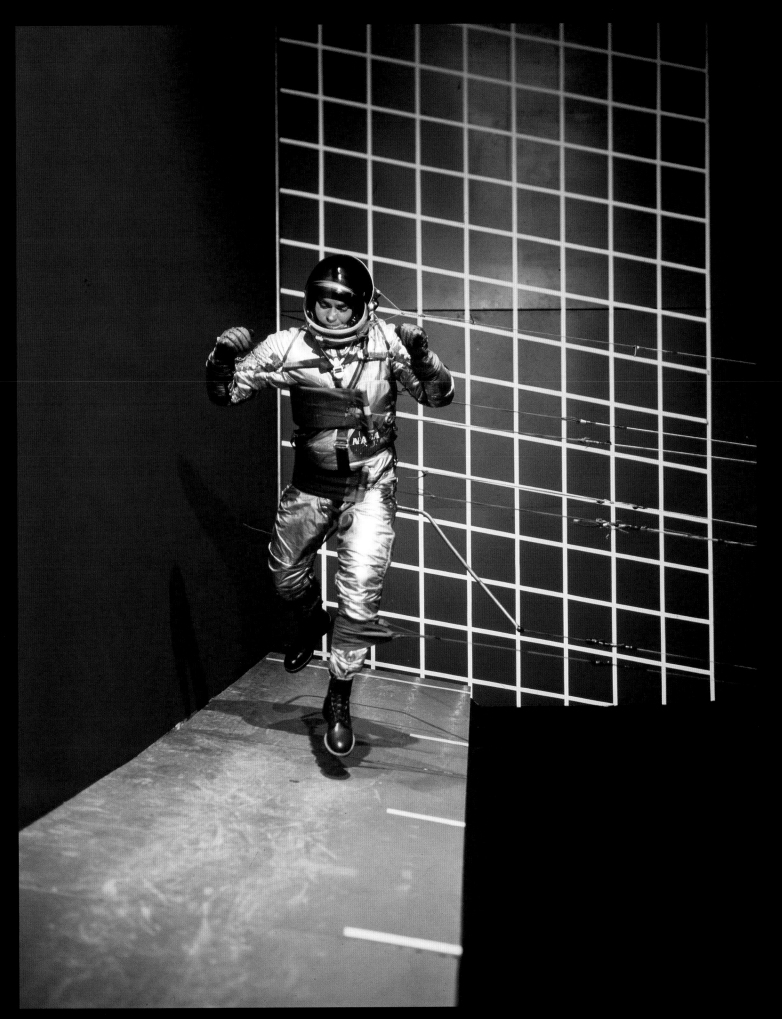

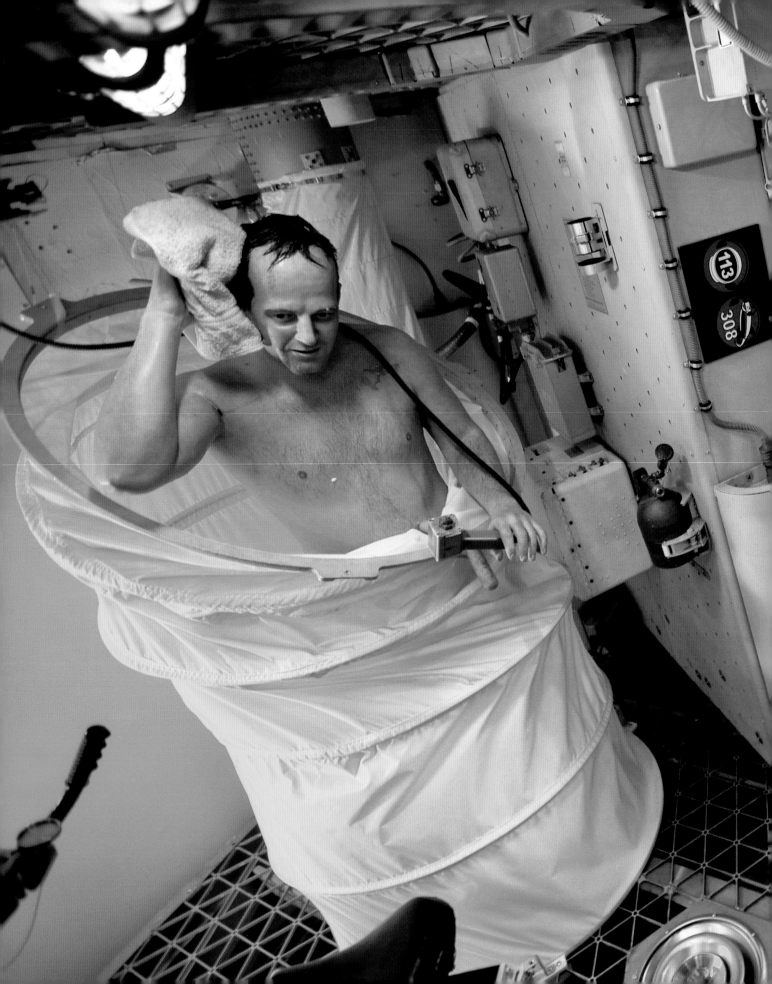

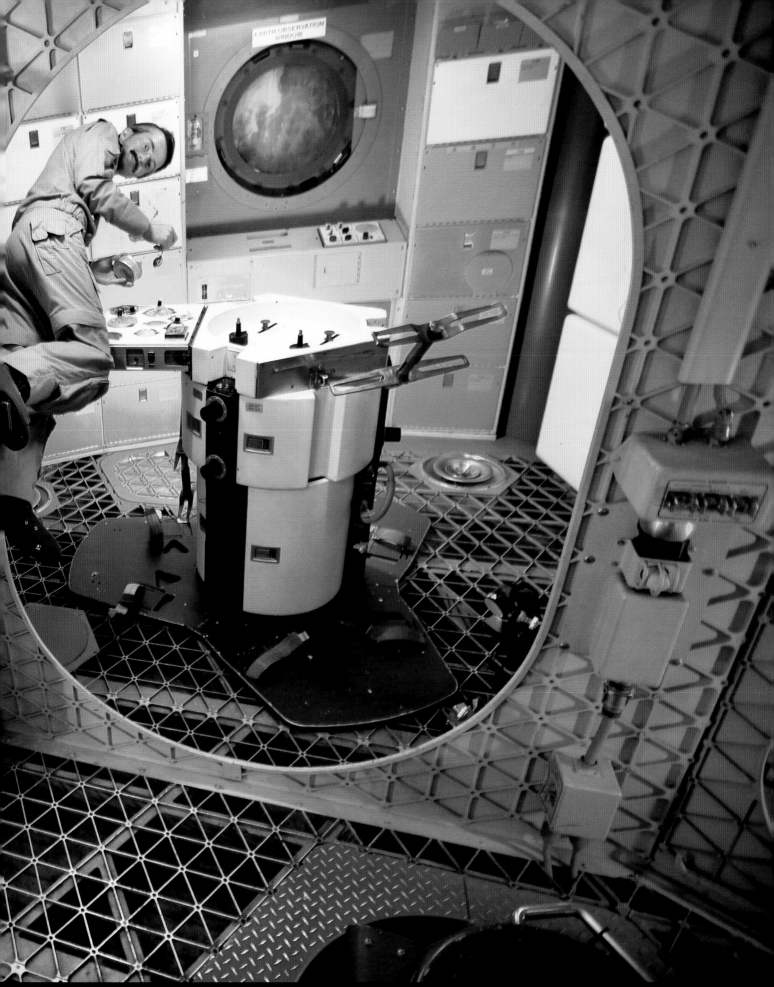

THE COLLECT

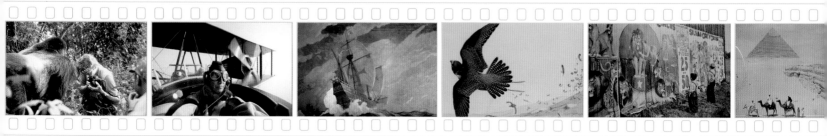

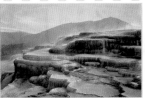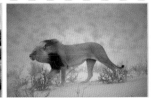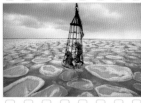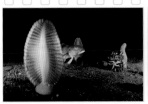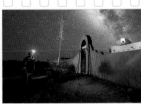

a conversation with **Maura Mulvihill** by **Leah Bendavid-Val**

LBV: Before asking you about the Image Collection I'd like to talk about you: You've been here a long time. Where did you come from? What was your field?

MM: When I was a student I couldn't have imagined or prepared myself for a life in the Image Collection. I went to school for philosophy and rhetoric. I then decided I'd get a minor in art history. But my father was horrified. He wanted me to do something more commercial, so I decided in my last year I'd go to London to study broadcasting.

I got my first job in New York City doing audience research for Group W Broadcasting's TV advertising sales. But I had actually never liked television, and within three months I realized this was a really big mistake. I had met a law student in London, he became my husband, and he told me there were lots of jobs in Washington for art history and policy people. I saw an ad announcing that the Image Bank photo agency was hiring for a new Washington, D.C., office. They hired me and trained me in New York, and I came down to Washington and opened their D.C. branch. I started going door-to-door selling pictures. Of all the places I went, National Geographic was the nicest. The campus was beautiful. And there were such great pictures all over the walls. When I was in their offices once I asked an editor why they didn't license their pictures to other publishers. It seemed so strange that they were licensing pictures from me, but not licensing their own pictures to other publishers. I was told that that would be like selling the family jewels.

LBV: How did you actually get a job at National Geographic?

MM: The first time I walked into the building I was amazed at how big and beautiful the NGS Headquarters was. At the front desk they asked me if I had an appointment, and I didn't, but I saw the guard's book

open. I looked down and the first name I saw was John Agnone with the words *picture editor*, so I said I had an appointment with John Agnone. They called upstairs to get him, and I thought, "Oh my God." He came down, but being very polite he apologized to me for forgetting our appointment. He said, "I'm so sorry, I just didn't remember you were coming; come on upstairs and I'll introduce you to people." I fell in love with National Geographic and ended up licensing Image Bank pictures to John for *World* magazine and for books.

LBV: What amazing nerve you had! OK, so how did you land a full-time job here?

MM: Well, I worked mainly on commission for Image Bank, so it was very appealing to work somewhere where I would get not only a salary but medical and dental benefits. One day somebody in the Illustrations Library, which was what the Image Collection was called at the time, quit. I happened to be in the building and got offered the job, by Fern Dame, the illustrations librarian. I was working before she realized I had never filled out an official application!

LBV: So when was that?

MM: September of 1979.

LBV: What was the collection like then? How big was it? How would you describe it?

MM: The Illustrations Library originally belonged to the Illustrations Division of *National Geographic* magazine. When I began most of us, almost entirely women, worked in one large room. Over in the 16th Street building, the room that is now the Board Room housed all the archival records, and the downstairs room with a big fireplace was filled floor to ceiling with film boxes. We thought of ourselves as primarily clerical. We got the pictures in, we had catalogers who typed up little green cards by subject, and we made sure they were in the file. We also had a Gaithersburg, Maryland, branch within driving distance. That's where the older pictures were kept.

LBV: What went on in Gaithersburg? Did National Geographic have offices there or was it just a warehouse?

MM: There were offices in the main building there but we didn't work in the main building. The photo archive (and staff) was located in the warehouse area right next to the loading dock. Giant trucks would pull up. Products were stored on outside skids. Our member relations departments were there, too. It was called MCB, the Membership Center Building.

LBV: What did you package and mail? What do you mean by *products*?

MM: Books, back issues of the magazine, and the membership promotional mailings and renewals for our magazines. Membership did the work. The whole basement floor of the main MCB building was filled with people just mailing and shipping. In the warehouse, there was a little office where people would monitor the trucks coming and going. The picture archive was right behind that office. Initially, some of the pictures, including the glass plates, were kept outside in the warehouse. The Image Collection staff would research requests and then pull pictures and pack them for shipping for review at the DC headquarters. Our staff had to be vigilant about cleaning; we had problems with mice from time to time.

LBV: Really? Oh my gosh!

MM: A couple of heroic employees noticed that Autochromes were filed in the warehouse, open to the elements much of the time, and brought them into the picture archive. It is amazing that the Autochromes appear to have sustained little damage from this exposure. You could never have left 35mm transparencies in these conditions for 10, 15 years with so little effect. I don't know how long the

plates were out there, but we filed them in the picture archive when they were discovered. One of my early projects was to gather the Autochromes, all 12,000 of them, and bring them downtown for low-resolution scanning for videodisc. We had to pack and wrap them, and record and number them. We were producing videodiscs, silver analog discs that contained images scanned at a very low "thumbnail" resolution and cataloged by subject and photographer. Using a database and the videodiscs, we could research and review thousands of images daily without handling the delicate originals

LBV: Did the collection have a purpose?

MM: I understand that the editors didn't want to give away the pictures, but they also didn't want to keep all the film in their offices. The film boxes, "blue boxes" from past stories, were lining the hallways. Meanwhile the photographers were shooting more and more. Photographs collected by the Grosvenors were kept in one place, and pictures that various editors had collected were kept in their offices. Eventually it was decided to have a centralized place to store all the photographs and art and keep track of it, like a book library. It was in 1919 that NGS established this library for the magazine's photography and art "illustrations," managed by the illustrations editor of the magazine. That is why we were called the Illustrations Library.

LBV: So it was basically the fact that we happened to own the material, had paid for it, and had it under our jurisdiction that impelled us to somehow figure out how to manage it, was that it?

MM: And being Geographic, even if we didn't have an exact purpose for it in mind, we wanted to make sure that we were taking very good care of our collections. We weren't doing it necessarily because we recognized the tremendous historical value of the photographs and art or because we had a purpose in mind. It was because that's the kind of organization we were, we took care of our things, we took care of our buildings, we took care of our assets. I think that's why later on, in the 1960s, when NGS management began directing a culling of the collection because of file overcrowding, people didn't really object and say we have a mission to preserve these photographs for posterity. I don't think people thought of the collection that way. Editorial staff began culling—the way libraries do. They threw out material, because there had never been a verbalized purpose for retaining it.

LBV: Did the blue boxes contain both slides and prints and pretty much anything that was visual output?

MM: Well of course they're gray now, but the blue boxes were filled with 35mm transparencies. The boxes began to be accumulated as early as the late 1930s and '40s. Black-and-white prints were kept in photo folios. We had drawers and drawers of those. The culling was discontinued, but not before many important collections were discarded.

LBV: So what was the size of the collection altogether when it was all assembled downtown and the culling was stopped?

MM: Nobody actually knows for sure. We've always said it was almost 11 million pictures. And we still say that today—almost 11 million pictures. Various reports state how many we think we have but there are different ways of counting. What if there are five images on one contact sheet? Do you count it as five or as one? Do we count our duplicates? We began a massive duplicating project in the '90s before digital took over because we realized we just couldn't charge out 35mm originals anymore—too many were getting lost or damaged or not returned, or misfiled. We began only charging out dupes. Now we have probably two or three million 35mm film dupes in our film room and we don't know what to do with them. We only provide digital scans—nobody uses dupes anymore.

LBV: What do you intend to do with them?

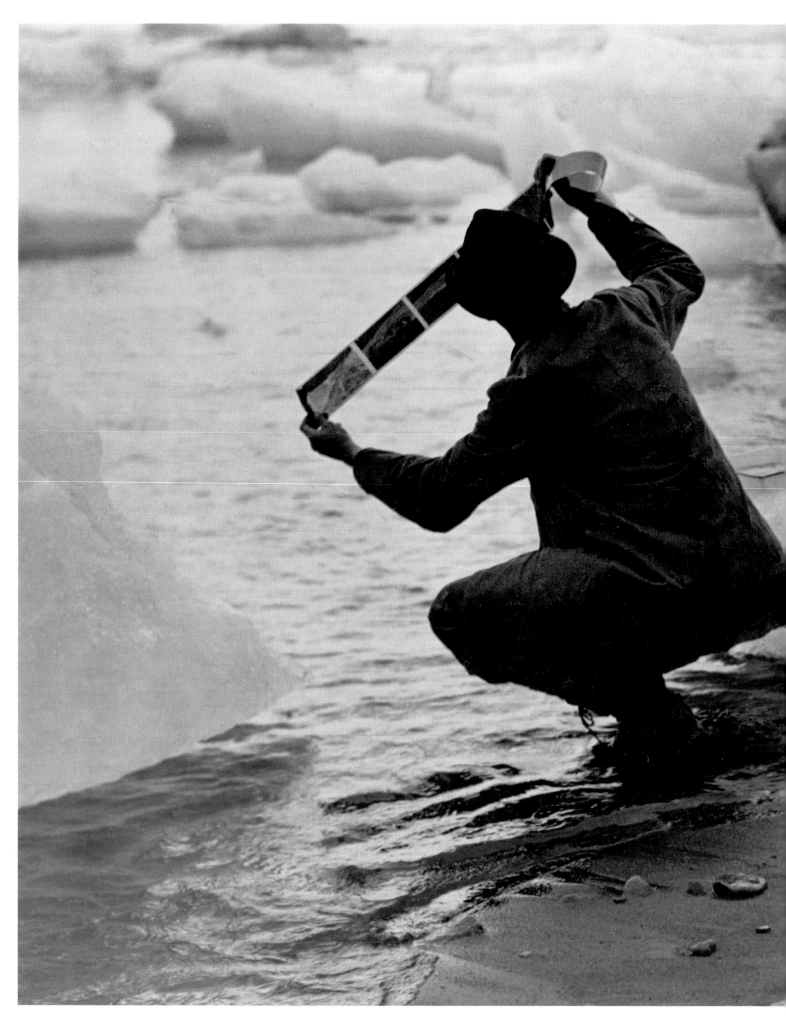

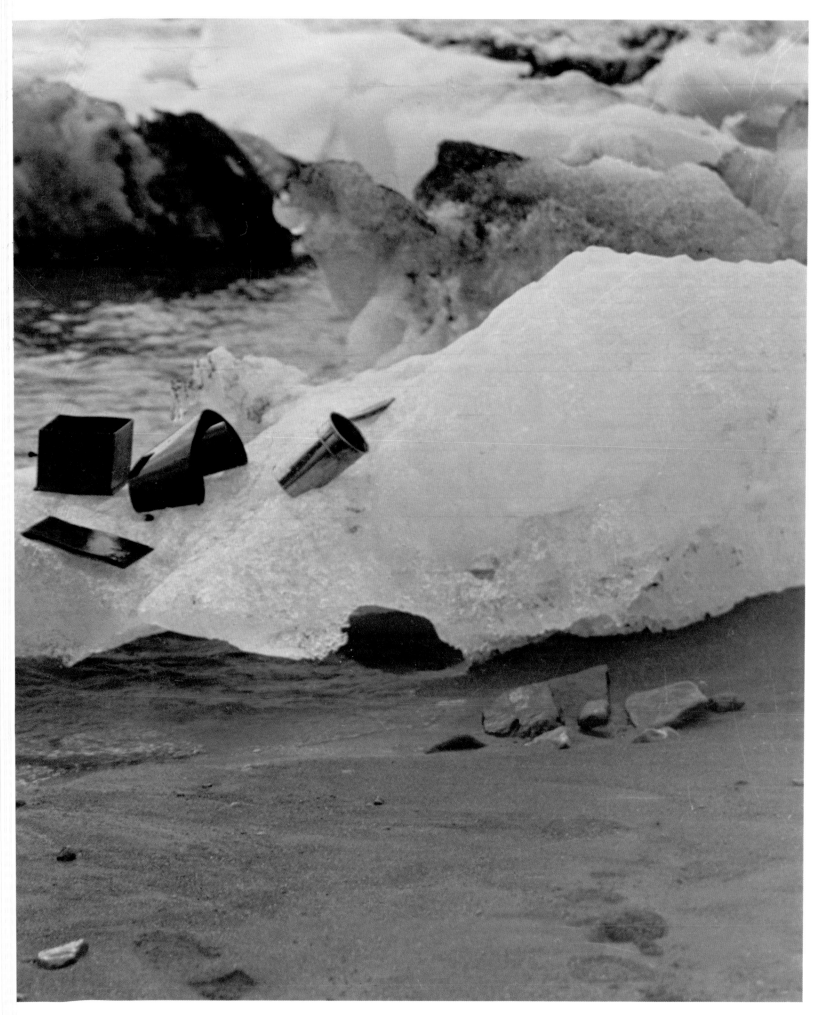

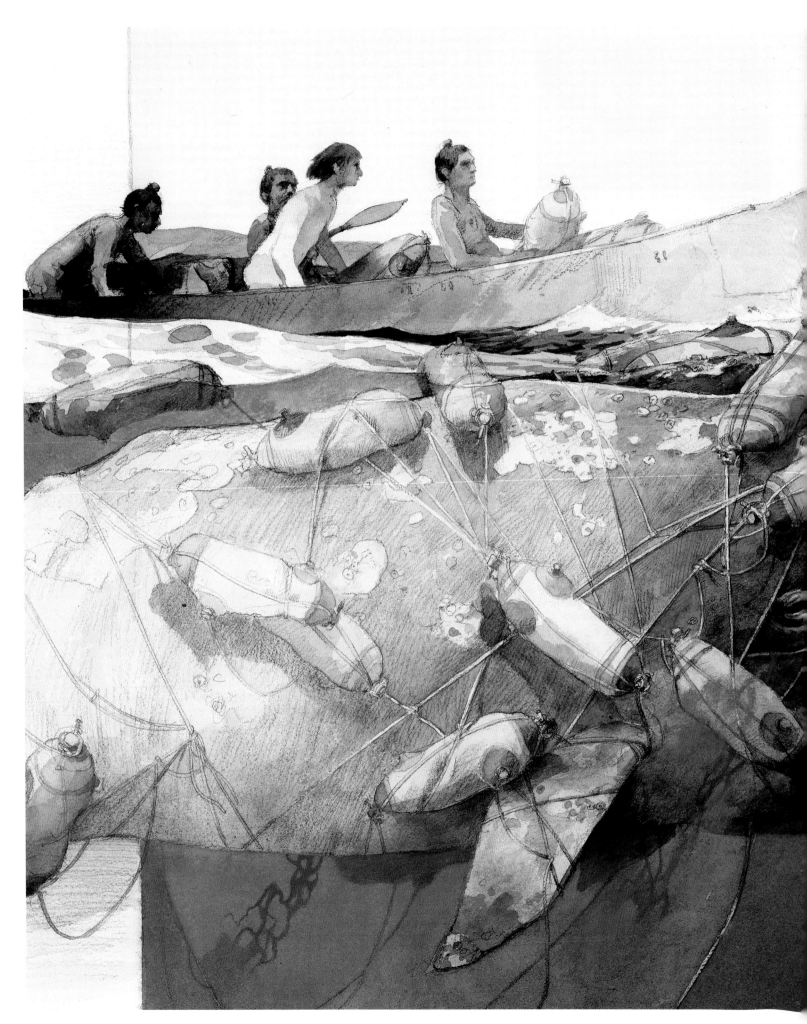

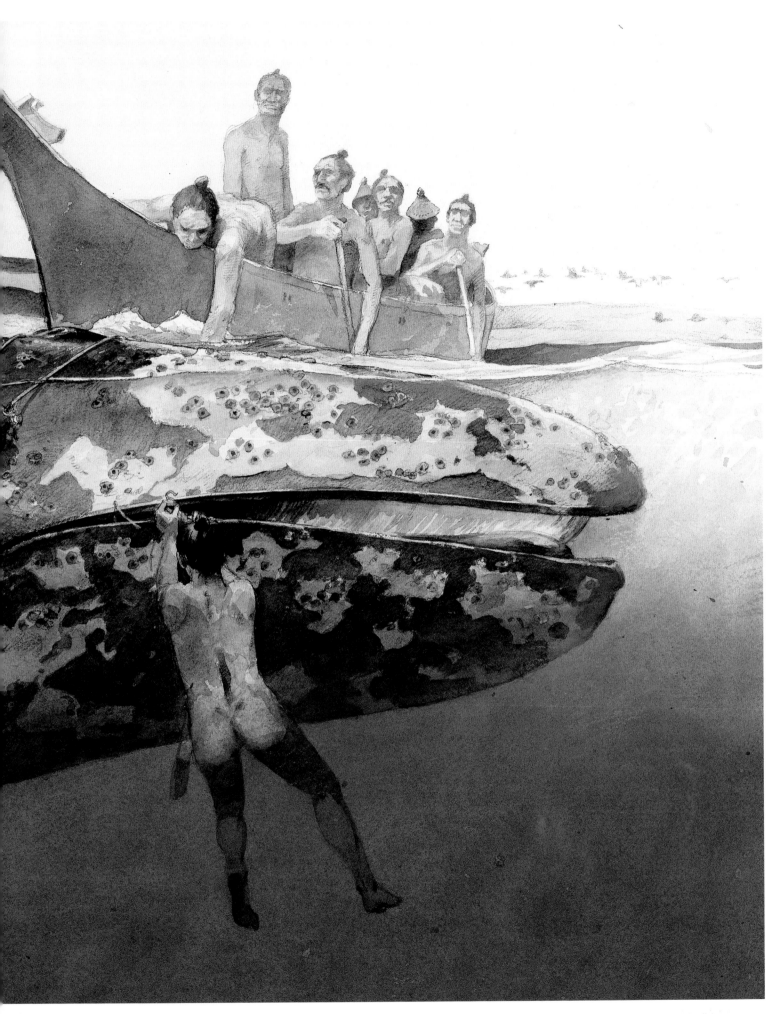

RICHARD SCHLECHT | 1991 | WASHINGTON STATE *Pre-Columbian Makah Indians hunting whales*

THE ARTISTS

ANDERSEN, ROY Roy Andersen studied at both the Chicago Academy of Fine Art and the Art Center School of Design in Los Angeles. Some of his paintings that were used as covers for *Time* magazine are in the collection of the National Portrait Gallery; he also contributed a series of illustrations for stamps for the U.S. Postal Service.

BEAUMONT, ARTHUR A native of England, Arthur Beaumont (1891-1978) served for many years as the official artist of the U.S. Navy. He painted on-site at battles during World War II. His paintings have been exhibited at the National Gallery of Art, the White House, and naval bases throughout the U.S.

BERANN, HEINRICH A resident of Lans, Austria, Heinrich Berann (1915-1999) painted European landscapes ranging from Mount Aetna to the Black Forest. In preparation for his view of the Himalaya mountains, he spent a month in India and Nepal and consulted with cartographers and Himalayan experts before beginning the 600 hours of work at his drawing board needed to complete the illustration. His paintings of the world ocean floors, commissioned by National Geographic, had a major impact on cartography.

BIANCHI, PETER Peter Bianchi was a staff illustrator for National Geographic for more than a decade in the 1950s and 1960s. He was an expert in historical re-creations, and his work was also included in the books *Everyday Life in Bible Times*, *The Age of Chivalry*, and *Great Adventures: Exploring Land, Sea, and Sky*.

BITTINGER, CHARLES A native of Washington, D.C., Charles Bittinger (1879-1970) studied physics at MIT before leaving in 1901 for the École des Beaux-Arts in Paris. He enjoyed a successful career as a painter; his work was exhibited at the National Arts Club, the Art Museum of St. Louis, and the Metropolitan Museum of Art.

BLACKSHEAR, THOMAS II Thomas Blackshear II graduated from the American Academy of Art in Chicago and worked for both the Hallmark Card Company and Godbold/Richter Studio before becoming a freelance illustrator in 1982. He has designed many stamps for the U.S. Postal Service, including 28 portraits of famous African Americans for the 1992 Black Heritage series.

BOND, WILLIAM H. Born in London, William H. Bond began his career in art after serving in the Royal Navy during World War II. He graduated from the Twickenham School of Art. Bond joined the staff of National Geographic in 1966. The illustrator for several U.S. postage stamps, he is known for his depiction of subjects in natural history and physical sciences.

BOSTELMANN, ELSE Else Bostelmann (1882-1961) attended the University of Leipzig, Germany, and the Grand-Ducal Academy of Fine Arts in Weimar. She later moved to the U. S. and from 1929 to 1934 accompanied oceanographic expeditions to Bermuda. During these trips, she created oil paintings underwater, using a diving helmet at depths of 14 feet.

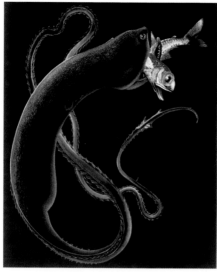

Else Bostelmann, The great gulper eel, *1934*

BROOKS, ALLAN Born in India, Allan Brooks (1869-1946) traveled widely before and after World War I military service. While he was living in British Columbia in the 1930s, the National Geographic Society commissioned him to paint hundreds of illustrations for a series of ten articles on bird families of the United States and Canada.

CALLE, PAUL Paul Calle was born in New York City and studied art at the Pratt Institute. He was named the official artist of the NASA Fine Arts Program; he created the illustration used for the U.S. postage stamp commemorating the Apollo lunar-landing mission.

CHAFFEE, DOUG Doug Chaffee has been illustrating space-related subjects for most of his career. A former head of IBM's art department, he has painted for NASA, the military, and for National Geographic, where he illustrated an article on Mars shortly before the Viking probes reached it.

CHANDLER, DAVID E. David E. Chandler's art for the National Geographic has ranged from illustrations of fleas, carriers of bubonic plague, to the Atacama Desert, to product development studies for such things as map placemats and geography coloring books.

CHEVERLANGE, ELIE An active marine and nature artist, Elie Cheverlange lived in Washington, D.C., and painted for the National Geographic Society during the 1930s. He later joined the staff of the Communicable Disease Center as an illustrator, and spent several years living in Tahiti.

CLEMENTS, EDITH S. Edith S. Clements (1874-1971) was born in Albany, New York, and received a Ph.D. from the University of Nebraska in 1904. She later moved to California and traveled back to the Midwest to find the floral specimens she painted for National Geographic. She also published two books of illustrations: *Flowers of Mountain and Plain* (1925) and *Flowers of Coast and Sierra* (1928).

CRAFT, KINUKO Y. Kinuko Y. Craft was born in Japan, where she attended the Kanazawa Municipal College of Fine and Industrial Arts.

Kinuko Y. Craft, Bringing news of war, *1984*

Craft's clients include *Time, Atlantic Monthly,* and *Sports Illustrated.* Her painting illustrating the Dallas Opera's production of *Madame Butterfly* received a gold medal from the New York Society of Illustrators.

CROWDER, WILLIAM Born in 1882, William Crowder was a writer and painter who specialized in marine life. He wrote numerous books, such as *Dwellers of the Sea and Shore,* and both wrote and painted articles for National Geographic on crabs, the aurora borealis, the moon jelly, and slime molds.

DALLISON, KEN Ken Dallison was born in England, attended the Twickenham Art College and trained as a cartographer in the army. He began specializing in vehicle illustration, especially automobiles, about 1959. He has created many U.S. postage stamps depicting such classics as the Stutz Bearcat and the Stanley Steamer.

DAVALOS, FELIPE Felipe Davalos is an illustrator and photographer who has produced a number of children's and young adults' books. For National Geographic he has illustrated articles on the Aztec, Tenochtitlan, and the Pueblo culture.

DAWSON, JOHN D. John D. Dawson studied at the Art Center College of Design in Pasadena. His illustrations have been published in *Audubon* and *Ranger Rick* magazines, and in the *World Book Encyclopedia;* other clients include the National Park Service and the American Museum of Natural History. He is co-author of the book *Grand Canyon: An Artist's View.*

DAWSON, MONTAGUE Montague Dawson (1895-1973) was one of Britain's premier maritime artists. To the manor born, he grew up in a yachting world and specialized in painting 18th- and 19th-century sailing ships bending beneath clouds of canvas.

DI FATE, VINCENT Vincent Di Fate has produced more than 3,000 illustrations. His work is included in many museum collections, including those of the Smithsonian Institution's National Air and Space Museum. His awards include both the Hugo and the Frank R. Paul Awards. Di Fate is the author of the 1997 book *Infinite Worlds: The Fantastic Visions of Science Fiction Art,* a history of the field.

DURENÇEAU, ANDRE Andre Durençeau (1904-1985) trained at the École des Beaux-Arts and the Germain Pilion in Paris before moving to the United States. As an illustrator, his clients included hotels, ocean liners, and the 1939 World's Fair in New York. He also worked as a muralist for prominent families such as those of Cornelius Vanderbilt Whitney.

DZANIKBEKOV, VLADIMIR Vladimir Dzanikbekov became a Soviet cosmonaut in 1970 and made five flights into space, for which he was twice decorated as a Hero of the Soviet Union. Unsurprisingly, when he retired from the cosmonaut program and took up painting as a hobby, he turned to space themes. He has a minor planet named after him.

EATON, MARY E. Born in Gloucestershire, England, Mary E. Eaton (1873-1961) studied art at several schools, including the Royal College of Art. After moving to the United States, she created illustrations for the New York Botanical Gardens for 21 years. Eaton made 672 paintings for the National Geographic Society; some 200 were published in the magazine and in the Society's 1924 *Book of Wildflowers.*

ELLIS, RICHARD A graduate of the University of Pennsylvania, Richard Ellis is known for his marine natural history illustrations. Among his many publications are *A Book of Whales* (1985), *A Book of Sharks* (1989), and, with John E. McCosker and Al Giddings, *Great White Shark* (1995). He has also contributed more than 80 articles to magazines such as *Audubon* and *Geo.* Ellis has led cruises for the American Museum of Natural History to Alaska and Antarctica.

EMERSON, GILBERT Gilbert Emerson was an artist on the National Geographic staff during the 1950s and '60s. He painted subjects as varied as Hannibal crossing the Alps, atomic energy, space satellites, underwater archaeology, the Dead Sea Scrolls, and notable trees.

ESTILL, ELLA A painter of botanicals, Ella Estill was born in Ohio but painted mostly the flora of the desert Southwest. A watercolorist, her depictions of cactuses and other plants were often painted for the Smithsonian Institution.

EUBANKS, TONY Tony Eubanks is a painter of the American West. Born in Texas, he studied at the Art Center in Los Angeles before returning home and taking up his craft. He has painted cowboys, landscapes, and Pueblo Indians, among a wide range of subjects.

FJELD, PAUL Paul Fjeld is a writer and illustrator whose paintings of Apollo, Skylab, and the space

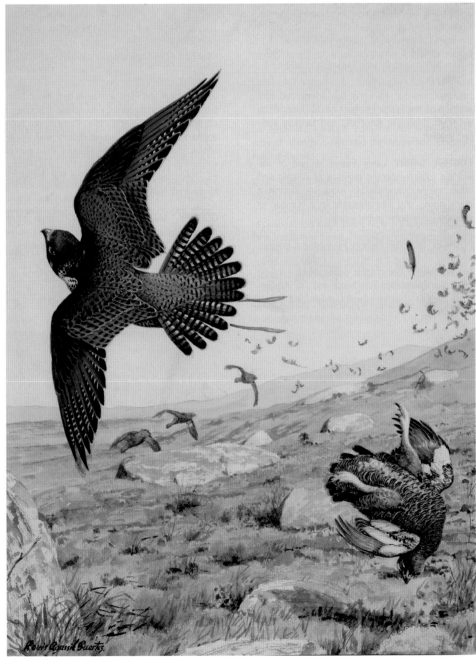

Louis Agassiz Fuertes, A hit on grouse, *1920*

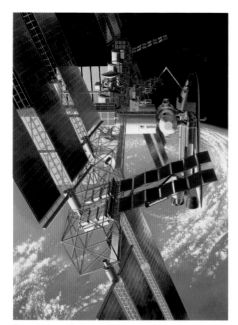

Davis Meltzer, Shrinking the space station, 1991

MEAD, SYDNEY Sydney Mead graduated from Art Center College in Los Angeles. He established his own company, Syd Mead Inc., in 1970, and has contributed designs to many major motion picture and automotive companies. Among the films to feature his work are *Tron, Star Trek: The Motion Picture,* and *Bladerunner.*

MELTZER, DAVIS Davis Meltzer painted illustrations for National Geographic for 25 years. He has created a number of stamp designs for the U.S. Postal Service, including a portrait of Eddie Rickenbacker, a ballooning aerogramme, and the 15 illustrations that made up the "Celebrate the Century 1920–1929" stamp series.

MELTZOFF, STANLEY Stanley Meltzoff (1917-2006) created more than 60 cover illustrations for *Scientific American.* His work also appeared in *Life* and *Saturday Evening Post.* Meltzoff began painting underwater subjects in 1969; he had portfolios of paintings in *Sports Illustrated* and *Field and Stream.*

MINER, EDWARD HERBERT Edward Herbert Miner (1882-1941) was an American wildlife artist who painted subjects, ranging from dogs to horses and cattle, for *National Geographic* magazine in the 1920s and '30s. His work appeared in numerous publications.

MION, PIERRE Pierre Mion studied at George Washington University and the Corcoran School of Art. His illustrations have appeared in *Air and Space Magazine, Smithsonian,* and *Reader's Digest.* Mion is known for his rendering of a tsunami that he painted from eyewitness accounts of the tidal wave on Prince William Sound in March 1964.

MURAYAMA, HASHIME Hashime Murayama (1878-1955) joined the staff of National Geographic at a time before reproducing color photography was common. Dedicated to pictorial precision, he was known to have counted the scales of a fish to ensure the accuracy of his paintings. His watercolors appeared regularly until his retirement in 1940.

OAKLEY, THORNTON A native of Pittsburgh, Thornton Oakley (1881-1953) studied architecture at the University of Pennsylvania before training as an illustrator under Howard Pyle. Oakley wrote and illustrated for many magazines, including *Century, Collier's, Scribner's,* and *Harper's Monthly.*

OTNES, FRED Fred Otnes studied at the American Academy and the School of the Art Institute of Chicago. His work has been included in publications such as *Saturday Evening Post, Fortune,* and *Reader's Digest;* among his clients for commissioned work are NASA, Exxon, and the National Academy of Sciences.

PESEK, LUDEK Ludek Pesek (1919-1999) was born in Czechoslovakia and attended the Academy of Fine Arts in Prague. Noted for his astronomical paintings, he created illustrations for books and magazines in Europe and the United States. In the early 1980s, he produced a series of 35 paintings on the planet Mars. Pesek wrote

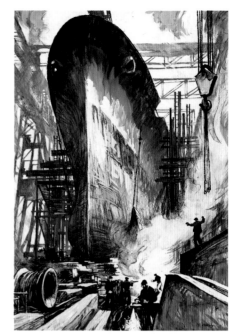

Thornton Oakley, Battleship Alabama, 1942

several science-fiction novels, which he also illustrated.

PETERSON, ROGER TORY The naturalist Roger Tory Peterson (1908–1996) was best known for his 50-volume Peterson Field Guide Series; the first, *A Field Guide to the Birds,* was originally published in 1934. Peterson established the Roger Tory Peterson Institute in Jamestown, Virginia, in 1984 to provide nature education to teachers.

PINKNEY, JERRY Jerry Pinkney is widely known for his illustrations for children's books, for which he has received five Caldecott Honor Medals. He has also received numerous medals from the Society of Illustrators. His work has been exhibited in more than 20 solo exhibitions and 100 group shows in the United States, Japan, Russia, Italy, Taiwan, and Jamaica.

RIDDIFORD, CHARLES E. Charles E. Riddiford (1887-1968) was for many years a cartographer with the National Geographic Society. He is best known for designing the distinctive typeface that was used on Geographic maps for the better part of the 20th century. He also drew elaborately decorated borders for certain maps in the 1930s.

RILEY, KEN Ken Riley was raised in Colorado and studied art at the University of Colorado in Boulder, graduating in 1992. Executing all of his work with pen and ink, he has been influenced by varied artistic traditions, including Japanese.

SANO, KAZUHIKO A native of Japan, Kazuhiko Sano studied painting in Tokyo before moving to San Francisco to study at the Academy of Art College in 1975. Fifteen of his illustrations are reproduced on the U.S. Postal Service's "Celebrate the Century 1970–1979" series. Sano's work has been shown at the Central Museum, Tokyo, and the Museum of American Illustration, New York City.

SANTORE, CHARLES A native of Philadelphia, Charles Santore's work has appeared in all the

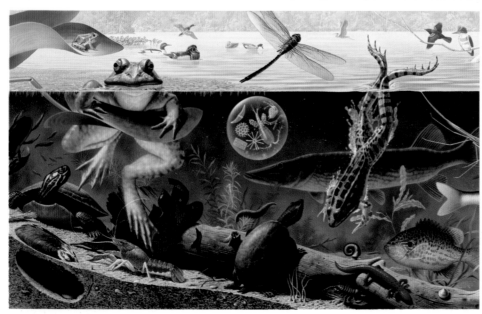

Ned M. Seidler, Teeming life of a pond, 1970

major illustration markets. In the mid-1980s, he began illustrating classic children's stories such as Aesop's Fables and the *Wizard of Oz*. Santore has received many awards, including the prestigious Hamilton King Award from the New York Society of Illustrators.

SCHALLER, ADOLF Adolf Schaller is a painter of space-related subjects who once worked closely with the late Carl Sagan. A writer and composer as well as a painter, Schaller has worked in media ranging from magazines to movies. He has won numerous awards for his creative work.

SCHLECHT, RICHARD Richard Schlecht began his career as a graphic artist while stationed in Washington, D.C., in the Army. His work has been published by Time-Life Books, the National Park Service, and Colonial Williamsburg. He has designed more than 24 stamps for the U.S. Postal Service, including the series commemorating Christopher Columbus' first voyage.

SEIDLER, MARK A former member of the National Geographic staff, Mark Seidler has been a frequent contributor to Society publications as a freelance artist, providing illustrations on topics ranging from archaeology to earthquakes, from elephants to El Niño.

SEIDLER, NED M. Born in New York and educated at Pratt College and the Art Students League, Ned M. Seidler worked as a freelance illustrator for 21 years before becoming a staff artist for National Geographic in 1967. Since his retirement from the magazine in 1985, Seidler has created designs for a number of stamps for the U.S. Postal Service. His work has been shown at the New York Society of Illustrators and at the Brandywine Museum in Pennsylvania.

SIBBICK, JOHN Born in Guildford, England, John Sibbick began a career as a freelance artist after being commissioned to illustrate a children's encyclopedia in 1972. His work appeared in the 1981 book *The Illustrated Encyclopedia of Dinosaurs* as well as in the BBC television series *Lost Worlds, Vanished Lives*.

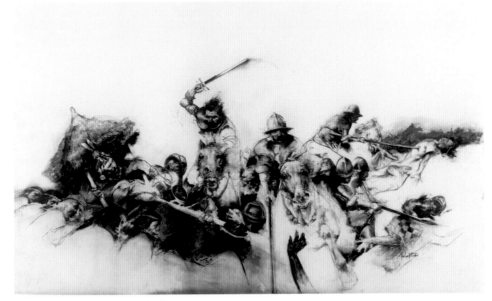

Herb Tauss, Pizarro, conqueror of the Inca, *1992*

SILVERMAN, BURTON A native of Brooklyn, Burton Silverman studied art at the Pratt Institute, Columbia University, and the Art Students League. He has had solo exhibitions in New York, Boston, Philadelphia, and Washington, D.C., and his paintings are in the collections of museums such as the National Museum of American Art and the National Portrait Gallery. Silverman was named to the New York Society of Illustrators Hall of Fame in 1996.

STOREY, BARRON Barron Storey's paintings have appeared in such publications as *Smithsonian* and *Scientific American;* he contributed 14 cover illustrations to *Time* magazine between 1974 and 1984. Among his corporate clients are Paramount Pictures and McDonald's. His mural of the South American rain forest is permanently installed at the American Museum of Natural History in New York.

TAUSS, HERB Herb Tauss's only training in art was at the High School of Industrial Arts in his native New York. He provided illustrations for

magazines such as *Saturday Evening Post, Redbook,* and *Good Housekeeping.* His recent work has concentrated on subjects of social significance such as the Holocaust and the Trail of Tears. He was named to the Hall of Fame of the Society of Illustrators in 1996.

UNRUH, JACK Jack Unruh studied at the University of Kansas and Washington University, St. Louis. His work has appeared in *Rolling Stone, Audubon,* and *Sports Illustrated* and he has received commissions from commercial clients such as IBM, American Airlines, and Nieman Marcus. Unruh received the Hamilton King Award from the New York Society of Illustrators in 1998.

WEBER, WALTER A. Walter A. Weber (1906-1979) served as a staff illustrator for National Geographic for 22 years. Trained both as a biologist and an artist, his first position was with the Field Museum of Natural History. His painting of snowy egrets was reproduced on a 1947 U.S. postage stamp issued upon the creation of the Everglades National Park and was reissued on a special postal card commemorating the 50th anniversary of the park.

WYETH, ANDREW Andrew Wyeth's (1917-2009) long career as an artist was recognized by both the Presidential Medal of Freedom, in 1963, and the congressional Gold Medal, in 1990. His work has been exhibited worldwide. The Center for the Wyeth Family, which opened in Maine in 1998, houses a collection of nearly 4,500 artworks by Andrew Wyeth.

WYETH, NEWELL CONVERS (N.C.) Newell Convers (N.C.) Wyeth (1882-1945) was born in Needham, Massachusetts. His first commercial sale, in 1903, was a cover illustration for *Saturday Evening Post,* for which he received $60. Between 1911 and 1939 he created widely acclaimed illustrations for more than 25 classic children's books published by Charles Scribner's and Sons. In the 1920s, the National Geographic Society commissioned Wyeth to paint five large murals for its headquarters in Washington, D.C.

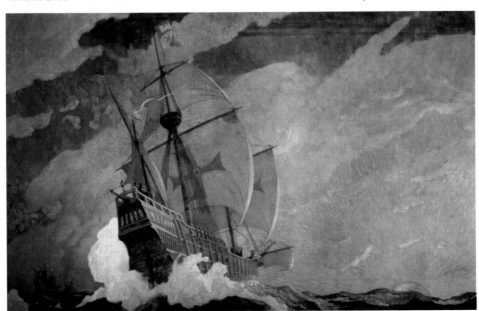

N. C. Wyeth, The caravels of Columbus, *1928*

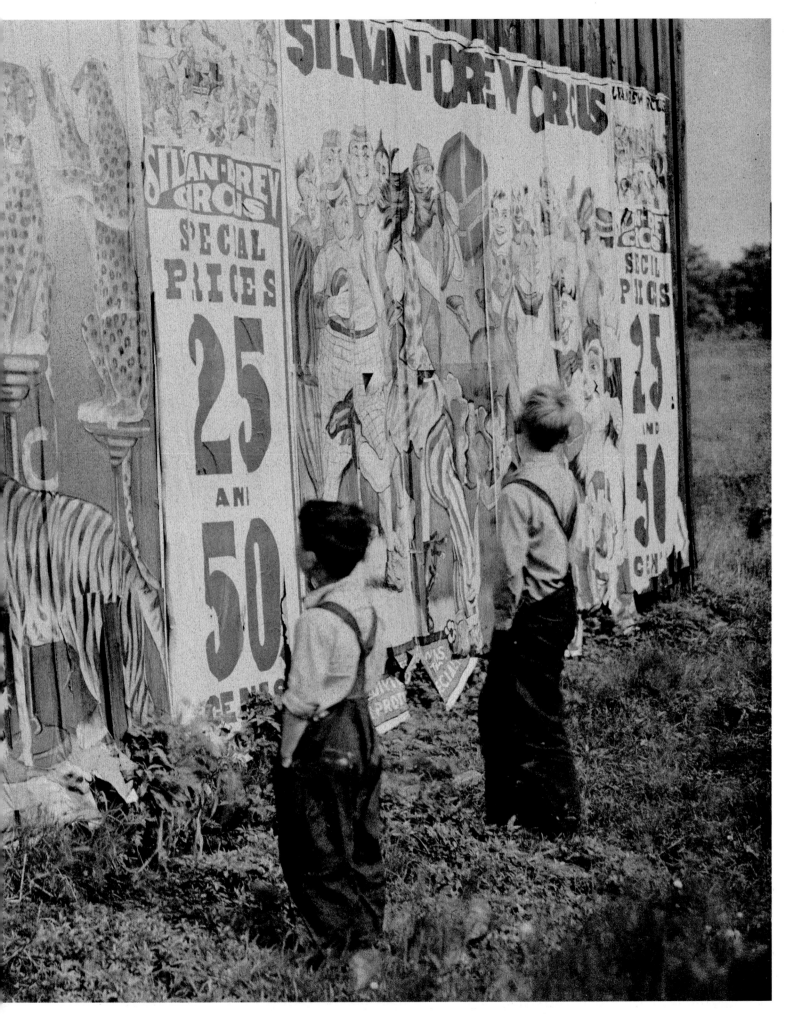

THE AUTOCHROMES

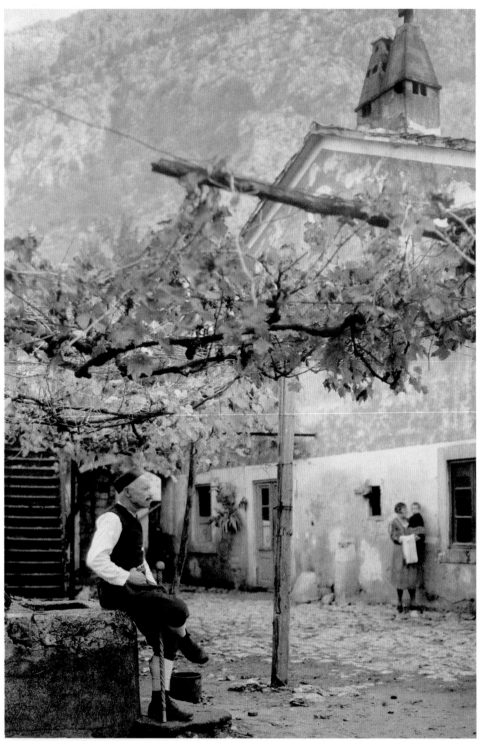

Wilhelm Tobien, 1930, Yugoslavia

Far East that Editor Gilbert H. Grosvenor published in the November 1910 *Geographic*. This experiment was so successful with the Society's members that color had come to stay. It was only a matter of time before hand-tinted pictures gave way to Autochromes.

Invented by the French brothers Auguste and Louis Lumière, the original Autochrome, made widely available in 1907, was a standard 5x7 glass plate evenly coated on one side with a fine mixture of minute starch grains, dyed subtle variations of the primary colors red, green, and blue. A standard panchromatic emulsion was applied to the other side, and the whole was covered by a protective plate. Slotted into a camera, the starched side faced the lens, the emulsion the cameraman. The image-bearing light would strike the starched side first, filtering through its colored mosaic before striking the emulsion.

The result, after development, was a positive image that reflected all the colors, though softened and muted, present in the original scene. As exposure times were slow, too slow to capture action or movement, Autochromes were used for landscapes and still lifes and posed portraits, all of which, however, were lent a beguiling tranquility, a painterly calm which, with that whisper of color, could be quietly enchanting.

The first Autochrome to appear in *National Geographic* was published in the July 1914 issue. "A Ghent Flower Garden," by Paul Guillumette, was a riot of bloom included for no other reason than to prove that real color, "color in the camera," could be engraved and printed in the magazine's pages.

Two years later several series of color plates, made by a former miniaturist painter named Franklin Price Knott and depicting American scenes, were published, heralding the opening of the Geographic's romance with the Autochrome.

When Gilbert Grosvenor, in 1920, installed the first color lab in American publishing, he was inaugurating the golden decade when

Jules Gervais-Courtellemont, 1930s, Algeria

EACH GLASS PLATE, and there are nearly 15,000 of them, is a survivor, having traveled perhaps thousands of miles, enduring falls, careless handling, and slipshod packing before reaching this final destination. Each is tucked into an identical brown paper sleeve. Remove the sleeve, however, and each plate is unique, not an infinitely reproducible negative but rather a positive image, luminous, with a delicacy of color that still remains tantalizingly elusive, like the color of a memory. That is the magic of Autochromes, the first practical

method of color photography, and the Image Collection houses one of the finest assemblages of Autochromes in the world, because in the 1920s *National Geographic* was its chief American purveyor.

The quest for color photography was almost as old as the medium itself. By the end of the 19th century some promising inroads had been made, but they were so time-consuming and cumbersome that most colored photographs were hand-tinted prints. These could be exquisite, such as those of the

Autochromes—over 1,800 of them—ruled the pages of the magazine. No more than 15 photographers were involved, roving all over the world with their cameras and tripods and magical glass plates that, sent in trunks and crates to Washington, might have been as close as they ever got to Society headquarters.

Helen Messinger Murdoch started the parade when eight of her Autochromes of India and Ceylon were published in the March 1921 issue. But soon Grosvenor had enlisted a corps of largely European "Autochromists" to fill his needs.

There was the Frenchman Jules Gervais-Courtellemont, a swashbuckling Orientalist traveler, lecturer, and author as well as photographer who had cut a romantic figure by the turn of the century. Courtellemont provided the Geographic with hundreds of Autochromes of the French countryside, dreamy Spain, sun-splashed North Africa, and exotic scenes from as far afield as India and Cambodia—enough to make up 24 color series.

Hans Hildenbrand, a former court photographer for the King of Wurttemberg and the only German cameraman to record World War I in color, had over 150 Autochromes of Germany, Central Europe, the Balkans, and Italy published. There are more than 700 of his Autochromes still remaining in the Image Collection; they are perhaps the only ones still extant, for the rest were destroyed during a 1944 air raid on Stuttgart.

His fellow countryman Wilhelm Tobien supplied plates enough for 15 color series, depicting not only European scenes but those in Madeira, the Canaries, and the Azores as well.

Gustav Heurlin supplied four color series portraying Scandinavia, while Luigi Pellerano, who had written a popular manual of Autochrome photography, had 41 photographs of Sicily, Rome, and Libya published.

There were Americans contributing Autochromes as well. Fred Payne Clatworthy, who owned a photographic studio in Colorado, supplied images of the peaks and scenic marvels of western North America. And in 1927, at age 73, Franklin Price Knott embarked on a 40,000 mile tour of the Orient, making hundreds of Autochromes from India to Bali and Japan expressly for the Geographic.

When it came to the exotic, however, there was no one quite like Joseph Rock. The Viennese-born plant hunter spent most of the 1920s and '30s, when not dodging bandits, combing the steep hills of southwestern China, collecting rare and useful species for science and making thousands of photographs—including 888 color plates—of wild tribes, otherworldly lamas, and picturesque Tibetan ceremonies.

By the 1920s, furthermore, Grosvenor was assembling his own photographic staff. It included the legendary Maynard Owen Williams, who actually lived abroad and sent back such a volume of material—pictures of Europe, the Mediterranean, the Near East, the Holy Land, and India—that at times it threatened to overwhelm the office. Jacob Gayer joined Williams in making Autochromes in the Arctic, supplying in addition colorful scenes of Latin America and the Caribbean.

The talented Clifton Adams set up his tripods all over the United States as well as in the British Isles, Mexico, and Haiti. And Edwin L. "Bud" Wisherd, making pictures from Louisiana to the desert Southwest, was among the first staff men to actually process Autochromes in the field.

The world was simply wide open for anyone with a camera, tripod, and trunkful of plates to record. In many places he was simply the first of his breed to arrive.

When W. Robert Moore surfaced in Ethiopia to photograph the spectacular coronation of Haile Selassie—he had the emperor hold still for nearly ten seconds, the time needed to expose his portrait—he was the only color photographer on the scene.

And in an era of "firsts," proudly proclaimed at every opportunity in the magazine—the first "natural color" pictures to be made underground, in Carlsbad Caverns, or in Arctic Greenland, where even in daylight flash powder

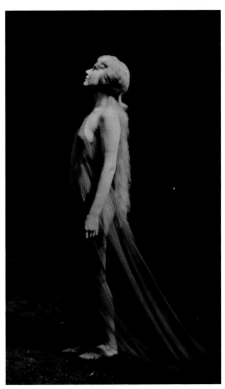

Franklin Price Knott, Unknown date and location

was needed under those leaden skies—there is one series of plates representing a genuine achievement.

In 1926, in the Dry Tortuga Islands off Florida, scientist William Longley and the Geographic's Lab Chief, Charles Martin, pushed the exposure time of the Autochrome plate by coating it with a special emulsion, making it just fast enough that, when one-quarter pound of magnesium flash powder was detonated on a surface raft, the resulting explosion was so bright it even lit up the underwater gloom, enough to capture swimming fish on the plates. Published in 1927, these were the first color photographs ever made beneath the sea.

Yet a few years later, in 1930, when the first color pictures were made from the air, they were exposed on Finlay plates, not on Autochromes. Finlays, which used a grainier emulsion and a dot pattern screen, was marginally faster, fast enough to be used on the relatively stable platform of a dirigible. Soon thereafter the Finlays began displacing the Autochromes, to be superseded in turn by film-based Dufaycolor before Kodachrome swept the field, opening a new era altogether.

By then the Autochrome had sunk into obscurity at the Geographic, the last one being printed in the 1940s. Altogether over 2,300 of them had been published in the quarter century of their reign.

Today, however, the Finlay plates have all fallen out of register, leaving only the black-and-white image behind. But tucked into their paper sleeves the Autochromes, which first brought the world in "natural colors" to millions of people, have proved remarkably resilient. Nearly 15,000 of them are in the Image Collection, and many still hold their magical color, the perfect color for portraying a vanished world; a world seen without war, without turmoil; a world soft, quiet, autumnal, and serene.

Franklin Price Knott, Unknown, Egypt

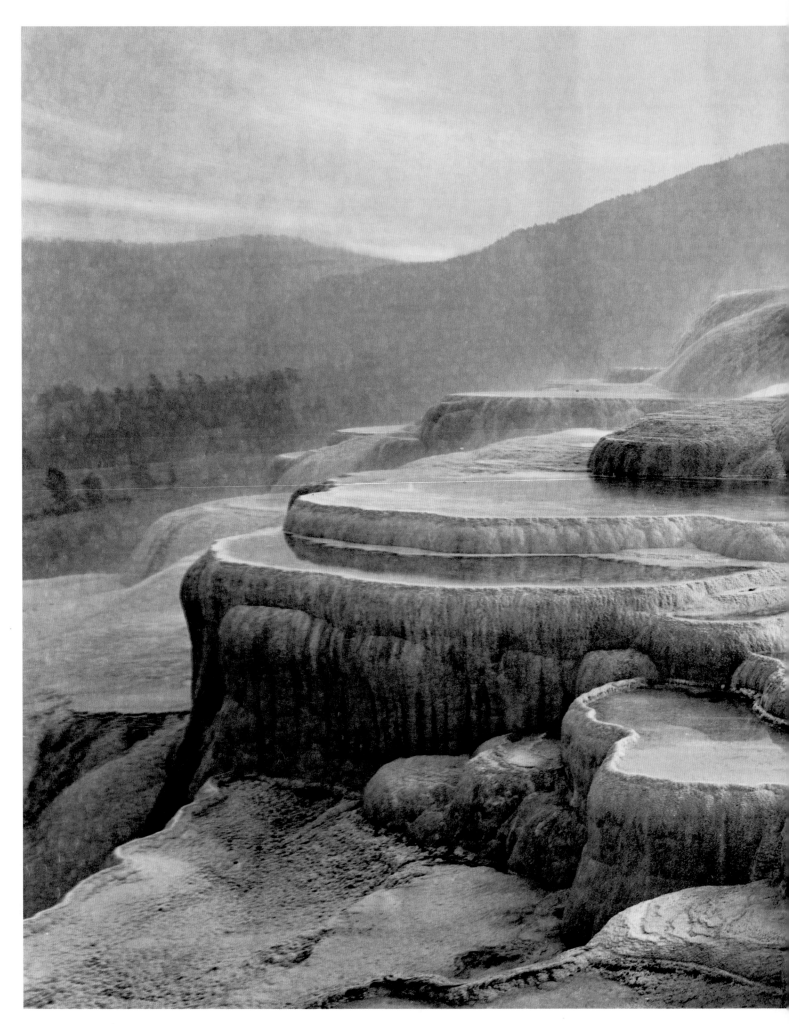

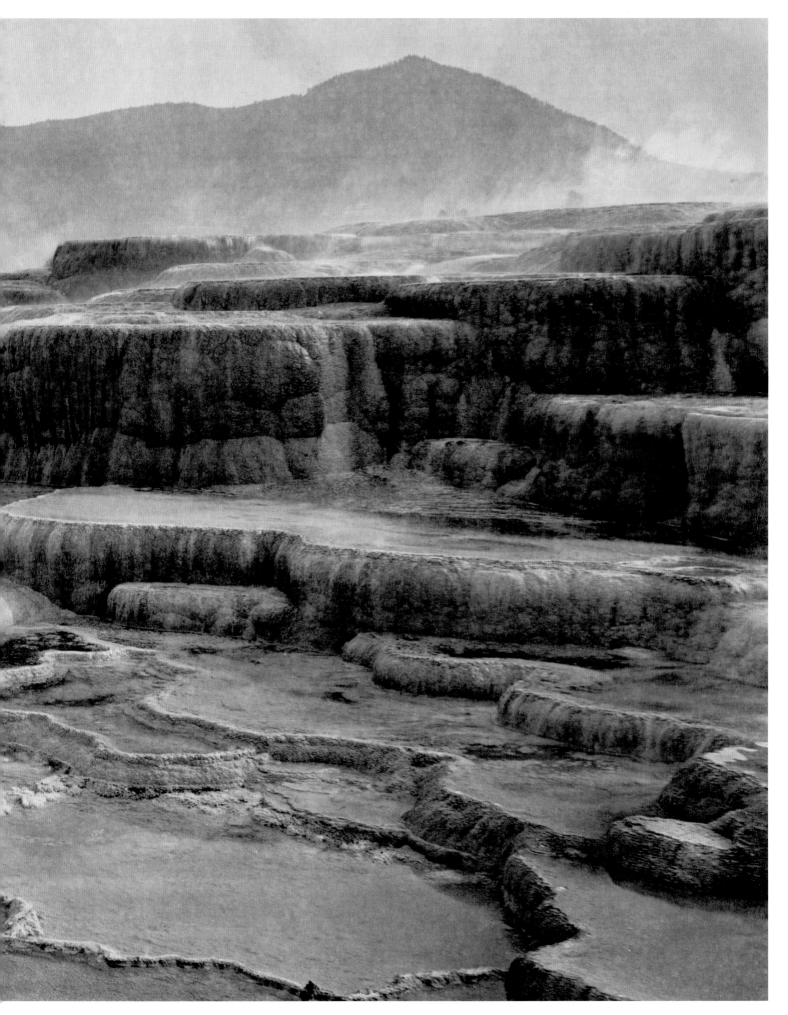

WILLIAM HENRY JACKSON | 1871 | WYOMING *Mammoth Hot Springs in Yellowstone*

THE BLACK & WHITE PRINTS

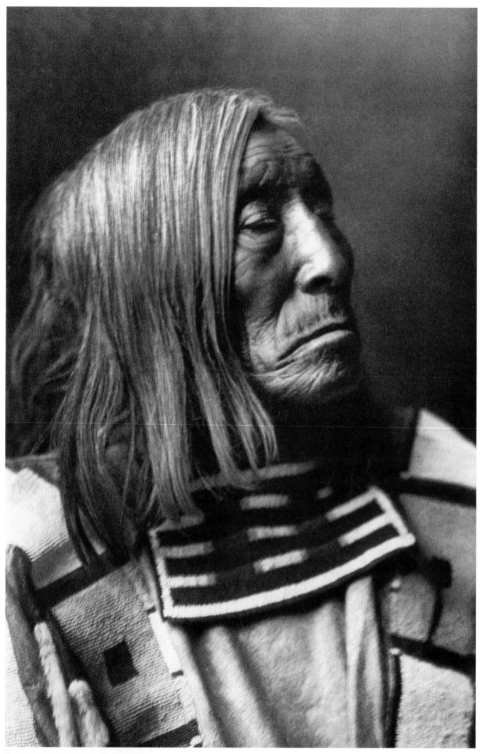

Edward S. Curtis, Unknown, Montana

LOOMING 14 FEET TALL and running seemingly into infinity, the shelves holding the Society's black-and-white print collection are completely filled with brown accordion files. Arranged geographically, beginning with Africa, they are filed not so much by the names of today's countries and continents but more often by those of yesterday. For to plunge into the black-and-white collection is to vanish into the past—it might be for a very long time, for nearly 500,000 prints are there, only a fraction of which have ever been published.

Reach anywhere into that past world—Abyssinia, for instance—and the prints found there will be mounted on boards, with captions, dates, credits, and relevant indexing information written on the back, alongside the occasional cryptic, and endlessly intriguing, comment. Such prints represent a time when pictures were assiduously collected from any and every source, a time rooted in the early years of the 20th century and the editorial genius of Gilbert Hovey Grosvenor.

Once Grosvenor and his endlessly inquisitive father-in-law, Alexander Graham Bell, had steered the *National Geographic* magazine on a photographic course, the young editor determined to build a stockpile of pictures. It would be a collection to draw from when needed, a repository containing more pictures, perhaps many more, than would ever likely be published. He bought collections seen and unseen; he picked up pictures on his travels; he tapped the endless supply of U.S. government plates and prints; but mostly he depended on a polyglot group of travelers, soldiers, diplomats, journalists, scientists, explorers, and the occasional rogue to provide him with photographs from the far parts of the world. The stockpile became the kernel of what, as the years and decades rolled past, became the black-and-white collection.

Yet not every print is snug in its brown accordion folder. There are collections within the collection, portfolios and albums containing enough related pictures to warrant a separate status. Many were simply picked up somewhere along the way. There are, for instance, the five large albums containing some of William Henry Jackson's original albumen prints. Widely regarded as *the* pioneering photographer of the American West, Jackson photographed in Nebraska, Wyoming, and Colorado in the 1870s while accompanying one of the great Western surveys that eventually coalesced in the U.S. Geological Survey. (The prints, in fact, are mounted on pages displaying the U.S.G.S. emblem.) There is also, in the Society's Rare Book Room, a rare complete set (number 276 of 300 printed) of Edward Curtis' monumental *The North American Indian*, all 20 volumes of it, which with the 20 additional portfolios of gravure prints make over 2,000 portraits of the 80 Indian tribes still found west of the Mississippi in Curtis' day.

Alexander Graham Bell originally obtained the first volume of this Curtis set; the great inventor is himself honored in the Bell Collection, 1,600 prints of tetrahedral kites and other fantastic flying machines, or the Aerial Experimental Association, or family life in and around the Bell summer estate in Nova Scotia.

In the late 1870s a Harvard graduate named Charles Harris Phelps embarked on a two-year round the world honeymoon. The marriage might not have lasted, but the pictures have, 26 portfolios of them—views, landmarks, cities, countryside, ruins, ceremonies—pictures from Java to Japan, India to Italy, the Balkans to the Baltic. Decades later, the enigmatic A. W. Cutler, of "Rose Hill House, Worcester, England," made some splendid pictures of Britain and Ireland for Grosvenor, who then sent him to Portugal and Italy for more, only the gentleman died of malaria in Calabria. Nevertheless, Cutler bequeathed his entire collection to the Geographic, and Grosvenor treasured those negatives for years.

Sometimes the collecting zeal ran to extremes. There are in the archive 200 prints made by Baron Wilhelm von Gloeden, the turn-of-the-century German expatriate whose portraits of young Sicilian men, garbed in classical wreaths and little else, long appealed to certain of the cognoscenti. These prints were obtained by Admiral Chester Colby, a veteran member of the Society's board, probably more out of ardor than aesthetics. Most of them, understandably, have never been published in the magazine. But after Mussolini's thugs destroyed so many of von Gloeden's negatives, such col-

Luis Marden, 1936, Guatemala

lections of his prints have assumed increasing importance.

The black-and-white collection not only affords a trip around a vanished world; it also provides a journey through the early years of the National Geographic itself. There are, for instance, the pictures of Lhasa, still in the box in which they arrived, that when published in the January 1905 issue did so much to spur popular interest in the magazine. Then there are George Shiras' original glass-plate negatives, some of the most important images in the history of wildlife photography. First published in the magazine in 1906, the nocturnal images of startled deer captured by flashlight launched the magazine in a direction from which it has never looked back.

Then again, the whole romantic story of the Society's early voyages and expeditions is also found among those tall shelves. Long before the explorer Anthony Fiala accompanied Theodore Roosevelt to the River of Doubt he led several abortive expeditions to the Arctic. The Ziegler Polar Expeditions of 1901-02 and 1903-05 came nowhere near the goal of reaching the North Pole, but you wouldn't know it from Fiala's lantern slides, glass plates, and negatives, which hold some classic images of dog-sledding excursions made at the height of the "heroic age" of polar exploration. So do the 7,000 prints that constitute the voluminous Robert E. Peary Collection, which ranges from some curious "ethnographic" studies of Intuit physical types to the much scrutinized, much debated images taken (or not) at the North Pole itself.

After Grosvenor, in 1911, listened to Hiram Bingham describing the site of Machu Picchu high in the Peruvian Andes, the National Geographic joined Yale in sponsoring several seasons of excavation there. The perennial appeal of Machu Picchu is due in no small part to the 9,000 prints in the Bingham Collection, which not only painstakingly document each stage in the labor, each wall cleared, each bit of masonry unearthed, each granite staircase tumbling sheer down the breathtaking slope, they also capture the excitement of exploration the old-fashioned way in a spectacular part of the world.

The Valley of Ten Thousand Smokes is the evocative name given the strange volcanic wonderland that Robert F. Griggs discovered in Alaska after Mount Katmai's tremendous 1912 eruption. A broad valley of steaming fumaroles, it offered a sublime vista to which no camera could do justice, although the 7,000 prints in the Image Collection represent the attempt to do just that. Publication of only a fraction of these pictures led President Woodrow Wilson to declare the Valley of Ten Thousand Smokes a national monument.

Dig a little deeper, and there are the 22 albums of prints illustrating the launches of the National Geographic-U.S. Army stratosphere balloons *Explorer I* and *Explorer II*, which latter attained a manned height record, towering nearly 11 miles in the sky, which stood for 21 years. They depict the launching site, the "Strato-Bowl," in South Dakota, the great tent city, the balloons as tall as a ten-story building, the daredevil aeronauts wearing leather football helmets—every aspect of those now-largely forgotten events that gave birth to the space program.

And on to the other side of the world, where more than 500 prints are marked "Byrd Antarctic Expedition." The Society helped sponsor Admiral Richard E. Byrd's highly mechanized assaults (1928-1930 and 1933-35) on the great white continent. The small armies of men and machines seen going about their duties marked the effective end of the heroic age of exploration. Nevertheless, at this same time, Grosvenor obtained not just one but two sets of Herbert Ponting prints depicting Captain Robert Falcon Scott's classic 1910-1912 Antarctic expedition. There was no editorial use for them, he admitted, but he wanted the more than 1,000 prints for

their historical value alone; they were something the Geographic should have.

There are a further nine albums of prints made by Bradford Washburn on his 1936 expedition to the Yukon, a world of majestic, glittering peaks and glaciers only just beginning to be mapped. And although ten of his abundantly illustrated articles were printed by the magazine in the 1920s and '30s, there still remain 2,500 of Joseph Rock's pictures of "the land that time forgot" in far southwestern China that have never yet been published.

Black-and-white photography at the Geographic rolled on, decade after decade, until the end of the 1950s. The gem-cut, large format negatives staff photographers made with their Linhofs; the square-cut, medium format ones they took with their Rolleiflexes, still offer abundant evidence of black-and-white's enduring appeal. It might have been the preferred medium for art photographers and photojournalists alike, but at the magazine, where color was king, black-and-white came to play a workmanlike role. Though it had carried the burden of National Geographic photography for so many years, when the magazine finally went all color in 1962, it retired from those pages altogether.

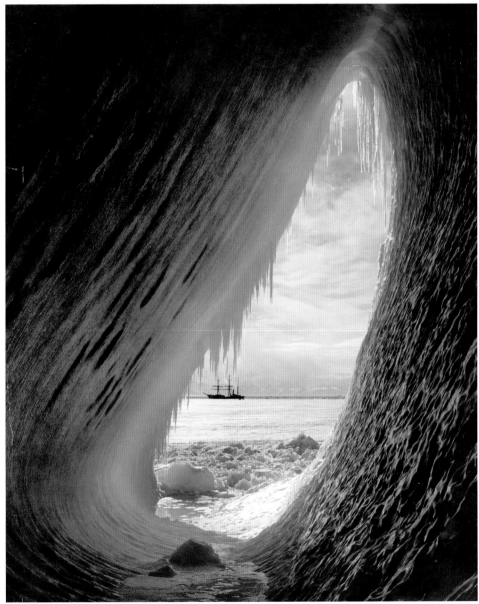

Herbert G. Ponting, 1922, Antarctica

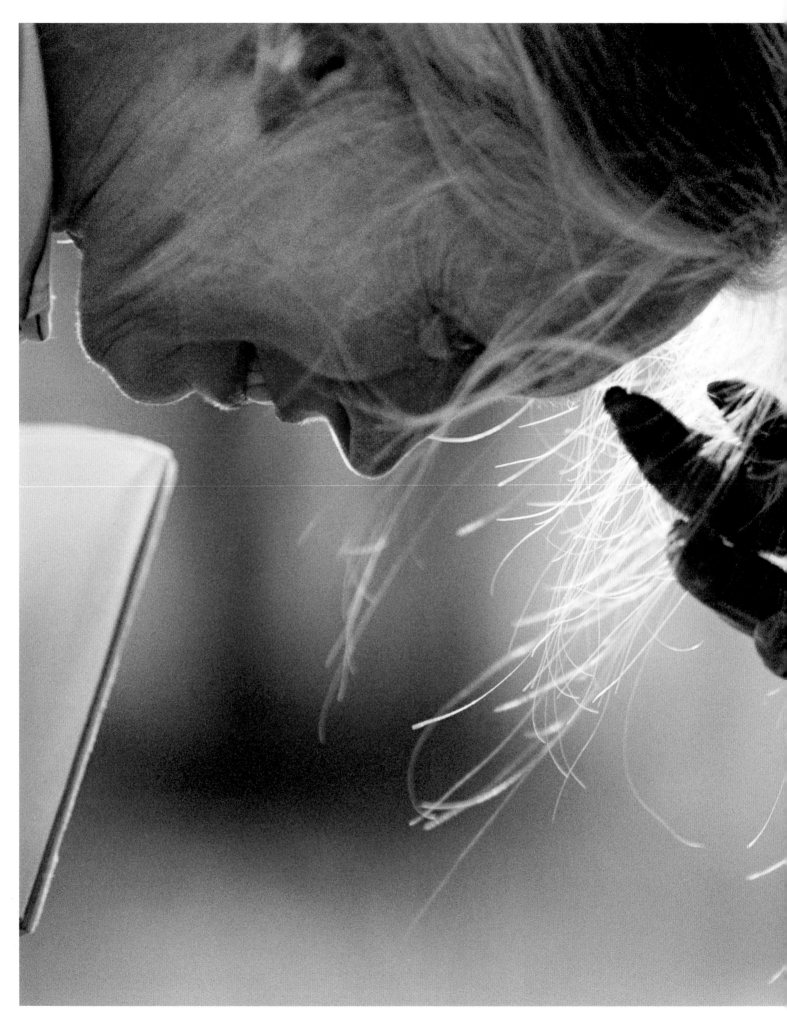

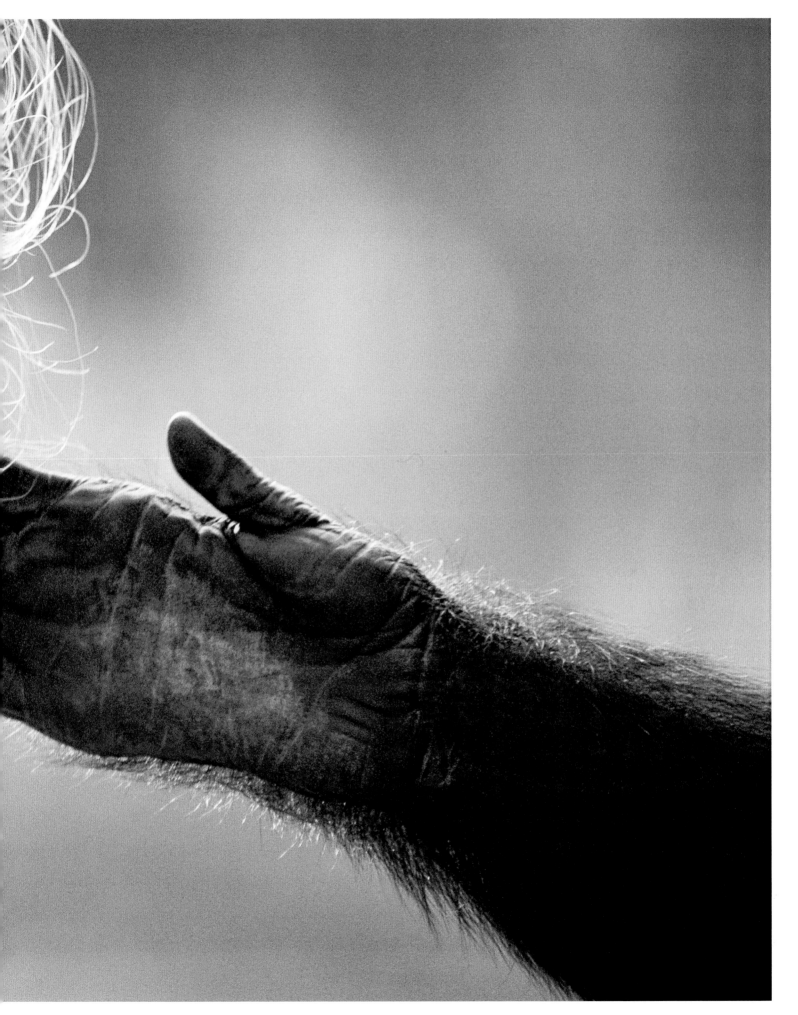

THE COLOR TRANSPARENCIES

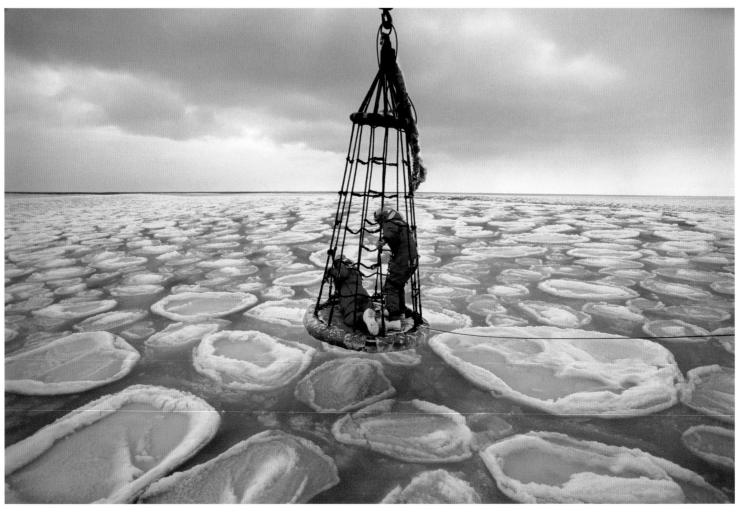

Maria Stenzel, 1996, Antarctica

IN OUTWARD APPEARANCE identical clones, distinguished only by the occasional notes and comments scribbled over some of their mounts, the slides line up by the million in long metal drawers, in filing cabinets, in cold dark storage. Each individual, mount included, is approximately two inches square; each has a single rectangular eye, set in a 3:2 aspect ratio, 24x36 mm, which, it has been observed, is very close to the proportions of the golden rectangle, supposedly the most pleasing of geometrical forms, found in the façade of the Parthenon as well as the whorl of the chambered nautilus.

That is certainly what it has been for the National Geographic Society, for, the accidental resemblance between the golden rectangle and the yellow rectangle that is the Society's logo aside, the 35mm transparency has played a central role in the evolution of National Geographic photography. And though the emulsion residing within those golden dimensions may differ—it may be Ektachrome or Ansochrome, for instance—by far and away the vast majority of those 35mm legions are Kodachrome. Surely one of the most repeated phrases in the history of the magazine must be that which appeared beneath innumerable pictures: "Kodachromes by _____"

In 1925, when the E. Leitz Company of Wetzlar, Germany, first introduced the Leica (*Leitz camera*), few people could have foreseen the revolutionary effect a 35mm camera would

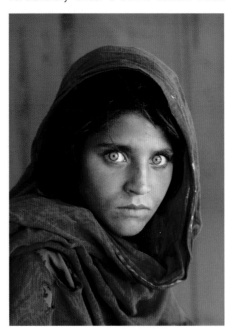

Steve McCurry, 1985, Afghanistan

have on photography. After all, the "miniature camera," as it was tagged, used tiny bits of old movie film, each frame no bigger than a postage stamp, which meant that it would have to be considerably enlarged before it could be of any use. Too much enlargement usually entailed some degradation in quality. Shortly thereafter, the first Leica appeared at the National Geographic, but significantly enough, it was purchased not by a photographer but rather by a writer.

The illustrations hierarchy at the Geographic was too wedded to the large format cameras that produced the tack-sharp negatives, easily engraved for optimum magazine reproduction, to give the toy "miniature camera" anything but a scornful look. Yet the Leica was making inroads on professionals elsewhere, who saw in its portability and proverbially quiet shutter an unobtrusiveness that allowed for a more natural, spontaneous kind of photography. When Luis Marden showed up at the Geographic for his first day of work in 1934, he had a Leica hanging from his neck. Despite having written a book on color photography with the "miniature camera" he had little opportunity of using it until, two years later, he tested some rolls of Eastman Kodak's new film, Kodachrome. Instantly he saw in the virtually grainless, (somewhat) fast film the royal road to a brighter future for the color-

obsessed National Geographic. Thus he was the first to champion the 35mm-Kodachrome combination that would become the magazine's most durable signature.

Although initially skeptical, even the hierarchy could see the rich color that Kodachrome promised, and once the technical challenge of engraving from the postage stamp-size negative was solved, it embraced the new format wholeheartedly. It was a tremendously exciting time, as Marden and such colleagues as W. Robert Moore, B. Anthony Stewart, and Volkmar Wentzel felt liberated from the tyranny of the tripod. The first Kodachromes were published in 1938; only two years later, of the 393 color photos published in the magazine, 350 were 35mm Kodachromes.

By World War II National Geographic was leading the magazine world in the editorial use of 35mm color. In the traveling kit of its staff photographers the large-format Linhofs and Graflexes and medium-format Rollieflexes were ceding priority to the now-privileged Leica, which was solely reserved for color work. That led to an occasional irony: Kodachrome, with an ASA rating of 8, was still not fast enough to capture dramatic action except in broad daylight, so the portable Leica was often on the tyrannous tripod while the Rollieflex, charged with black-and-white film, was kept in the hand.

Field photographers in the 1940s and '50s, however, were more hobbled by the realities of National Geographic publishing at that time. Editors still demanded the scenic color that characterized the "humanized geography" that was obtained before the war. The advantages of 35mm were often wasted on contrived setups using models decked out in red scarves or sweaters, also part of the photographers' traveling kit because red was said to make Kodachrome "pop."

It remained for a new generation of staff photographers to overturn the old editorial order and get the most out of the versatile 35mm format. In 1957, Melville Bell Grosvenor, son of the pioneering editor who had been for so long the Society's guiding spirit, took the helm for a decade. He recruited young photographers trained by the rigors of daily newspaper work or at the University of Missouri School of Journalism: Bill Garrett, Tom Abercrombie, Dean Conger, Win Parks, George Mobley, Jim Blair, Bruce Dale, and Jim Stanfield among them. And "at the heart of his system," remembered Garrett of Grosvenor, "like the core of a nuclear reactor—he enshrined the magical little 1x1½-inch color slide."

Everything was bent to its service. New printing presses provided capacity for an all-color magazine. New films were tested—including Kodachrome II and High-Speed Ektachrome—to fill its magic proportions. New single-lens reflex cameras were adopted in preference to the old Leica rangefinders. By the early 1960s, staff photographers armed with SLRs were shooting about 20 percent less film on any given assignment. And that was important because the tide of 35mm transparencies was starting to flood: In 1961, for instance, more than 3,600 36-exposure rolls of Kodachrome alone were logged in, not to mention rolls of Ektachrome and other formats. Those numbers would only swell.

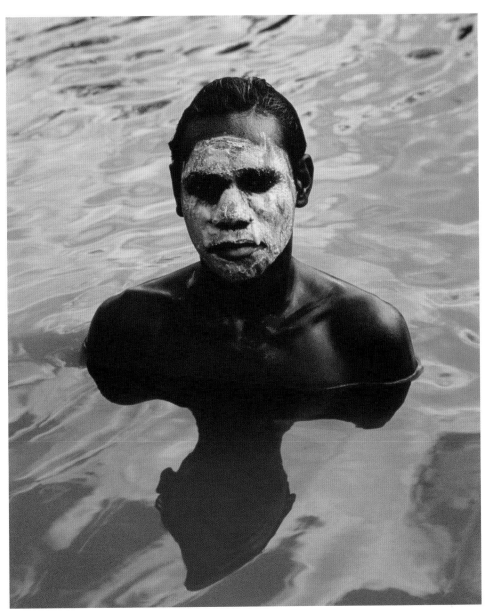

Sam Abell, 1996, Australia

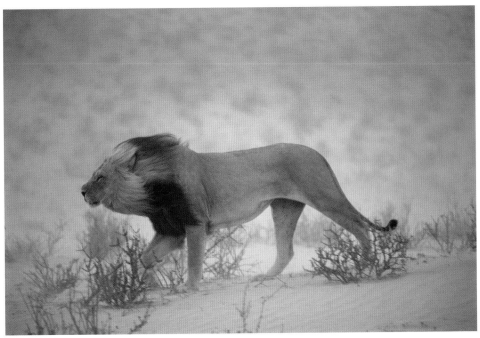

Chris Johns, 1995, South Africa

William Albert Allard, 1994, Italy

images—35mm transparencies, medium-format cut film negatives, black-and-white prints, and more, assembled by Illustrations Editor Jon Schneeberger. It includes images of rocket launches as well as pictures documenting astronaut training and aerospace work all over the country. It also holds spectacular images made by the astronauts themselves, because Schneeberger ensured that National Geographic received from NASA a master copy of all mission photography from Apollo through the space shuttle.)

By the 1970s and '80s, under the leadership of Editors Gilbert M. Grosvenor, third of his family to serve, and Bill Garrett, the tide of 35mm documentary photography at the magazine only continued to advance. National Geographic photographers garnered a stupefying number of national awards and accolades. Legendary Director of Photography Robert E. Gilka harnessed a pool of talented staff as well as contract and freelance photographers, including Sam Abell, Bill Allard, Jodi Cobb, and Dave Harvey, many of whom developed distinct individual styles that sometimes complemented and sometimes diverged from traditional Geographic norms. All were equipped with 35mm.

Increasingly sophisticated cameras, equipped with battery-powered motor drives, autoexposure, and autofocus, coupled with advanced electronic flash, allowed for greater flexibility in illustrating scientific and technological stories. An already versatile system, 35mm was given even broader latitude by ingenious tinkering in the Society's lab and custom equipment shops. There was hardly a subject, it seemed, that given enough flair and imagination, a photographer could not cover using the format.

Above all, however, a fully fledged photojournalism was at last liberated. The images accompanying articles on South Africa, Haiti, or Harlem turned the old pattern on its head: Here poverty and despair and injustice coexisted with smiling faces or scenic grandeur. An increasingly ecological turn led to in-depth coverages of pollution, pesticides, energy challenges, water resources, deforestation, and the decline of biodiversity. It was all captured on those magical little slides.

The staff photographer's kit, by the 1960s, had also changed in response. Gone were the larger-format cameras that had once carried the burden of black-and-white. With occasional exceptions for specialized needs, and the Polaroids for making friends and checking exposure, it was all 35mm: one to three Nikon Fs, perhaps, with a full complement of lenses from 21mm to 400mm, and some Leicas for good measure.

The resulting images bloomed in the magazine and overran the staid old oak-and-laurel cover. The Kodachrome-infused articles were a heady mixture of travelogue, Vietnam, archaeology, and such photogenic characters as Louis Leakey, Jane Goodall, and Jacques Cousteau. Portable 35mm cameras could be carried to the summits of the highest mountains. Together with faster films they promoted a flowering of wildlife photography; images of birds on the wing and animals on the move were made with greater accuracy and artistry. Luis Marden and Bates Littlehales pushed the frontiers of modern underwater photography using 35mm; they passed the torch, or rather the Oceaneye 35mm underwater housing Littlehales helped devise, to their acolyte, David Doubilet, now widely recognized as one of the great masters of the art. And a host of Geographic photographers snapped pictures of every aspect of the manned space program from Projects Mercury to Apollo. (Two large cabinets house what is called the Space Collection, a treasury comprising some 80,000

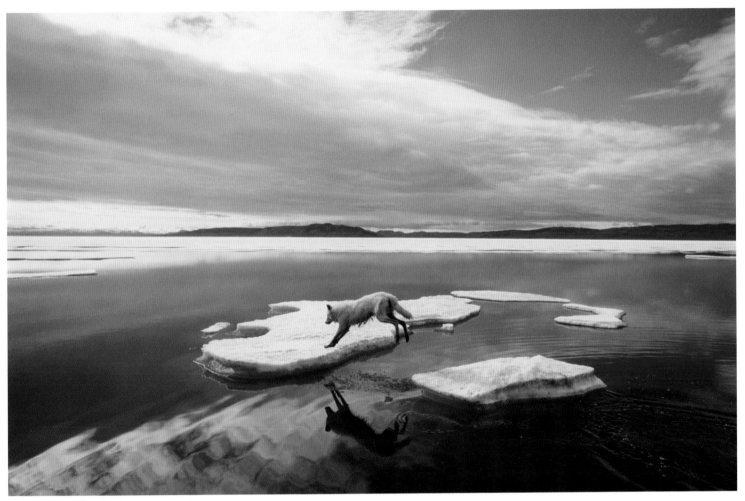

Jim Brandenburg, 1987, Canada

Though the magazine did not cover breaking news, save for the occasional natural disaster, it did publish articles on the geographical context giving rise to the headlines. Articles on the Middle East might depict a war-torn Beirut, while those on the Soviet invasion of Afghanistan portray that conflict's toll on human beings. What many people have come to see as the "iconic" National Geographic image—Steve McCurry's 1985 portrait of Sharbat Gula, the "Afghan Girl," was made on 35mm Kodachrome.

That was when 35mm was at full flood. Day in and day out, the shipments would roll in—36 rolls to a shipment—thousands of transparencies flowing in from every point of the compass and depicting a bewildering variety of subjects. Once processed, they entered the bloodstream of the Society; were arranged and spread out across light tables, where their fate was summarily meted out—discards, file selects, seconds, firsts—even images of exceptional quality might not make the final cut. The chosen few that did were then pumped into the Society's books, magazines, filmstrips, and educational products. Once published, the images went out to the world, educating, illuminating, and inspiring millions of people, while the slide joined the hosts of its fellows, taking up its appointed place in one of those long metal file drawers.

Now that, too, has passed. Inevitably, the usurper has been in turn usurped. It had a long reign, spanning some six decades, and though today the tide of transparencies is on the ebb, giving place faster and faster to the onrush of electronic images, its rival and successor has adopted many of its features. Digital cameras are often styled like 35mm ones, and those equipped with a full-frame sensor have inherited the golden rectangle.

Before the digital shadow fell across those banks of slides, Luis Marden, who had played such a pivotal role in ushering in the Kodachrome era, looked about him and saw the triumph of 35mm color in everything from family snapshots to scientific applications to the gallery wall. A photographer, he once mused, could only be thankful to have lived through "the greatest revolution in photography since the invention of film."

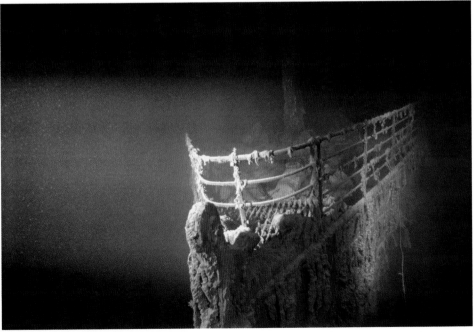

Emory Kristof, 1991, Atlantic Ocean

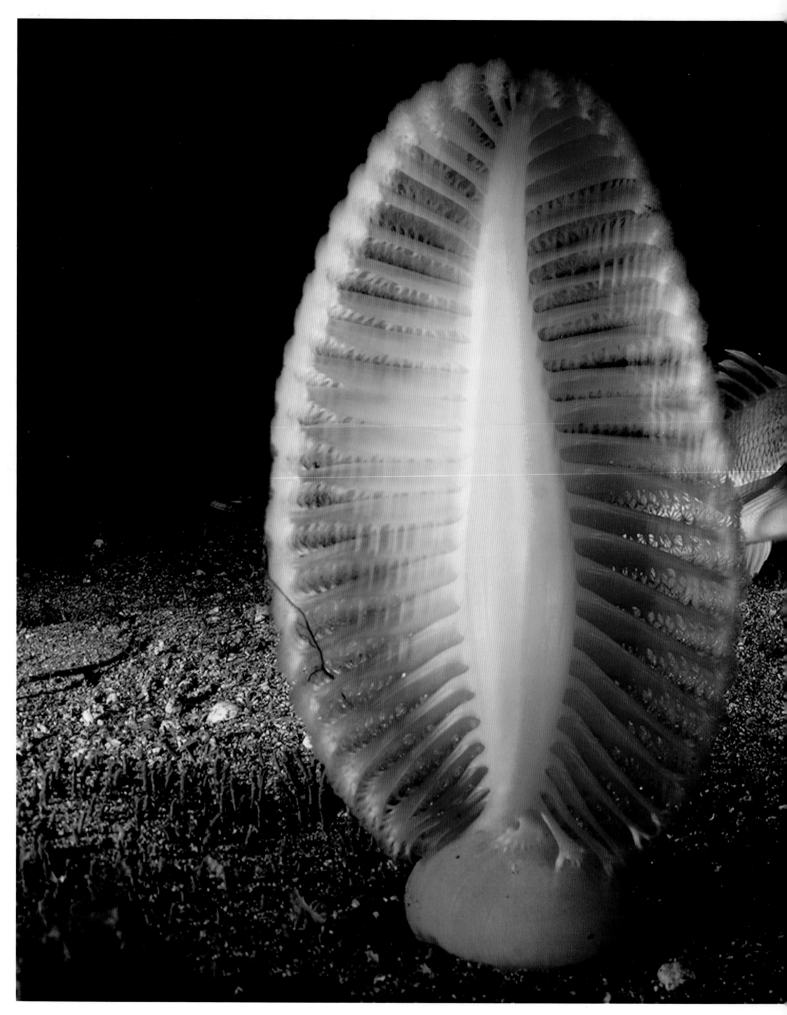

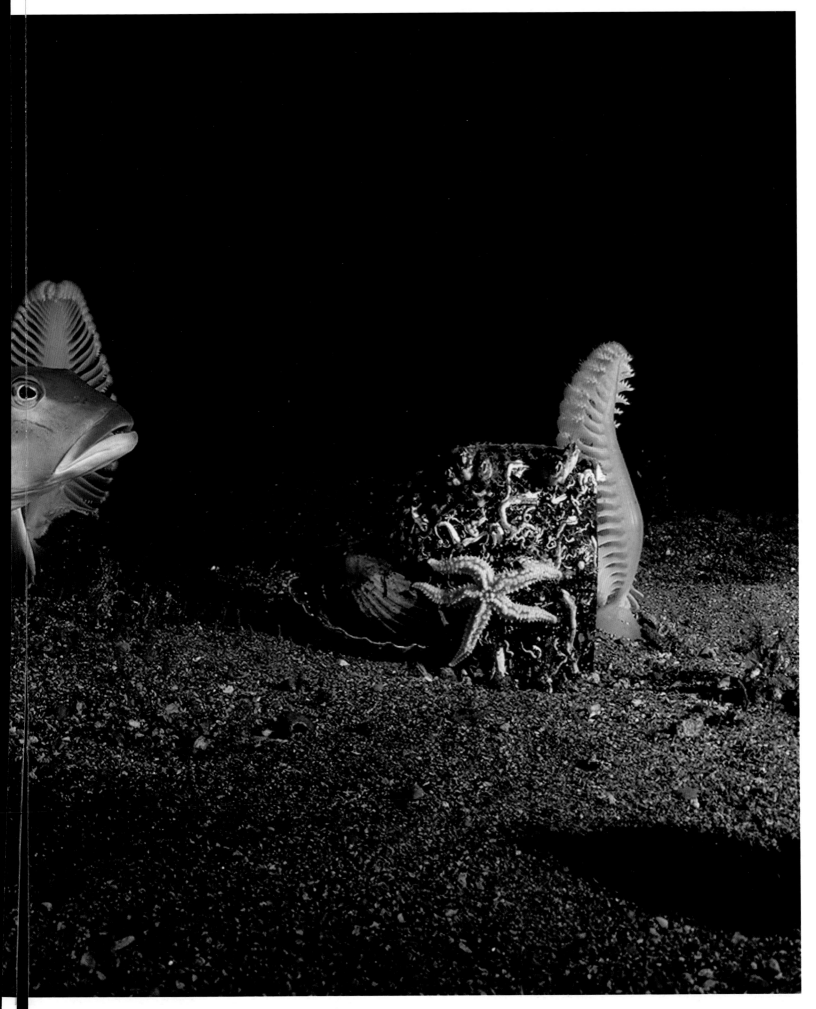

DIGITAL

WHEN IN THE 1970s Emory Kristof embarked on his career-long photographic exploration of the deep sea, he rigged up 35mm cameras and lowered them into the deep. He has ever since been tethering or mounting ingeniously devised imaging systems to longlines, submersibles, or remotely operated underwater robots. With these he has made pioneering images of shipwrecks and sea creatures in the dark abyss. In 1997, having lowered a computer-controlled digital video camera a mile into the ocean off New Zealand, he filmed a sequence of a squid attacking a shark. When frames from that video were published in the June 1998 *National Geographic*, they were probably the first digital images ever printed in the magazine.

They would not be the last. But at least four years passed, while the Geographic kept a weather eye on the new technology, before the illustrations for a major magazine article on the future of flight, published in December 2003, were planned as being all digital from the get-go. Photographer Joe McNally had proved himself a wizard depicting technological subjects with 35mm. Cutting-edge digital seemed somehow appropriate for photographing dazzling new supersonic aircraft, but it also offered other advantages photographers were discovering: wider amplitude in the kinds of images possible, and greater freedom in the making of them.

Underwater photographers like Brian Skerry and Paul Nicklen, for instance, are not limited to shooting a 36-frame roll at a fixed ISO before having to surface to change film. They can now shoot hundreds of pictures on a single dive, and as light conditions change, raise or lower the camera's ISO correspondingly. They can move back and forth from portraits of sea creatures to depictions of entire ecosystems with comparative ease.

So can wildlife photographers like Beverly Joubert, photographing leopards in the dappled sun and shade of the wooded savanna. No more great shots missed because she was changing rolls. No more fumbling for a different speed film when the quarry moves deeper into the gloom. The ability to run up and down the ISO scale allows her to shift her focus from sunlight to shadow instantly while maintaining the proper exposure. The result is more and better pictures and a better understanding of such intriguing animals.

What George Shiras, stringing his clumsy trip wires back in 1900, might have given for the camera traps Nick Nichols devised to photograph elephants is anyone's guess. The pioneering wildlife photographer of a century ago had only one shot at any animal that happened to trip the wire at night—flash, bang, develop the single plate the next morning, and hope for the best. Digital camera traps today can take hundreds of pictures under a great range of lighting conditions, providing a more comprehensive portrait of elephant habits and activities. As a result, Nichols is getting not just stunning pictures but is adding to our knowledge of these majestic beings as well.

In 1971, naturalist George Schaller had made the first photographs of rare snow leopards in the wild, glimpsed through a telephoto lens and

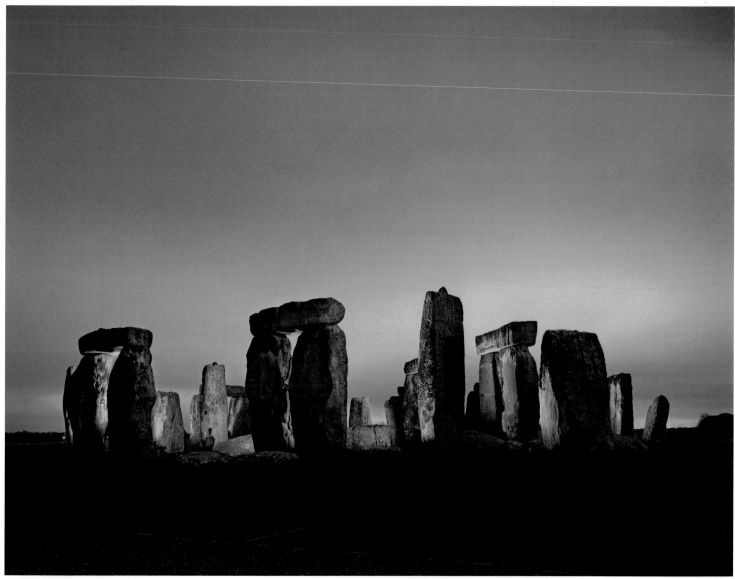

Ken Geiger, 2008, England

a screen of swirling snow. Steve Winter, using a digital camera trap, has obtained a breathtaking up-close image of this most beautiful but elusive of creatures.

Even photojournalists and street shooters are acknowledging the advantages of digital photography. And it's not merely the ability to slip indoors or outside without having to change film or worry about the effects of flash. Photographers in the field once worked blind. They depended on periodic reports from headquarters informing them about the quality of their exposures. Today they have the luxury of checking those exposures with their own eyes—instantly. It's comforting to know that never again, dozens of rolls into an assignment, will they be cabled that their camera seems to be malfunctioning, that all their hard-won pictures are, say, light-struck. Those photographers working for weeks on end in remote places are also freed of one of 35mm's most onerous burdens: the slew of film-crammed Halliburton cases they had to drag from airport to back of beyond and then protect against heat, humidity, and rain. Today the kit is stripped down almost to cameras, memory cards, lenses, and laptop.

There are photographers who still feel that film has a look and feel about it that digital, despite its many advantages, can't always emulate. Yet even they are subject to the digital nature of today's workflow, for sooner or later their transparencies must be scanned as part of the print production process. For the most part, however, the flood of film that once streamed into headquarters has

David Liittschwager, 2007

ebbed. Today it is about hard drives, and digital images are stored on computer servers.

So with each new published image and each new digital file select cataloged, a new chapter is being added to the story of the Image Collection. The digital archive is comparatively small but

growing rapidly—and it has this advantage over the small stockpile of pictures that originally gave rise to the Collection: it is being daily swelled by newly scanned images pulled from that Collection's broad and deep repository, legacy of a century and more of National Geographic photography.

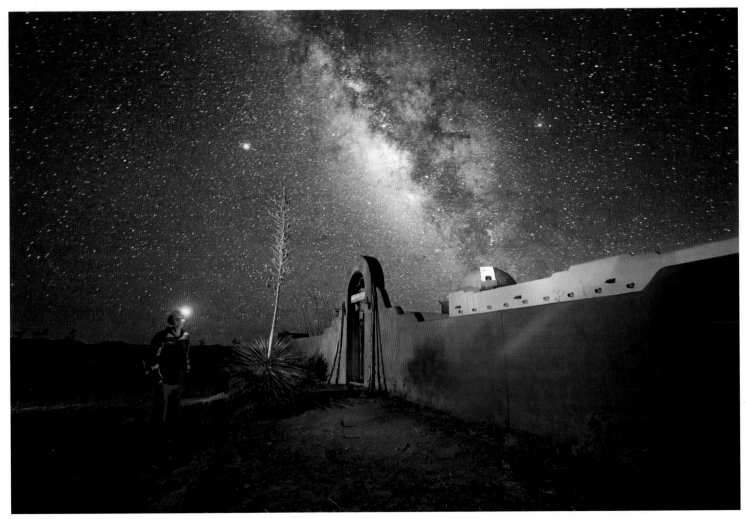

James Richardson, 2008, Arizona

NATIONAL GEOGRAPHIC
IMAGE COLLECTION

Published by the National Geographic Society

John M. Fahey, Jr., *President and Chief Executive Officer*

Gilbert M. Grosvenor, *Chairman of the Board*

Tim T. Kelly, *President, Global Media Group*

John Q. Griffin, *Executive Vice President; President, Publishing*

Nina D. Hoffman, *Executive Vice President;*
 President, Book Publishing Group

Maura Mulvihill, *Vice President, Image Collection and Image Sales*

Prepared by the Book Division

Barbara Brownell Grogan, *Vice President and Editor in Chief*

Leah Bendavid-Val, *Director of Photography Publishing*
 and Illustrations

Marianne R. Koszorus, *Director of Design*

Carl Mehler, *Director of Maps*

R. Gary Colbert, *Production Director*

Jennifer A. Thornton, *Managing Editor*

Meredith C. Wilcox, *Administrative Director, Illustrations*

Staff for This Book

Leah Bendavid-Val, *Editor*

Adrian Coakley, *Illustrations Editor*

William Bonner, Steve St. John, *Contributing Illustrations Editors*

Melissa Farris, *Art Director*

Rebecca Lescaze, *Text Editor*

Mark Collins Jenkins, *Contributing Writer*

Mike Horenstein, *Production Project Manager*

Marshall Kiker, *Illustrations Specialist*

Al Morrow, *Design Assistant*

Michael J. Walsh, *Contributing Designer*

Manufacturing and Quality Management

Christopher A. Liedel, *Chief Financial Officer*

Phillip L. Schlosser, *Vice President*

Chris Brown, *Technical Director*

Nicole Elliott, *Manager*

Rachel Faulise, *Manager*

Kodak

National Geographic Image Collection is published in conjunction with a major exhibit sponsored by Eastman Kodak Company at National Geographic headquarters in Washington, D.C. For more than a century, National Geographic and Kodak have shared in breakthroughs in every sphere of traditional and digital photography. Kodak technology has made many of the pictures in this book possible, and this book itself was produced using Kodak digital prepress technology, including software, computer-to-plate machines, and digital printing plates.

The National Geographic Society is one of the world's largest non-profit scientific and educational organizations. Founded in 1888 to "increase and diffuse geographic knowledge," the Society works to inspire people to care about the planet. It reaches more than 325 million people worldwide each month through its official journal, *National Geographic,* and other magazines; National Geographic Channel; television documentaries; music; radio; films; books; DVDs; maps; exhibitions; school publishing programs; interactive media; and merchandise. National Geographic has funded more than 9,000 scientific research, conservation and exploration projects and supports an education program combating geographic illiteracy. For more information, visit nationalgeographic.com.

For more information, please call 1-800-NGS LINE
(647-5463) or write to the following address:

National Geographic Society
1145 17th Street N.W.
Washington, D.C. 20036-4688 U.S.A.

Visit us online at www.nationalgeographic.com

For information about special discounts for bulk purchases, please contact National Geographic Books Special Sales: ngspecsales@ngs.org

For rights or permissions inquiries, please contact National Geographic Books Subsidiary Rights: ngbookrights@ngs.org

For professionals interested in licensing images,
visit www.nationalgeographicstock.com

Illustrations credits for "The Photographers": 472 lower right, William Allen; 473, Robert F. Benson; 475 upper right, Bruce Dale; 476 upper right, Gilbert H. Grosvenor; 477 lower left, Wilbur E. Garrett; 479 right, Winfield I. Parks. Jr.; 480 upper, Peter Wilkins; 481, James E. Russell; 483 lower left, Mauricio Handler; 483 lower right, Toby Bakos; 484 upper right, Kenneth Love; 485 upper left, Courtesy the Weems Family

Library of Congress Cataloging-in-Publication Data
National Geographic Image Collection.
 p. cm.
ISBN 978-1-4262-0503-3 (hardcover)
 1. National Geographic Society—Photograph collections. 2. Travel photography. 3. Nature photography. 4. Documentary photography. I. National Geographic Society (U.S.)
 TR 790 .N36 2009
 779—dc22
 2009012387

Printed in Italy

09/MV/1